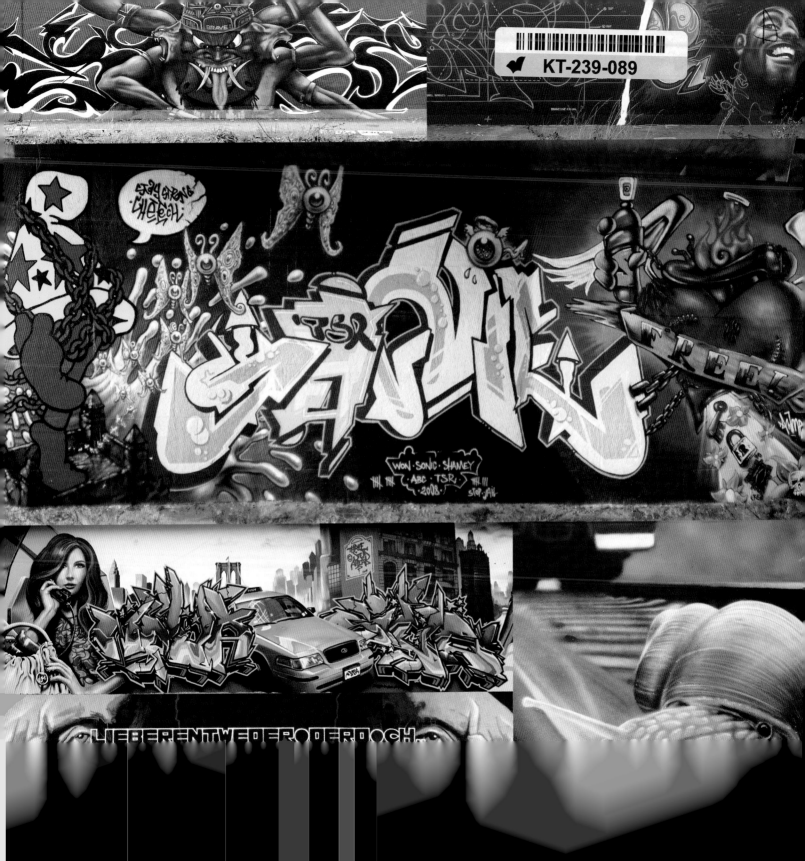

1,000 IDEAS FOR GRAFFITI AND STREET ART

Cristian Campos

ROCKPORT

Books are to be returned on or before
the last date below.

3 0 NOV 2011

LIBREX-

Copyright © 2010 by **maomao** publications
First published in 2010 in the United States of America by
Rockport Publishers, a member of Quayside Publishing Group
100 Cummings Center
Suite 406-L
Beverly, MA 01915-6101
Telephone: (978) 282-9590
Fax: (978) 283-2742
www.rockpub.com

ISBN-13: 978-1-59253-658-0
ISBN-10: 1-59253-658-1

10 9 8 7 6 5 4 3 2 1

Publisher: Paco Asensio
Editorial coordination: Anja Llorella Oriol
Editor and texts: Cristian Campos
Art director: Emma Termes Parera
Layout: Maira Purman
English translation: Cillero & de Motta

Editorial Project:
maomao publications
Via Laietana, 32 4th fl. of. 104
08003 Barcelona, España
Tel. : +34 93 268 80 88
Fax : +34 93 317 42 08
www.maomaopublications.com

Printed in China

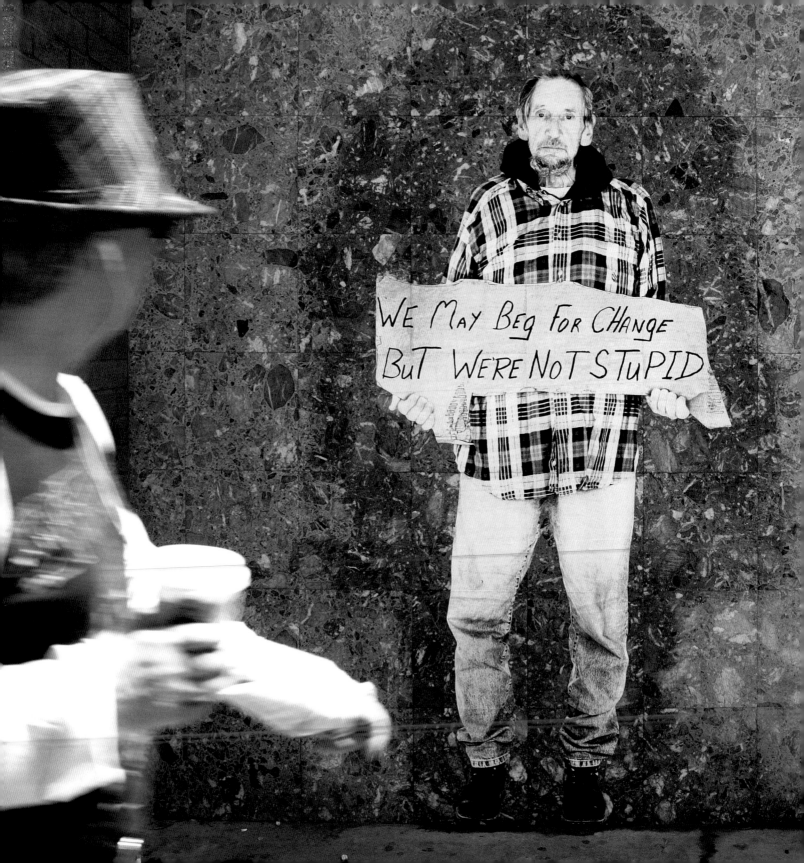

INTRODUCTION

Art or vandalism? If I had a dollar for every time I heard this question referred to graffiti or contemporary urban art in general, I'd be the leading Apple stockholder by now.

The witty and highly sarcastic British scientist Peter Brian Medawar once said that "the spread of secondary and latterly tertiary education has created a large population of people, often with well-developed literary and scholarly tastes, who have been educated far beyond their capacity to undertake analytical thought." There is no doubt in my mind that most graffiti detractors would unquestionably use this phrase to refer to young urban artists, and they may be right. The huge spread and popularization of urban art and the ease with which any teenager in any city in the world, whatever their social or economic circumstances, can start out in the world of graffiti and leave their tags on dozens of walls at a speed similar to that of breeding rabbits, have led to a genuine avalanche of spray paint and marker extremists. It is clear that most of them have a totally self-taught ability to cover several square feet of wall with paint. However, it is also obvious that this skill often goes beyond their ability to develop analytical thought and an artistic discourse of their own that rises above straightforward vandalism or that is something more than an urban pseudo-philosophy with such a lack of sophistication that it would make a child of nine blush with shame.

This is not the case of the artists included in this book.

A number of criteria have been utilized when choosing the artists and works to be featured in these pages. The first are the most evident: quality of work, originality, the artists' skill for conveying personal and untransferable style, etc. The second are not so obvious: Which artists are advancing the cause of urban art with their work? Which ones are breaking its barriers and associated conventions? And third, something which the old school graffiti purists will probably not like, which urban artists would keep their cool in a hypothetical face off with the totems of "official" art?

This book includes 1,000 images of works located in the world's main cities, the nerve centers of what we call graffiti. Urban art has definitively crossed its traditional boundaries (the street, spray paint, the eternal teenager, and the imposed and limiting spirit of rebellion) and it has done so for good, even becoming a feature of art galleries and the best museums of contemporary art on the planet. In fact, what is currently known as urban art includes spray painted street art, but also art installations, oil paintings, and sculpture, among others. Graffiti traditionalists must think this is a high price to pay, but this is what happens in all fields of art once they come of age.

The book is divided into three chapters, although readers initiated in the world of graffiti will know how difficult it is to classify graffiti as abstract or figurative, or to determine whether a certain piece of work was mainly done in spray paint or plastic paint. We therefore make our apologies to readers beforehand: many works on the following pages could easily appear in any of the three chapters in this book, and often the reasons for including them in one or another will appear to be as arbitrary as they are impenetrable. Once again, who would dare to bring order to such a wild and untamed artistic terrain as graffiti? Maybe the best thing would simply be to browse these pages and be taken away by the brutal explosion of color that assails readers' eyes like no other branch or school of art has ever done before.

Every graffiti artist is a typesetter on the inside, or so it would seem given the intricate, complex, and often quantum (due to their impenetrability) works on the following pages. This chapter includes the ground zero of graffiti, i.e. total abstraction. From tags and 3D style to the more recent organic graffiti, letters and tags are the starting point from where the other schools and trends in urban art have evolved. For some artists, pure graffiti is what is on the following pages: elaborate and almost illegible letters repeated over and over throughout the city.

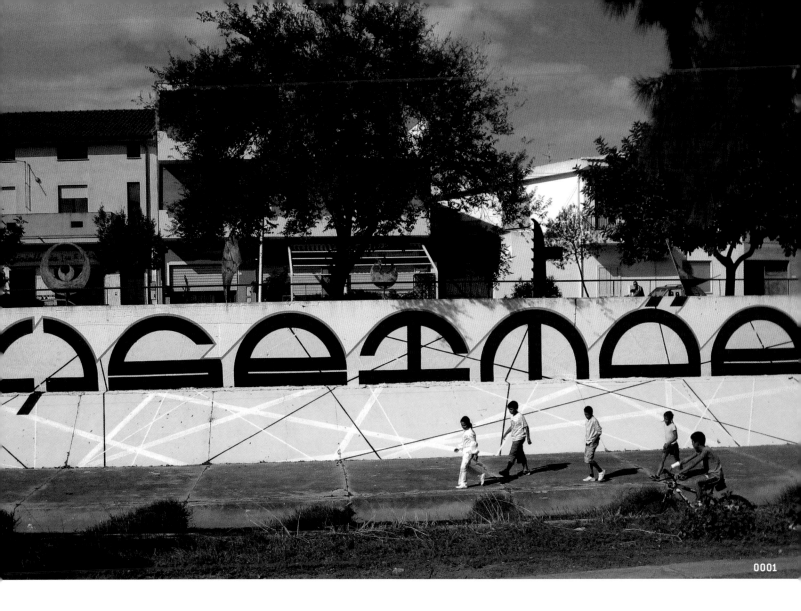

0001

0001 Dyset. Munich, Germany / **0002** Registred Kid. Barcelona, Spain

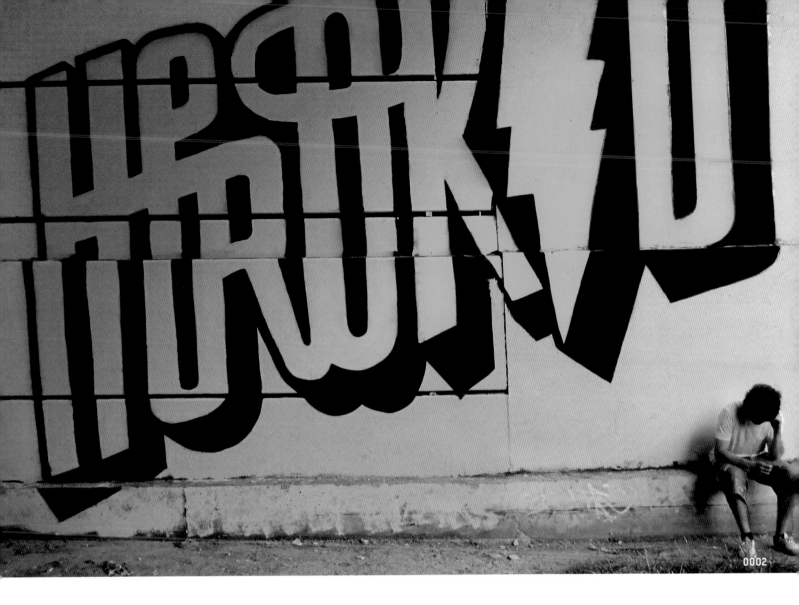

0002

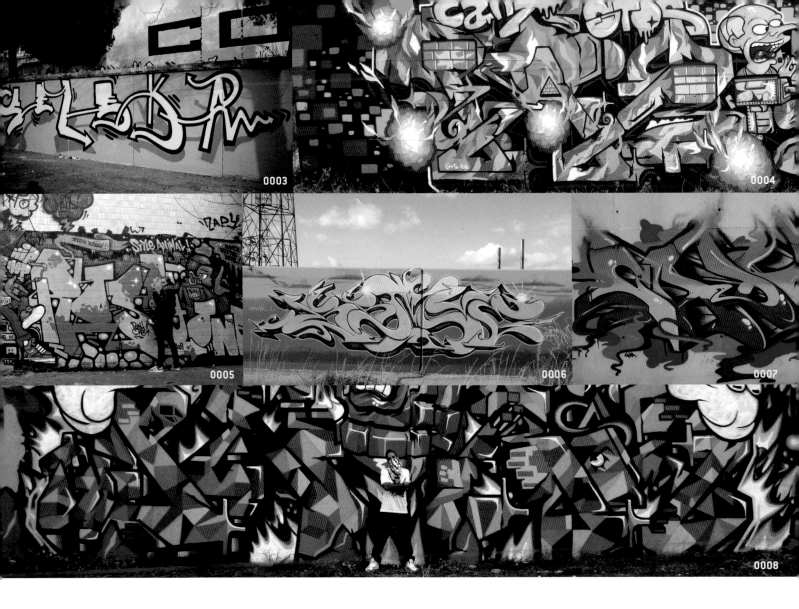

0003 Seleka. Seville, Spain / 0004 Pariz One. Lisbon, Portugal / 0005 RosyOne. Biel-Bienne, Switzerland / 0006 Brave 1 AKA Scotty~B. Essex, UK / 0007 Cade. Vitoria, Spain /
0008 Pariz One. Lisbon, Portugal / 0009 Doc Nova (Uwe H. Krieger). Gießen, Germany / 0010 Cade. Vitoria, Spain / 0011 Doc Nova (Uwe H. Krieger). Gießen, Germany /
0012 Pariz One. Lisbon, Portugal

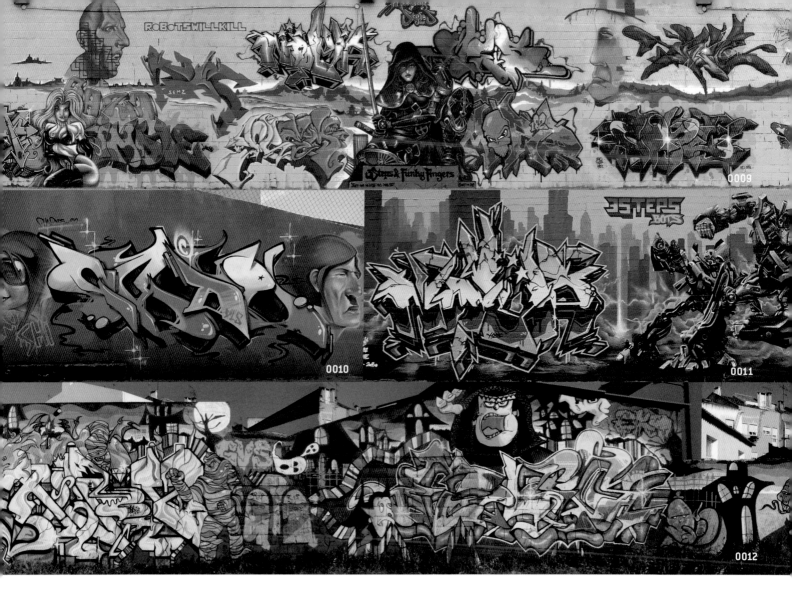

0009

0010

0011

0012

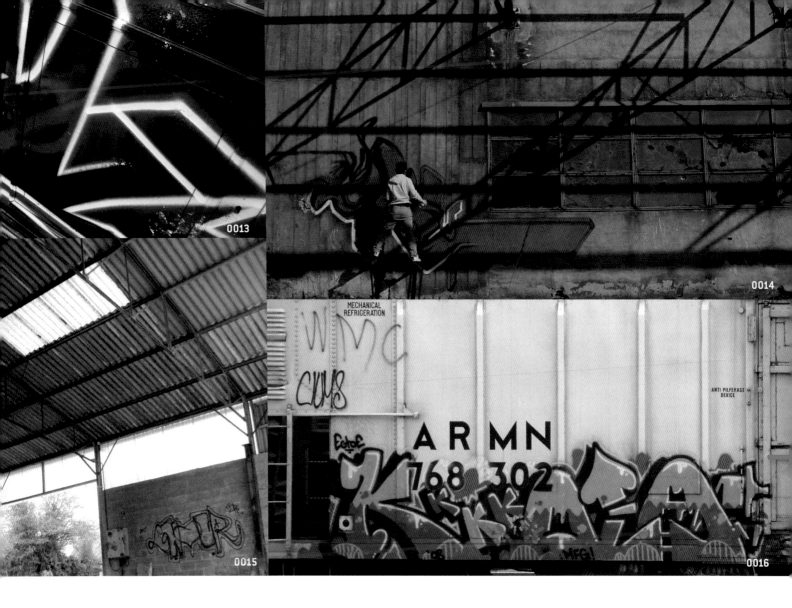

0013 Darco FBI. Paris, France / **0014** Koes. Bassano del Grappa, Italy / **0015** Astrid AKA CHOUR (3PP crew). Paris, France / **0016** MFG Freight Crew (ECTOE, RTYPE, HAIKU, KOLA, SMUT). Oakland, CA, USA / **0017** Dyset. Munich, Germany

0017

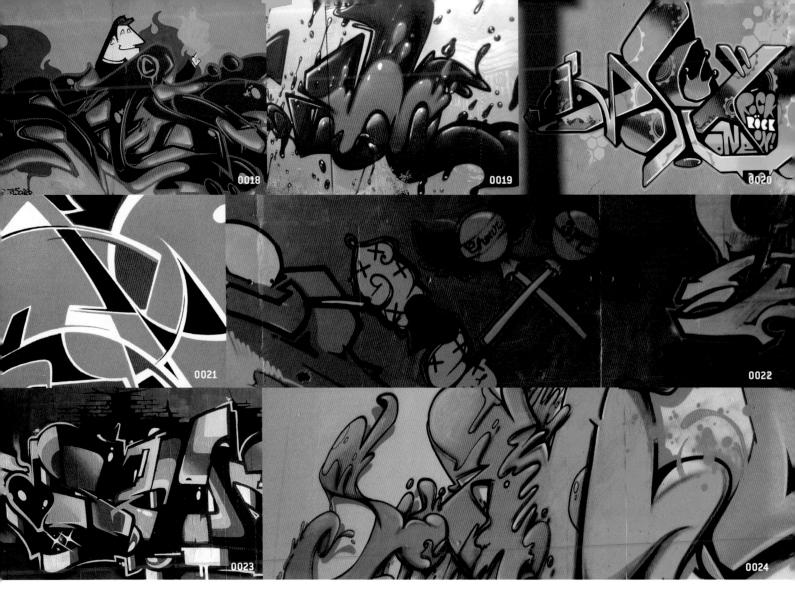

0018 Cade. Vitoria, Spain / 0019 Joan. Aschaffenburg, Germany / 0020 Mosaik. Lisbon, Portugal / 0021 Pariz One. Lisbon, Portugal / 0022 Astrid AKA CHOUR (3PP crew). Paris, France / 0023 Seantwo (Loveletter crew). Lausanne, Switzerland / 0024 Joan. Aschaffenburg, Germany / 0025 Cade. Vitoria, Spain / 0026 MFG Freight Crew (ECTOE, RTYPE, HAIKU, KOLA, SMUT). Oakland, CA, USA / 0027 Brave 1 AKA Scotty~B. Essex, UK / 0028 Pariz One. Lisbon, Portugal / 0029 Mr. Wany (Heavy Artillery Crew). Milan, Italy / 0030 Fafa. Seville, Spain

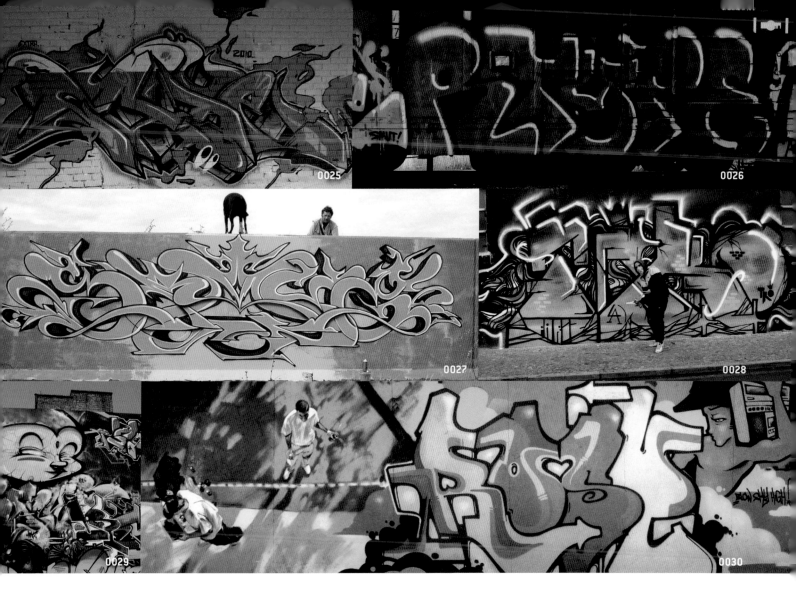

0025

0026

0027

0028

0029

0030

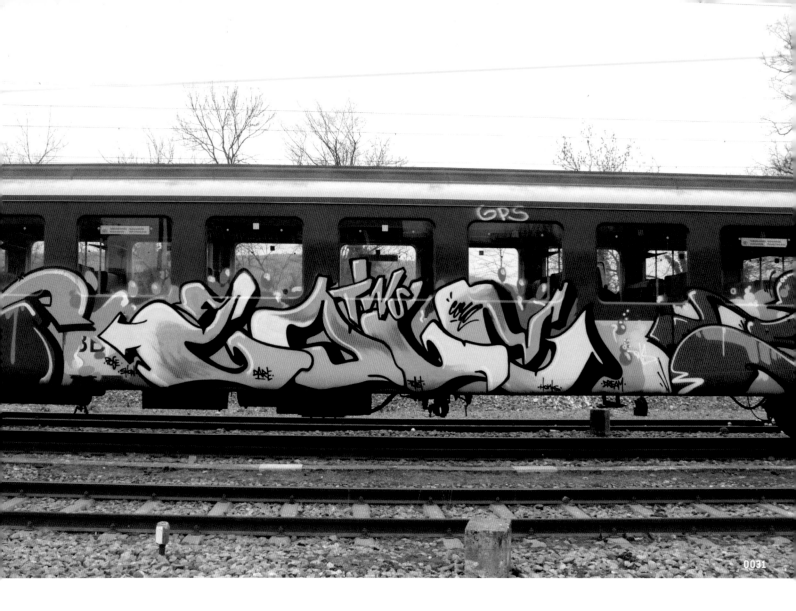

0031

0031 Wolfgang Krell. Dortmund, Germany / **0032** MFG Freight Crew (ECTOE, RTYPE, HAIKU, KOLA, SMUT). Oakland, CA, USA

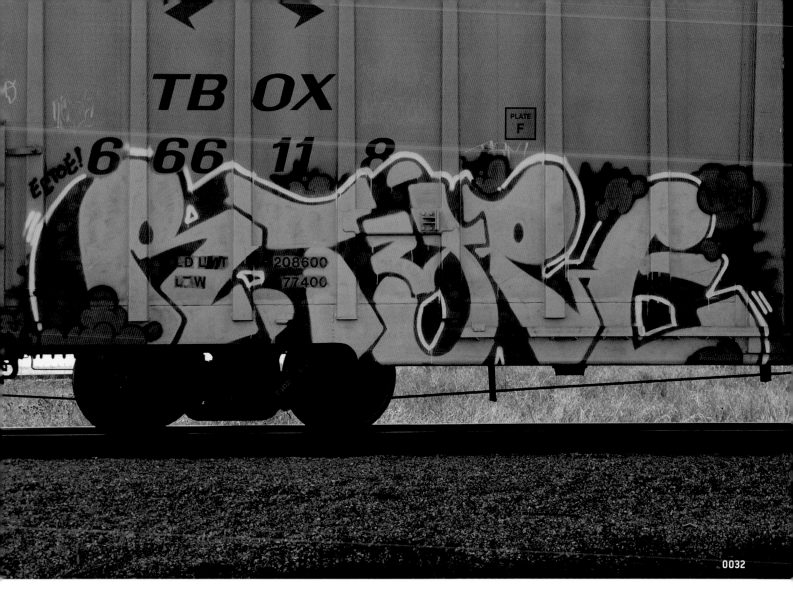

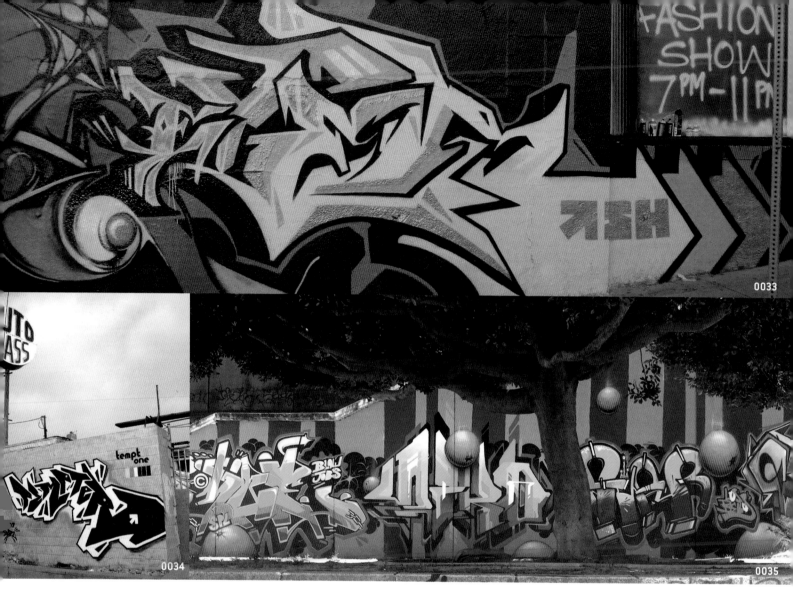

0033 Eyeone. Los Angeles, CA, USA / **0034** Eyeone. Los Angeles, CA, USA / **0035** Joe. Seville, Spain / **0036** Eyeone. Los Angeles, CA, USA / **0037** Astrid AKA
CHOUR (3PP crew). Paris, France / **0038** Fafa. Seville, Spain

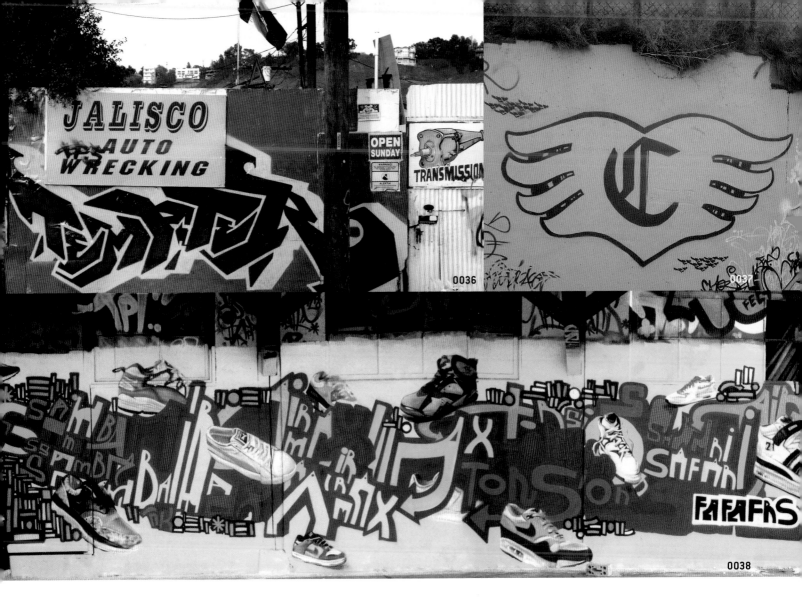

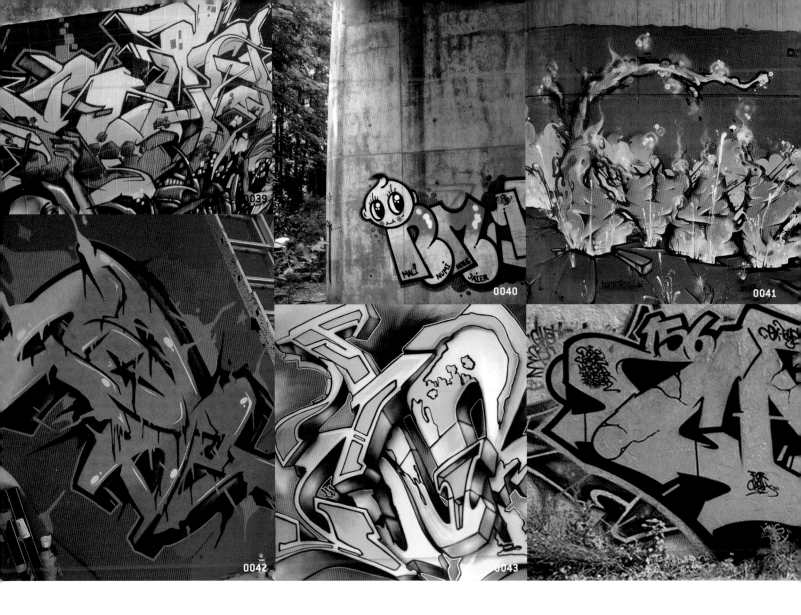

0039 Brave 1 AKA Scotty ~ B. Essex, UK / **0040** Numi. Seoul, South Korea / **0041** Rusl. Stuttgart, Germany / **0042** Cade. Vitoria, Spain / **0043** Wolfgang Krell. Dortmund, Germany / **0044** Pariz One. Lisbon, Portugal / **0045** Fasim. Barcelona, Spain / **0046** Bomber. Hofheim am Taunus, Germany

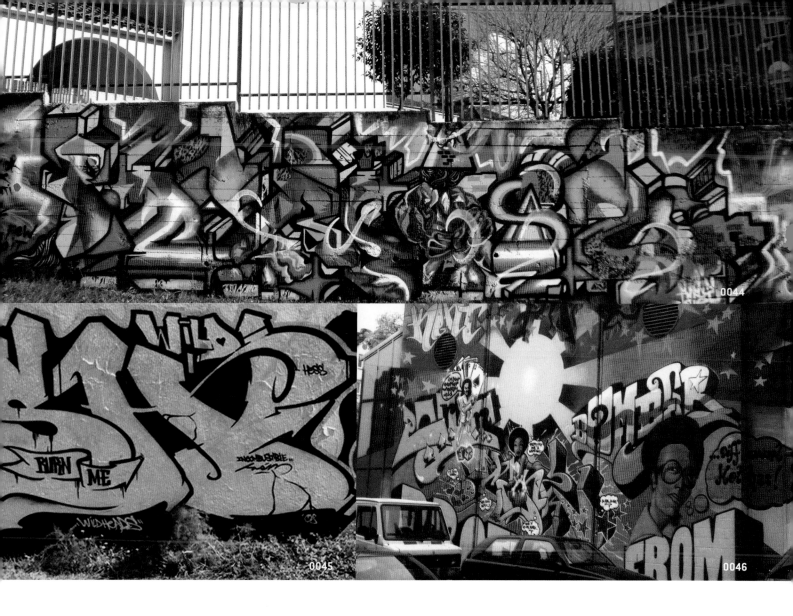

0044

0045

0046

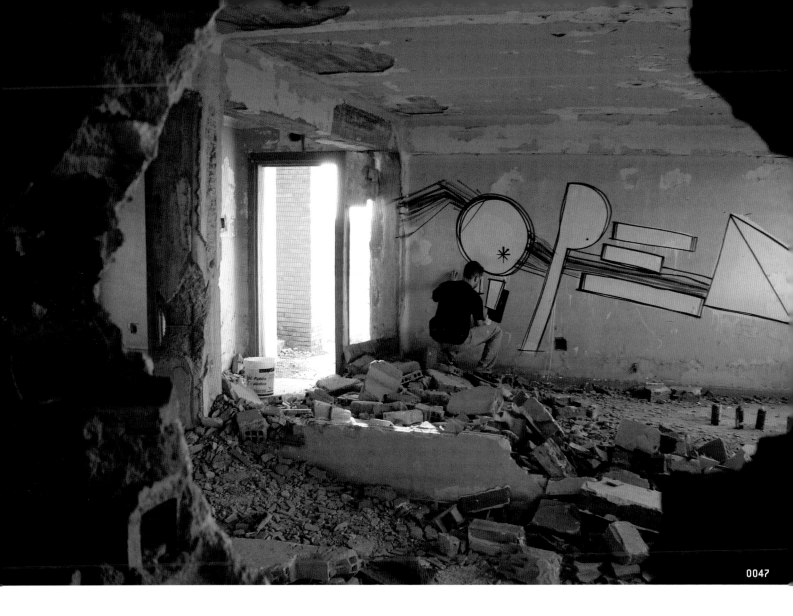

0047

0047 SRG/Ger. Seville, Spain / 0048 Eyeone. Los Angeles, CA, USA / 0049 Azek. Toulouse, France / 0050 Darco FBI. Paris, France/ 0051 Tasso. Meerane, Germany

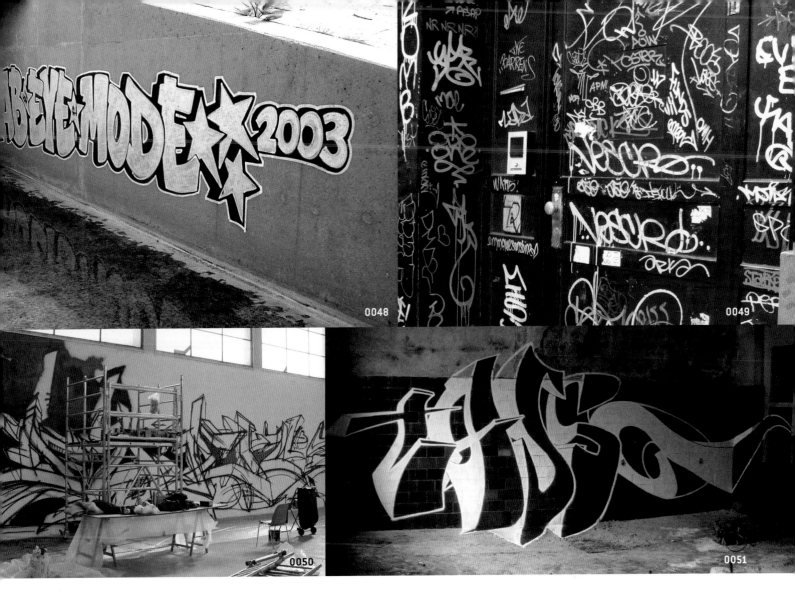

0048

0049

0050

0051

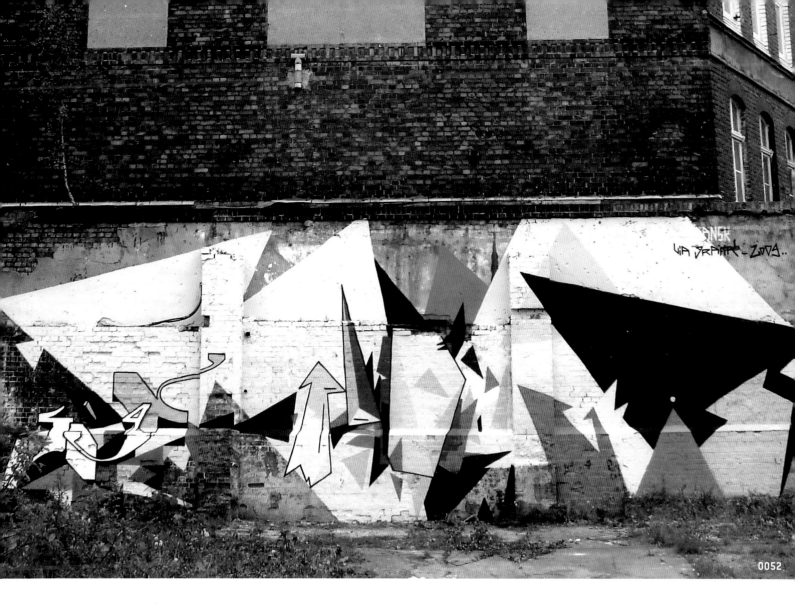

0052 Via Grafik. Wiesbaden, Germany / **0053** Above. San Francisco, CA, USA

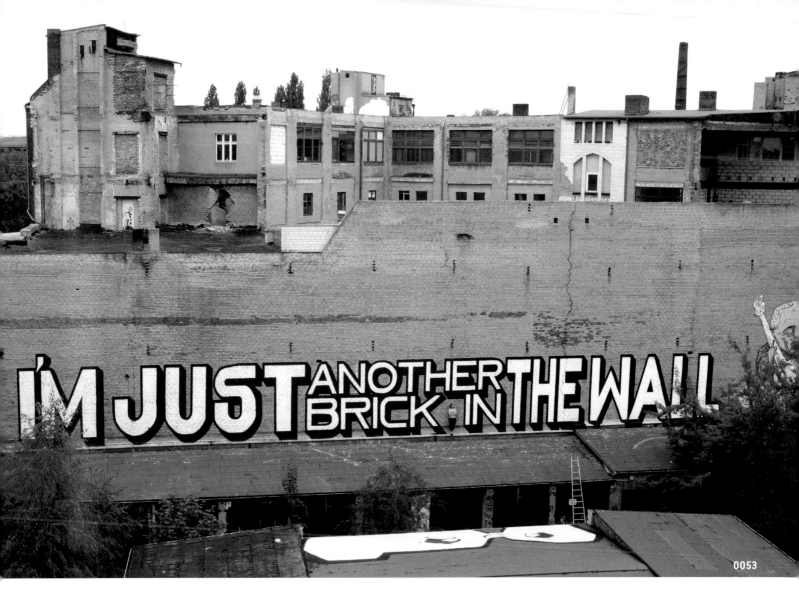

0053

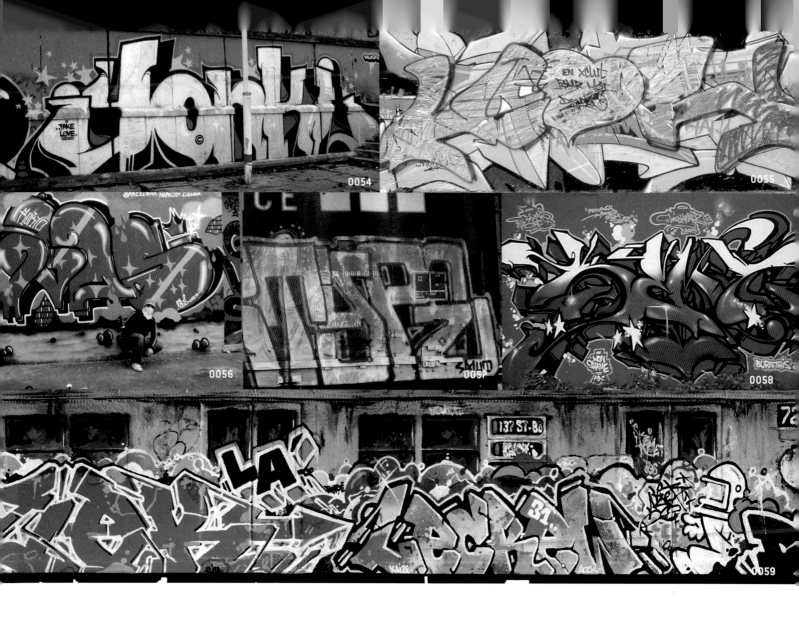

0054 Joe. Seville, Spain / 0055 Darco FBI. Paris, France / 0056 Pariz One. Lisbon, Portugal / 0057 MFG Freight Crew (ECTOE, RTYPE, HAIKU, KOLA, SMUT). Oakland, CA, USA / 0058 Fasim. Barcelona, Spain / 0059 Azek. Toulouse, France / 0060 Eyeone. Los Angeles, CA, USA / 0061 Azek. Toulouse, France / 0062 Azek. Toulouse, France / 0063 Azek. Toulouse, France / 0064 Joan. Aschaffenburg, Germany / 0065 Tasso. Meerane, Germany / 0066 Chaz Bojorquez. Los Angeles, CA, USA / 0067 BASK. Florida, USA

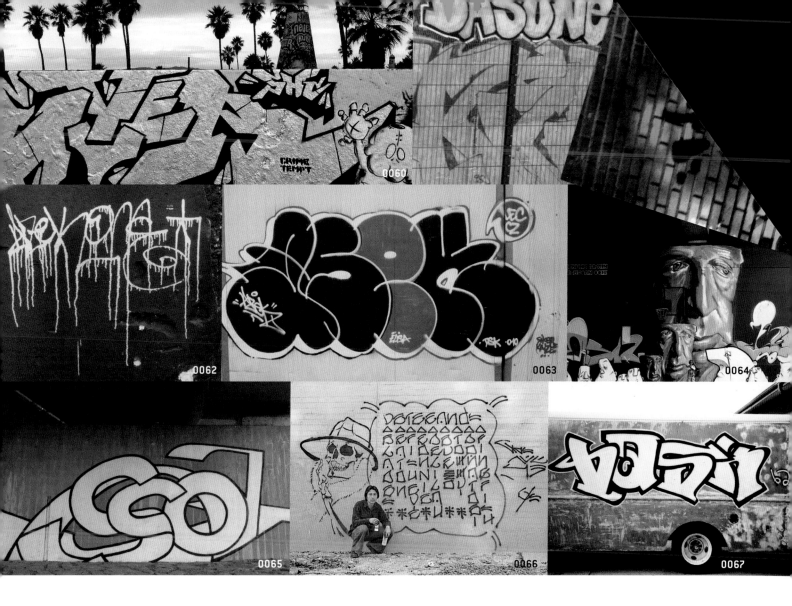

0060

0062

0063

0064

0065

0066

0067

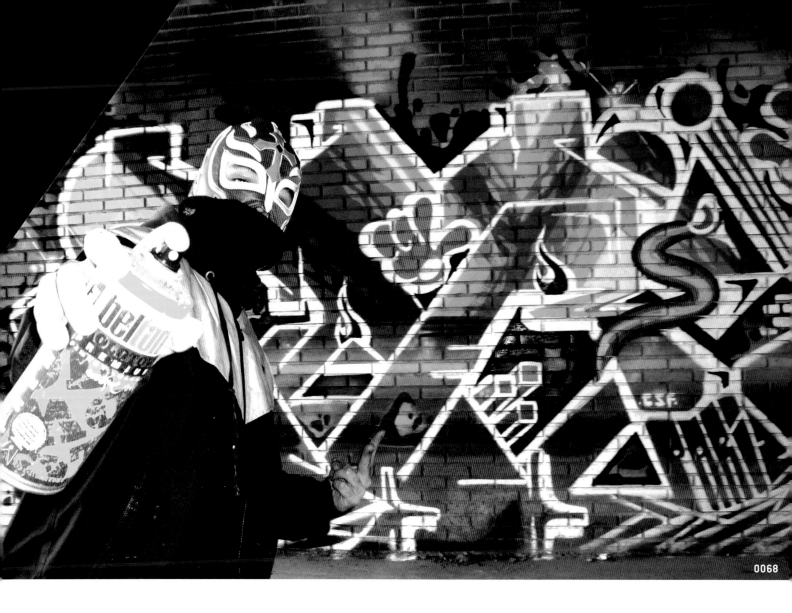

0068

0068 Pariz One. Lisbon, Portugal / **0069** SUS033. Madrid, Spain

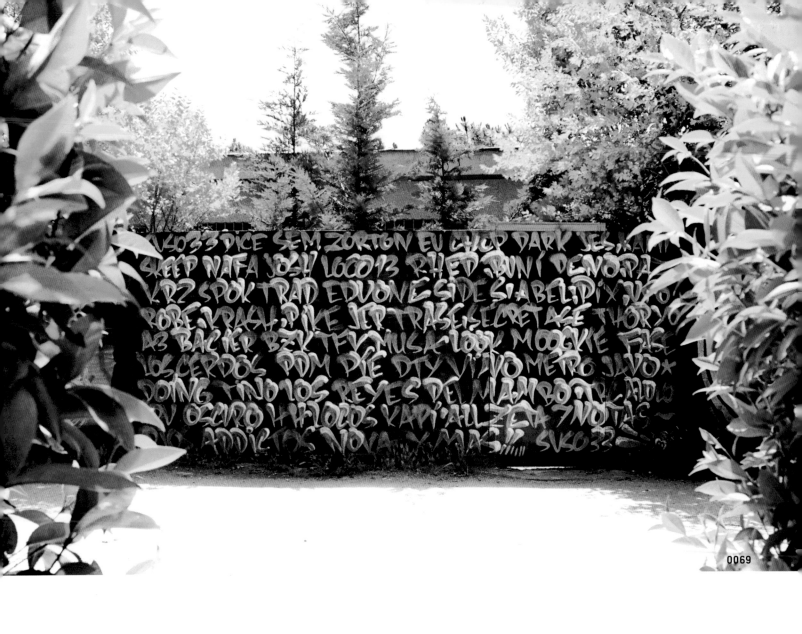

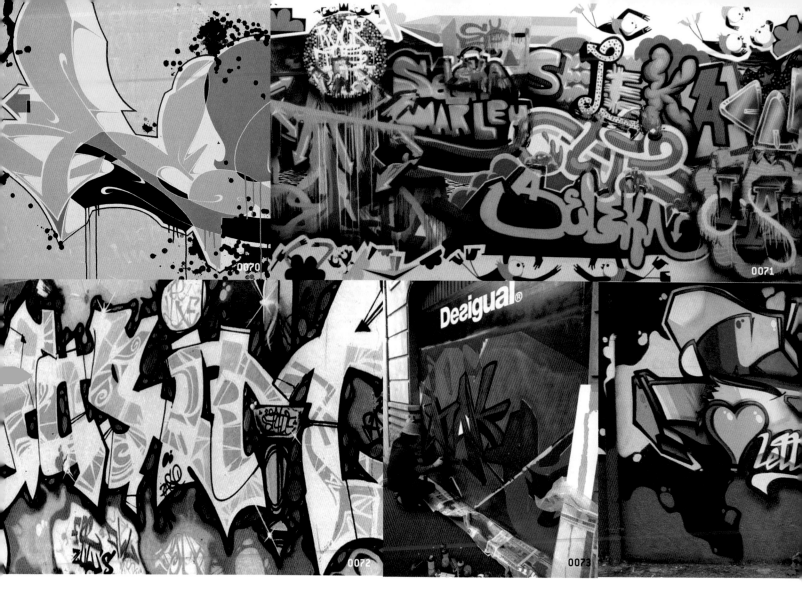

0070 Reso. Saarbrücken, Germany / 0071 Seleka. Seville, Spain / 0072 Fasim. Barcelona, Spain / 0073 Nados. Barcelona, Spain / 0074 MFG Freight Crew (EC-TOE, RTYPE, HAIKU, KOLA, SMUT). Oakland, CA, USA / 0075 Pariz One. Lisbon, Portugal / 0076 Seantwo (Loveletter crew). Lausanne, Switzerland / 0077 Azek. Toulouse, France

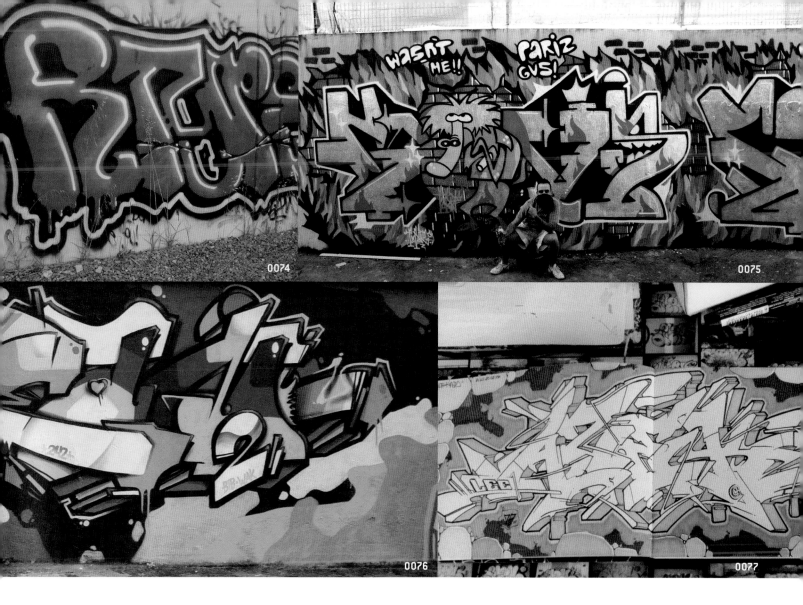

0074

0075

0076

0077

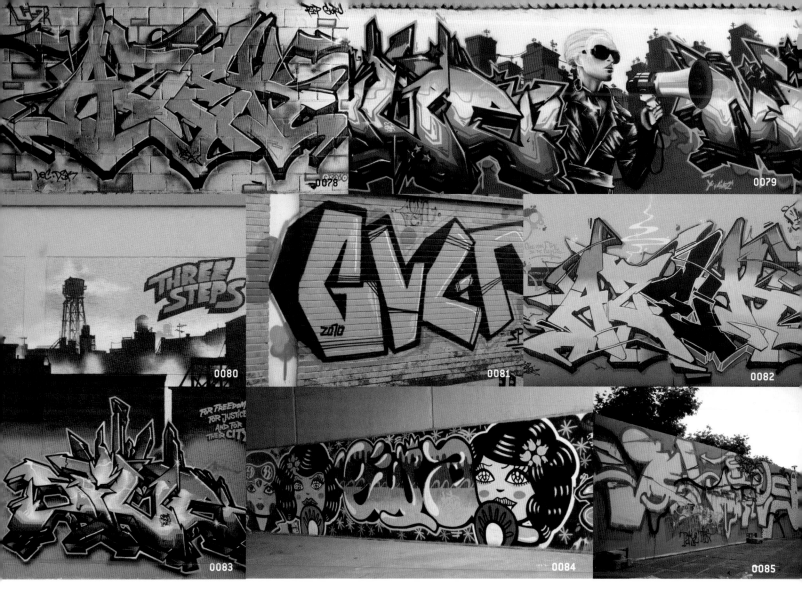

0078 Azek. Toulouse, France / 0079 Doc Nova (Uwe H. Krieger). Gießen, Germany / 0080 SiveOne (Kai H. Krieger). Gießen, Germany / 0081 Insanewen (SPL Crew). Seville, Spain / 0082 Azek. Toulouse, France / 0083 SiveOne (Kai H. Krieger). Gießen, Germany / 0084 Malicia. Barcelona, Spain / 0085 Seleka. Seville, Spain / 0086 Nychos. Vienna, Austria / 0087 Asia Komarova. Utrecht, Netherlands / 0088 Cade. Vitoria, Spains / 0089 Mr. Wany (Heavy Artillery Crew). Milan, Italy / 0090 MFG Freight Crew (ECTOE, RTYPE, HAIKU, KOLA, SMUT). Oakland, CA, USA / 0091 Rusl. Stuttgart, Germany / 0092 Joe. Seville, Spain

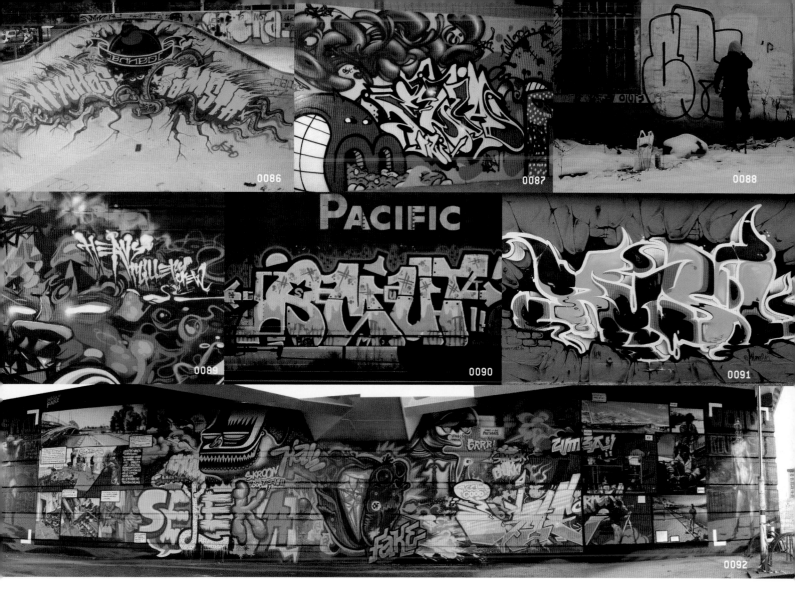

PACIFIC

0086
0087
0088
0089
0090
0091
0092

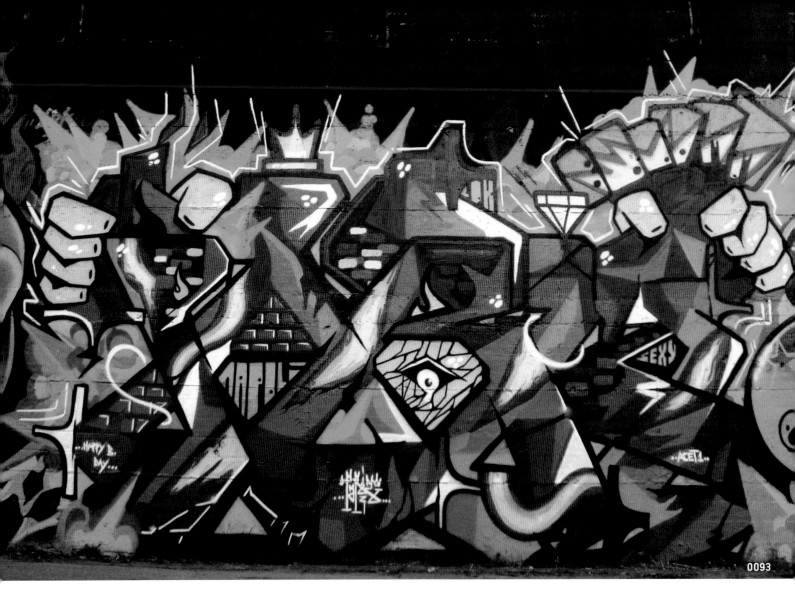

0093

0093 Pariz One. Lisbon, Portugal / **0094** Cade. Vitoria, Spain

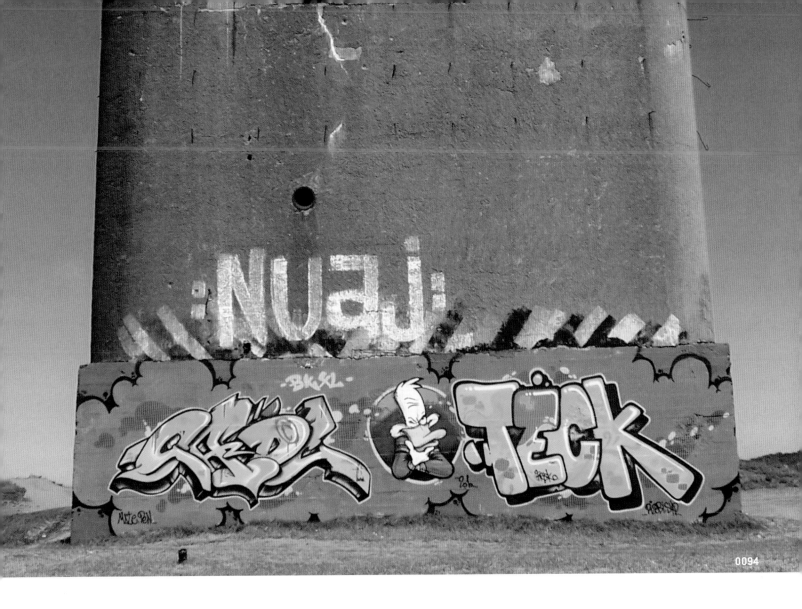

0094

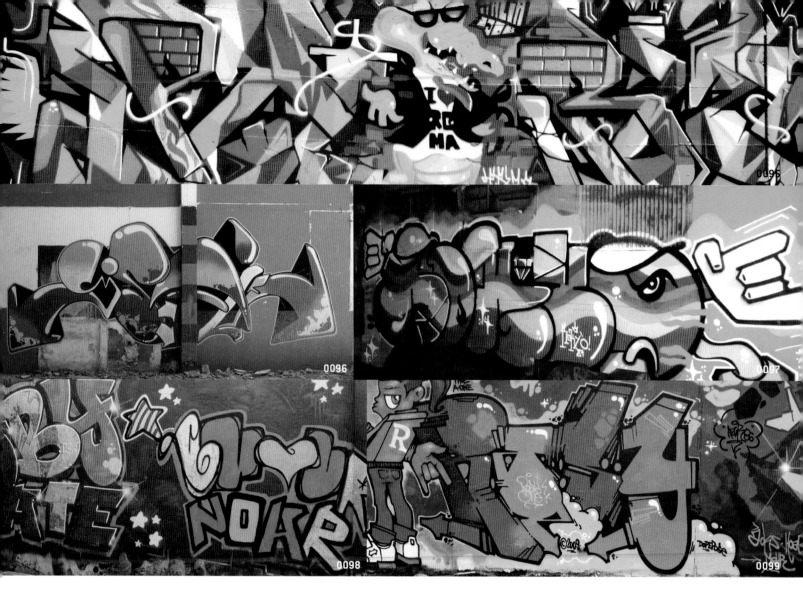

0095 Pariz One. Lisbon, Portugal / 0096 Mosaik. Lisbon, Portugal / 0097 Pariz One. Lisbon, Portugal / 0098 Astrid AKA CHOUR (3PP crew). Paris, France / 0099 RosyOne. Biel-Bienne, Switzerland / 0100 Nuria Mora. Madrid, Spain

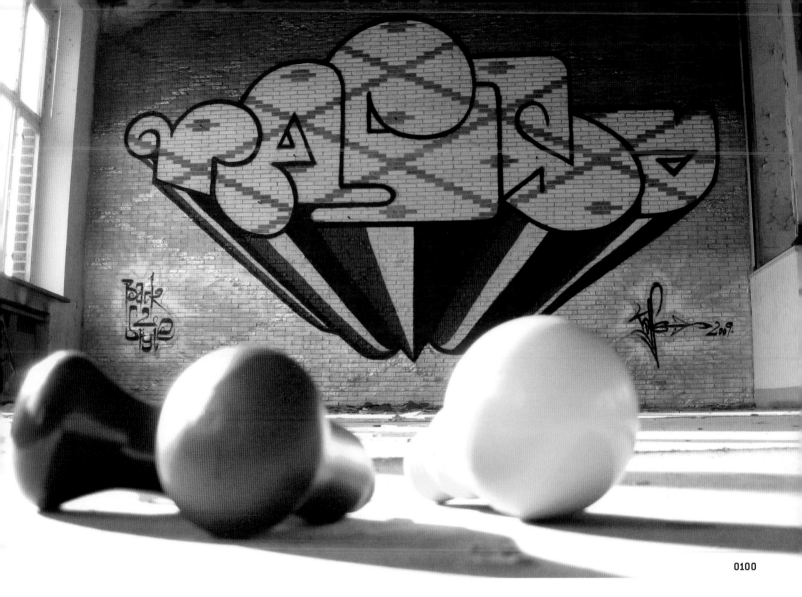

0100

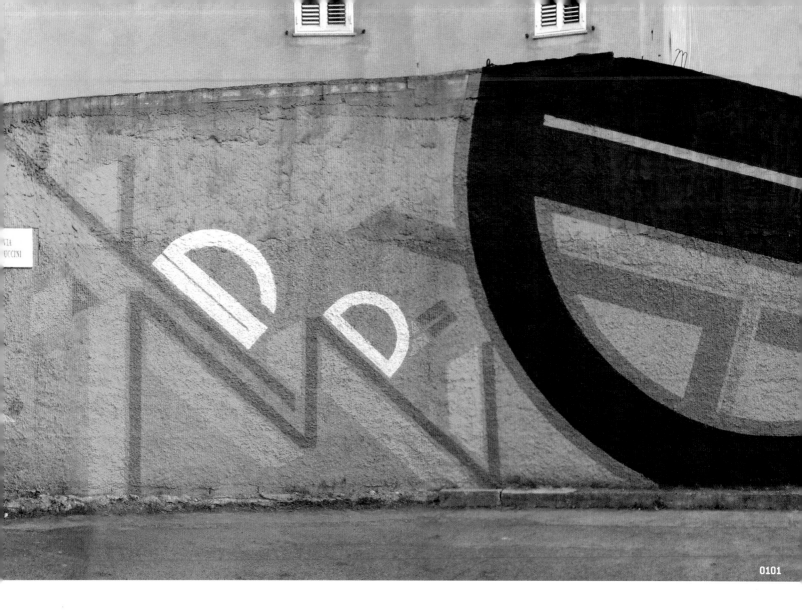

0101

0101 Dyset. Munich, Germany / **0102** Toast One. Zurich, Switzerland

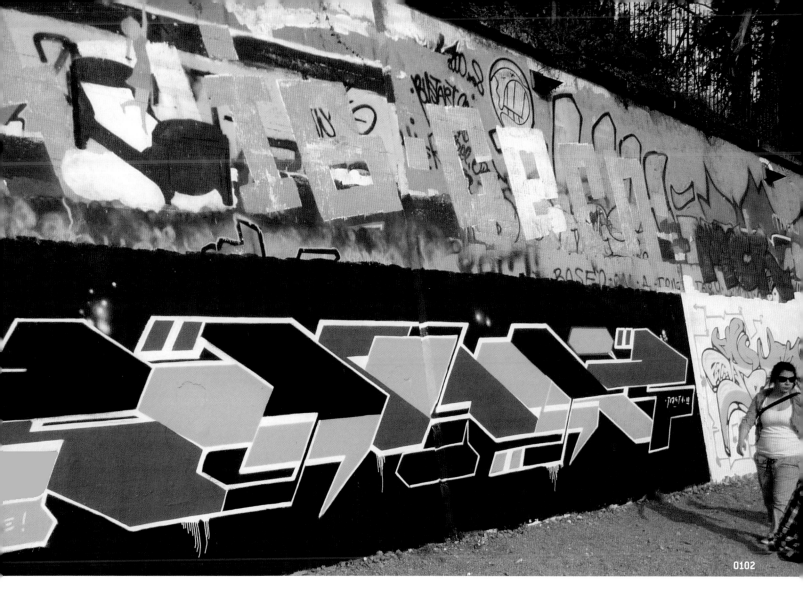

0102

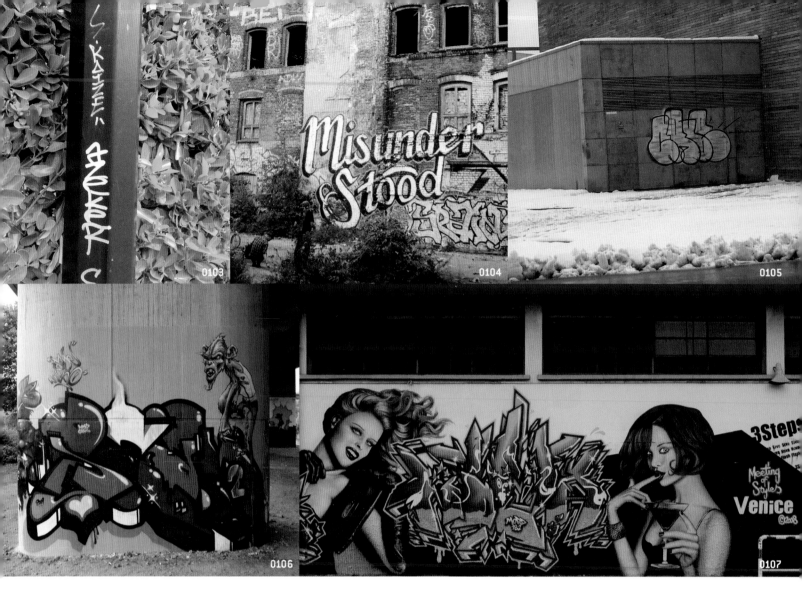

0103 Azek. Toulouse, France / 0104 Ripo. Barcelona, Spain, and New York, USA / 0105 Cade. Vitoria, Spain / 0106 Seantwo (Loveletter crew). Lausanne, Switzerland /
0107 Doc Nova (Uwe H. Krieger). Gießen, Germany / 0108 Joan. Aschaffenburg, Germany

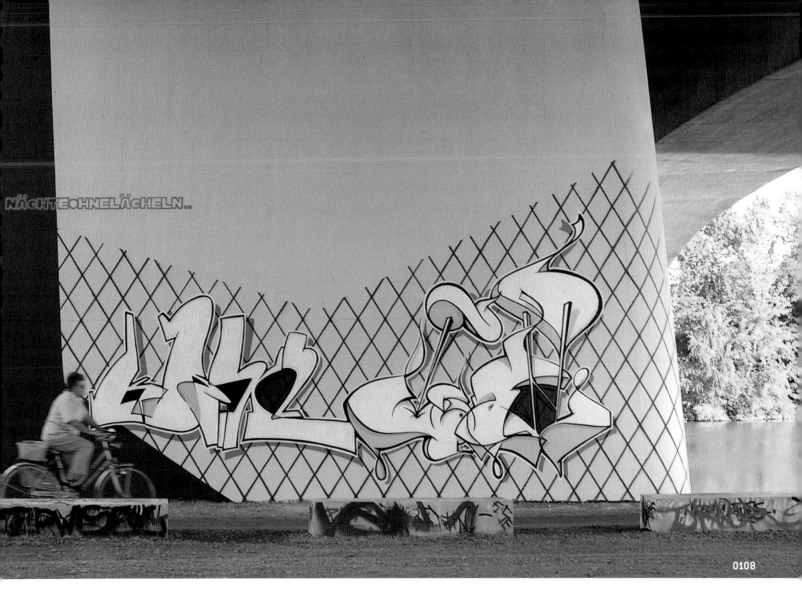

0108

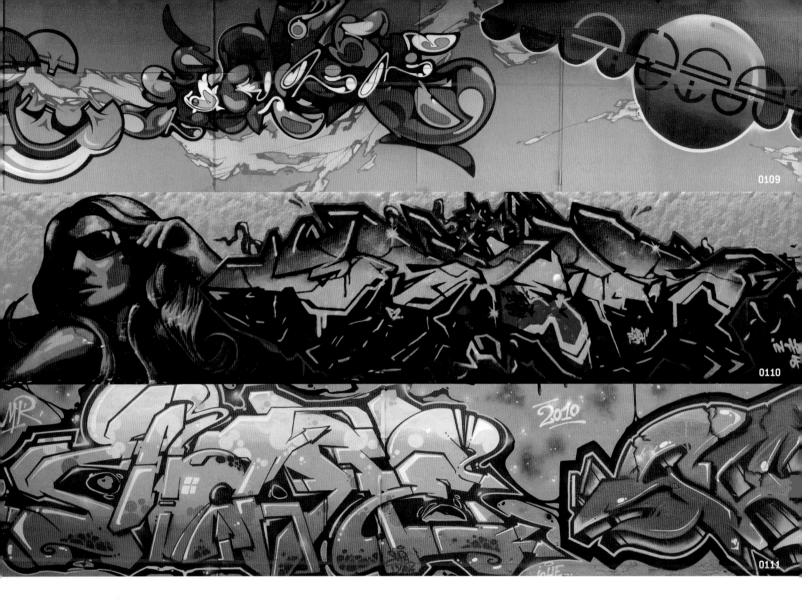

0109 Dyset. Munich, Germany / **0110** Doc Nova (Uwe H. Krieger). Gießen, Germany / **0111** Cade. Vitoria, Spain / **0112** Reso. Saarbrücken, Germany

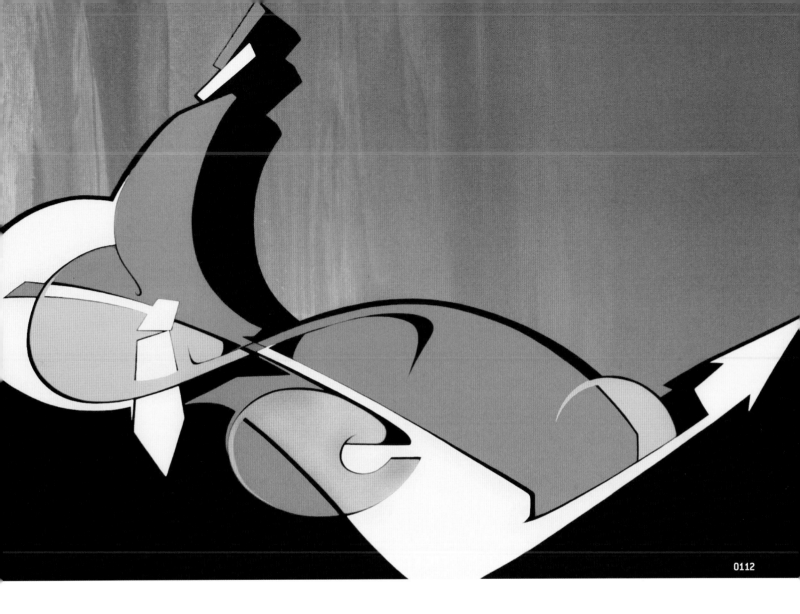

0112

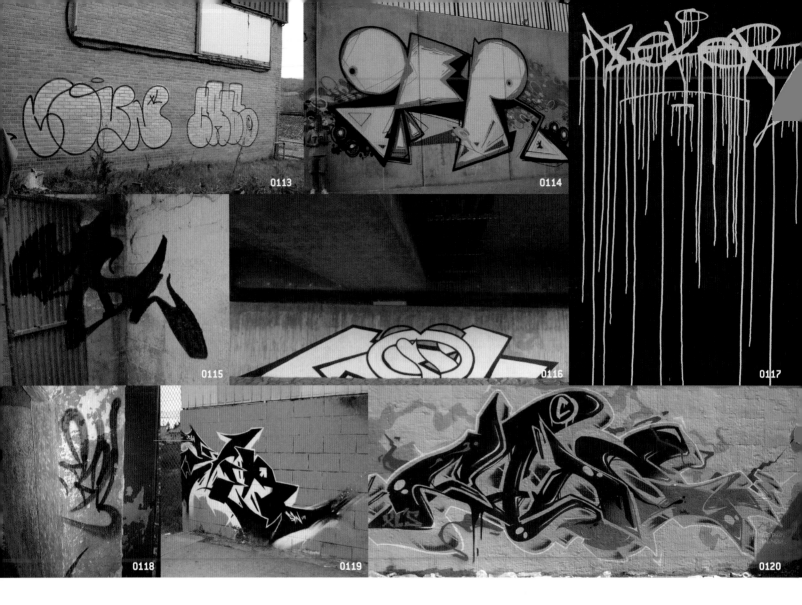

0113 Cade. Vitoria, Spain / 0114 SRG/Ger. Seville, Spain / 0115 Cade. Vitoria, Spain / 0116 Tasso. Meerane, Germany / 0117 Azek. Toulouse, France / 0118 Eyeone. Los Angeles, CA, USA / 0119 Eyeone. Los Angeles, CA, USA / 0120 Cade. Vitoria, Spain / 0121 Eyeone. Los Angeles, CA, USA / 0122 MFG Freight Crew (ECTOE, RTYPE, HAIKU, KOLA, SMUT). Oakland, CA, USA / 0123 Darco FBI. Paris, France / 0124 Azek. Toulouse, France / 0125 Marc C. Woehr. Stuttgart, Germany / 0126 Darco FBI. Paris, France

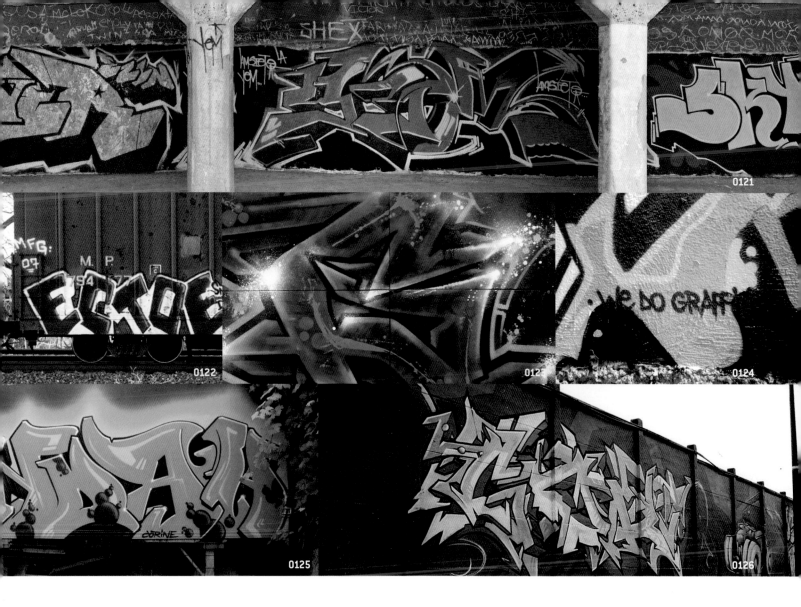

0121

0122

0123

0124

0125

0126

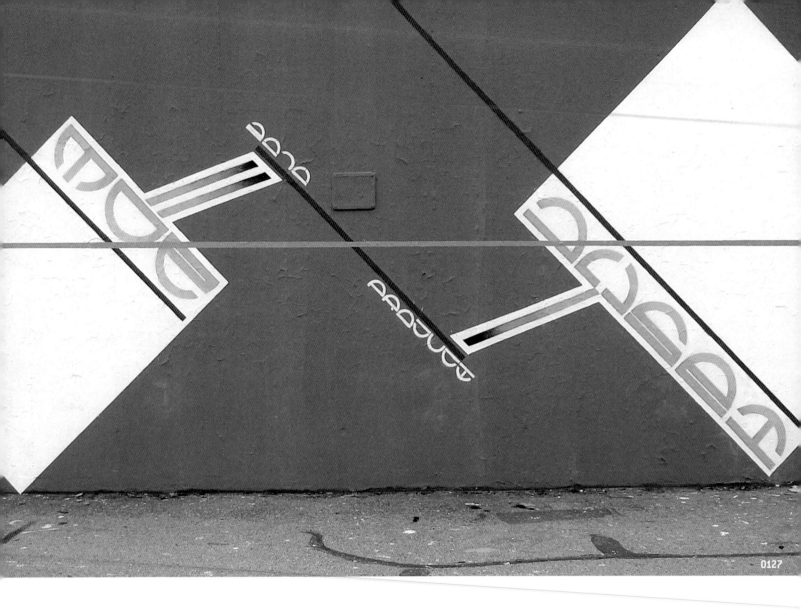

0127

0127 Dyset. Munich, Germany / 0128 Mr. Wany (Heavy Artillery Crew). Milan, Italy

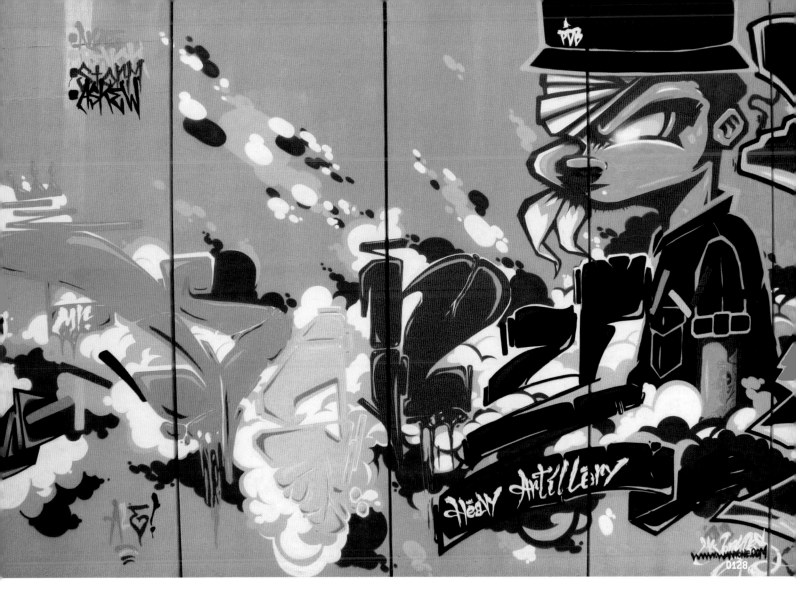

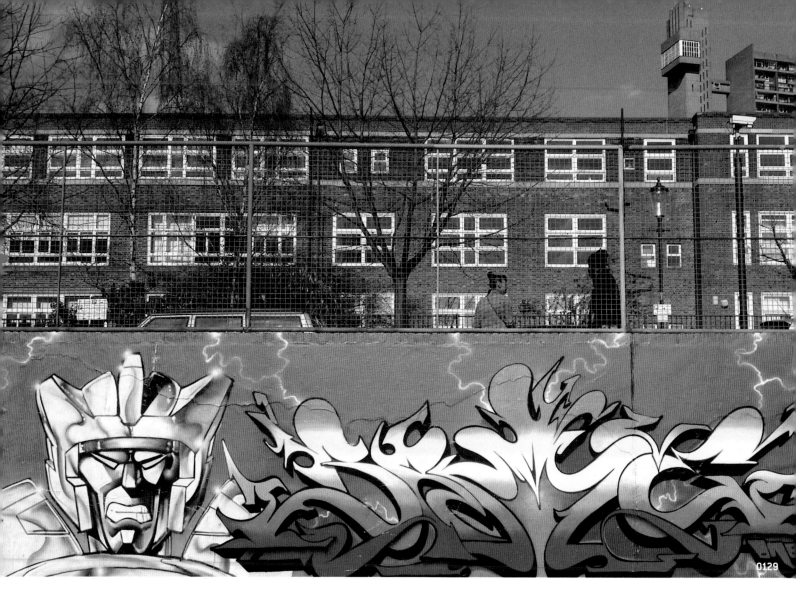

0129 Brave 1 AKA Scotty~B. Essex, UK / **0130** MFG Freight Crew (ECTOE, RTYPE, HAIKU, KOLA, SMUT). Oakland, CA, USA / **0131** Ripo. Barcelona, Spain, and New York, USA /
0132 Bomber. Hofheim am Taunus, Germany / **0133** Joe. Seville, Spain

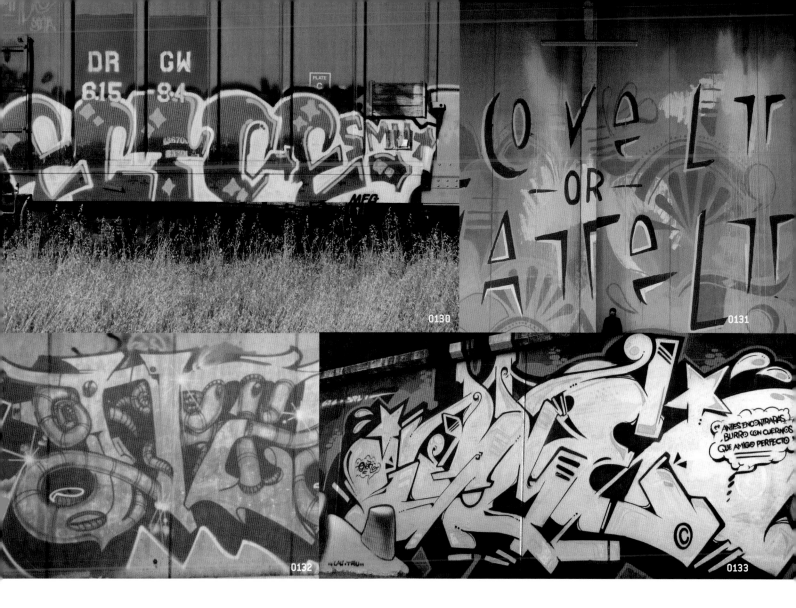

0130

0131

0132

0133

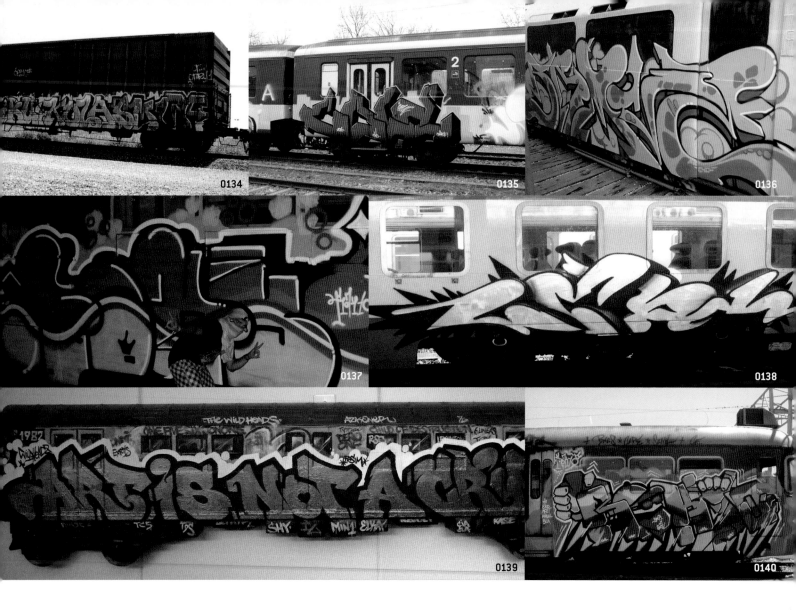

0134 MFG Freight Crew (ECTOE, RTYPE, HAIKU, KOLA, SMUT). Oakland, CA, USA / 0135 Wolfgang Krell. Dortmund, Germany / 0136 Brave 1 AKA Scotty~B. Essex, UK / 0137 Pariz One. Lisbon, Portugal / 0138 Zed1. Florence, Italy / 0139 Fasim. Barcelona, Spain / 0140 Pariz One. Lisbon, Portugal / 0141 Pariz One. Lisbon, Portugal / 0142 Pariz One. Lisbon, Portugal / 0143 MFG Freight Crew (ECTOE, RTYPE, HAIKU, KOLA, SMUT). Oakland, CA, USA/ 0144 Pariz One. Lisbon, Portugal / 0145 SRG/Ger. Seville, Spain / 0146 Pariz One. Lisbon, Portugal

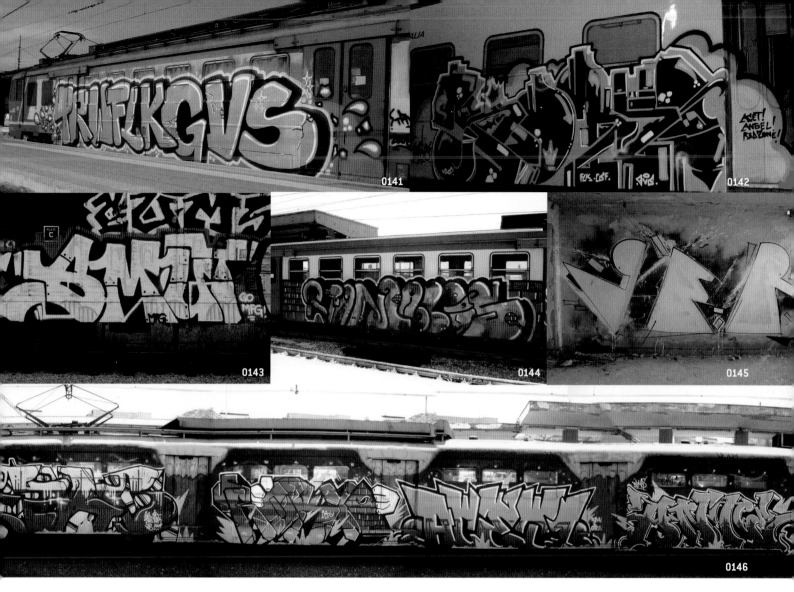

0141

0142

0143

0144

0145

0146

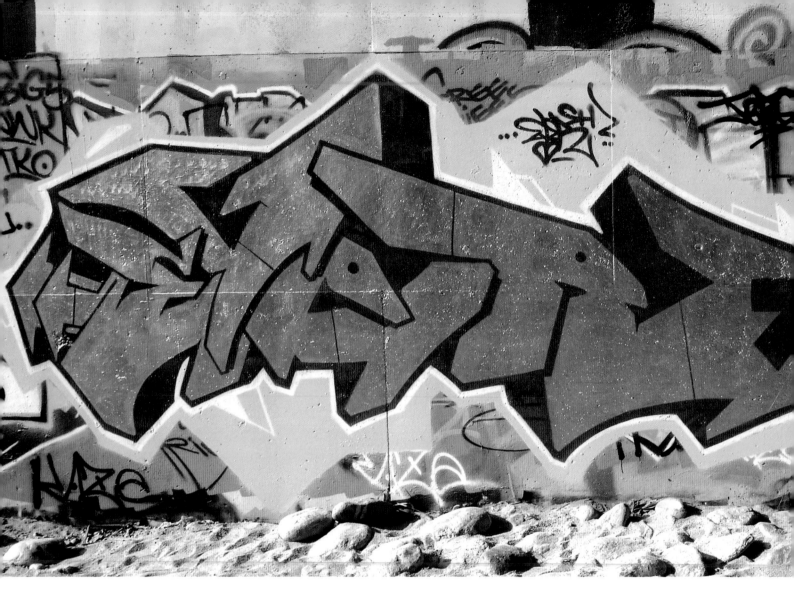

0147 Eyeone. Los Angeles, CA, USA

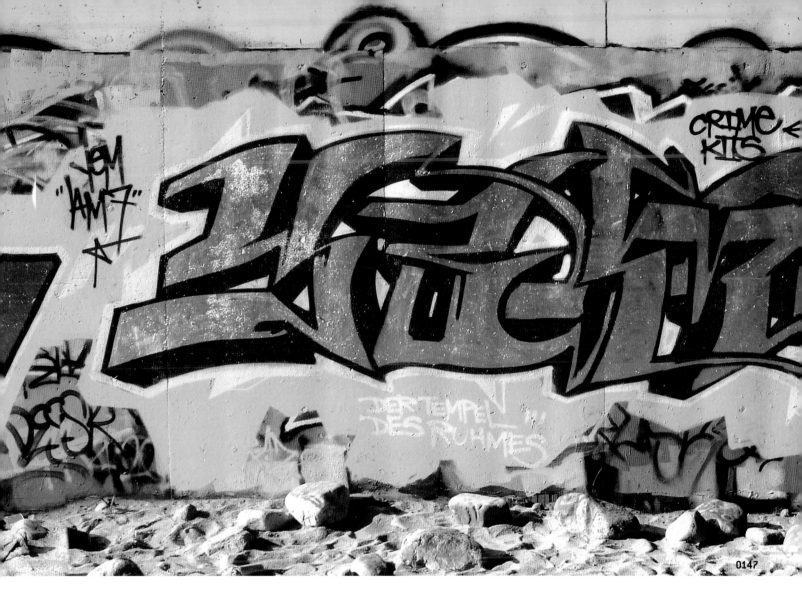

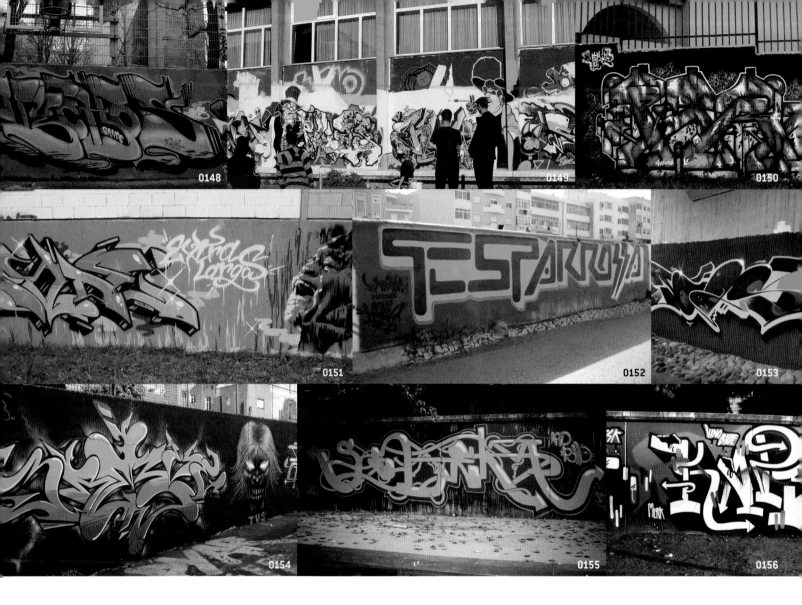

0148 Nychos. Vienna, Austria / 0149 Seantwo (Loveletter crew). Lausanne, Switzerland / 0150 Pariz One. Lisbon, Portugal / 0151 Cade. Vitoria, Spain / 0152 Mosaik. Lisbon, Portugal / 0153 Toast One. Zurich, Switzerland / 0154 Brave 1 AKA Scotty~B. Essex, UK / 0155 Seleka. Seville, Spain / 0156 Seleka. Seville, Spain / 0157 Azek. Toulouse, France / 0158 Seantwo (Loveletter crew). Lausanne, Switzerland / 0159 Pariz One. Lisbon, Portugal / 0160 SRG/Ger. Seville, Spain / 0161 Eyeone. Los Angeles, CA, USA / 0162 Mr. Wany (Heavy Artillery Crew). Milan, Italy / 0163 Seleka. Seville, Spain

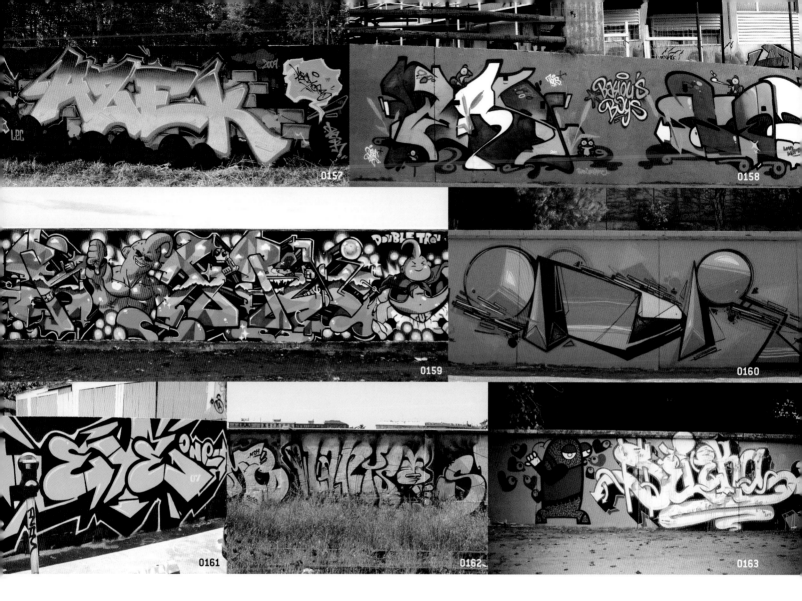

0157

0158

0159

0160

0161

0162

0163

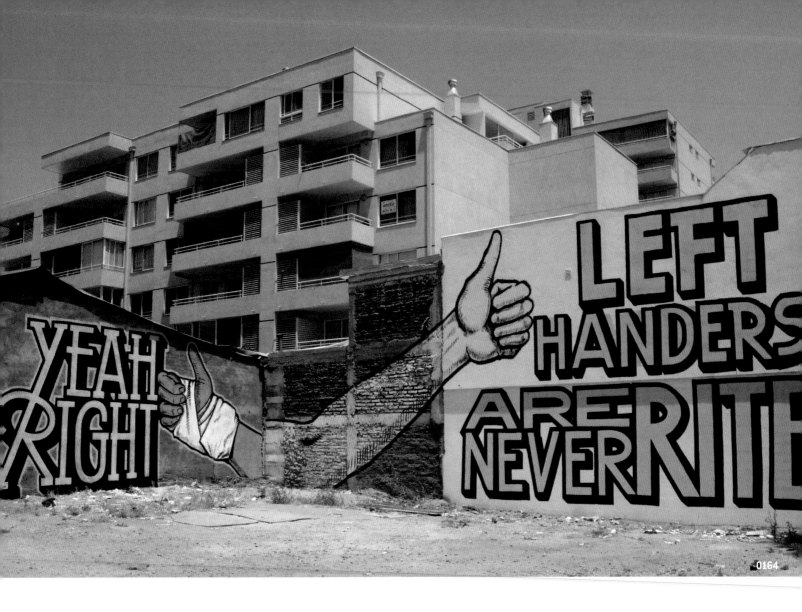

0164 Above. San Francisco, CA, USA / **0165** Ripo. Barcelona, Spain, and New York, USA

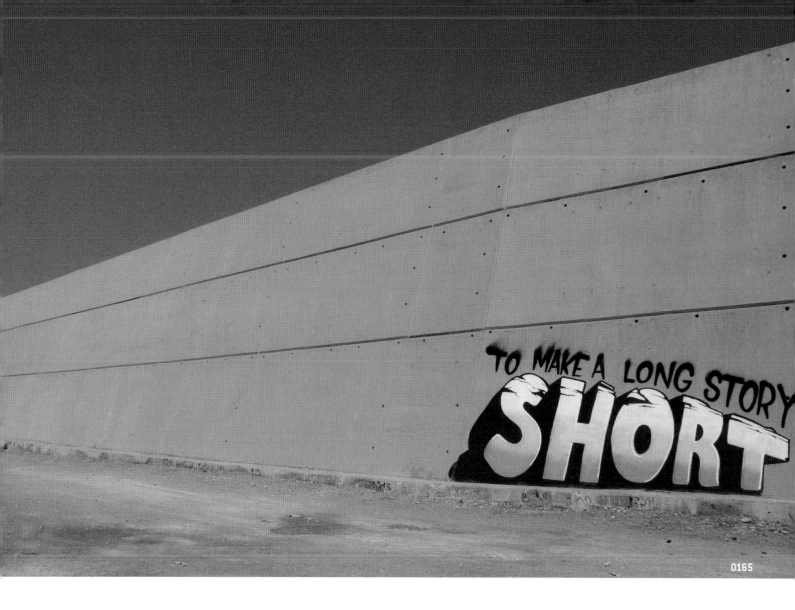

0165

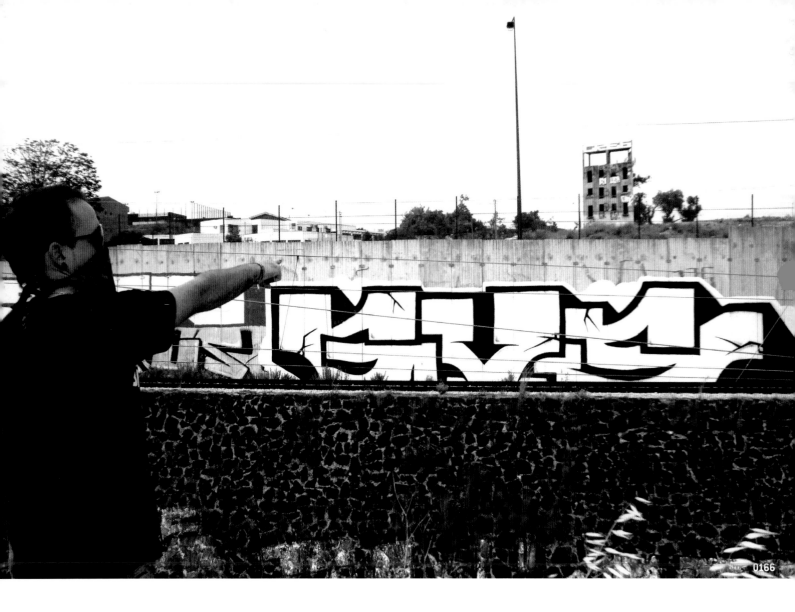

0166 Pariz One. Lisbon, Portugal / **0167** Pariz One. Lisbon, Portugal

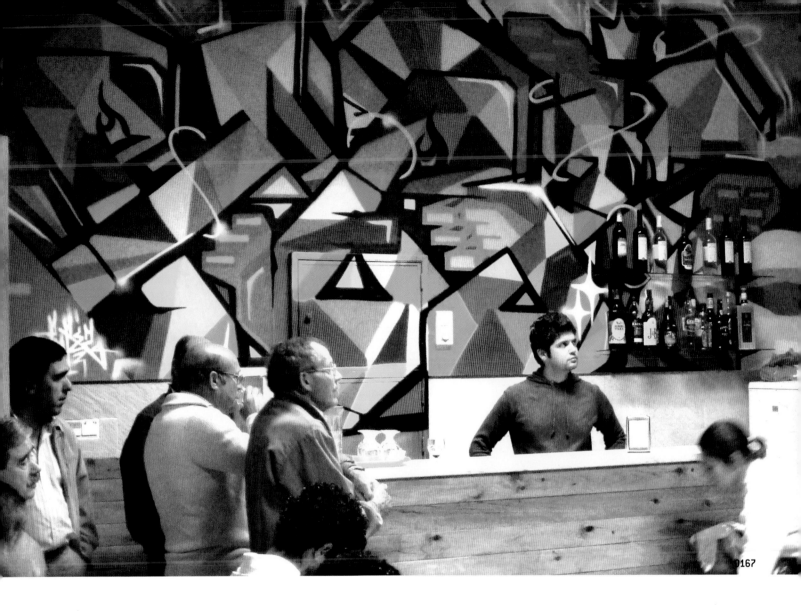

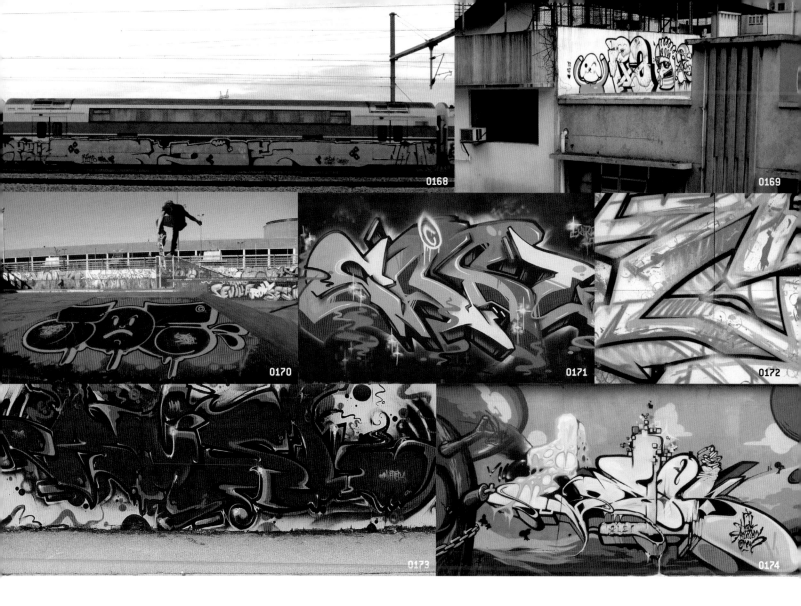

0168 Pariz One. Lisbon, Portugal / 0169 Numi. Seoul, South Korea / 0170 Joe. Seville, Spain / 0171 Cade. Vitoria, Spain / 0172 Darco FBI. Paris, France / 0173 Rusl. Stuttgart, Germany / 0174 Mr. Wany (Heavy Artillery Crew). Milan, Italy / 0175 Brave 1 AKA Scotty~B. Essex, UK / 0176 Mr. Wany (Heavy Artillery Crew). Milan, Italy / 0177 Pariz One. Lisbon, Portugal

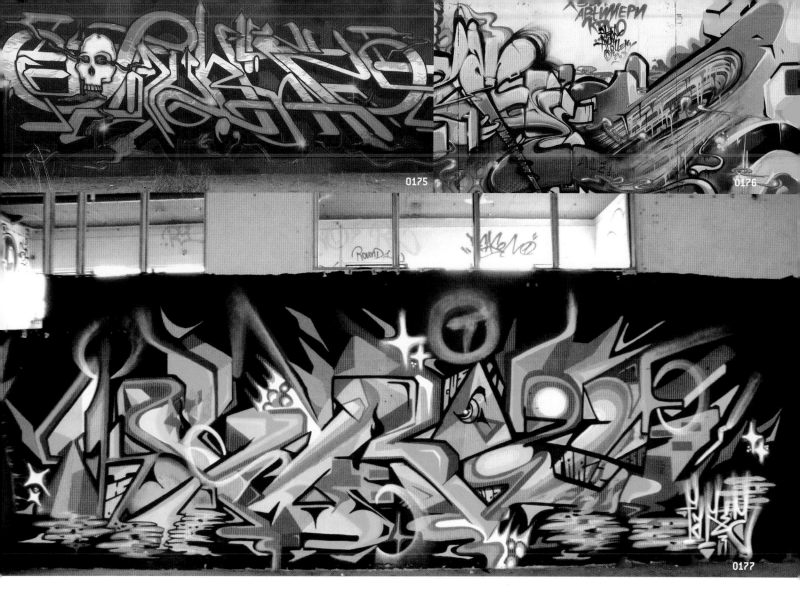

0175

0176

0177

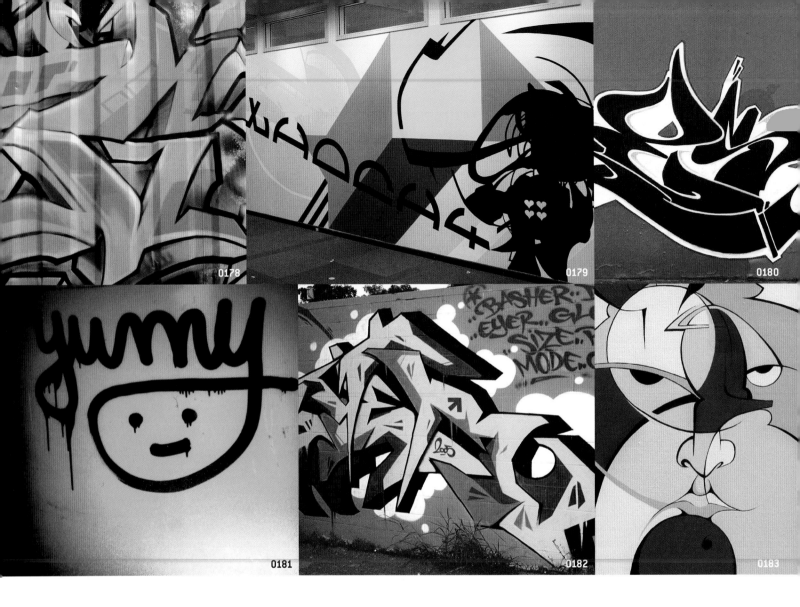

0178 Darco FBI. Paris, France / 0179 Dyset. Munich, Germany / 0180 Reso. Saarbrücken, Germany / 0181 Numi. Seoul, South Korea / 0182 Eyeone. Los Angeles, CA, USA / 0183 Reso. Saarbrücken, Germany / 0184 Toast One. Zurich, Switzerland

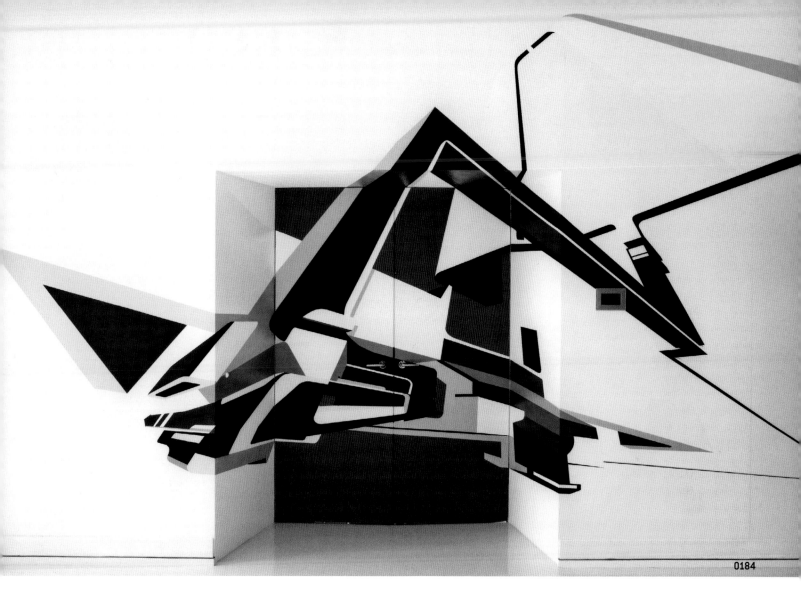

0184

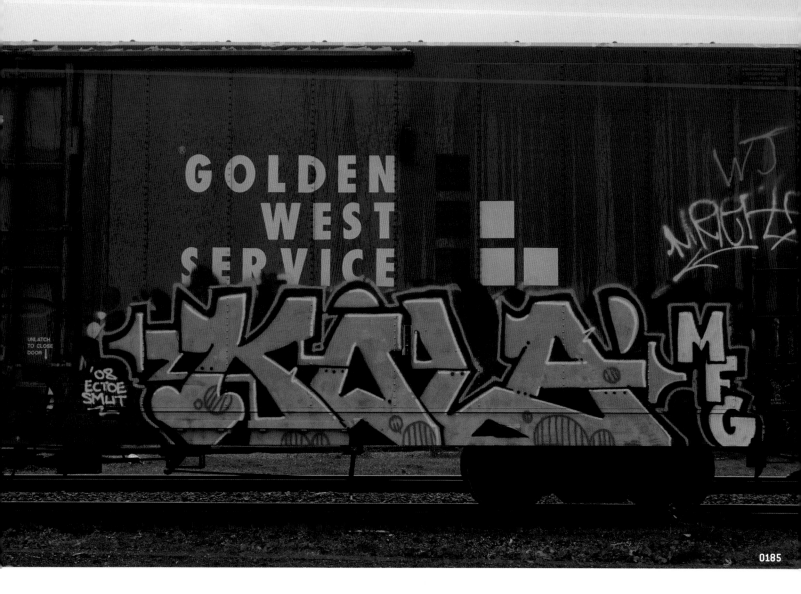

0185 MFG Freight Crew (ECTOE, RTYPE, HAIKU, KOLA, SMUT). Oakland, CA, USA / **0186** Fafa. Seville, Spain

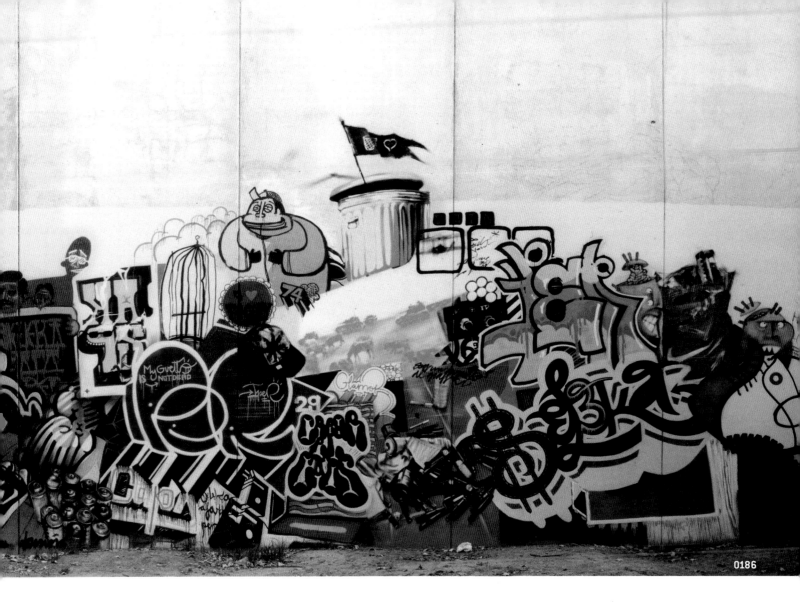

0186

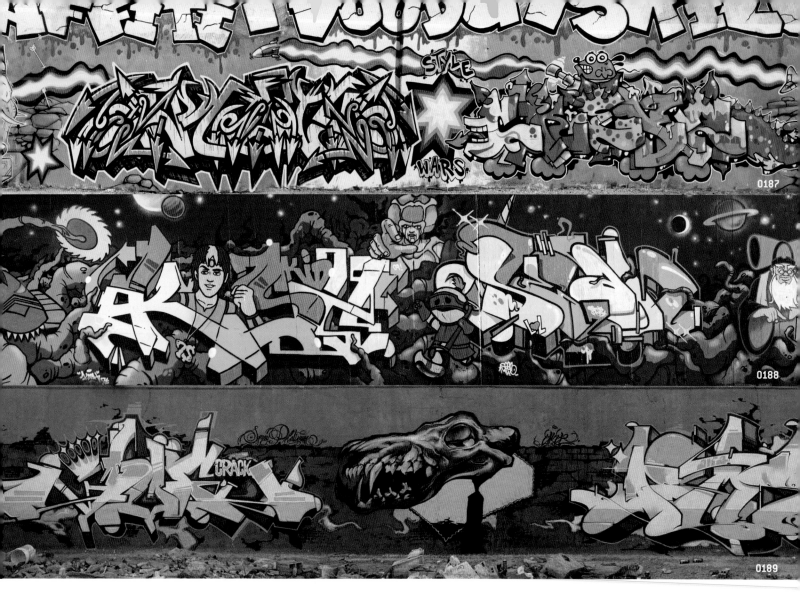

0187 Pariz One. Lisbon, Portugal / **0188** Seantwo (Loveletter crew). Lausanne, Switzerland / **0189** Joe. Seville, Spain / **0190** Cade. Vitoria, Spain / **0191** Joe. Seville, Spain / **0192** Astrid AKA CHOUR (3PP crew). Paris, France

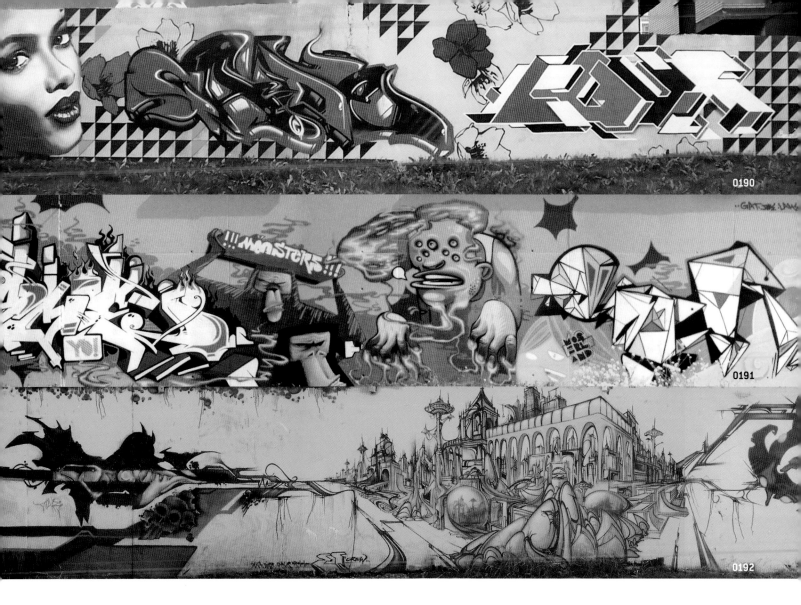

0190

0191

0192

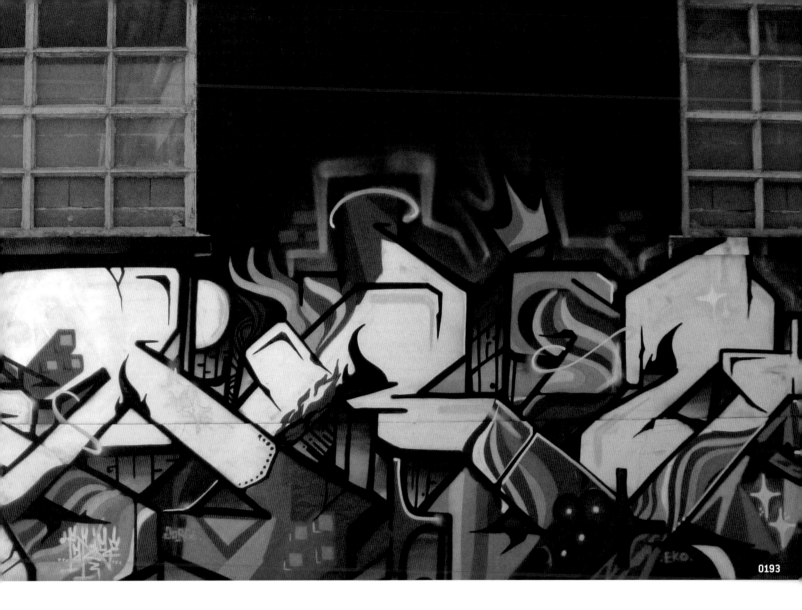

0193

0193 Pariz One. Lisbon, Portugal / **0194** Pos. Muri, Switzerland

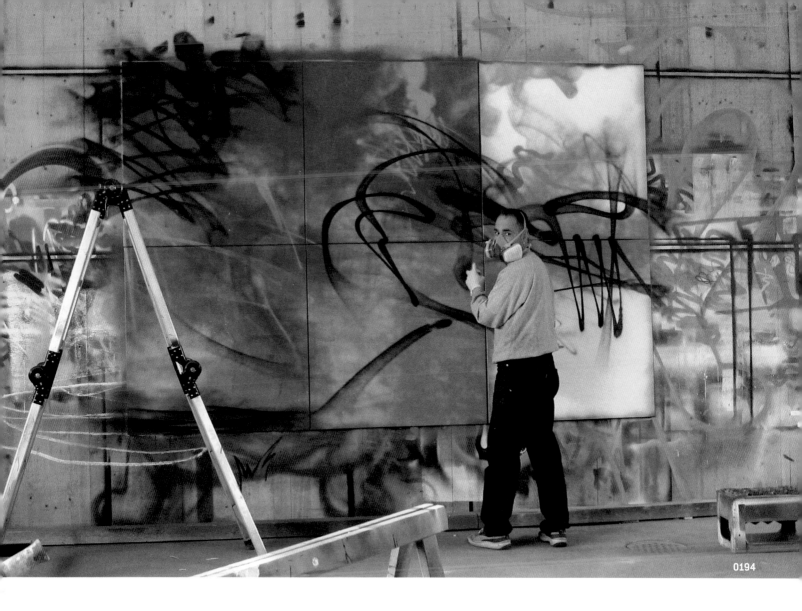

0194

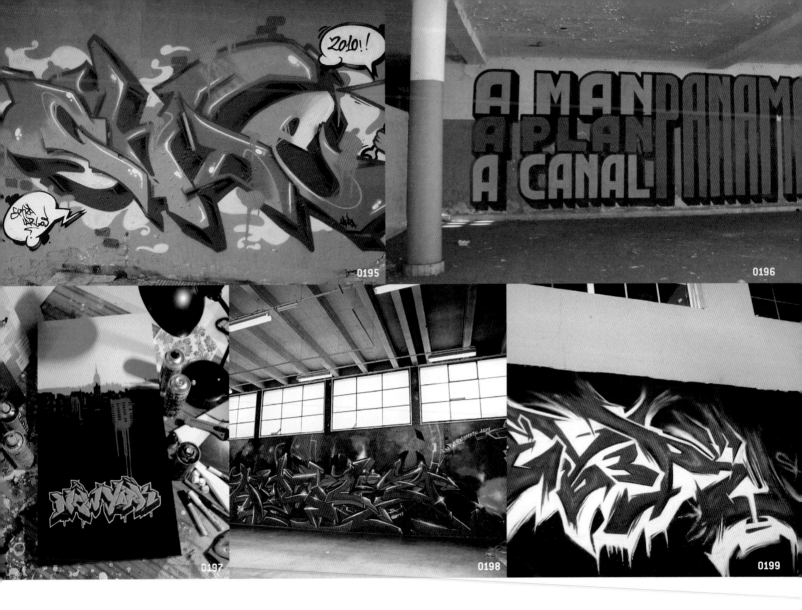

0195 Cade. Vitoria, Spain / **0196** Above. San Francisco, CA, USA / **0197** Doc Nova (Uwe H. Krieger). Gießen, Germany / **0198** Darco FBI. Paris, France / 199 Eyeone. Los Angeles, CA, USA / **0199** Eyeone. Los Angeles, CA, USA / **0200** Seleka. Seville, Spain

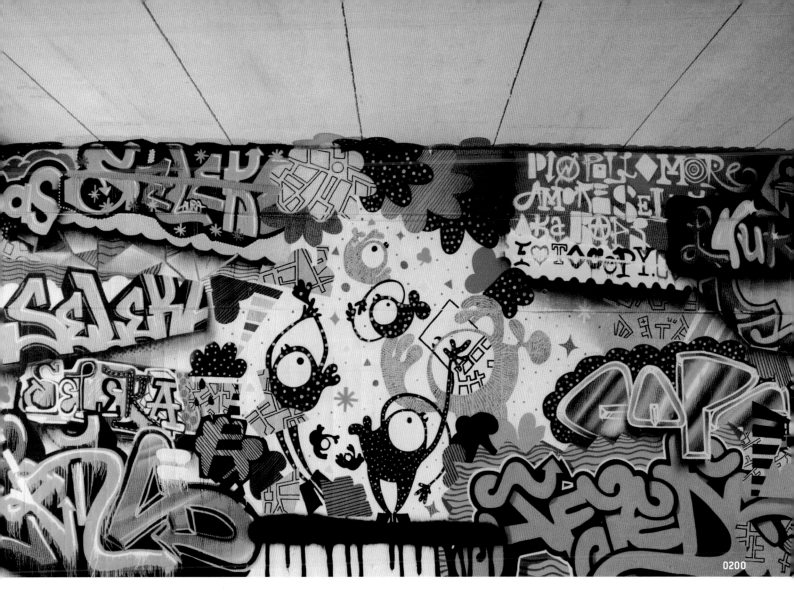

0200

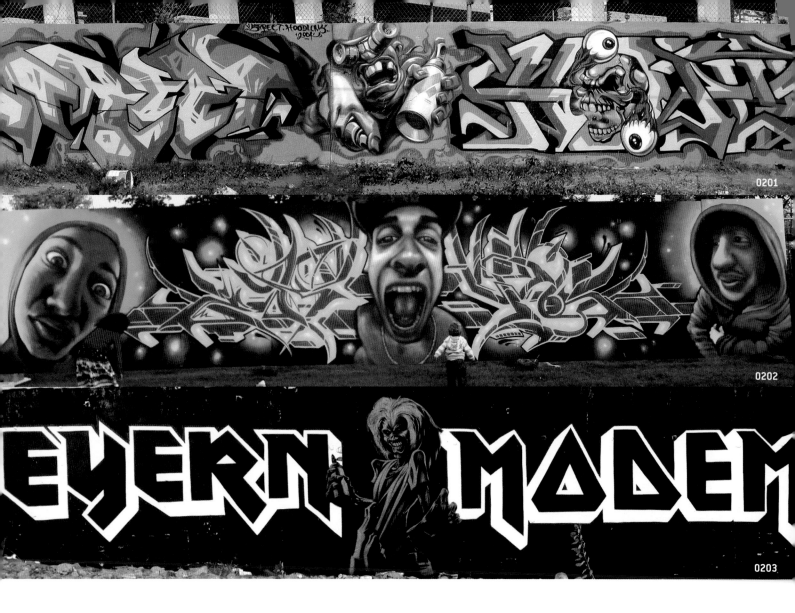

0201 Eyeone. Los Angeles, CA, USA / 0202 Brave 1 AKA Scotty~B. Essex, UK / 0203 Eyeone. Los Angeles, CA, USA / 0204 Eyeone. Los Angeles, CA, USA / 0205 Joe. Seville, Spain / 0206 Pariz One. Lisbon, Portugal

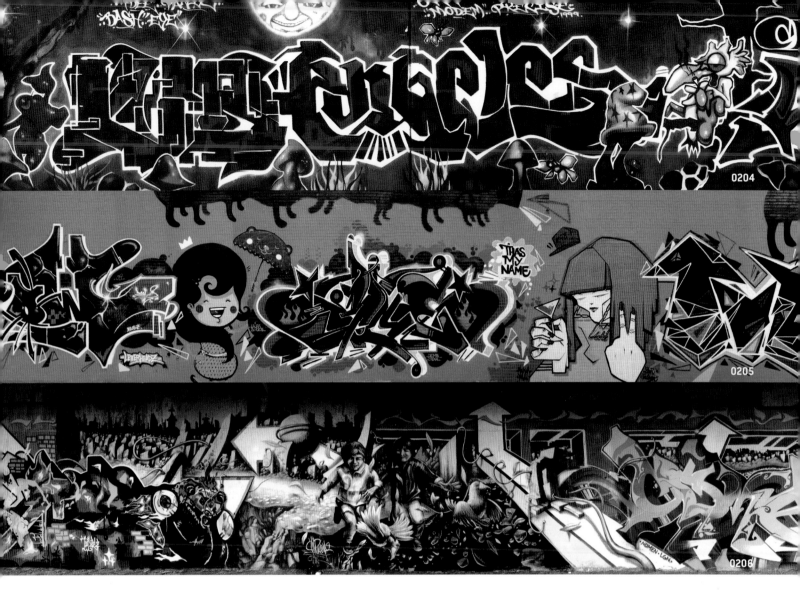

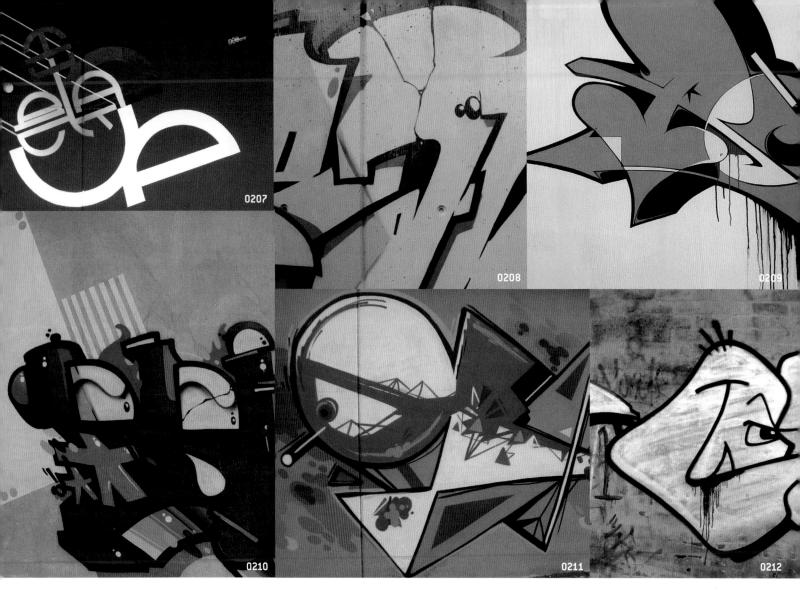

0207 Dyset. Munich, Germany / 0208 Seantwo (Loveletter crew). Lausanne, Switzerland / 0209 Reso. Saarbrücken, Germany / 0210 Seantwo (Loveletter crew). Lausanne, Switzerland / 0211 SRG/Ger. Seville, Spain / 0212 Darco FBI. Paris, France / 0213 Mr. Wany (Heavy Artillery Crew). Milan, Italy

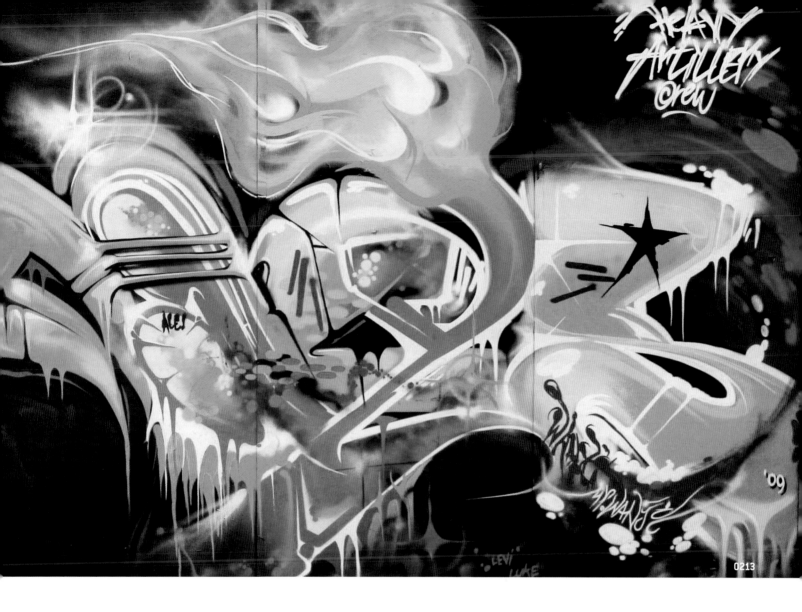

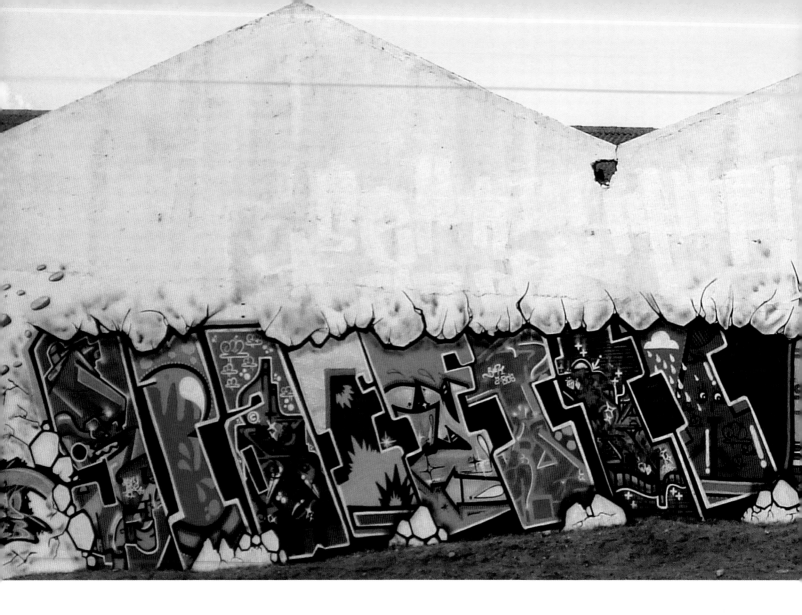

0214 Pariz One. Lisbon, Portugal

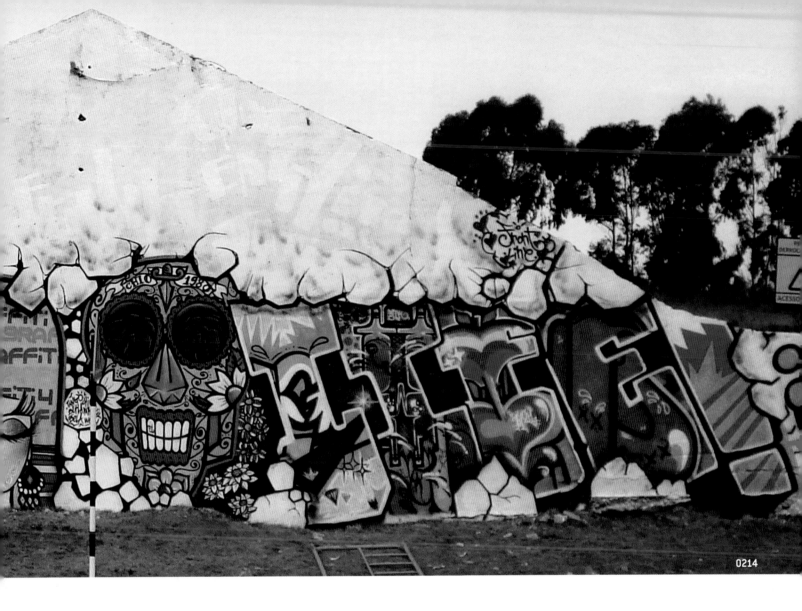

0214

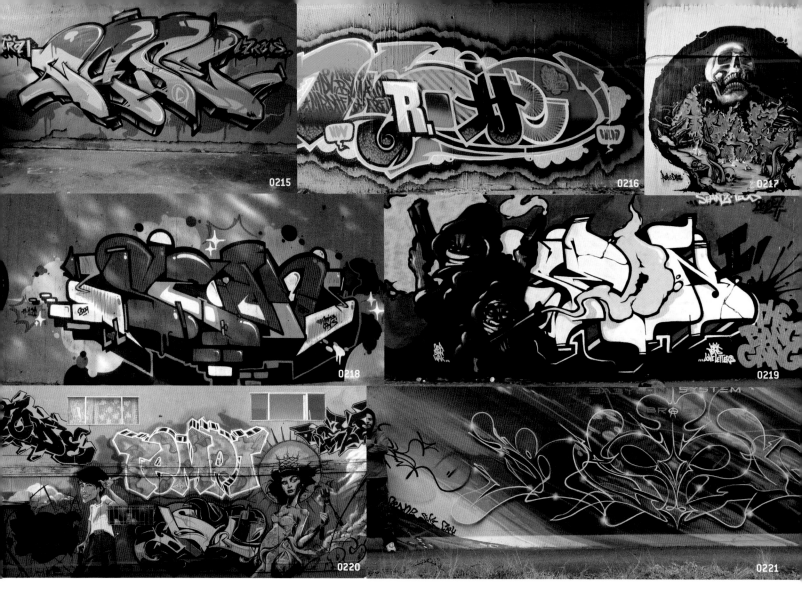

0215 Cade. Vitoria, Spain / **0216** Mr. Dheo. Porto, Portugal / **0217** Rusl. Stuttgart, Germany / **0218** Seantwo (Loveletter crew). Lausanne, Switzerland / **0219** Seantwo (Loveletter crew). Lausanne, Switzerland / **0220** Eyeone. Los Angeles, CA, USA / **0221** Brave 1 AKA Scotty~B. Essex, UK / **0222** Pariz One. Lisbon, Portugal

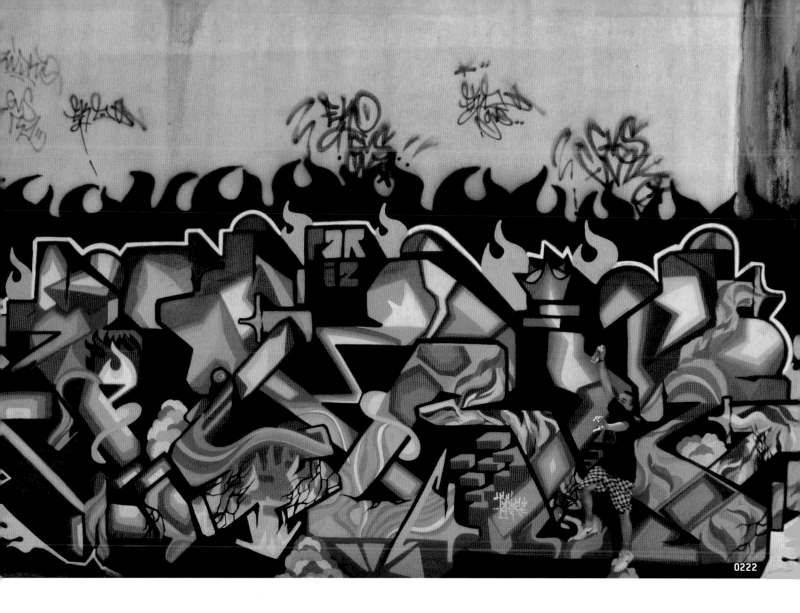

0222

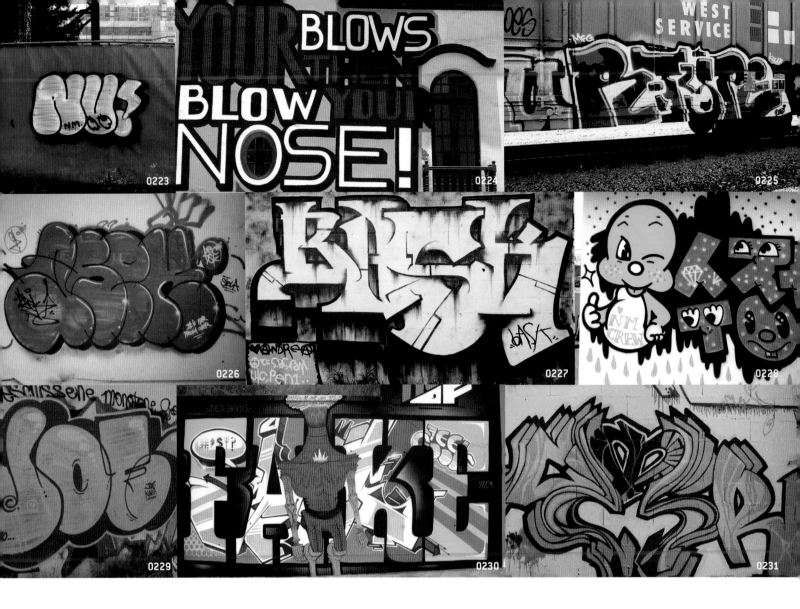

0223 Numi. Seoul, South Korea / 0224 Above. San Francisco, CA, USA / 0225 MFG Freight Crew (ECTOE, RTYPE, HAIKU, KOLA, SMUT). Oakland, CA, USA / 0226 Azek. Toulouse, France / 0227 BASK. Florida, USA / 0228 Numi. Seoul, South Korea / 0229 Joe. Seville, Spain / 0230 Joe. Seville, Spain / 0231 Astrid AKA CHOUR (3PP crew). Paris, France / 0232 Pariz One. Lisbon, Portugal

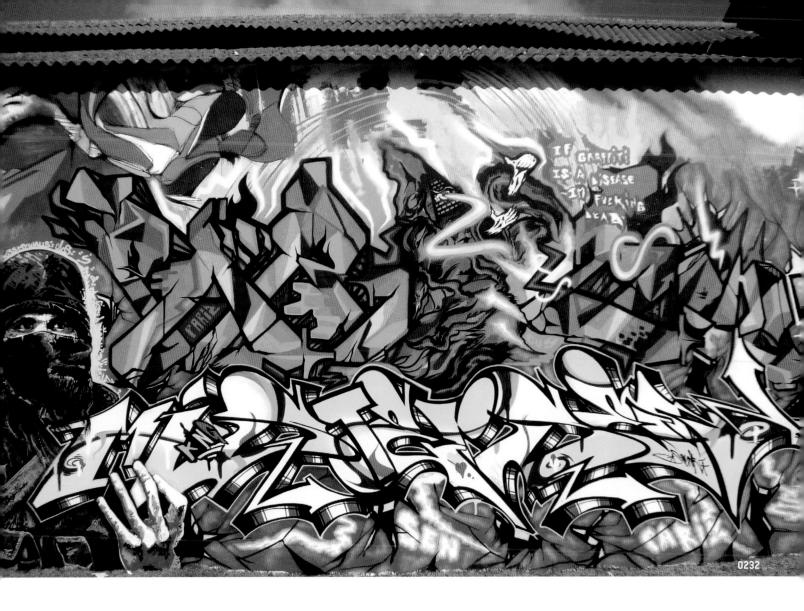

0232

0233

0233 Ripo. Barcelona, Spain, and New York, USA / 0234 Phil Ashcroft AKA PhlAsh. London, UK

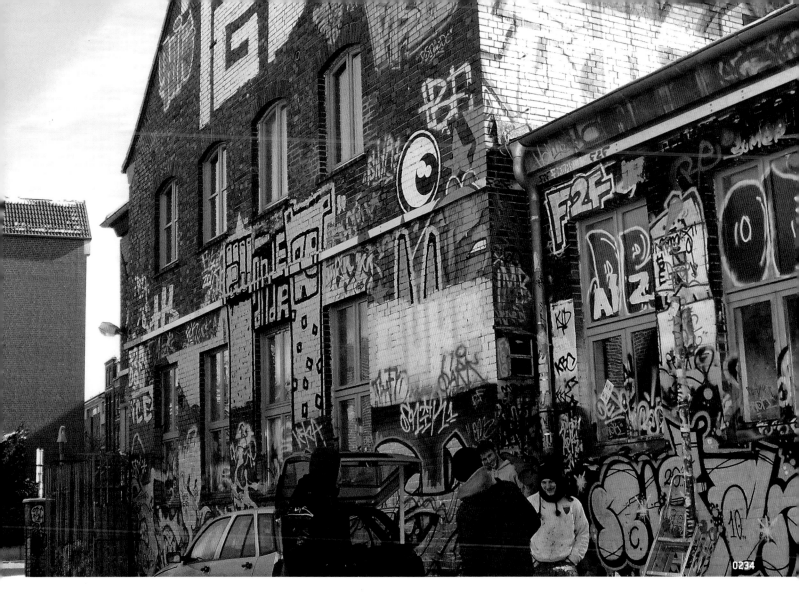

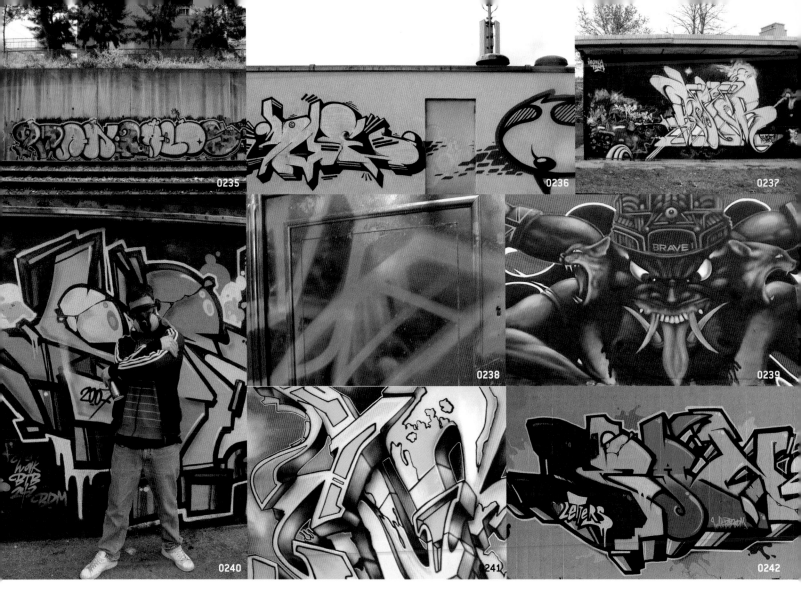

0235 Pariz One. Lisbon, Portugal / 0236 Joe. Seville, Spain / 0237 Mr. Wany (Heavy Artillery Crew). Milan, Italy / 0238 Darco FBI. Paris, France / 0239 Brave 1 AKA Scotty~B. Essex, UK / 0240 Seantwo (Loveletter crew). Lausanne, Switzerland / 0241 Wolfgang Krell. Dortmund, Germany / 0242 Seantwo (Loveletter crew). Lausanne, Switzerland / 0243 Mr. Wany (Heavy Artillery Crew). Milan, Italy / 0244 Joe. Seville, Spain / 0245 Joe. Seville, Spain / 0246 Cade. Vitoria, Spain / 0247 Bomber. Hofheim am Taunus, Germany / 0248 SRG/Ger. Seville, Spain / 0249 Joe. Seville, Spain / 0250 Joe. Seville, Spain

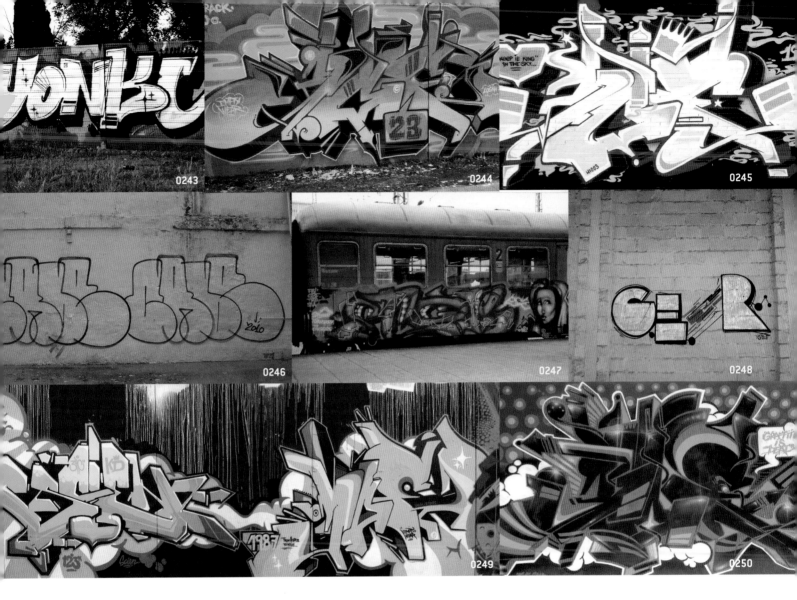

0243

0244

0245

0246

0247

0248

0249

0250

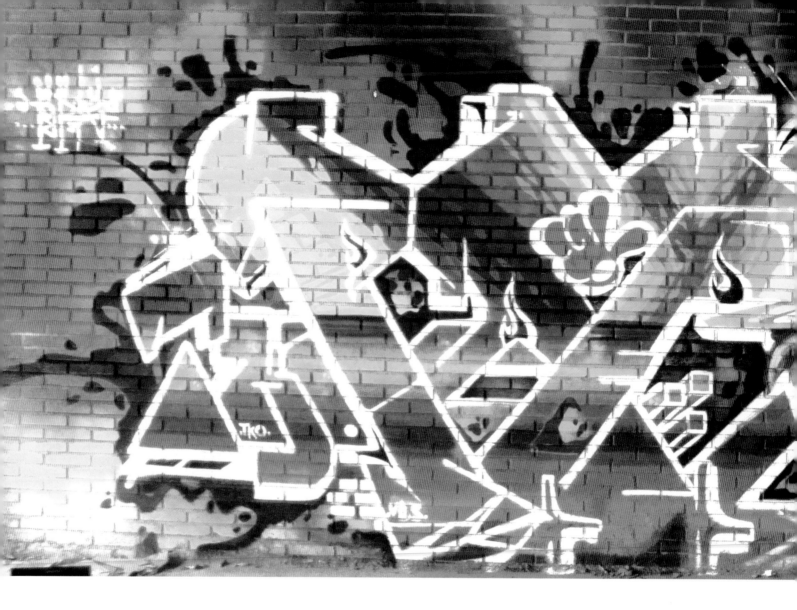

0251 Pariz One. Lisbon, Portugal

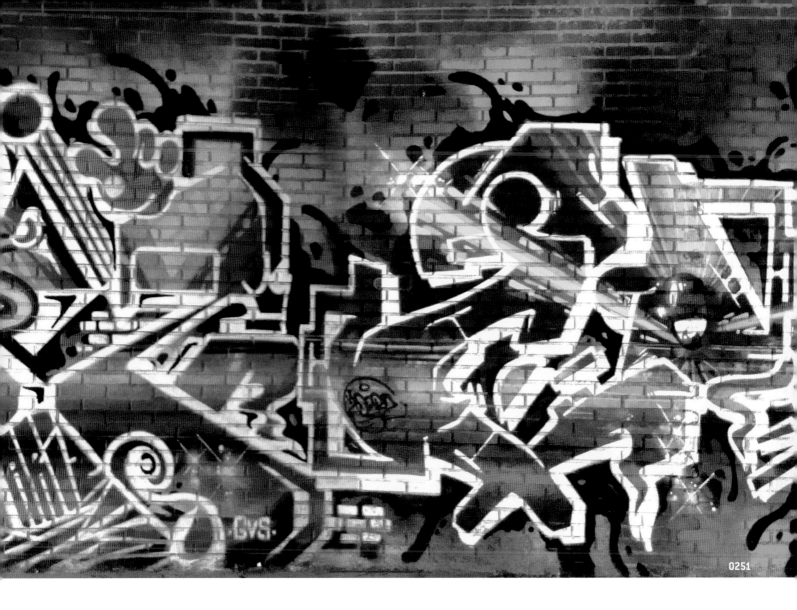

0251

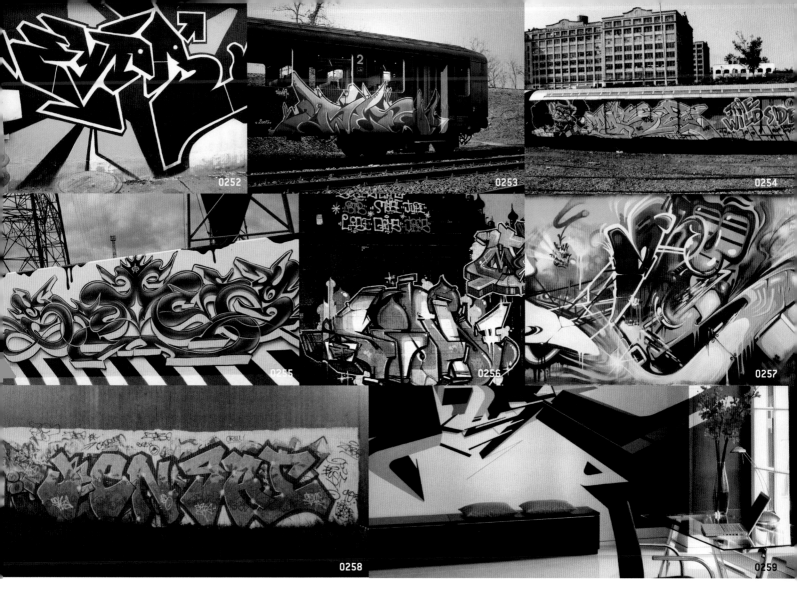

0252 Eyeone. Los Angeles, CA, USA / 0253 Reso. Saarbrücken, Germany / 0254 Pos. Muri, Switzerland / 0255 Brave 1 AKA Scotty~B. Essex, UK / 0256 Seantwo (Loveletter crew). Lausanne, Switzerland / 0257 Mr. Wany (Heavy Artillery Crew). Milan, Italy / 0258 Joan. Aschaffenburg, Germany / 0259 Toast One. Zurich, Switzerland / 0260 Darco FBI. Paris, France / 0261 Bomber. Hofheim am Taunus, Germany / 0262 Asia Komarova. Utrecht, Netherlands / 0263 Bomber. Hofheim am Taunus, Germany / 0264 Mosaik. Lisbon, Portugal / 0265 Nados. Barcelona, Spain / 0266 Rusl. Stuttgart, Germany / 0267 MAC 1. Birmingham, UK

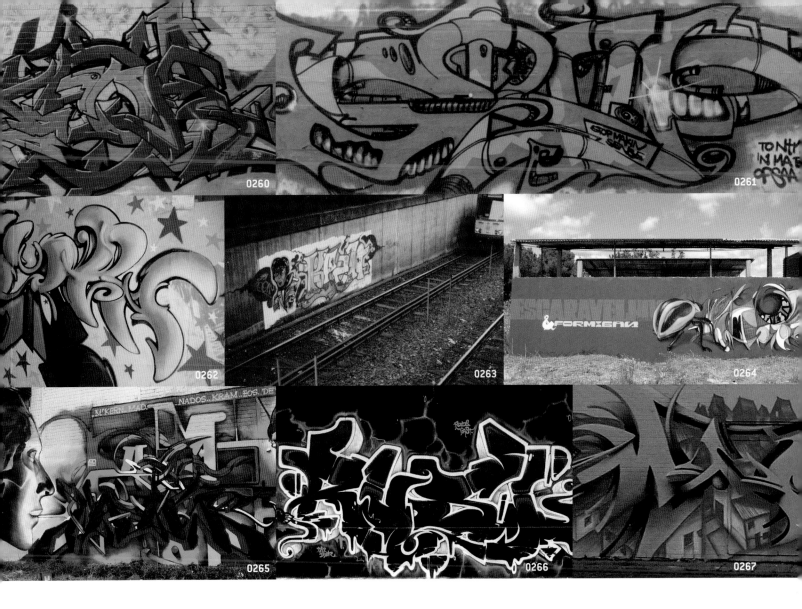

0260

0261

0262

0263

0264

0265

0266

0267

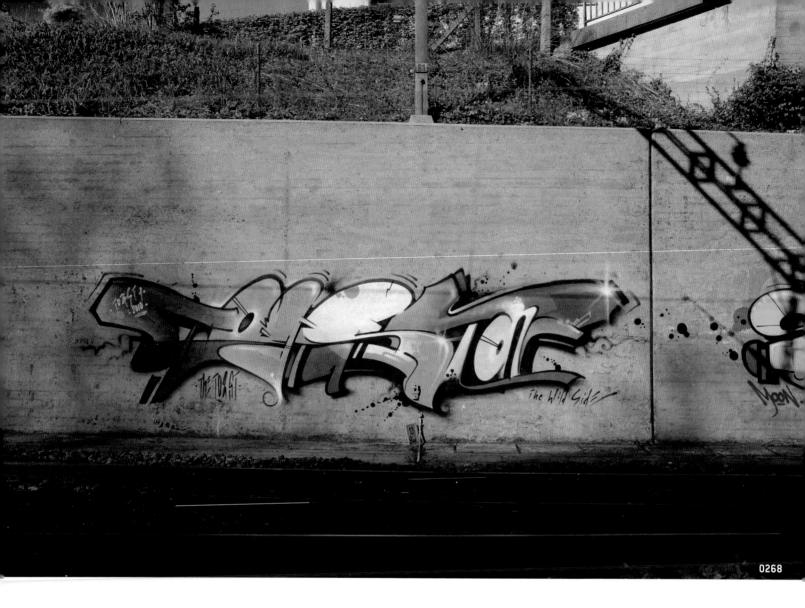

0268

0268 Toast One. Zurich, Switzerland / 0269 Seleka. Seville, Spain

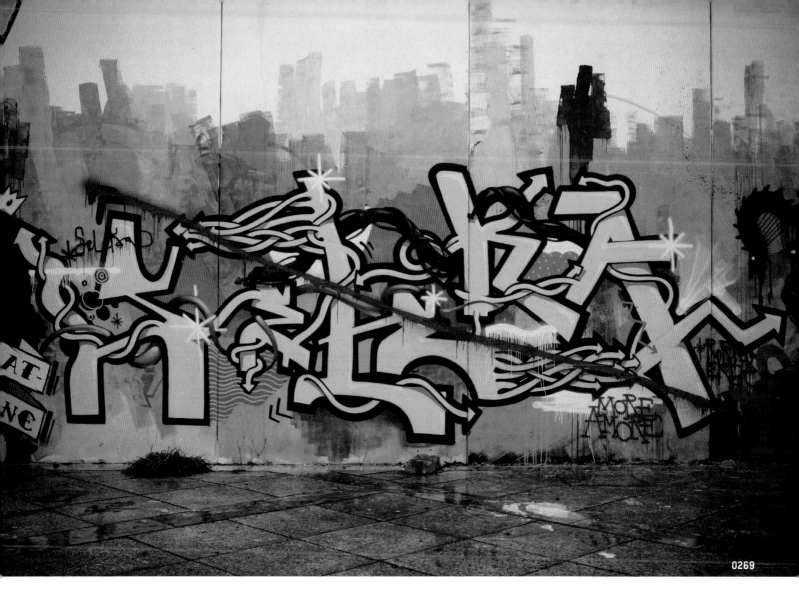

0269

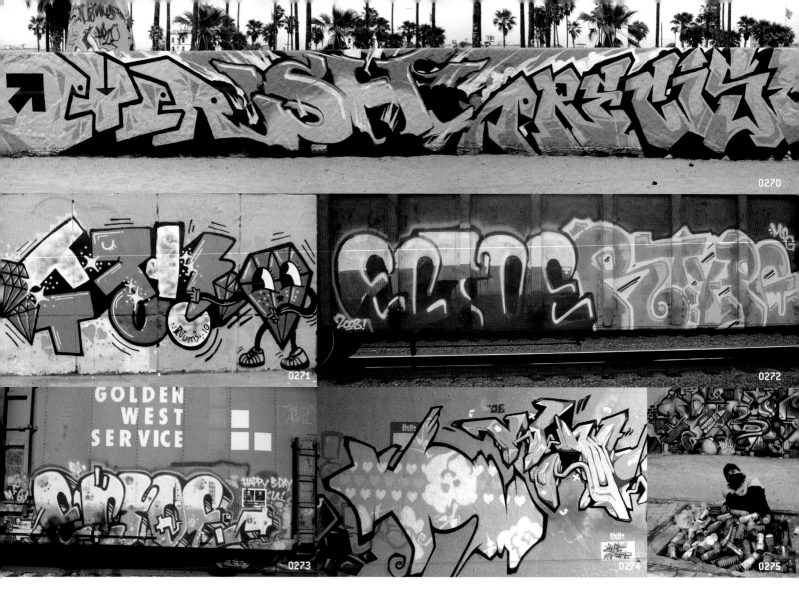

0270 Eyeone. Los Angeles, CA, USA / **0271** Numi. Seoul, South Korea / **0272** MFG Freight Crew (ECTOE, RTYPE, HAIKU, KOLA, SMUT). Oakland, CA, USA / **0273** MFG Freight Crew (ECTOE, RTYPE, HAIKU, KOLA, SMUT). Oakland, CA, USA / **0274** Astrid AKA CHOUR (3PP crew). Paris, France / **0275** Pariz One. Lisbon, Portugal / **0276** Pariz One. Lisbon, Portugal / **0277** Eyeone. Los Angeles, CA, USA / **0278** Rusl. Stuttgart, Germany / **0279** Rusl. Stuttgart, Germany

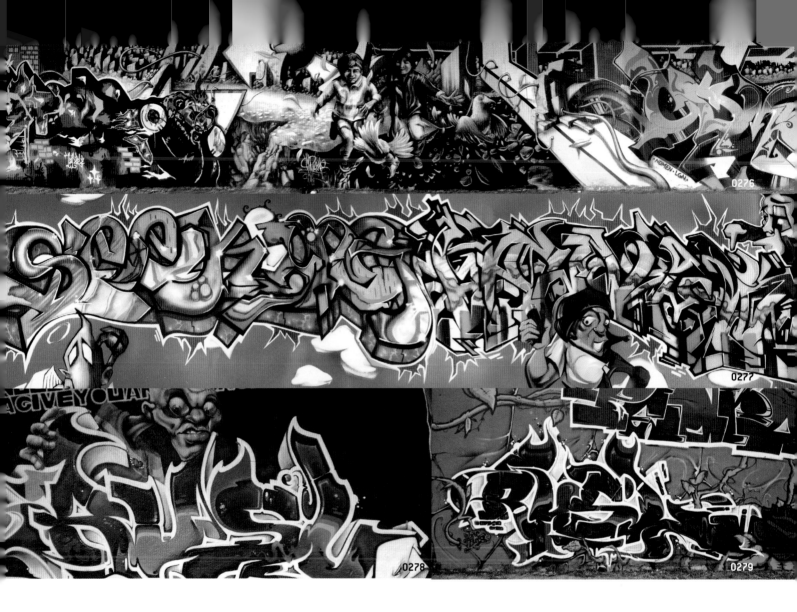

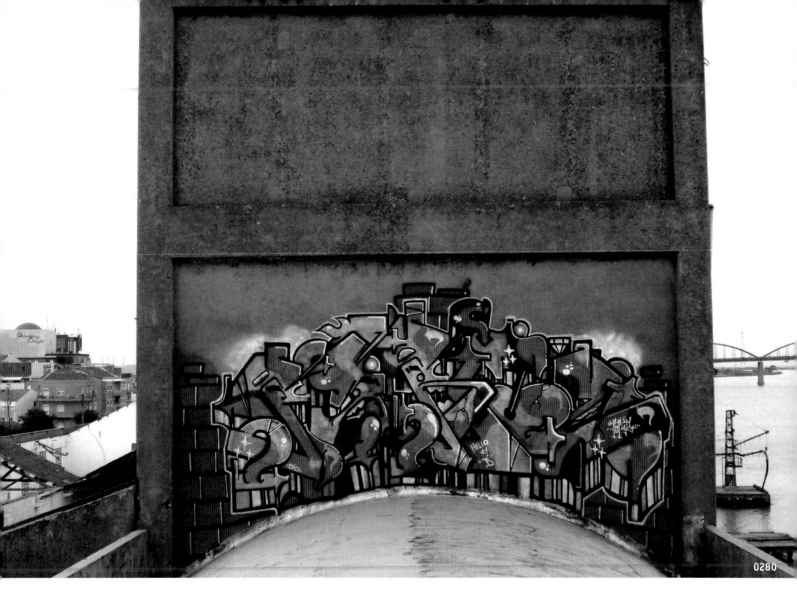

0280 Pariz One. Lisbon, Portugal / 0281 Pariz One. Lisbon, Portugal

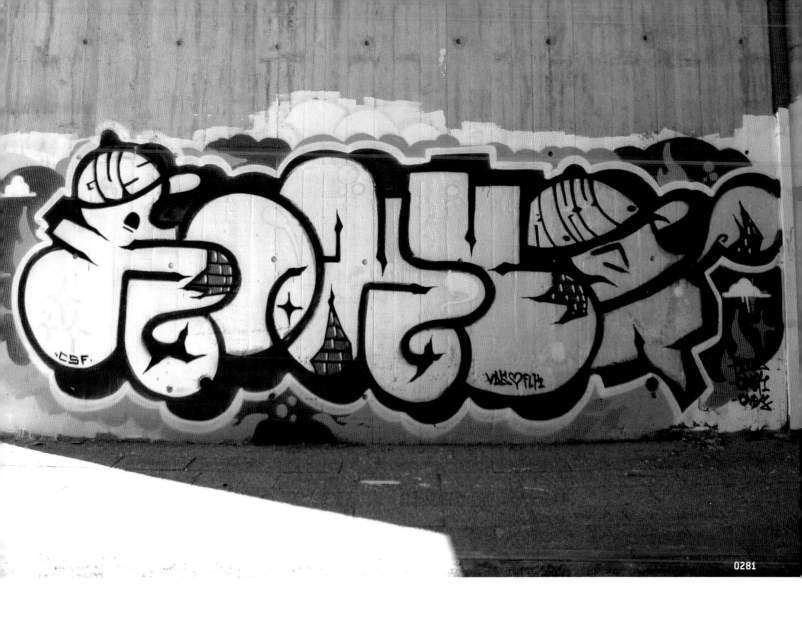

0281

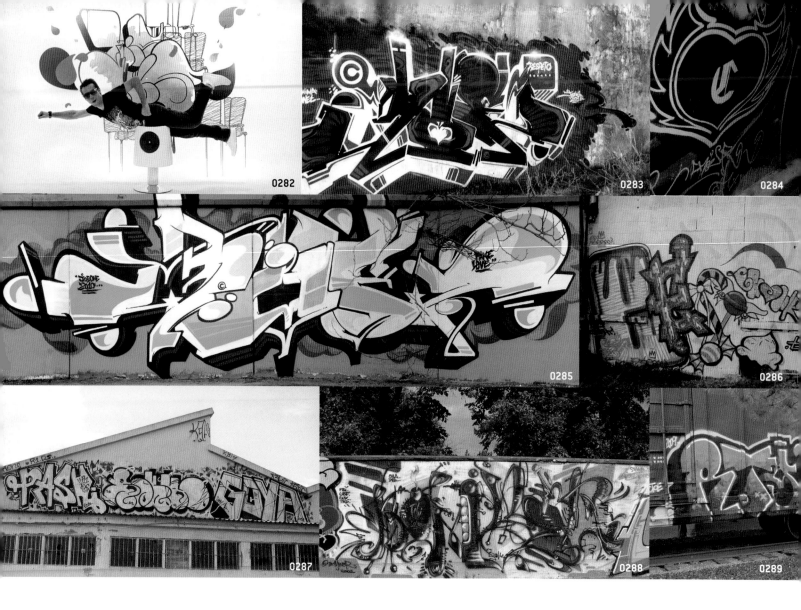

0282 Nados. Barcelona, Spain / 0283 Joe. Seville, Spain / 0284 Astrid AKA CHOUR (3PP crew). Paris, France / 0285 Joe. Seville, Spain / 0286 Astrid AKA CHOUR (3PP crew). Paris, France / 0287 Pariz One. Lisbon, Portugal / 0288 Bomber. Hofheim am Taunus, Germany / 0289 MFG Freight Crew (ECTOE, RTYPE, HAIKU, KOLA, SMUT). Oakland, CA, USA / 0290 Seantwo (Loveletter crew). Lausanne, Switzerland / 0291 Rusl. Stuttgart, Germany / 0292 Rusl. Stuttgart, Germany / 0293 Darco FBI. Paris, France / 0294 Asia Komarova. Utrecht, Netherlands

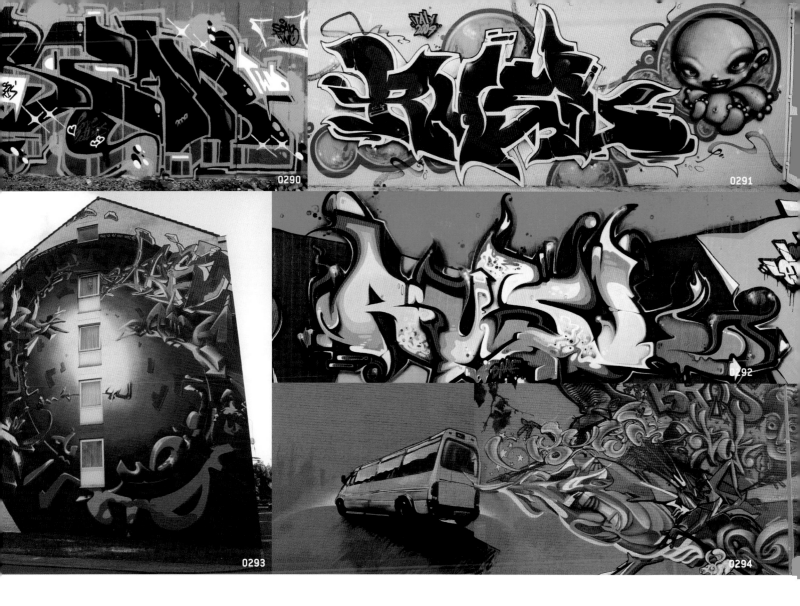

0290

0291

0292

0293

0294

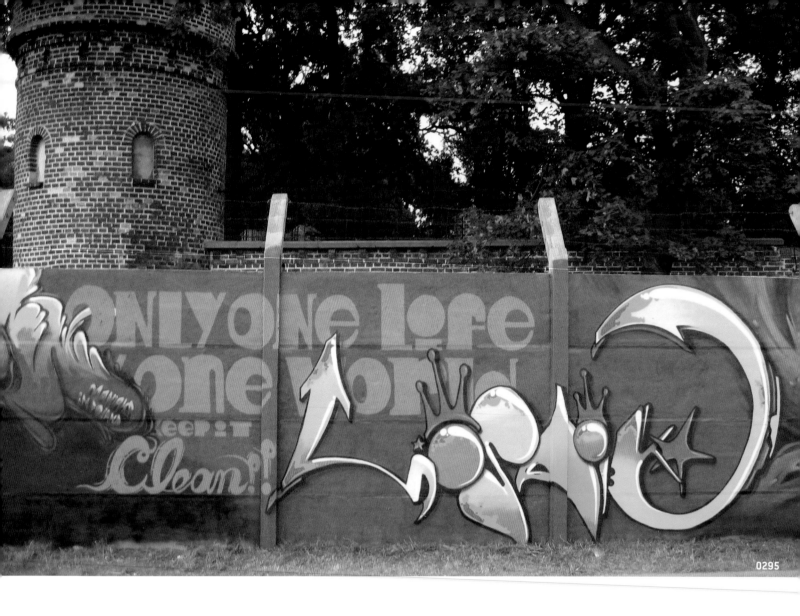

0295 Mosaik. Lisbon, Portugal / 0296 Above. San Francisco, CA, USA

BY THE TIME YOU READ THIS I'LL ALREADY BE GONE

0296

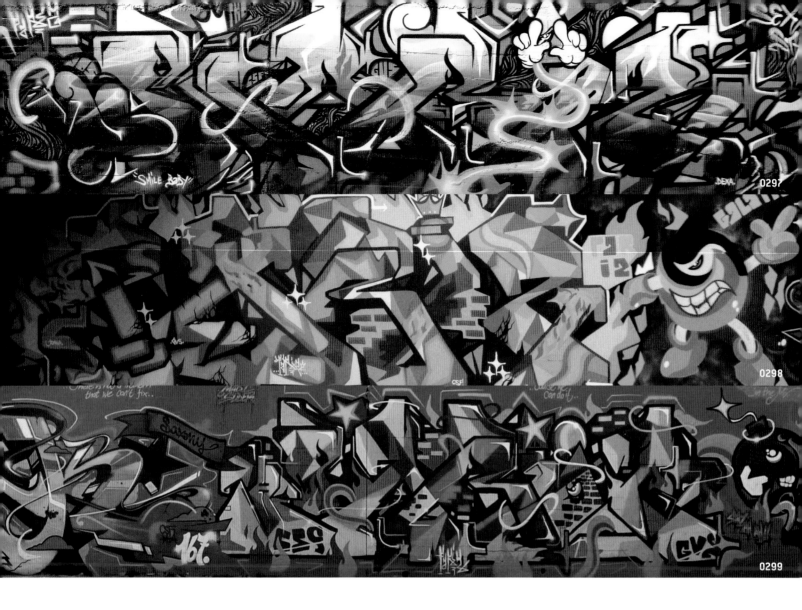

0297 Pariz One. Lisbon, Portugal / 0298 Pariz One. Lisbon, Portugal / 0299 Pariz One. Lisbon, Portugal / 0300 MFG Freight Crew (ECTOE, RTYPE, HAIKU, KOLA, SMUT). Oakland, CA, USA / 0301 Bomber. Hofheim am Taunus, Germany / 0302 Joe. Seville, Spain / 0303 MFG Freight Crew (ECTOE, RTYPE, HAIKU, KOLA, SMUT). Oakland, CA, USA / 0304 Joe. Seville, Spain / 0305 Ripo. Barcelona, Spain, and New York, USA

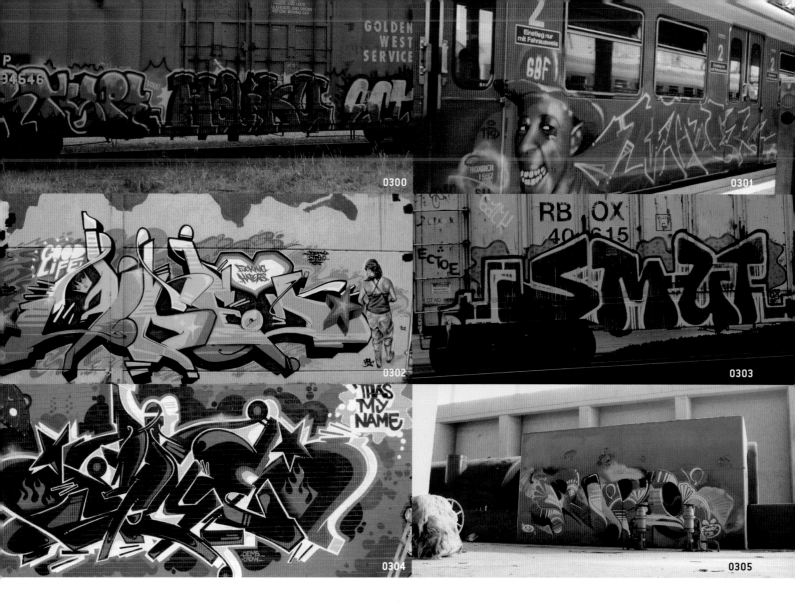

0300

0301

0302

0303

0304

0305

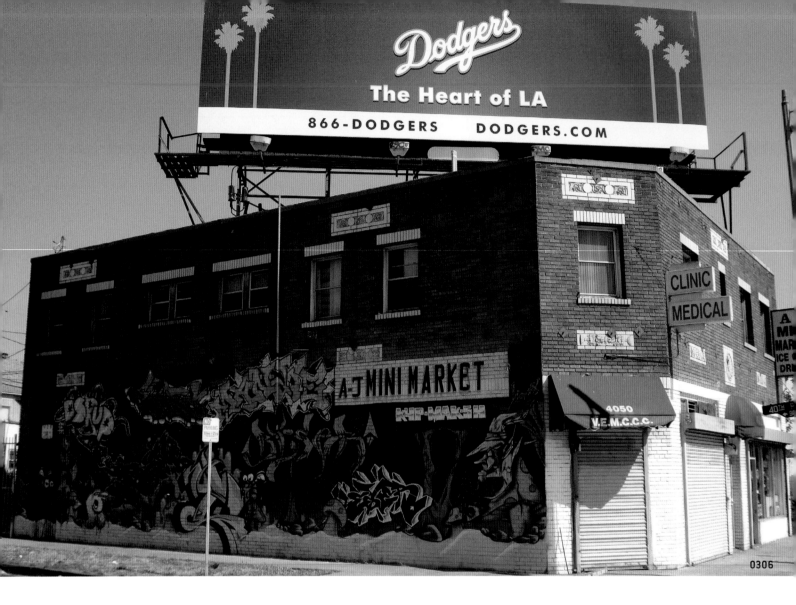

0306

0306 Eyeone. Los Angeles, CA, USA / **0307** Pariz One. Lisbon, Portugal

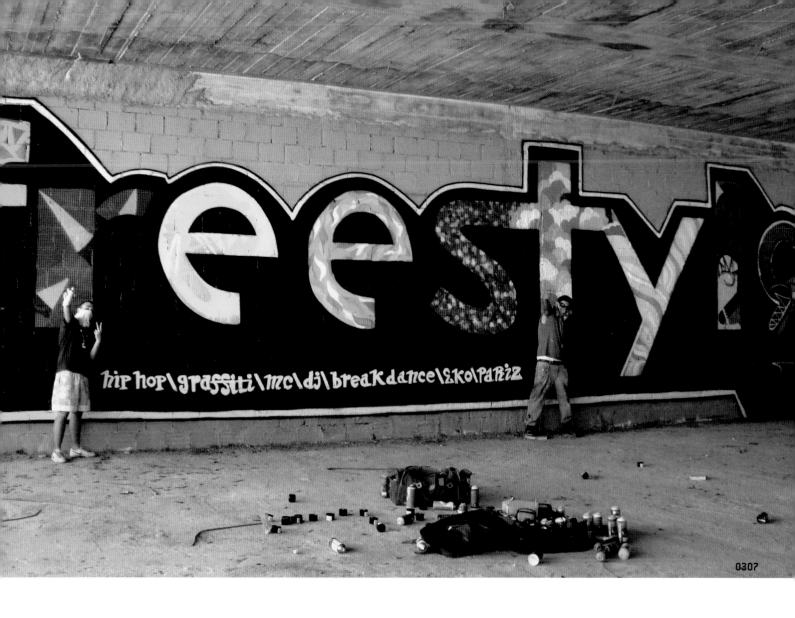

0307

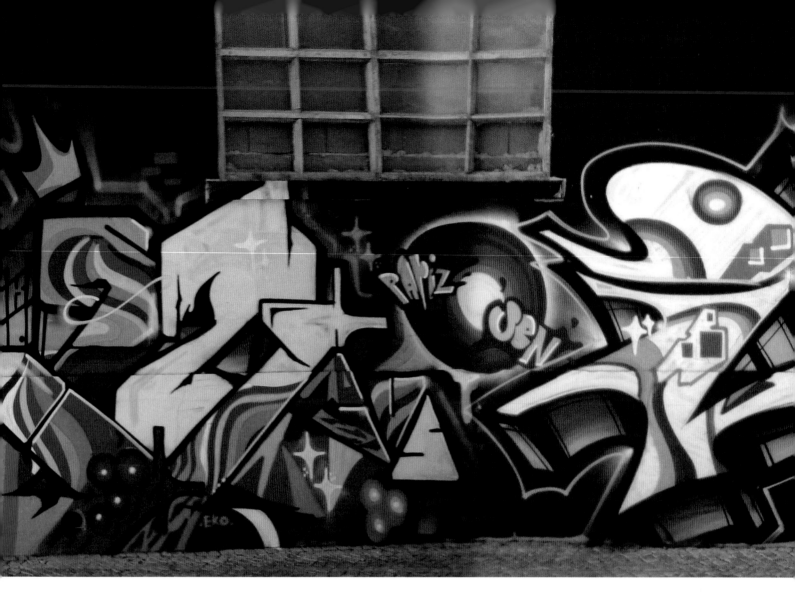

0308 Pariz One. Lisbon, Portugal

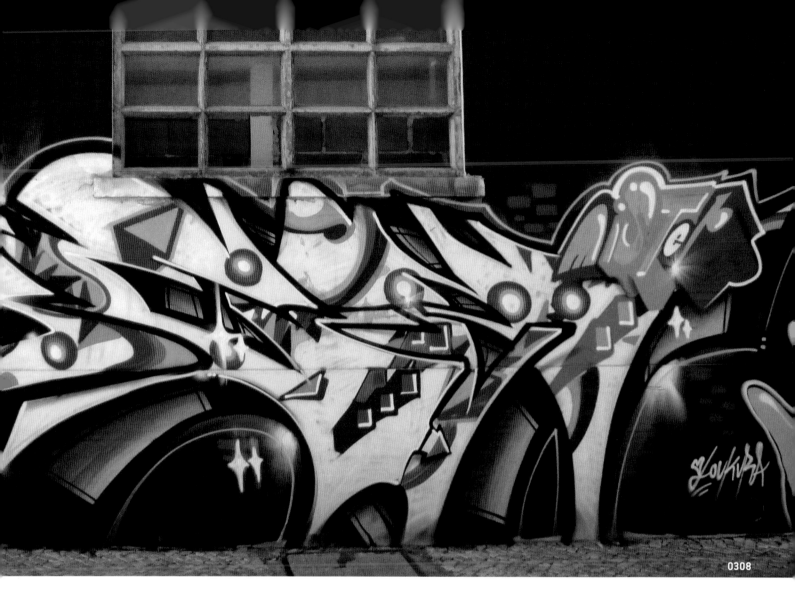

0308

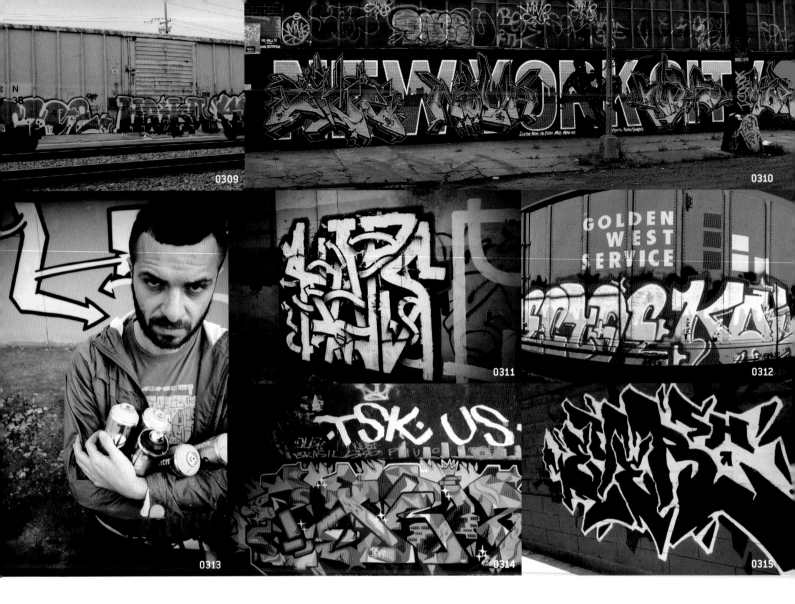

0309 MFG Freight Crew (ECTOE, RTYPE, HAIKU, KOLA, SMUT). Oakland, CA, USA / **0310** Doc Nova (Uwe H. Krieger). Gießen, Germany / **0311** Seleka. Seville, Spain / **0312** MFG Freight Crew (ECTOE, RTYPE, HAIKU, KOLA, SMUT). Oakland, CA, USA / **0313** Seleka. Seville, Spain / **0314** Pariz One. Lisbon, Portugal / **0315** Eyeone. Los Angeles, CA, USA / **0316** SRG/Ger. Seville, Spain / **0317** Rusl. Stuttgart, Germany / **0318** Rusl. Stuttgart, Germany / **0319** Seleka. Seville, Spain / **0320** Cade. Vitoria, Spain / **0321** Bomber. Hofheim am Taunus, Germany

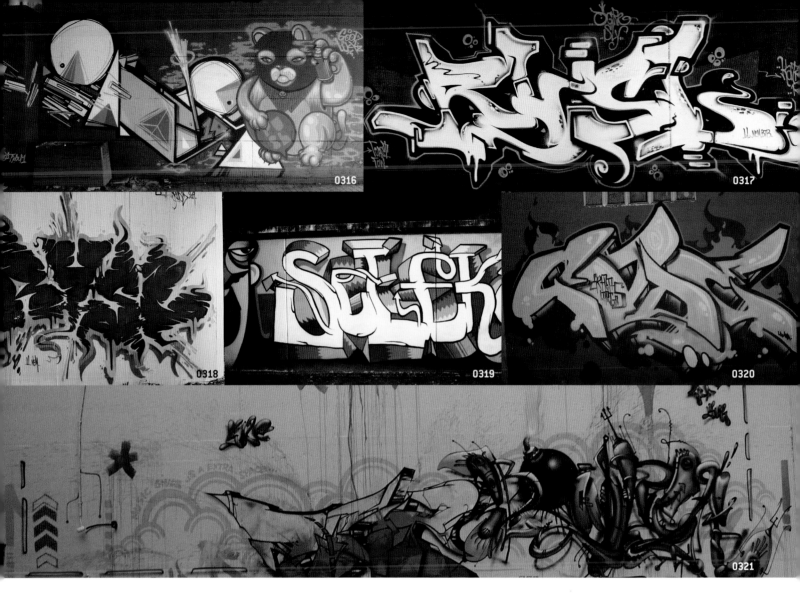

0316

0317

0318

0319

0320

0321

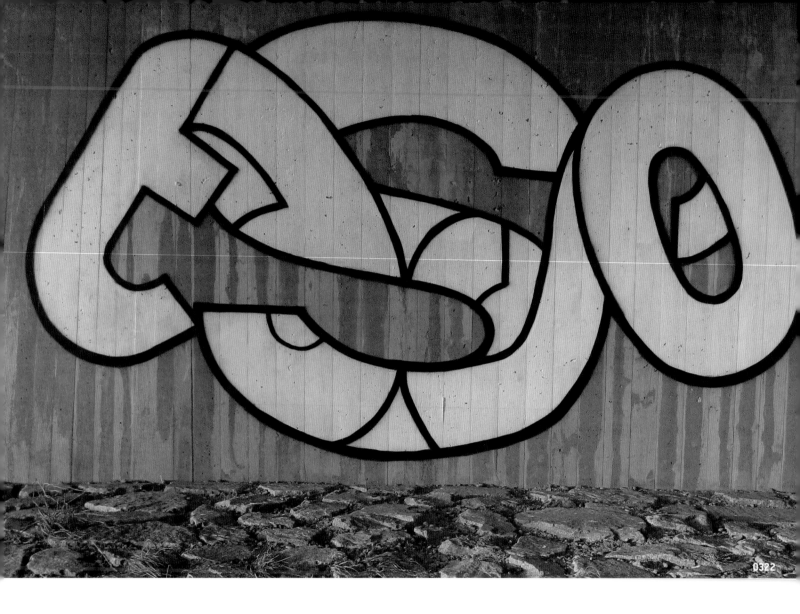

0322

0322 Tasso. Meerane, Germany / 0323 Numi. Seoul, South Korea

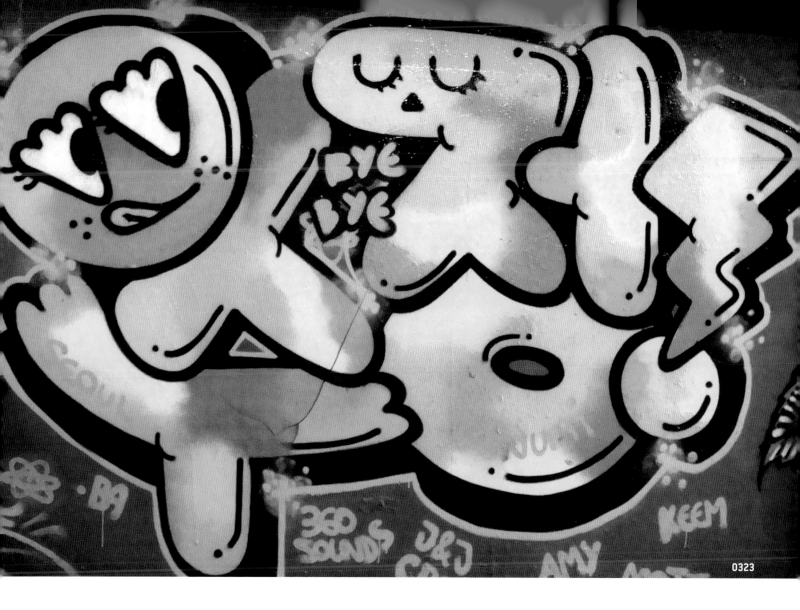

0323

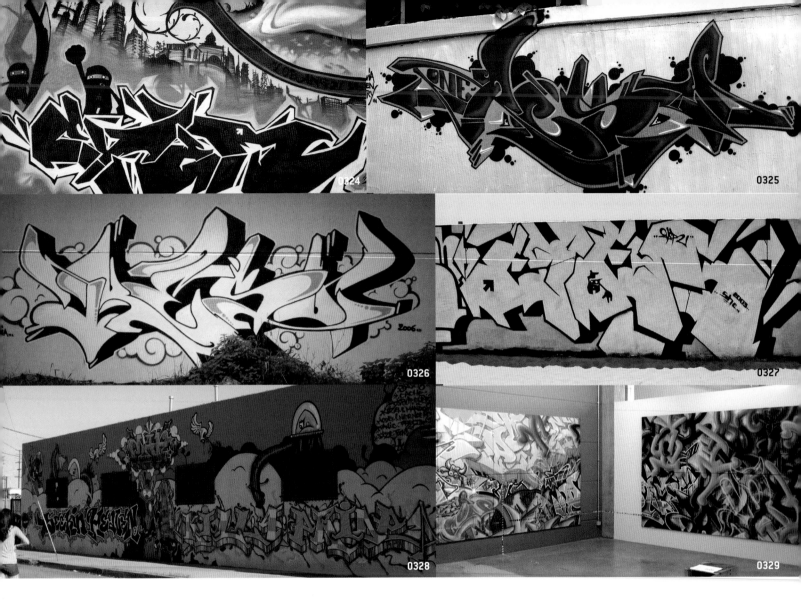

0324 Eyeone. Los Angeles, CA, USA / 0325 Reso. Saarbrücken, Germany / 0326 Reso. Saarbrücken, Germany / 0327 Eyeone. Los Angeles, CA, USA / 0328 Eyeone. Los Angeles, CA, USA / 0329 Pos. Muri, Switzerland / 0330 MFG Freight Crew (ECTOE, RTYPE, HAIKU, KOLA, SMUT). Oakland, CA, USA / 0331 Malicia. Barcelona, Spain / 0332 Pariz One. Lisbon, Portugal / 0333 MFG Freight Crew (ECTOE, RTYPE, HAIKU, KOLA, SMUT). Oakland, CA, USA / 0334 Malicia. Barcelona, Spain / 0335 Chaz Bojorquez. Los Angeles, CA, USA

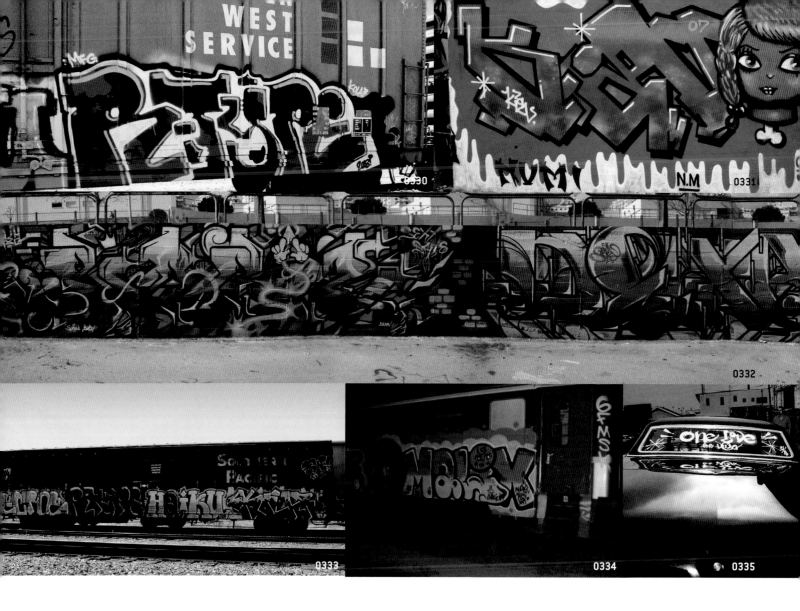

0330

0331

0332

0333

0334

0335

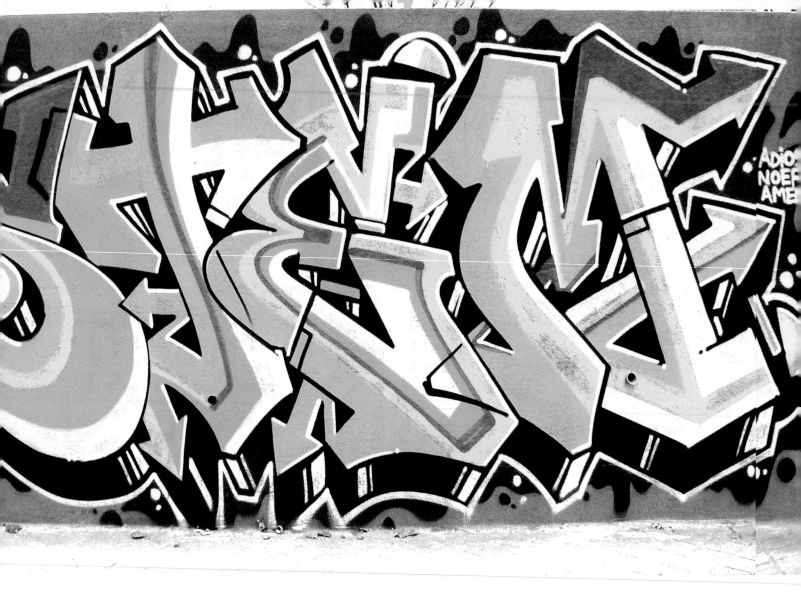

0336 Pariz One. Lisbon, Portugal

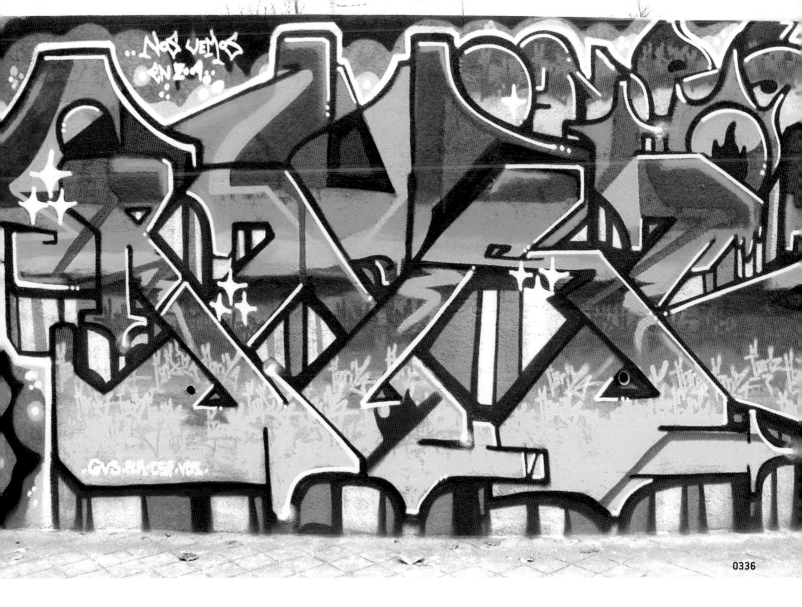

0336

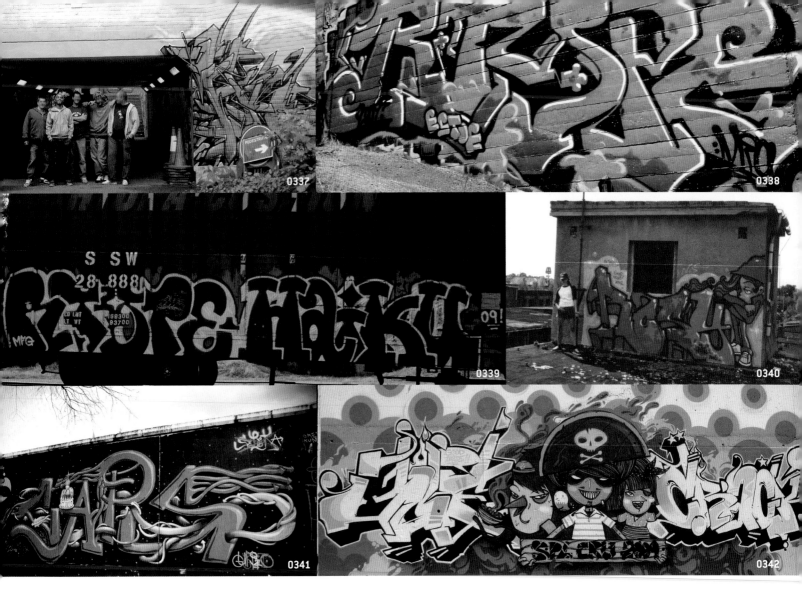

0337 Brave 1 AKA Scotty~B. Essex, UK / 0338 MFG Freight Crew (ECTOE, RTYPE, HAIKU, KOLA, SMUT). Oakland, CA, USA / 0339 MFG Freight Crew (ECTOE, RTYPE, HAIKU, KOLA, SMUT). Oakland, CA, USA / 0340 RosyOne. Biel-Bienne, Switzerland / 0341 Seleka. Seville, Spain / 0342 Joe. Seville, Spain / 0343 Joe. Seville, Spain / 0344 SRG/Ger. Seville, Spain / 0345 Grito. Barcelona, Spain / 0346 MFG Freight Crew (ECTOE, RTYPE, HAIKU, KOLA, SMUT). Oakland, CA, USA / 0347 MFG Freight Crew (ECTOE, RTYPE, HAIKU, KOLA, SMUT). Oakland, CA, USA / 0348 MFG Freight Crew (ECTOE, RTYPE, HAIKU, KOLA, SMUT). Oakland, CA, USA

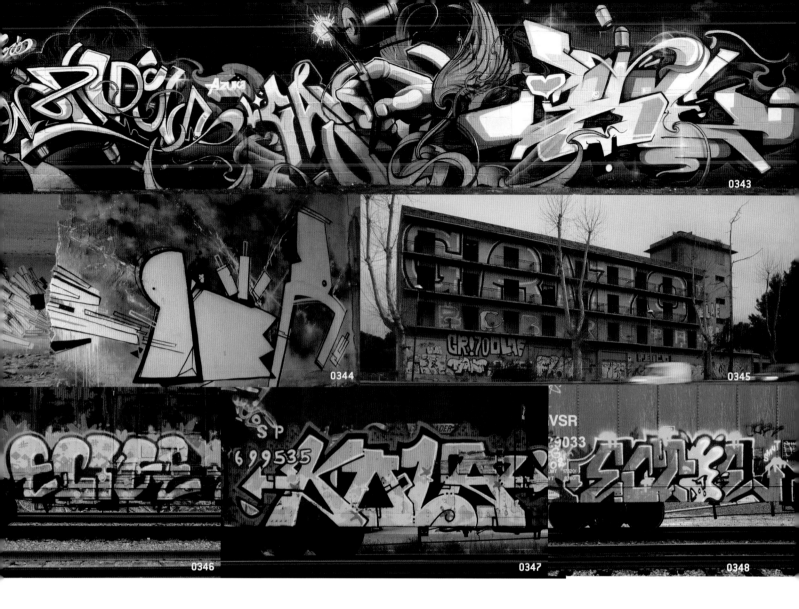

0343

0344

0345

0346

0347

0348

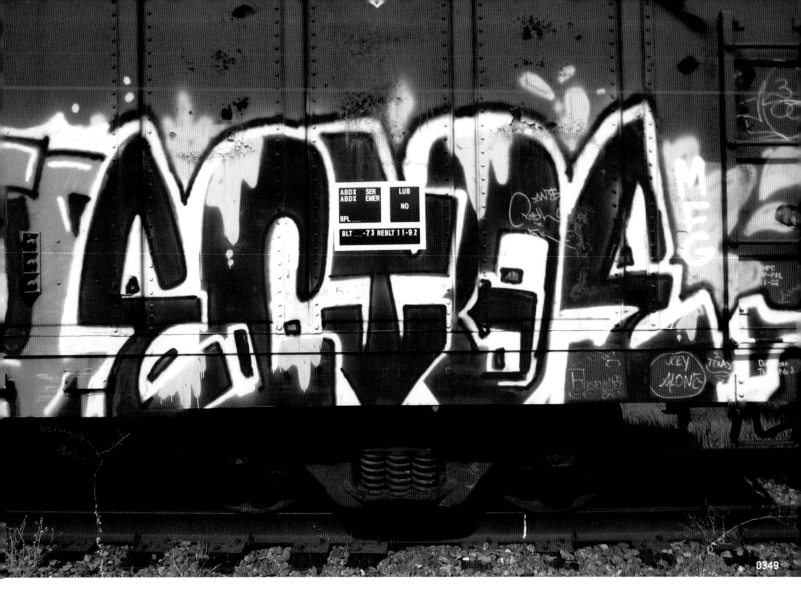

0349

0349 MFG Freight Crew (ECTOE, RTYPE, HAIKU, KOLA, SMUT). Oakland, CA, USA / **0350** MFG Freight Crew (ECTOE, RTYPE, HAIKU, KOLA, SMUT). Oakland, CA, USA

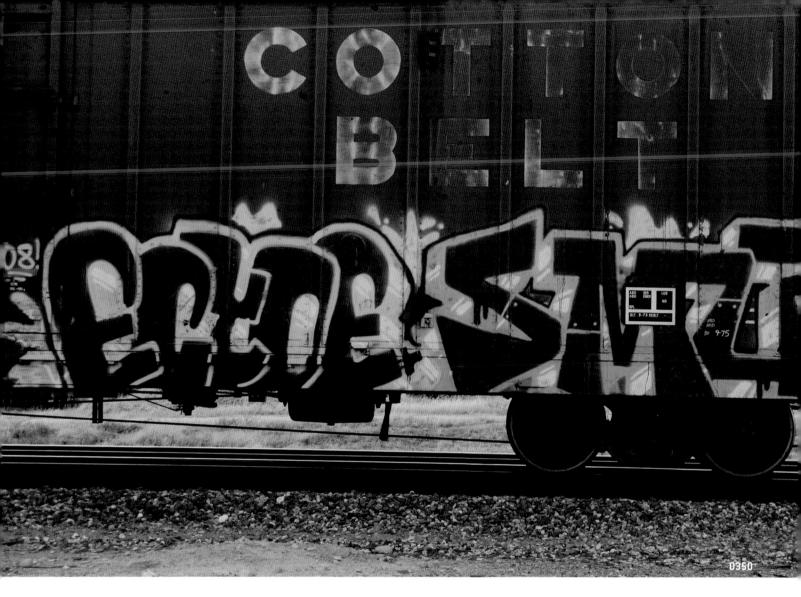

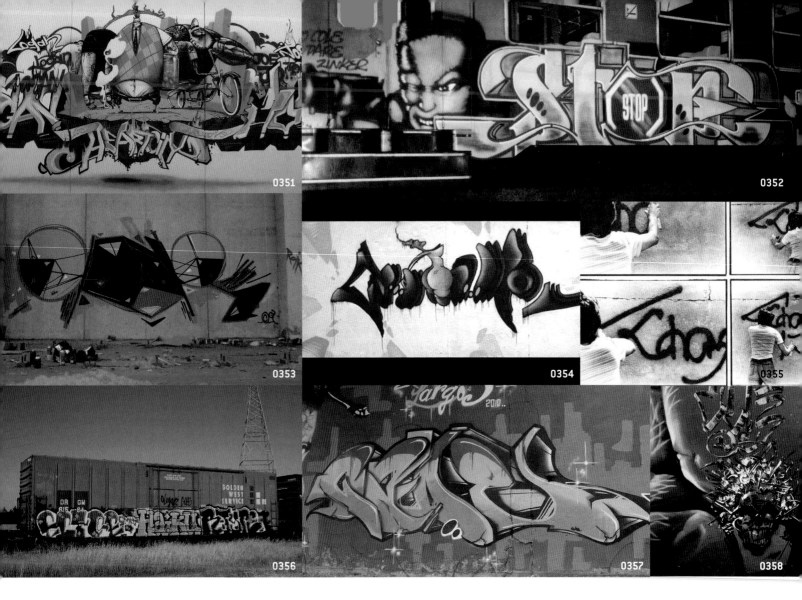

0351 Joe. Seville, Spain / 0352 Bomber. Hofheim am Taunus, Germany / 0353 SRG/Ger. Seville, Spain / 0354 Astrid AKA CHOUR (3PP crew). Paris, France / 0355 Chaz Bojorquez. Los Angeles, CA, USA / 0356 MFG Freight Crew (ECTOE, RTYPE, HAIKU, KOLA, SMUT). Oakland, CA, USA / 0357 Cade. Vitoria, Spain / 0358 Chaz Bojorquez. Los Angeles, CA, USA / 0359 Malicia. Barcelona, Spain / 0360 BASK. Florida, USA / 0361 Pariz One. Lisbon, Portugal / 0362 AKIT. London, UK / 0363 MFG Freight Crew (ECTOE, RTYPE, HAIKU, KOLA, SMUT). Oakland, CA, USA

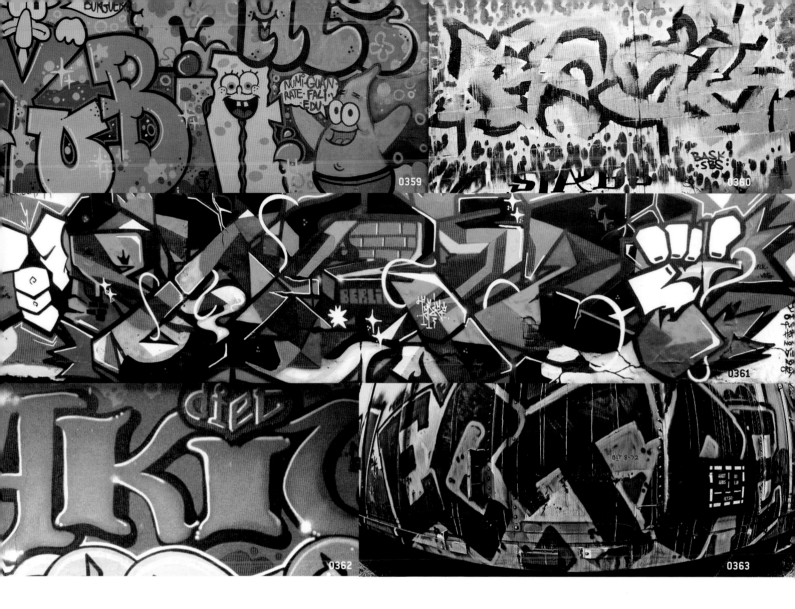

0359

0360

0361

0362

0363

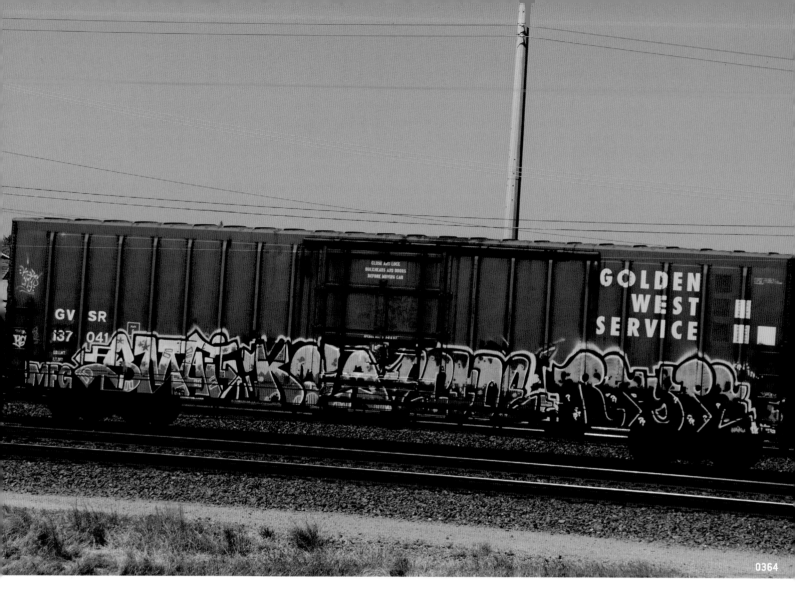

0364

0364 MFG Freight Crew (ECTOE, RTYPE, HAIKU, KOLA, SMUT). Oakland, CA, USA / **0365** Seleka. Seville, Spain

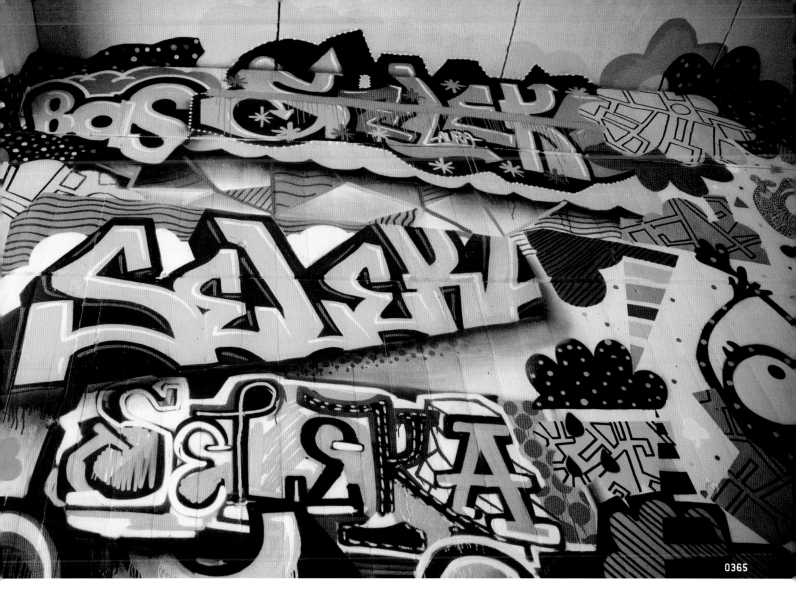

0365

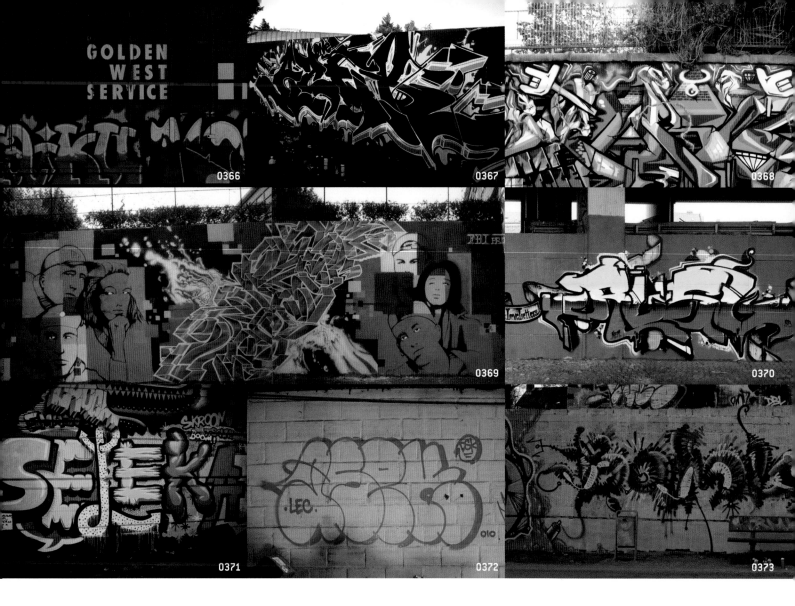

0366 MFG Freight Crew (ECTOE, RTYPE, HAIKU, KOLA, SMUT). Oakland, CA, USA / 0367 Azek. Toulouse, France / 0368 Pariz One. Lisbon, Portugal / 0369 Bomber. Hofheim am Taunus, Germany / 0370 Rusl. Stuttgart, Germany / 0371 Seleka. Seville, Spain / 0372 Azek. Toulouse, France / 0373 Bomber. Hofheim am Taunus, Germany / 0374 MFG Freight Crew (ECTOE, RTYPE, HAIKU, KOLA, SMUT). Oakland, CA, USA

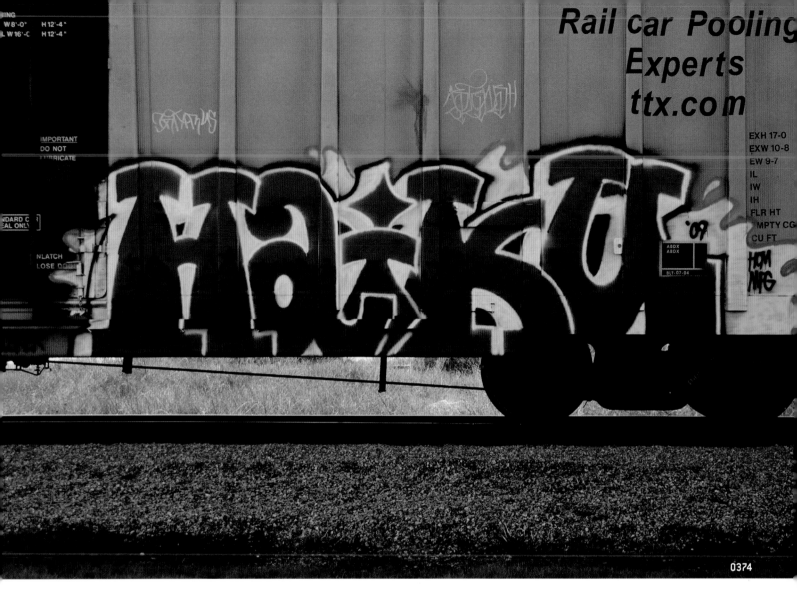

Although it may seem otherwise, figurativism appeared on the graffiti scene much later than letters and abstraction. At first, figures and caricatures were used to accompany letters and were conceived as a secondary element, although the great majority of urban artists are currently 100 percent figurative and show no abstraction in their work. The influence of comics and illustration is evident, as is the world of cartoons. Many figurative artists also incorporate a degree of realism, which is surprising when you consider that their weapon of choice is a spray can and not a paintbrush.

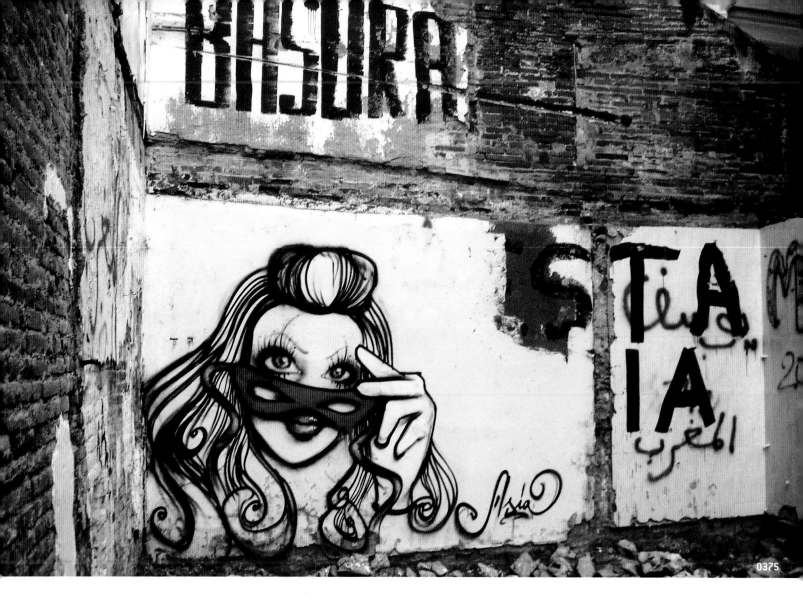

0375 Asia Komarova. Utrecht, Netherlands / **0376** Danny "casroc" Casu. Antwerp, Belgium

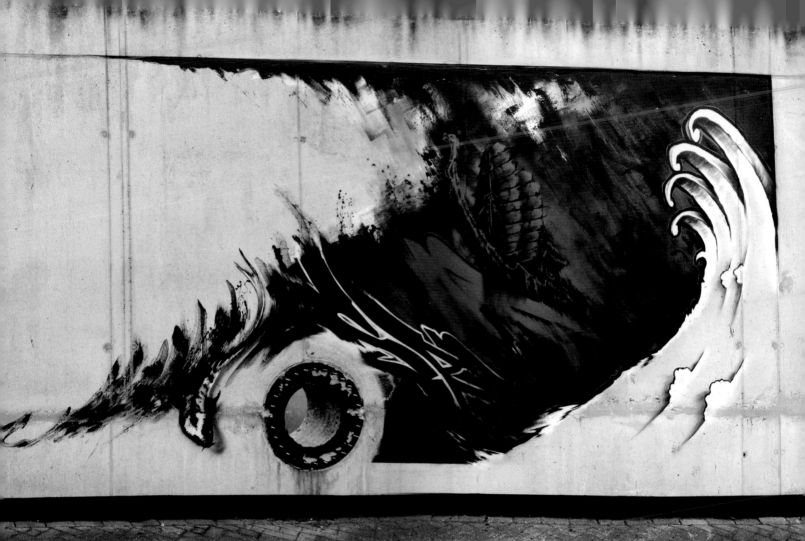

0376

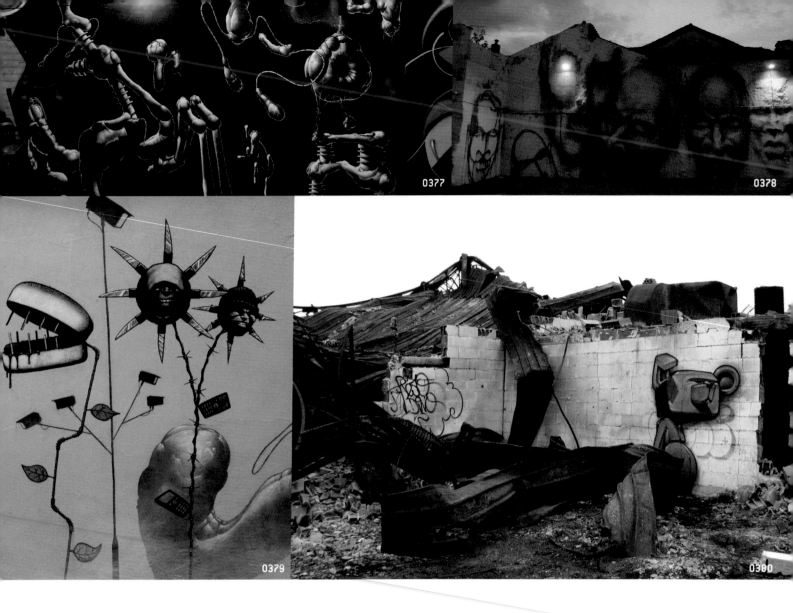

0377 SHOK-1. London, UK / 0378 SUS033. Madrid, Spain / 0379 SHOK-1. London, UK / 0380 Koes. Bassano del Grappa, Italy / 0381 SHOK-1. London, UK / 0382 MAC 1. Birmingham, UK / 0383 Insanewen (SPL Crew). Seville, Spain / 0384 Klaas Van der Linden. Ghent, Belgium / 0385 Mosaik. Lisbon, Portugal

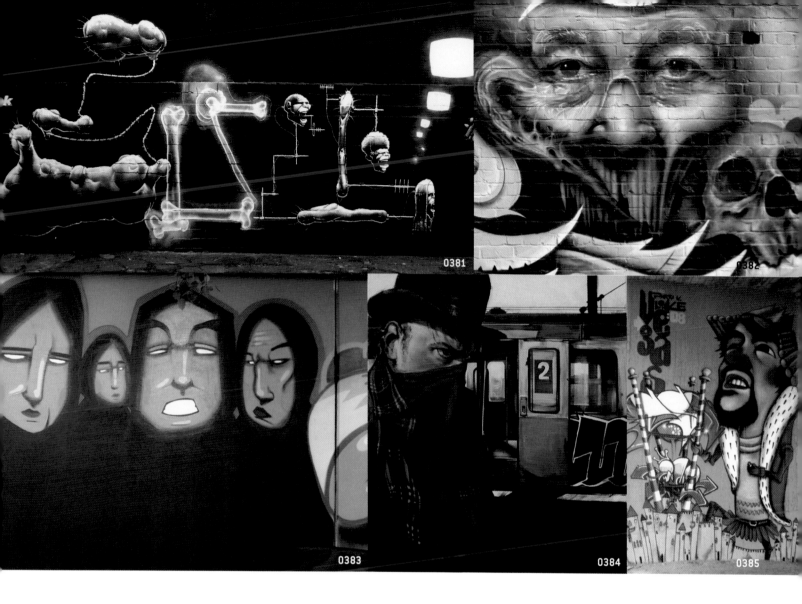

0381

0382

0383

0384

0385

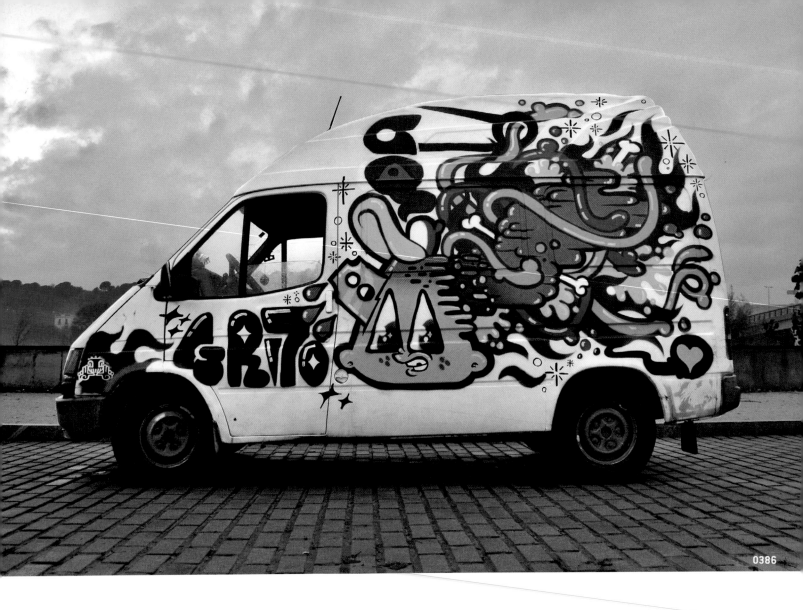

0386 Grito. Barcelona, Spain / **0387** Grito. Barcelona, Spain

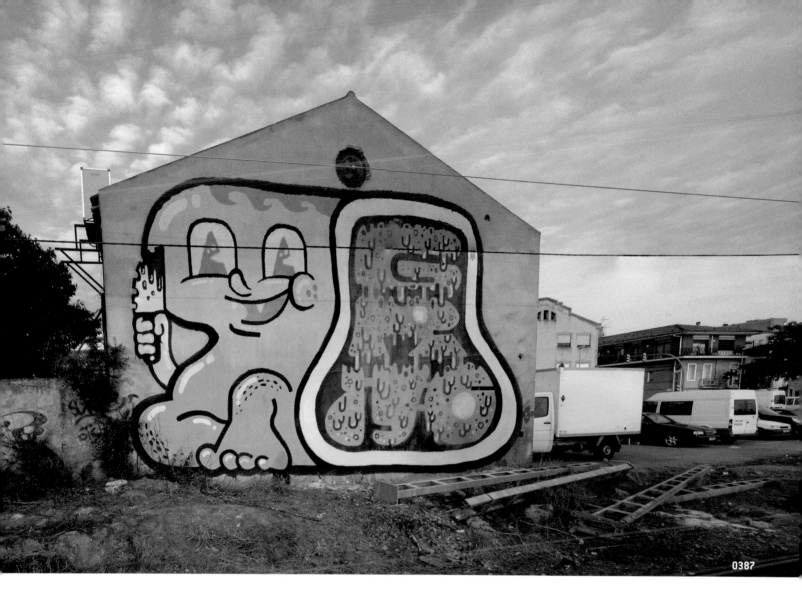

0387

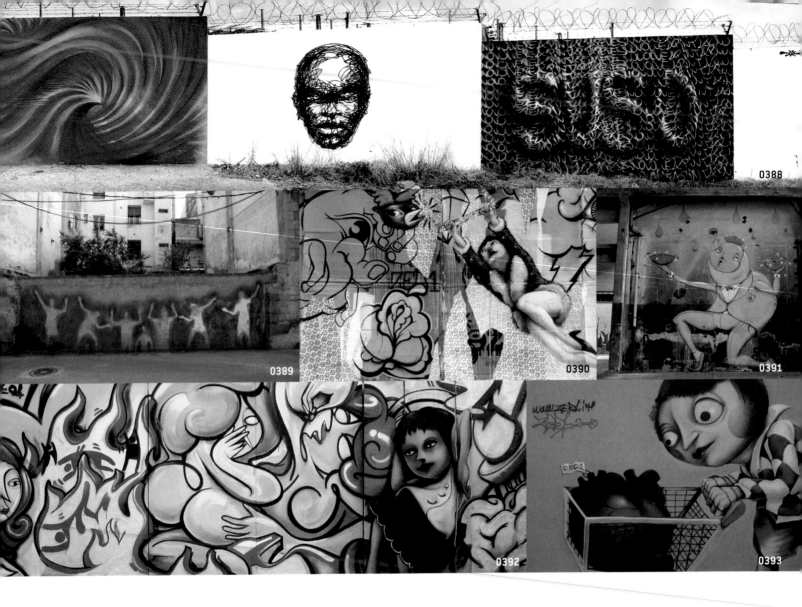

0388 SUSO33. Madrid, Spain / 0389 SUSO33. Madrid, Spain / 0390 Zed1. Florence, Italy / 0391 Zed1. Florence, Italy / 0392 Zed1. Florence, Italy / 0393 Zed1. Florence, Italy /
0394 Fasim. Barcelona, Spain / 0395 Zed1. Florence, Italy

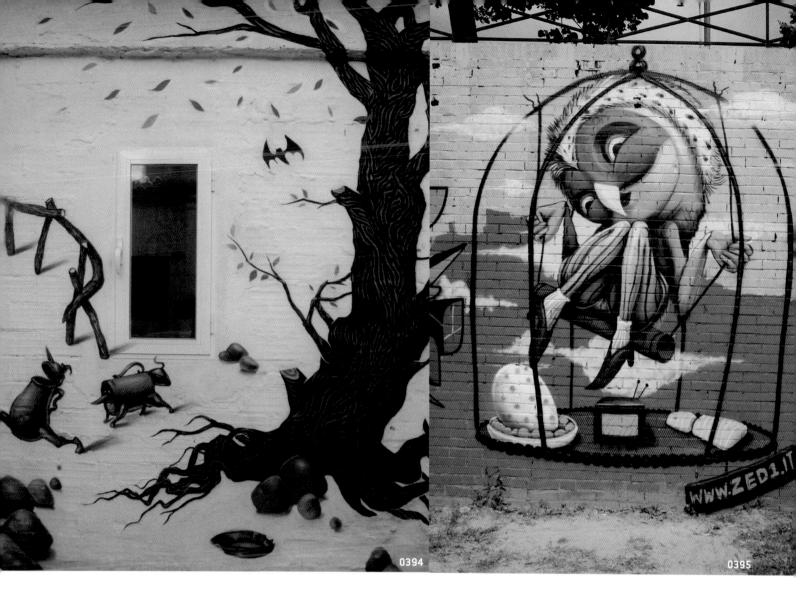

0394

0395

WWW.ZED1.IT

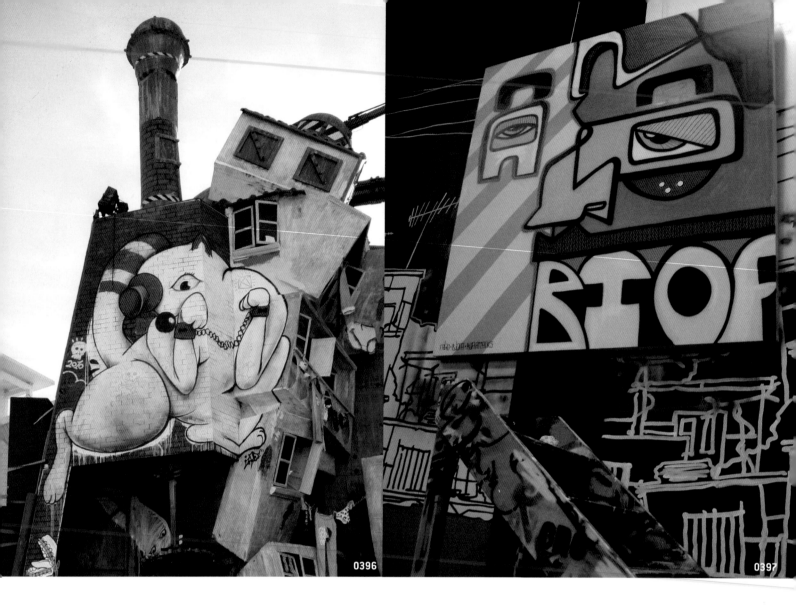

0396 Zed1. Florence, Italy / 0397 Biofa. São Paulo, Brazil / 0398 Biofa. São Paulo, Brazil

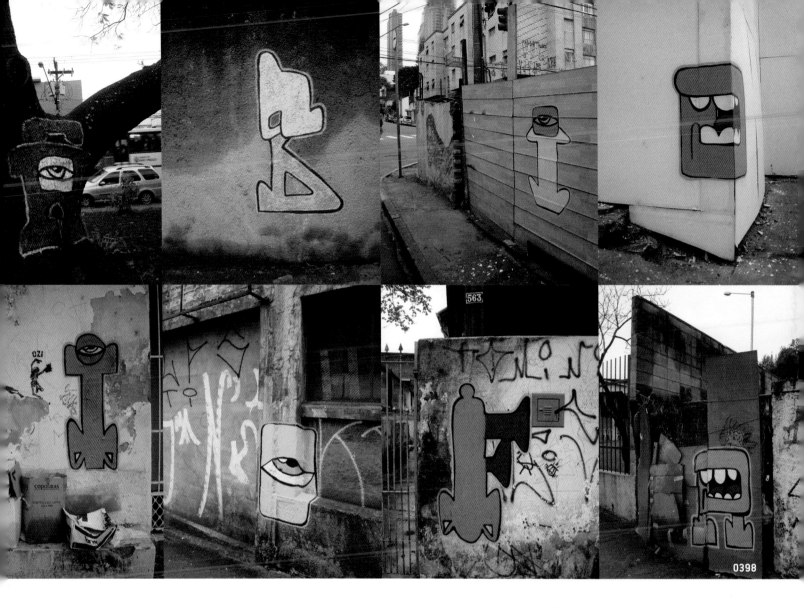

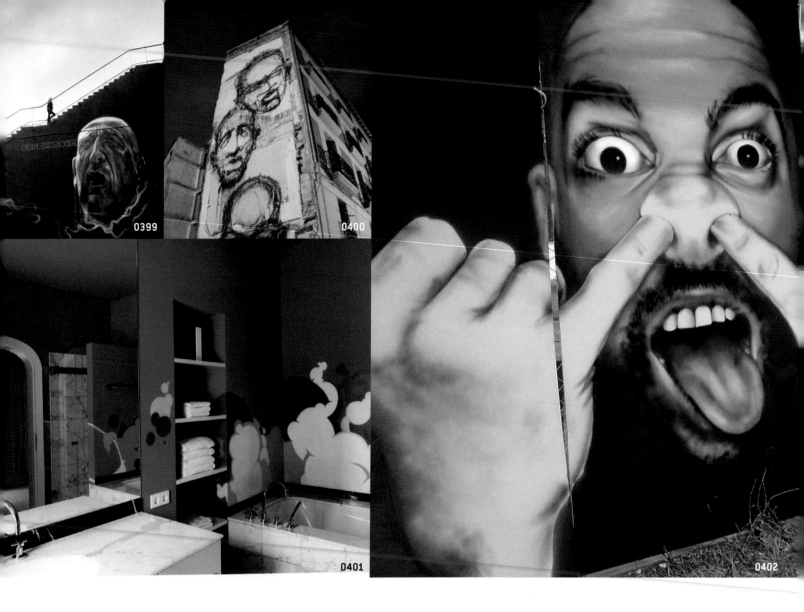

0399 Toast One. Zurich, Switzerland / 0400 SUSO33. Madrid, Spain / 0401 Toast One. Zurich, Switzerland / 0402 Brave 1 AKA Scotty~B. Essex, UK / 0403 Wonabc. Munich, Germany / 0404 Brave 1 AKA Scotty~B. Essex, UK / 0405 Wolfgang Krell. Dortmund, Germany / 0406 Sat One. Munich, Germany

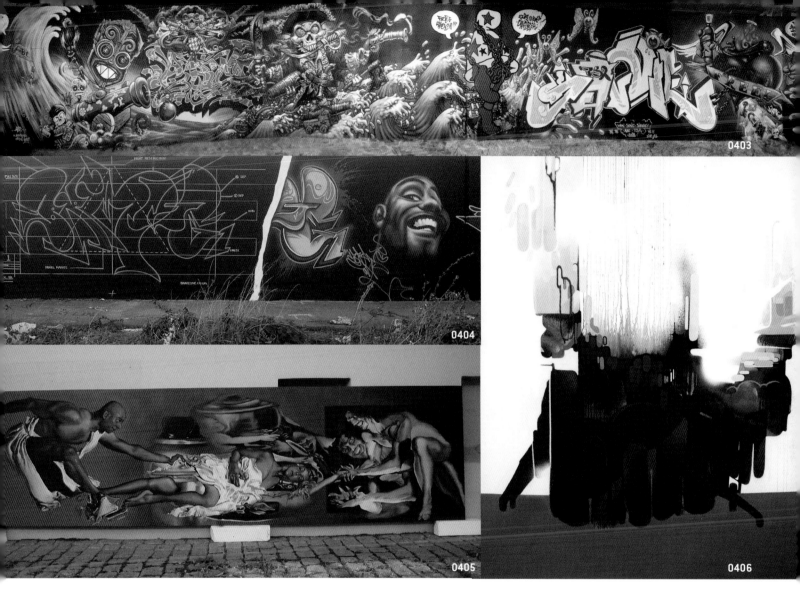

0403

0404

0405

0406

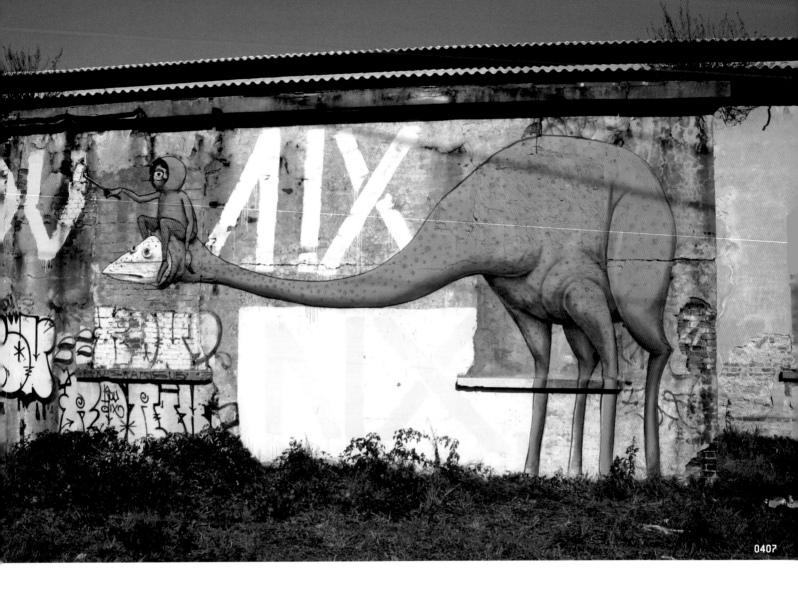

0407 Zed1. Florence, Italy / 0408 Zed1. Florence, Italy

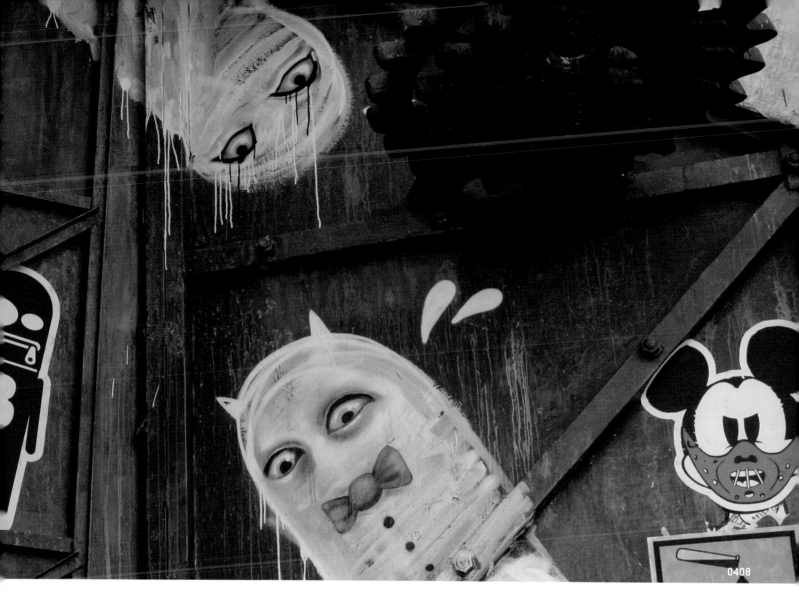

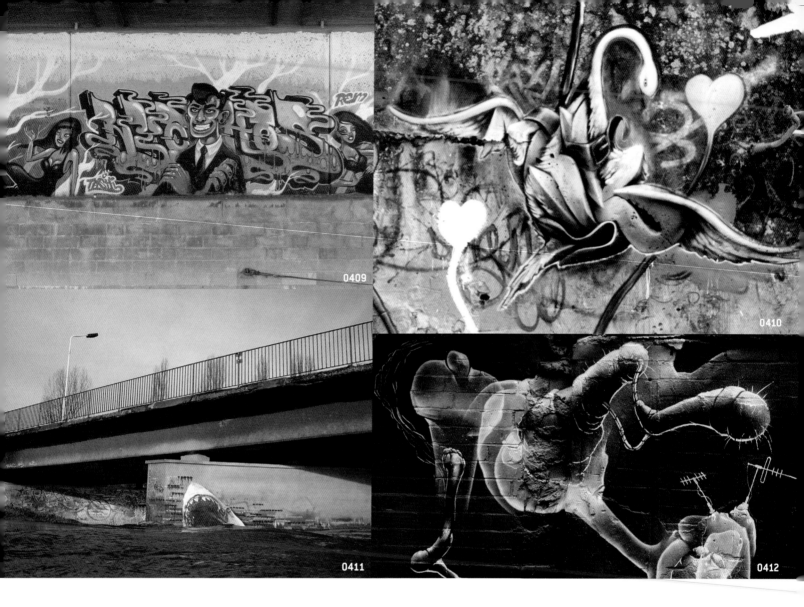

0409 Nychos. Vienna, Austria / 0410 Zed1. Florence, Italy / 0411 Tasso. Meerane, Germany / 0412 SHOK-1. London, UK / 0413 SUSO33. Madrid, Spain / 0414 SUSO33. Madrid, Spain / 0415 Zed1. Florence, Italy / 0416 SUSO33. Madrid, Spain / 0417 Pos. Muri, Switzerland / 0418 Toast One. Zurich, Switzerland / 0419 Ma'La. Mataró, Spain / 0420 Ma'La. Mataró, Spain / 0421 Biofa. São Paulo, Brazil / 0422 Pixote Mushi. Diadema, São Paulo, Brazil / 0423 Ma'La. Mataró, Spain

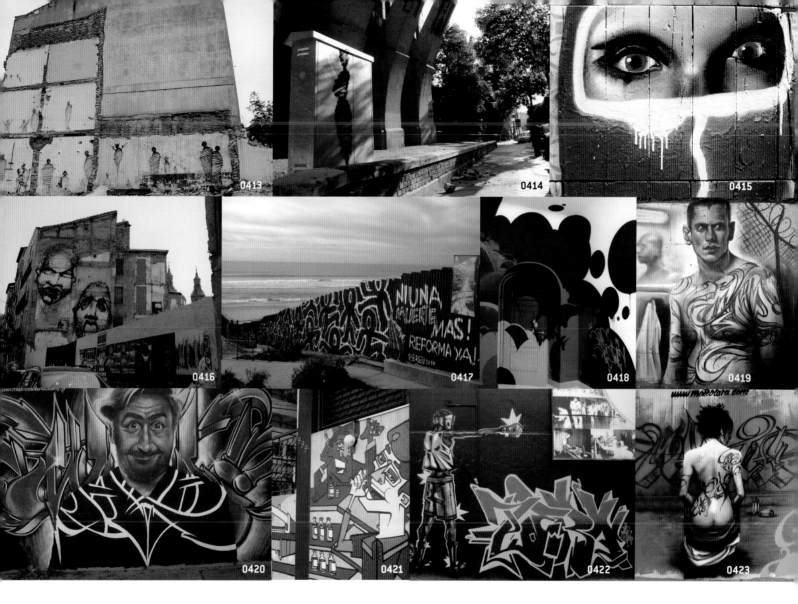

0413

0414

0415

0416

0417

0418

0419

0420

0421

0422

0423

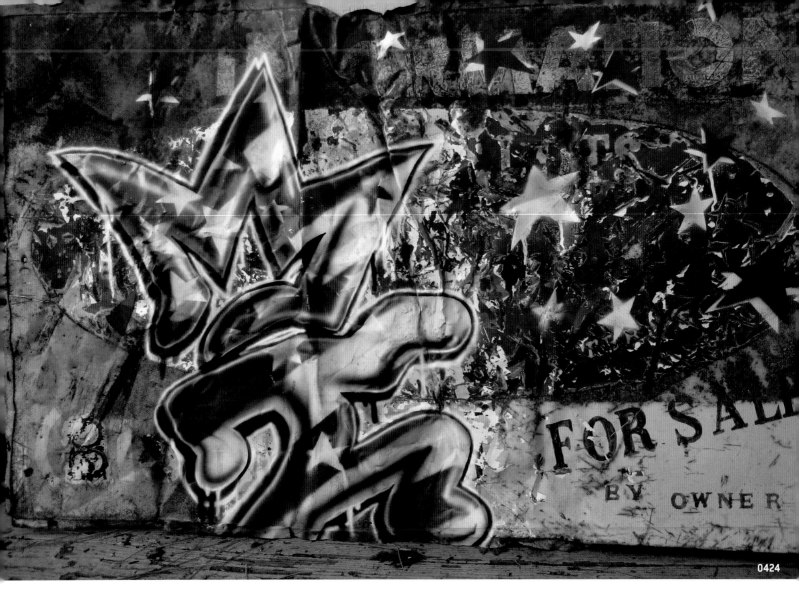

0424

0424 Pos. Muri, Switzerland / 0425 SHOK-1. London, UK

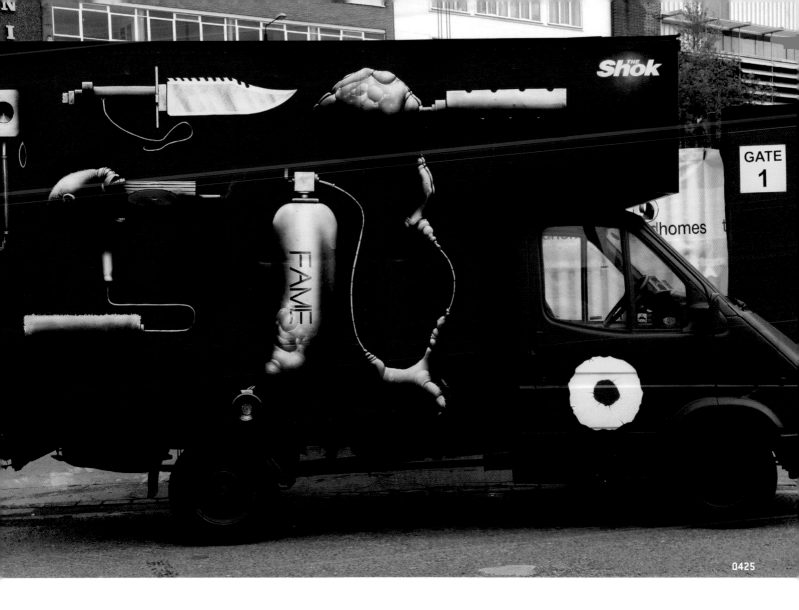

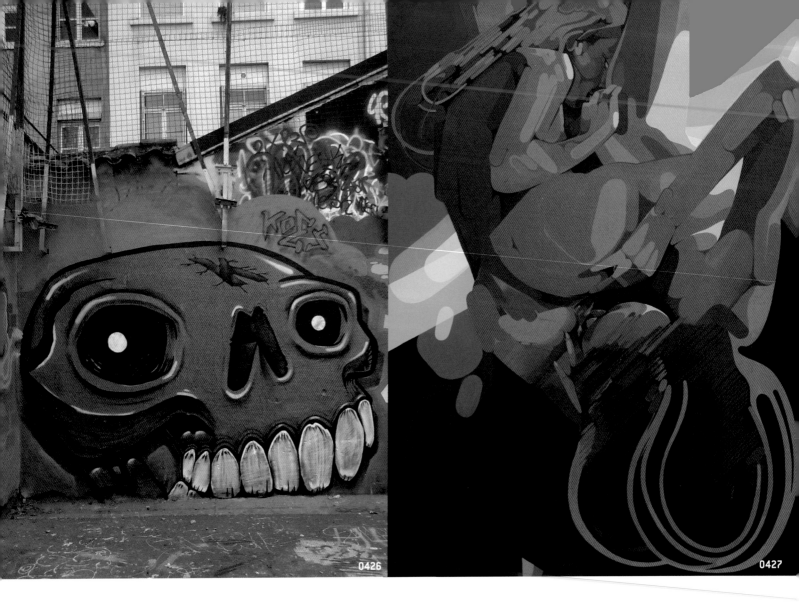

0426

0427

0426 Koes. Bassano del Grappa, Italy / **0427** Sat One. Munich, Germany / **0428** Mr. Wany (Heavy Artillery Crew). Milan, Italy / **0429** Nychos. Vienna, Austria / **0430** Nychos. Vienna, Austria / **0431** Brave 1 AKA Scotty~B. Essex, UK / **0432** Brave 1 AKA Scotty~B. Essex, UK

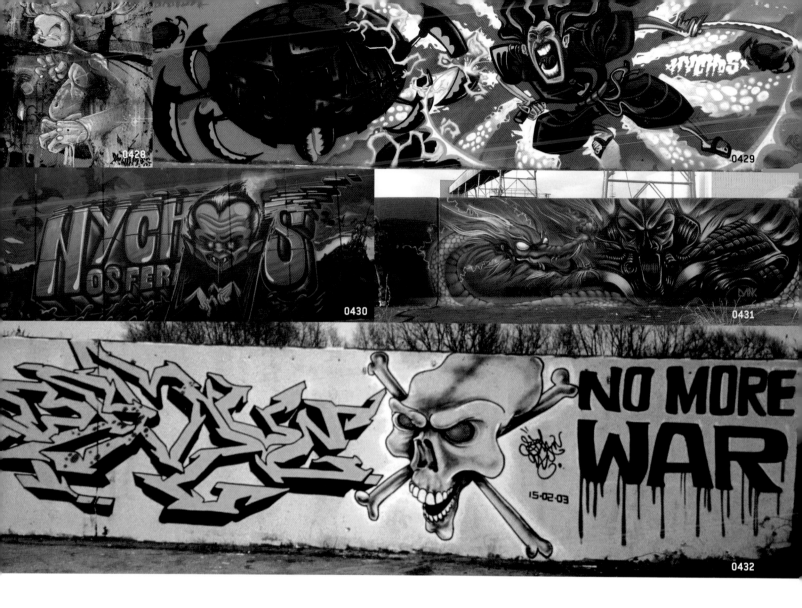

0428

0429

0430

0431

NO MORE WAR

15-02-03

0432

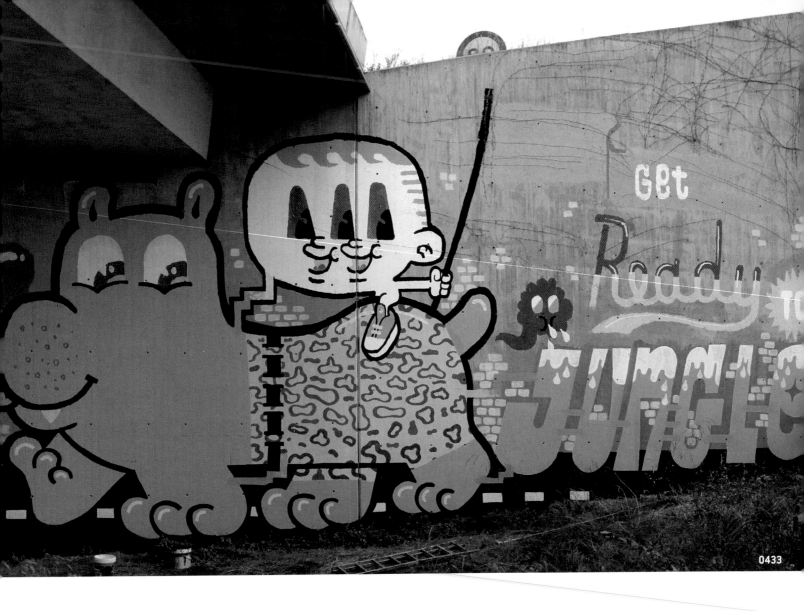

0433

0433 Grito. Barcelona, Spain / 0434 Fafa. Seville, Spain

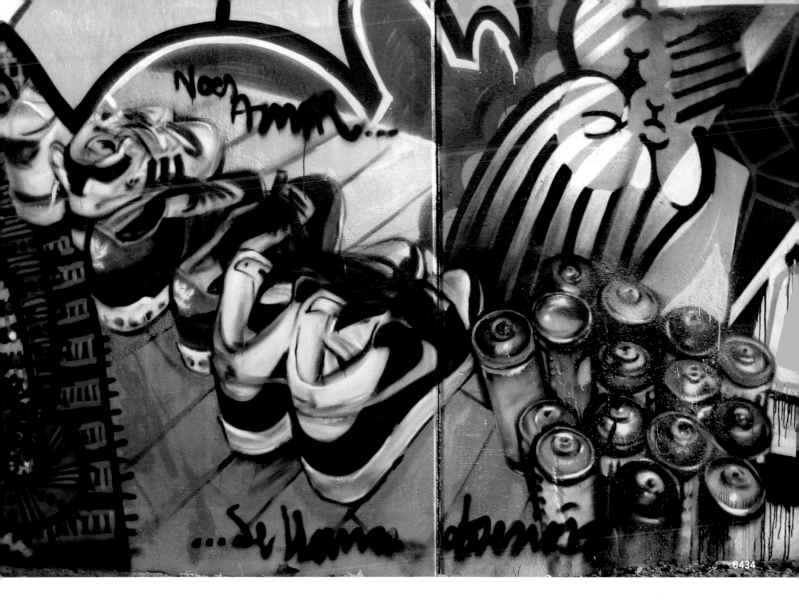

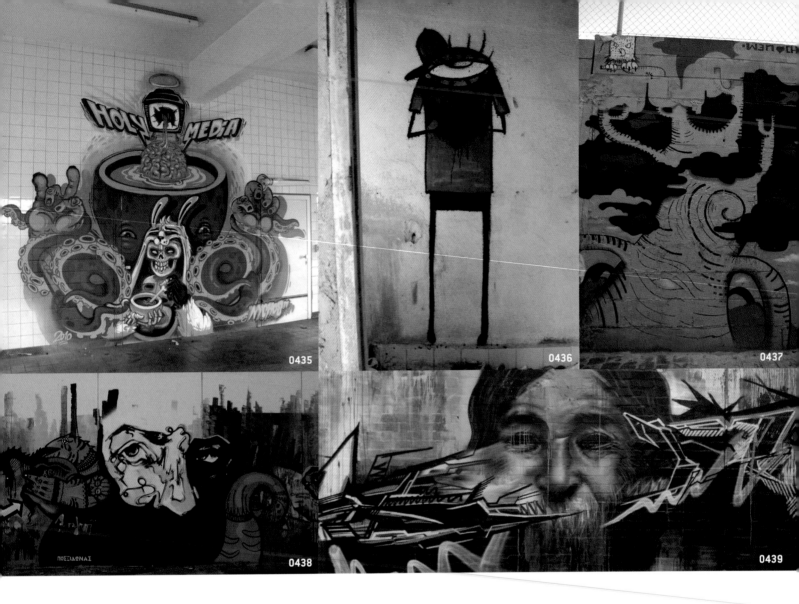

0435 Nychos. Vienna, Austria / 0436 Insanewen (SPL Crew). Seville, Spain / 0437 Insanewen (SPL Crew). Seville, Spain / 0438 Insanewen (SPL Crew). Seville, Spain / 0439 MAC 1. Birmingham, UK / 0440 Mr. Wany (Heavy Artillery Crew). Milan, Italy / 0441 Insanewen (SPL Crew). Seville, Spain

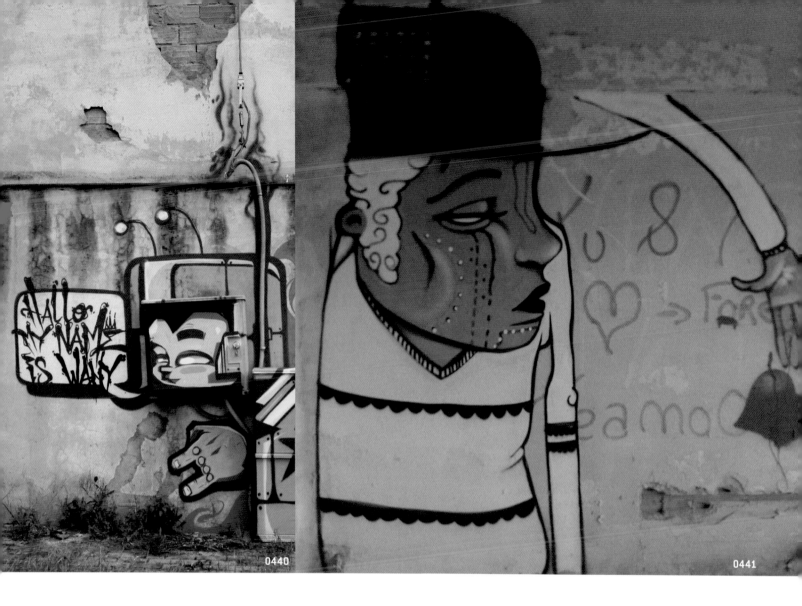

0440

0441

0442

0442 Koes. Bassano del Grappa, Italy / **0443** Koes. Bassano del Grappa, Italy

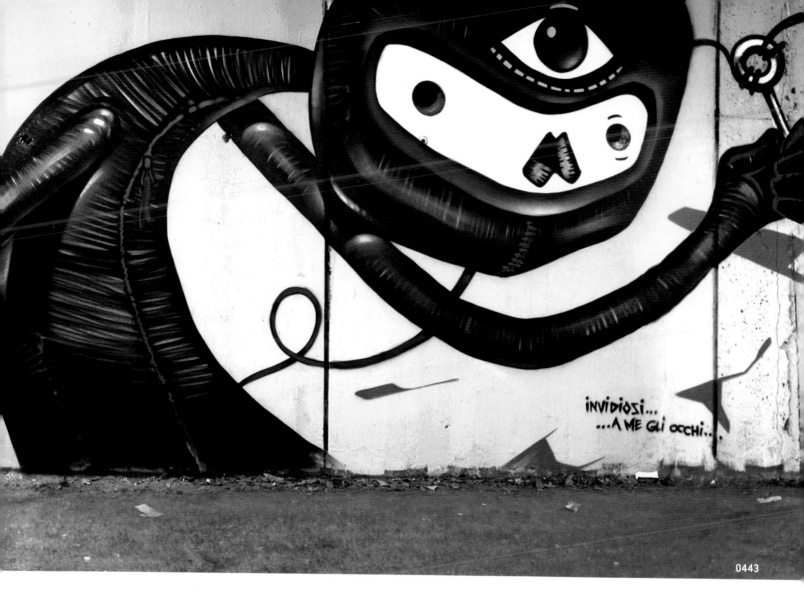

0443

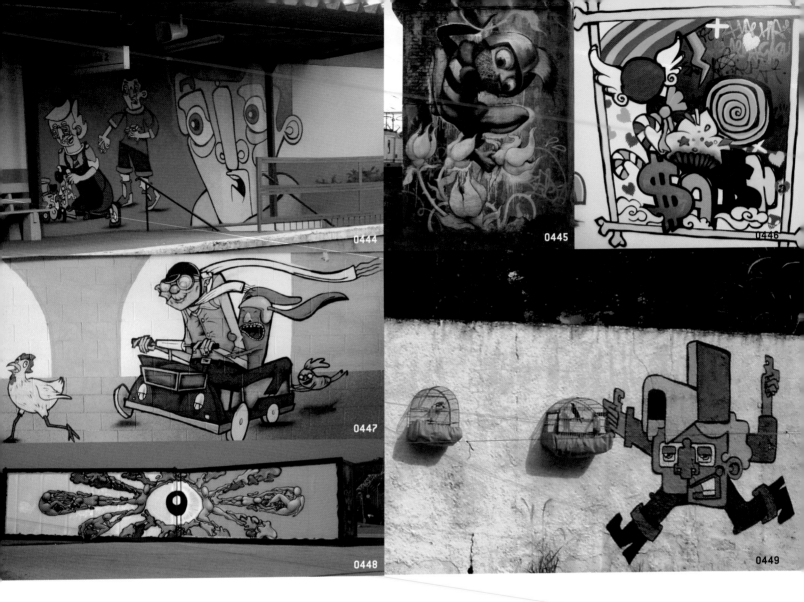

0444 Biofa. São Paulo, Brazil / **0445** Zed1. Florence, Italy / **0446** Astrid AKA CHOUR (3PP crew). Paris, France / **0447** Pixote Mushi. Diadema, São Paulo, Brazil / **0448** SUSO33. Madrid, Spain / **0449** Biofa. São Paulo, Brazil / **0450** SRG/Ger. Seville, Spain / **0451** SUSO33. Madrid, Spain / **0452** Sat One. Munich, Germany / **0453** Fasim. Barcelona, Spain / **0454** Zed1. Florence, Italy / **0455** SHOK-1. London, UK / **0456** Sat One. Munich, Germany / **0457** Mosaik. Lisbon, Portugal / **0458** Sat One. Munich, Germany

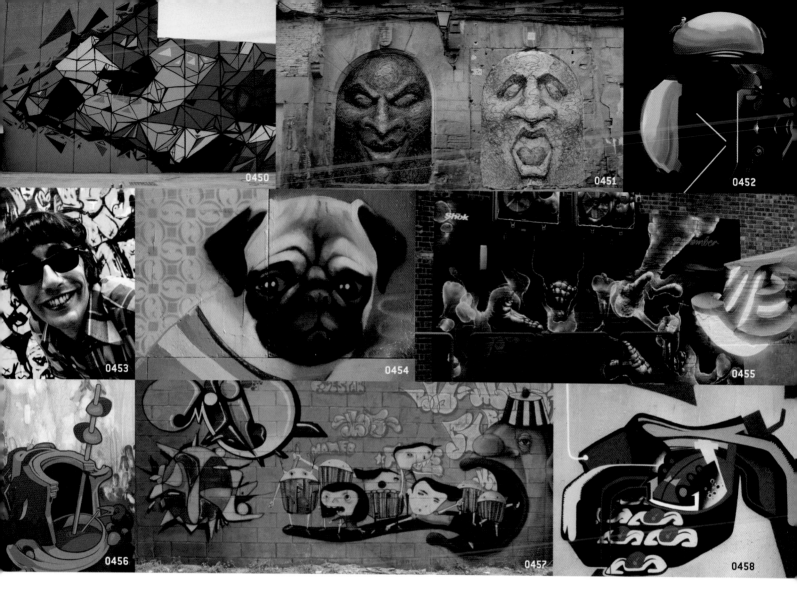

0450

0451

0452

0453

0454

0455

0456

0457

0458

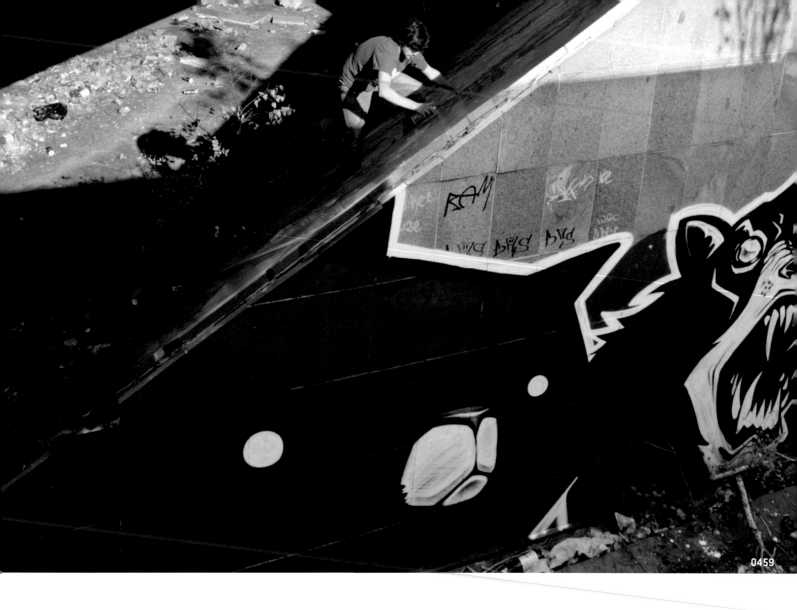

0459

0459 Koes. Bassano del Grappa, Italy / **0460** Mr. Wany (Heavy Artillery Crew). Milan, Italy

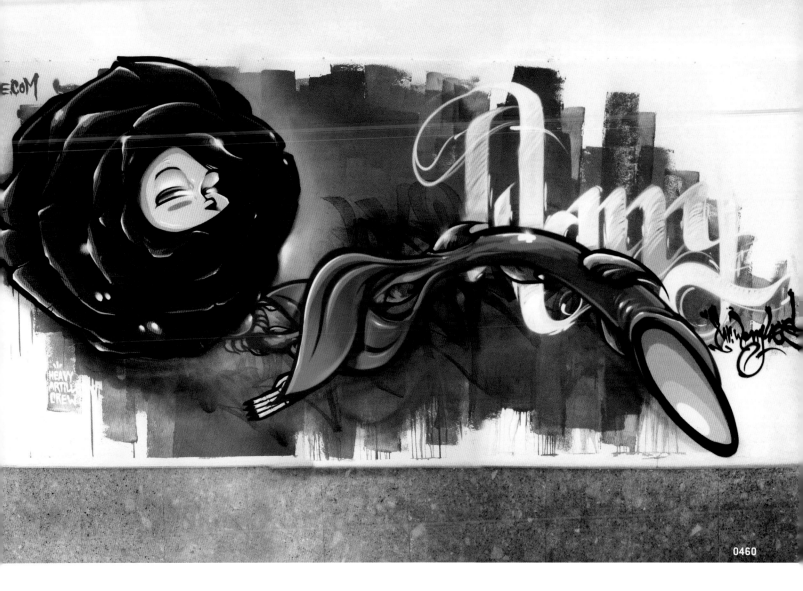

0460

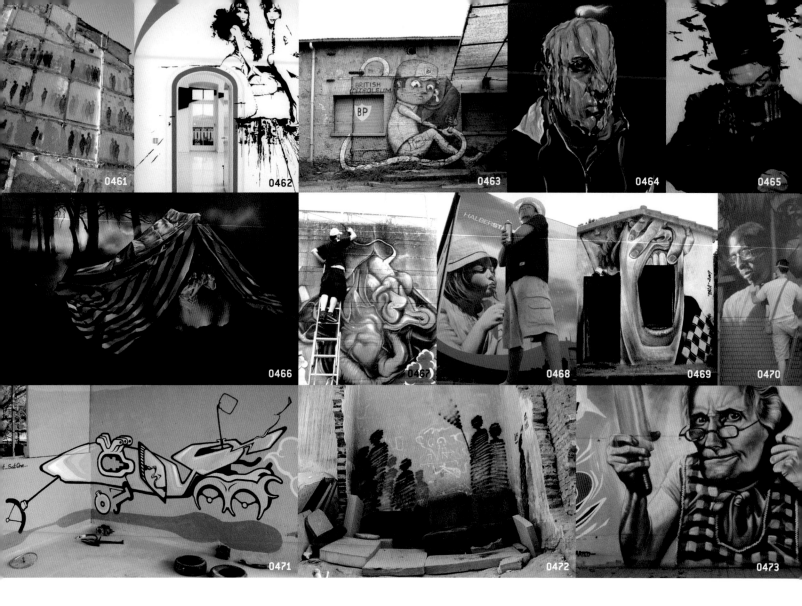

0461 SUSO33. Madrid, Spain / 0462 Toast One. Zurich, Switzerland / 0463 Zed1. Florence, Italy / 0464 Klaas Van der Linden. Ghent, Belgium / 0465 Klaas Van der Linden. Ghent, Belgium / 0466 Klaas Van der Linden. Ghent, Belgium / 0467 Zed1. Florence, Italy / 0468 Tasso. Meerane, Germany / 0469 Ma'La. Mataró, Spain / 0470 Ma'La. Mataró, Spain / 0471 Dyset. Munich, Germany / 0472 SUSO33. Madrid, Spain / 0473 Ma'La. Mataró, Spain / 0474 Ma'La. Mataró, Spain / 0475 Sat One. Munich, Germany / 0476 SHOK-1. London, UK / 0477 Koes. Bassano del Grappa, Italy / 0478 Klaas Van der Linden. Ghent, Belgium / 0479 Mosaik. Lisbon, Portugal / 0480 SUSO33. Madrid, Spain / 0481 Mr. Wany (Heavy Artillery Crew). Milan, Italy / 0482 Ma'La. Mataró, Spain / 0483 SiveOne (Kai H. Krieger). Gießen, Germany / 0484 SUSO33. Madrid, Spain

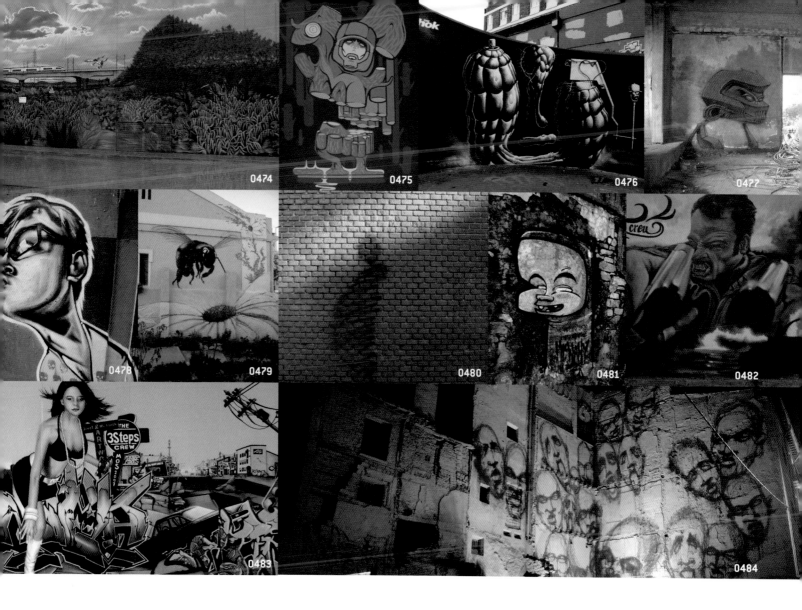

0474 0475 0476 0477 0478 0479 0480 0481 0482 0483 0484

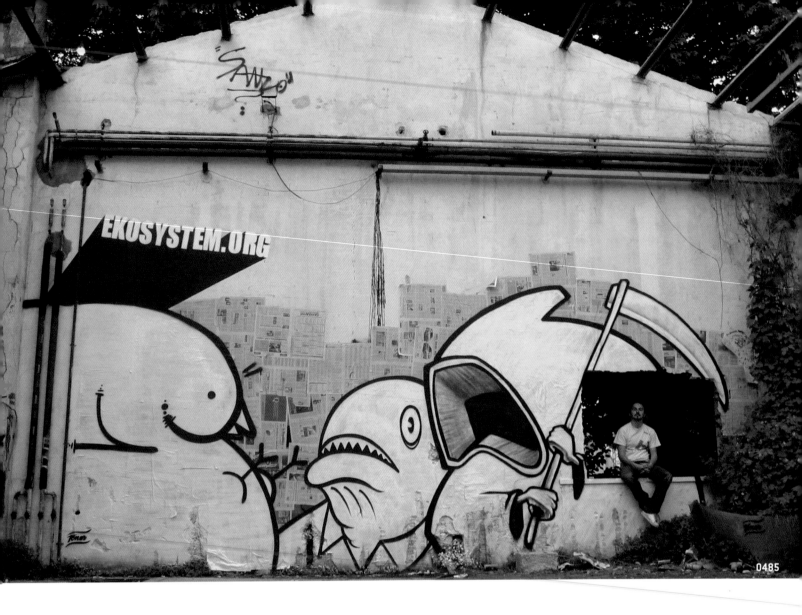

0485

0485 Koes. Bassano del Grappa, Italy / **0486** Astrid AKA CHOUR (3PP crew). Paris, France

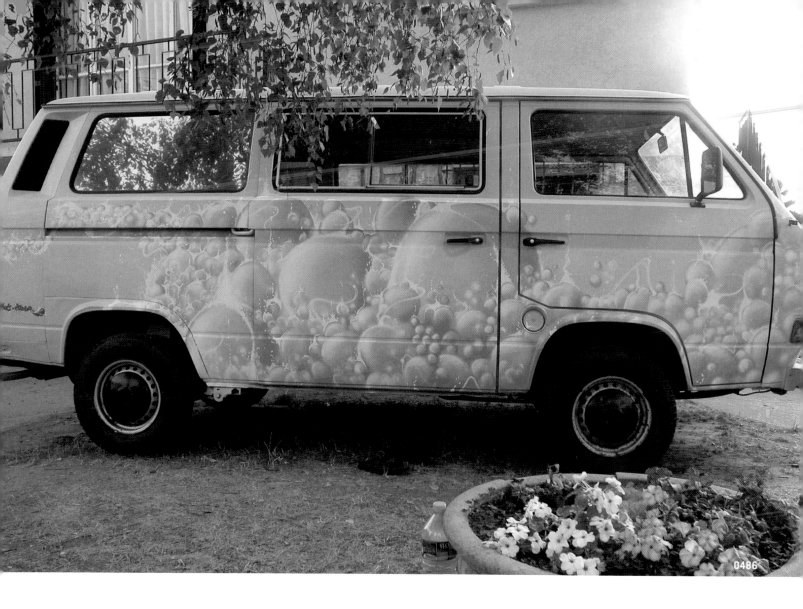

0486

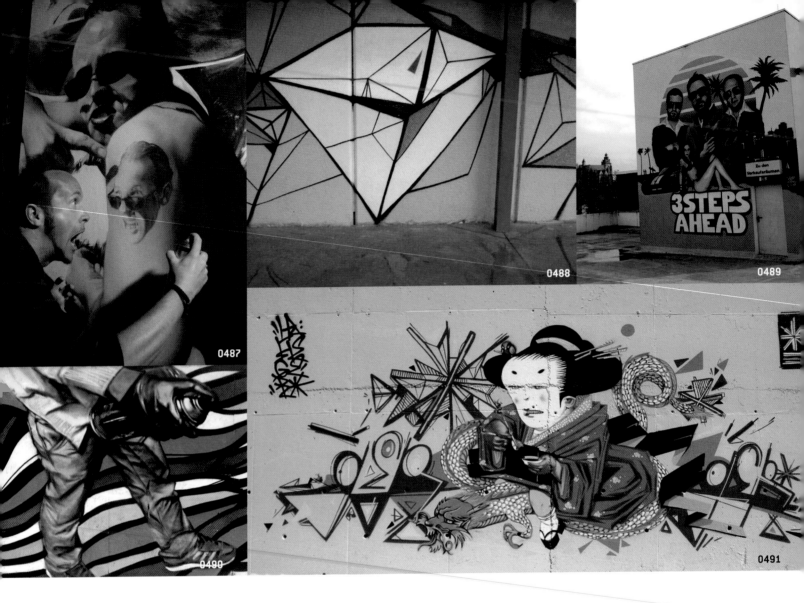

0487 Tasso. Meerane, Germany / **0488** SRG/Ger. Seville, Spain / **0489** Mr. Flash (Joachim Pitt). Gießen, Germany / **0490** Fafa. Seville, Spain / **0491** SRG/Ger. Seville, Spain / **0492** Astrid AKA CHOUR (3PP crew). Paris, France / **0493** Fafa. Seville, Spain

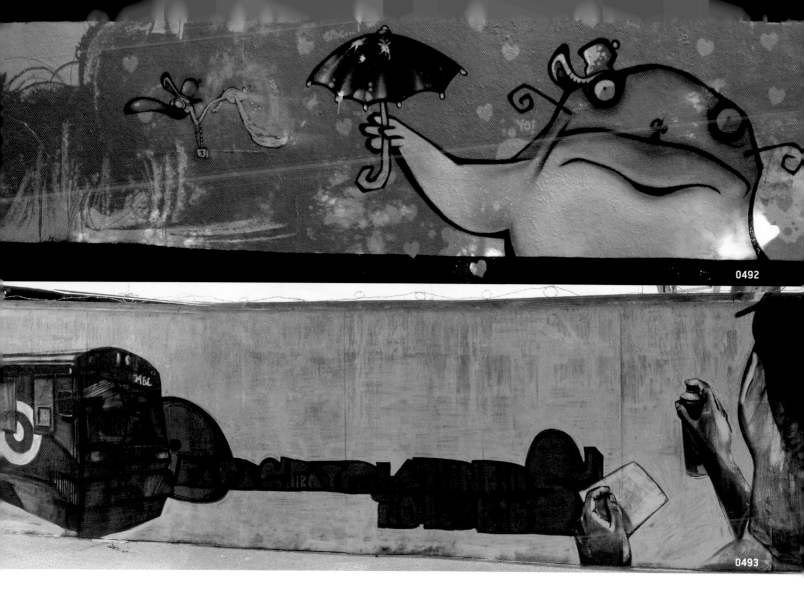

0492

0493

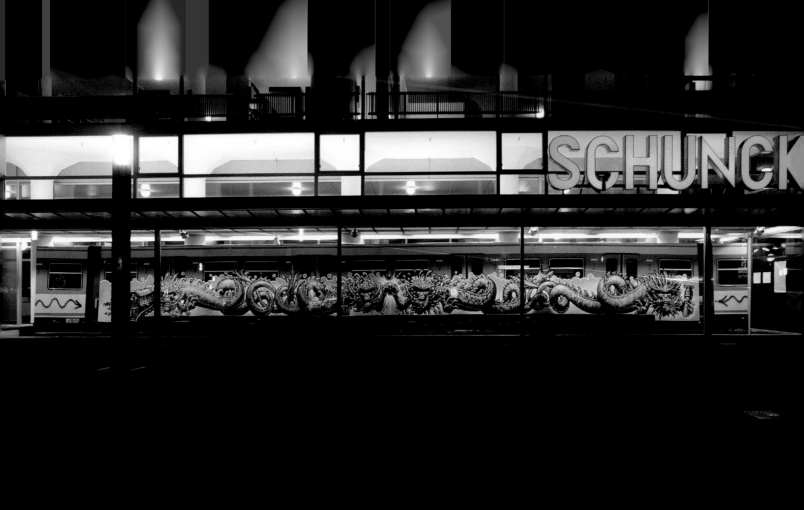

0494

0494 Wonabc. Munich, Germany / 0495 Nychos. Vienna, Austria

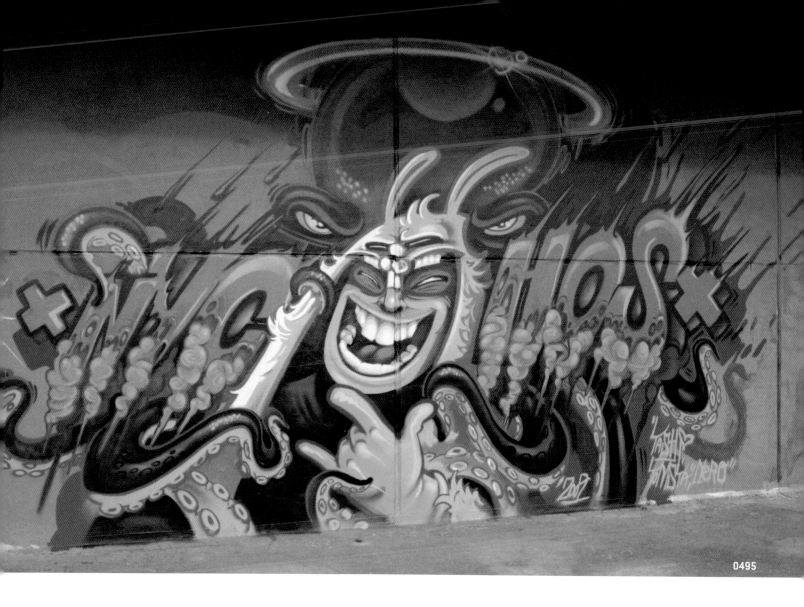

0495

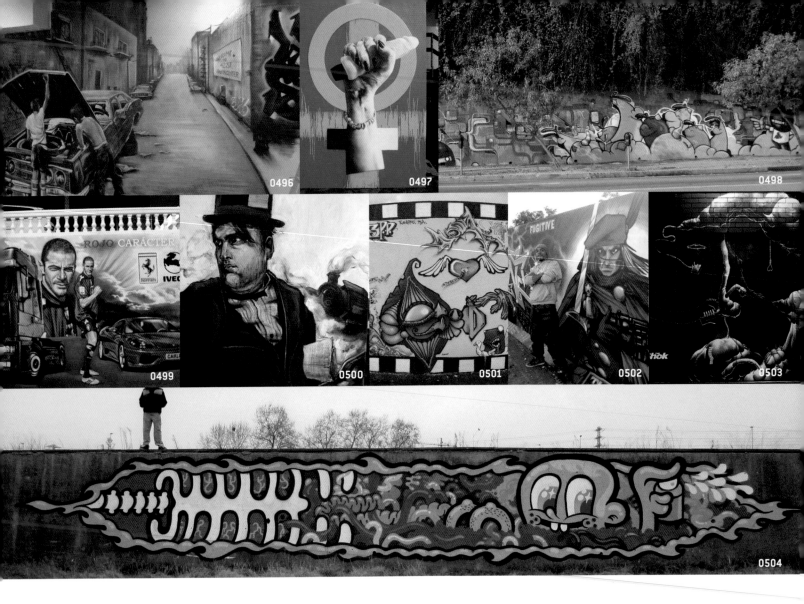

0496 Ma'La. Mataró, Spain / 0497 Tasso. Meerane, Germany / 0498 Eyeone. Los Angeles, CA, USA / 0499 Ma'La. Mataró, Spain / 0500 Klaas Van der Linden. Ghent, Belgium / 0501 Astrid AKA CHOUR (3PP crew). Paris, France / 0502 Brave 1 AKA Scotty~B. Essex, UK / 0503 SHOK-1. London, UK / 0504 Grito. Barcelona, Spain / 0505 Pixote Mushi. Diadema, São Paulo, Brazil / 0506 Numi. Seoul, South Korea / 0507 MAC 1. Birmingham, UK / 0508 Klaas Van der Linden. Ghent, Belgium / 0509 Klaas Van der Linden. Ghent, Belgium / 0510 Fafa. Seville, Spain / 0511 Mr. Dheo. Porto, Portugal / 0512 Fafa. Seville, Spain

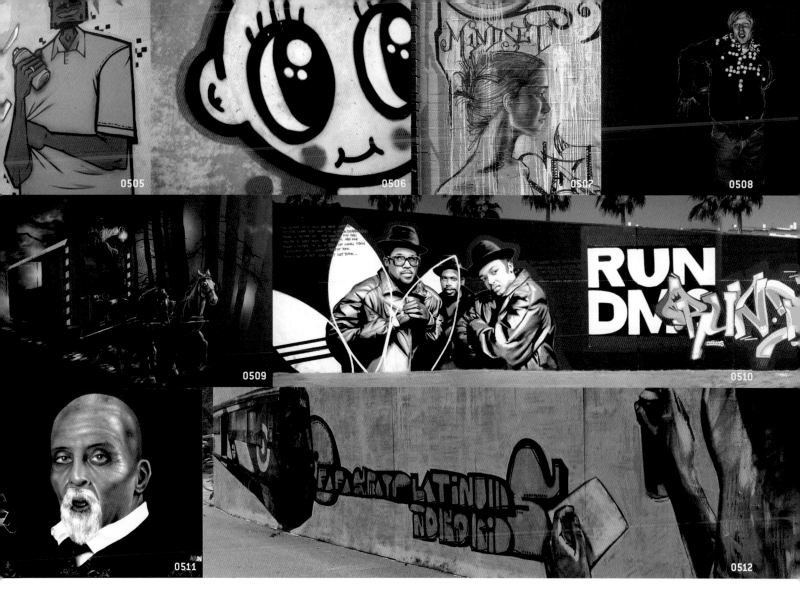

0505

0506

0507

0508

0509

0510

0511

0512

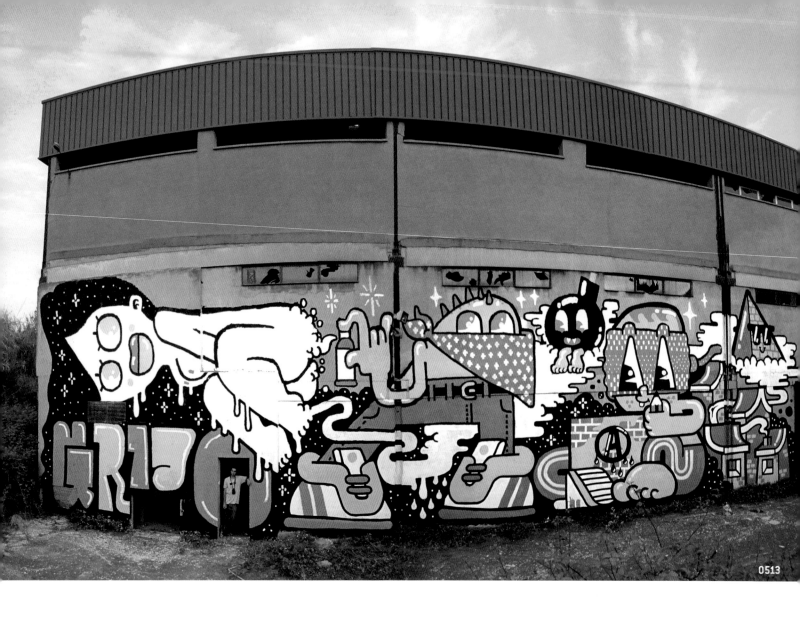

0513 Grito. Barcelona, Spain / 0514 Eyeone. Los Angeles, CA, USA

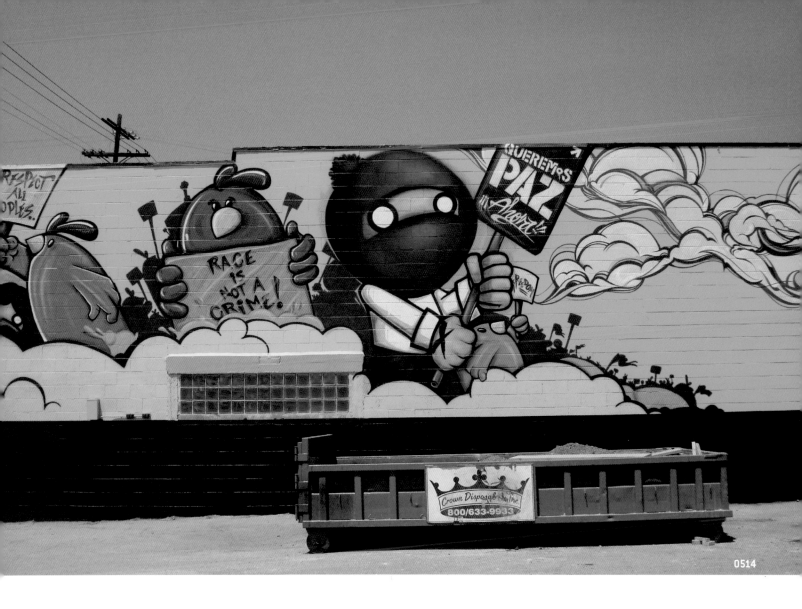

0514

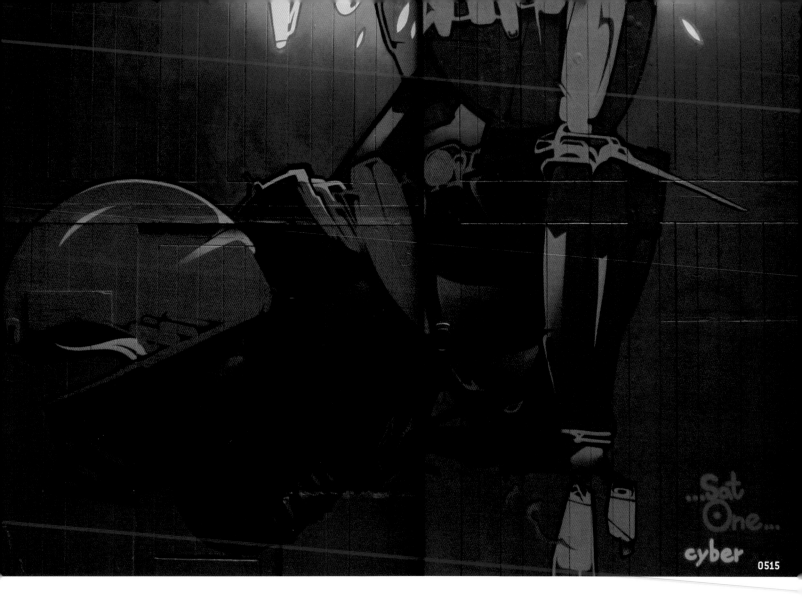

0515 Sat One. Munich, Germany / **0516** Dan Witz. New York, USA / **0517** Zed1. Florence, Italy

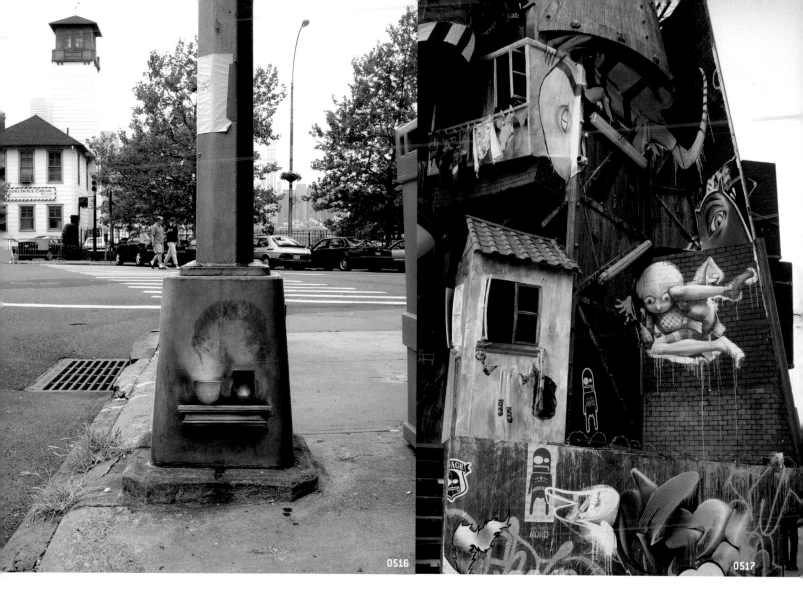

0516

0517

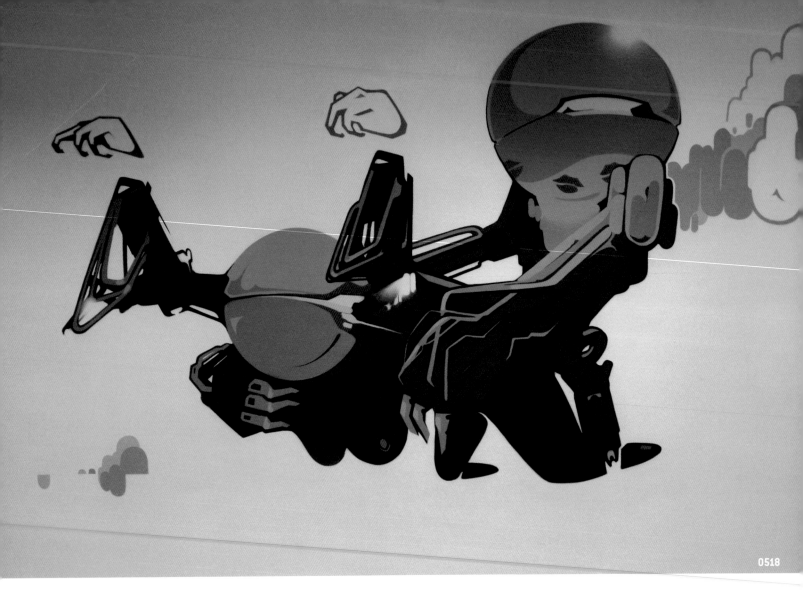

0518

0518 Sat One. Munich, Germany / 0519 Mr. Wany (Heavy Artillery Crew). Milan, Italy

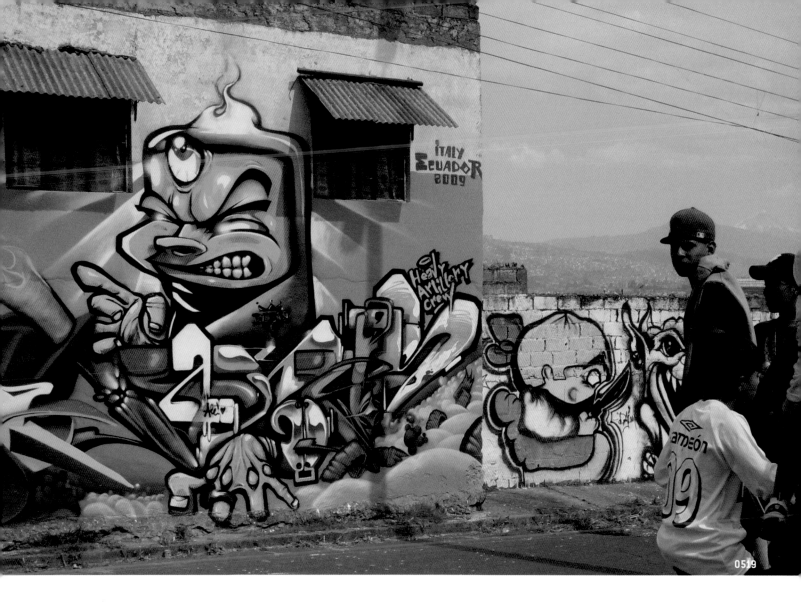

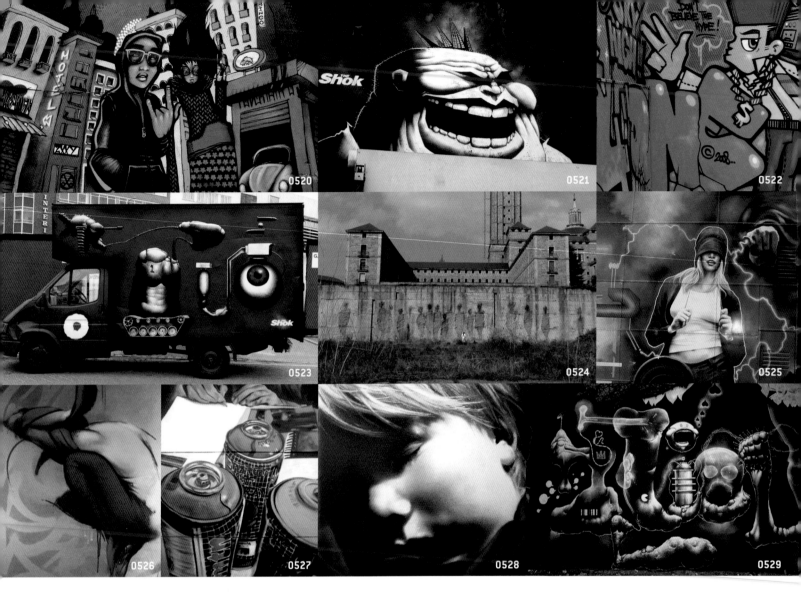

0520 Nick Alive. São Paulo, Brazil / 0521 SHOK-1. London, UK / 0522 RosyOne. Biel-Bienne, Switzerland / 0523 SHOK-1. London, UK / 0524 SUSO33. Madrid, Spain / 0525 MAC 1. Birmingham, UK / 0526 Zed1. Florence, Italy / 0527 Fafa. Seville, Spain / 0528 Tasso. Meerane, Germany / 0529 SHOK-1. London, UK / 0530 Eyeone. Los Angeles, CA, USA / 0531 Insanewen (SPL Crew). Seville, Spain / 0532 Nick Alive. São Paulo, Brazil / 0533 Fafa. Seville, Spain / 0534 Fafa. Seville, Spain / 0535 Astrid AKA CHOUR (3PP crew). Paris, France / 0536 SUSO33. Barcelona, Spain / 0537 Mr. Wany (Heavy Artillery Crew). Milan, Italy

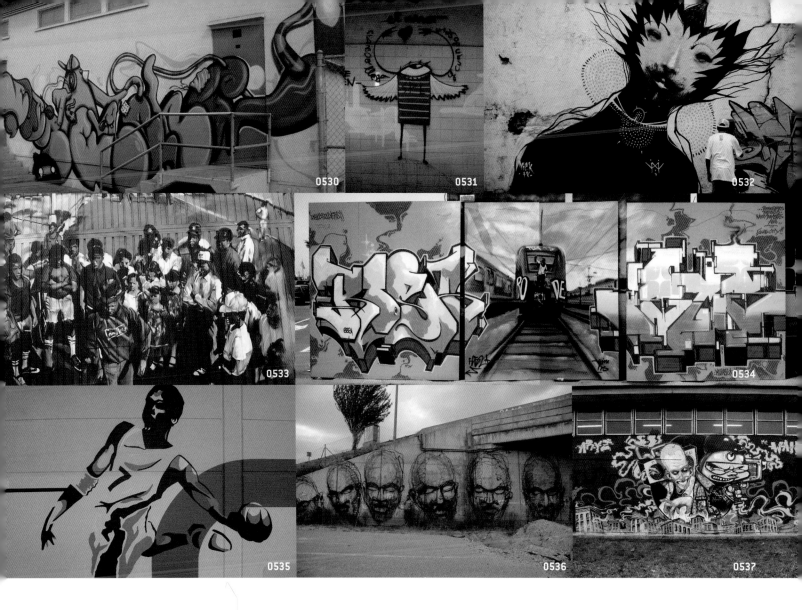

0530 0531 0532
0533 0534
0535 0536 0537

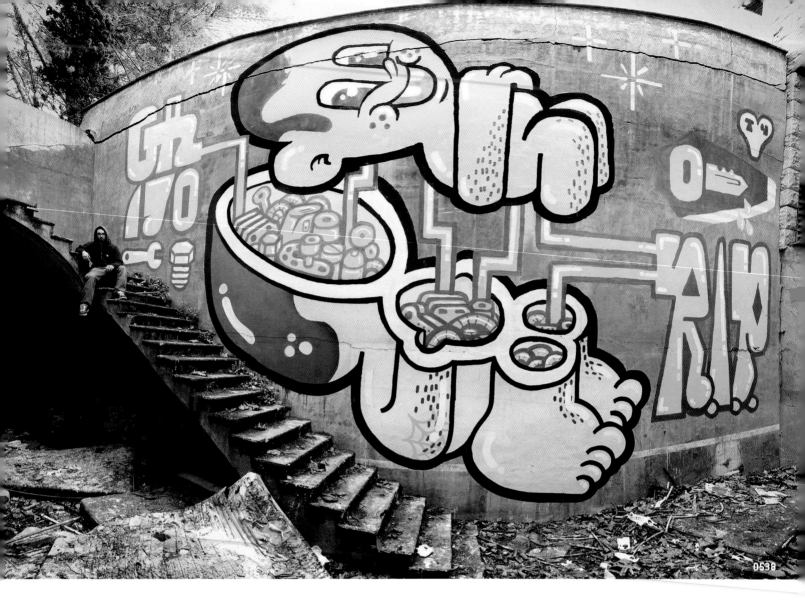

0538 Grito. Barcelona, Spain / 0539 Fafa. Seville, Spain

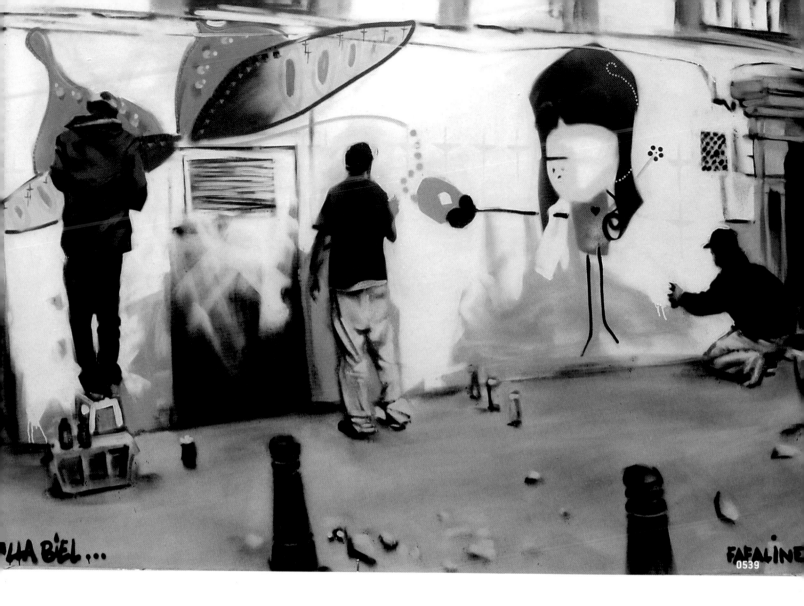

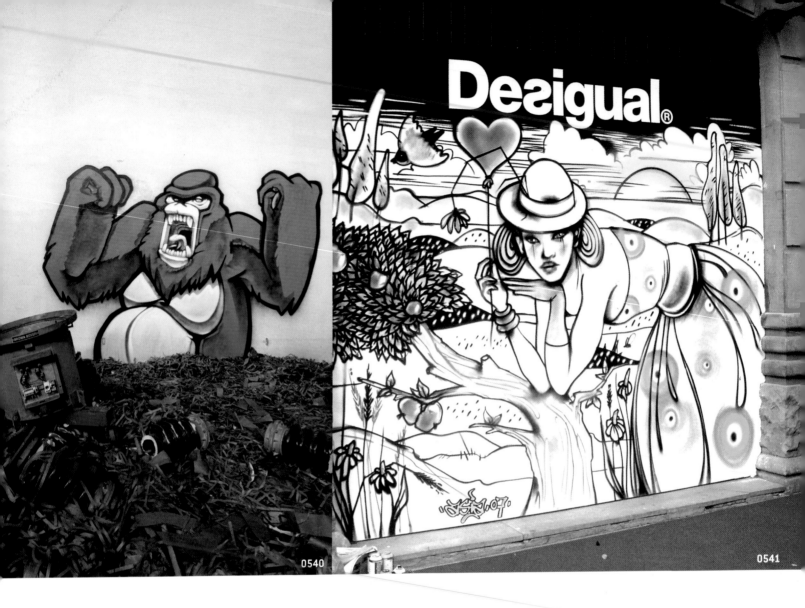

0540

Desigual®

0541

0540 Koes. Bassano del Grappa, Italy / **0541** Asia Komarova. Utrecht, Netherlands / **0542** Eyeone. Los Angeles, CA, USA

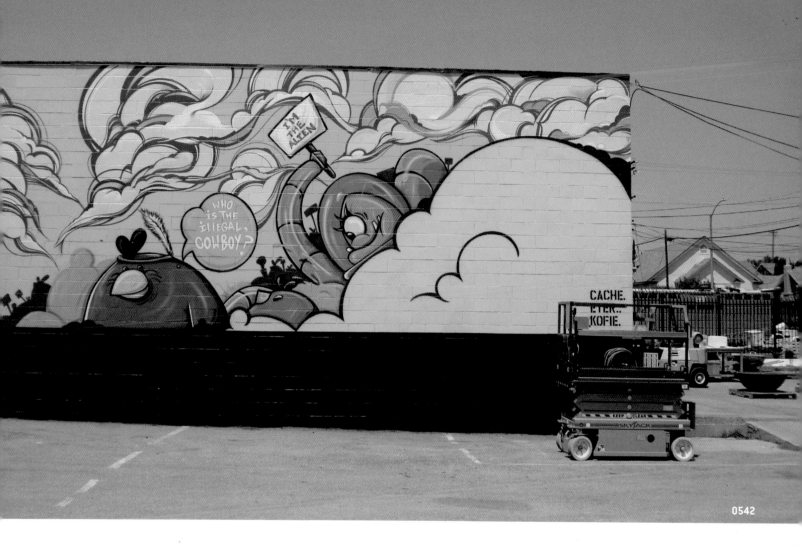

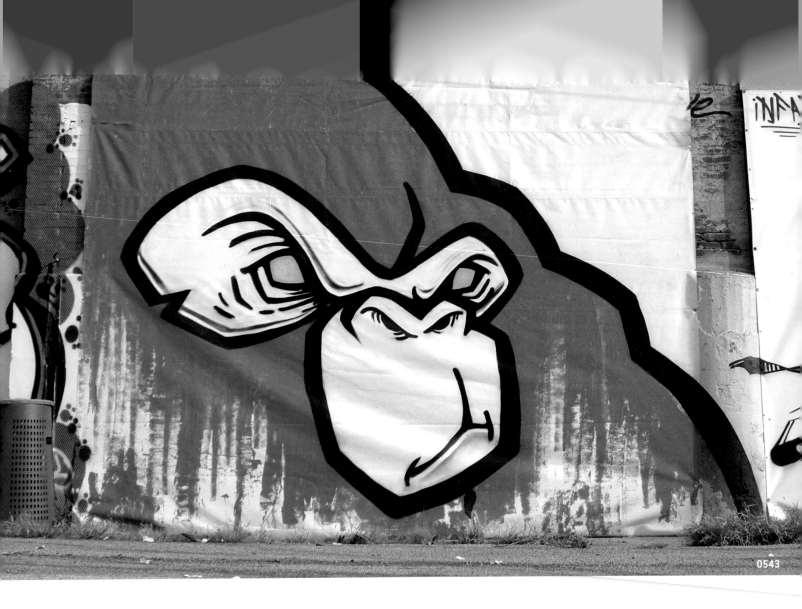

0543

0543 Koes. Bassano del Grappa, Italy / **0544** Koes. Bassano del Grappa, Italy

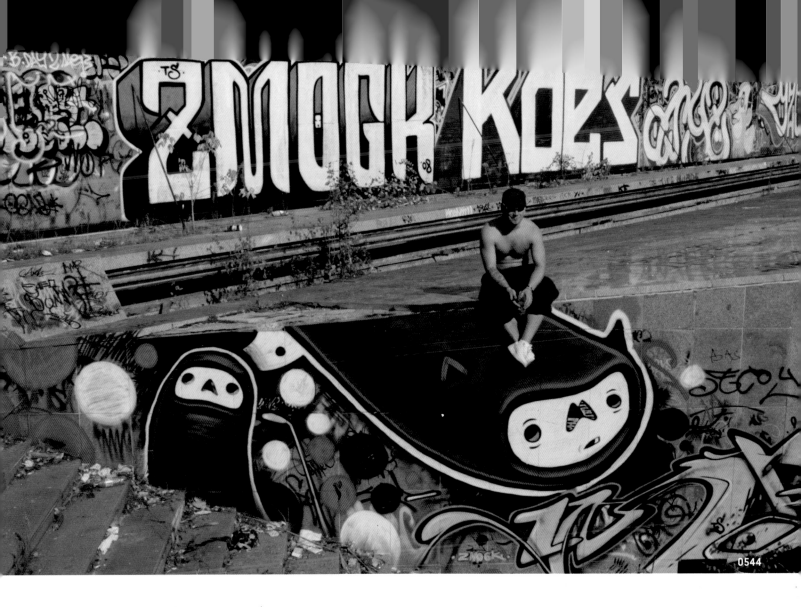

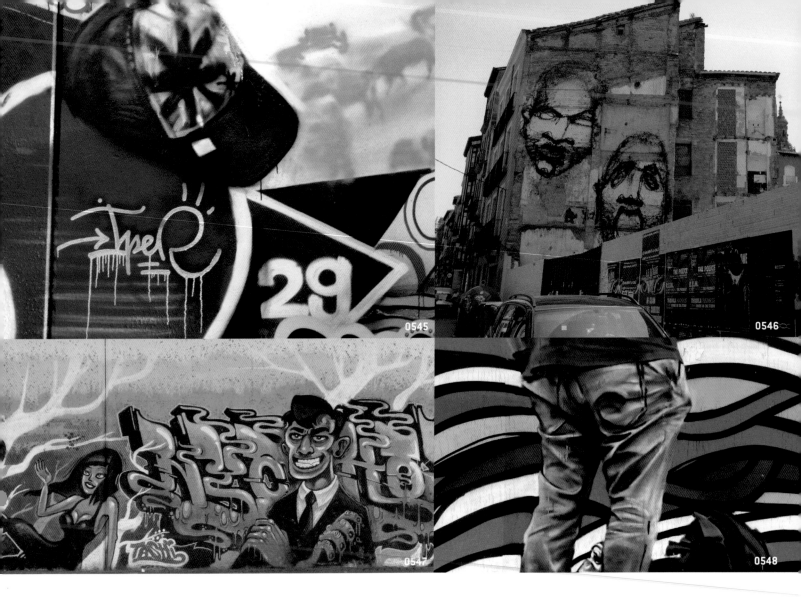

0545 Fafa. Seville, Spain / 0546 SUS033. Madrid, Spain / 0547 Nychos. Vienna, Austrias / 0548 Fafa. Seville, Spain / 0549 SHOK-1. London, UK / 0550 SHOK-1. London, UK / 0551 Zed1. Florence, Italy / 0552 Fafa. Seville, Spain

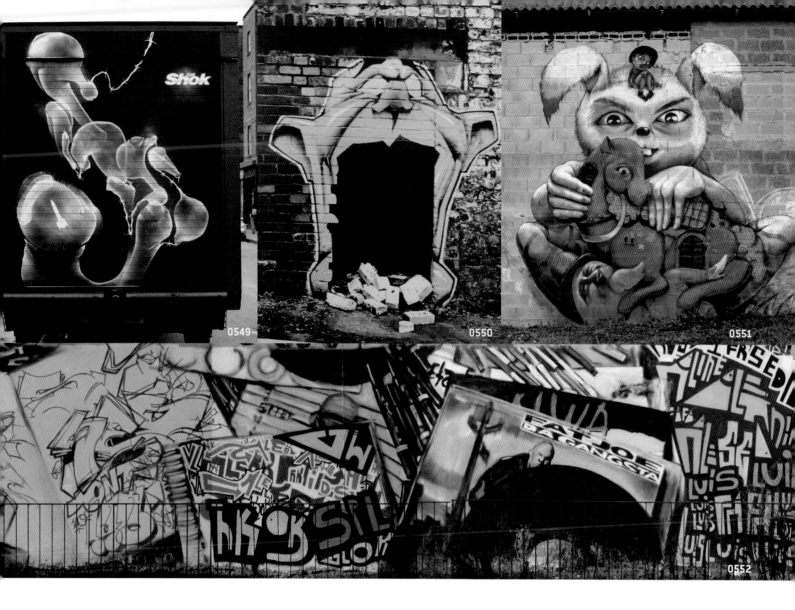

0549

0550

0551

0552

TI VA DI Emergere ?

0553

0553 Zed1. Florence, Italy / 0554 SHOK-1. London, UK

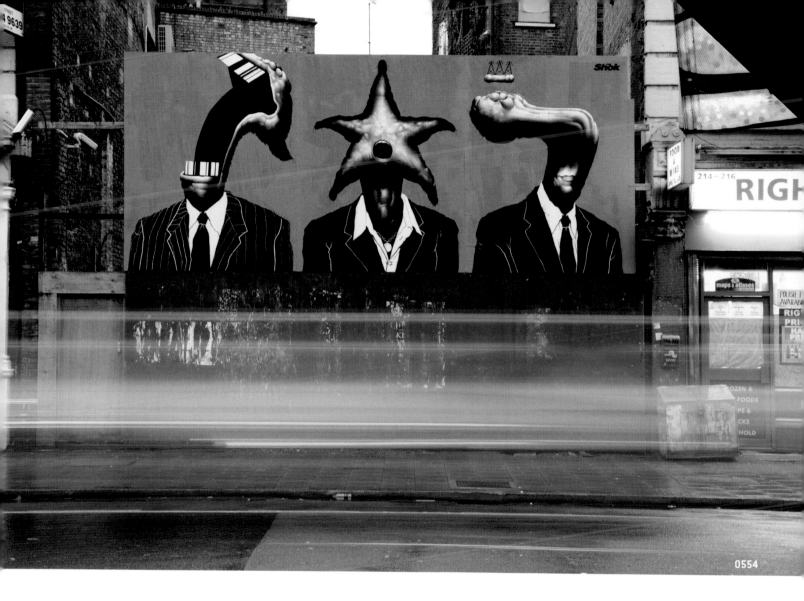

0554

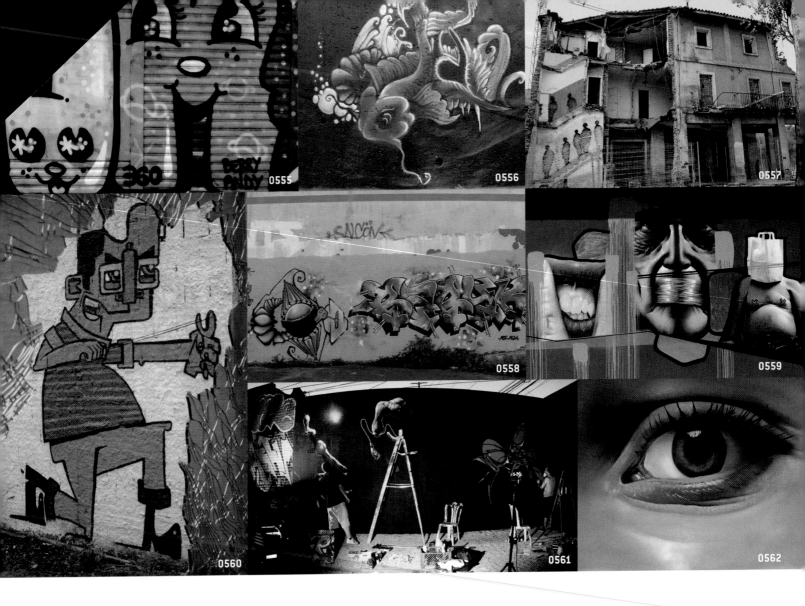

0555 Numi. Seoul, South Korea / 0556 Astrid AKA CHOUR (3PP crew). Paris, France / 0557 SUSO33. Madrid, Spain / 0558 Astrid AKA CHOUR (3PP crew). Paris, France / 0559 Mr. Dheo. Porto, Portugal / 0560 Biofa. São Paulo, Brazil / 0561 SHOK-1. London, UK / 0562 Mr. Dheo. Porto, Portugal / 0563 Mr. Flash (Joachim Pitt). Gießen, Germany / 0564 Pariz One. Lisbon, Portugal / 0565 Cade. Vitoria, Spain

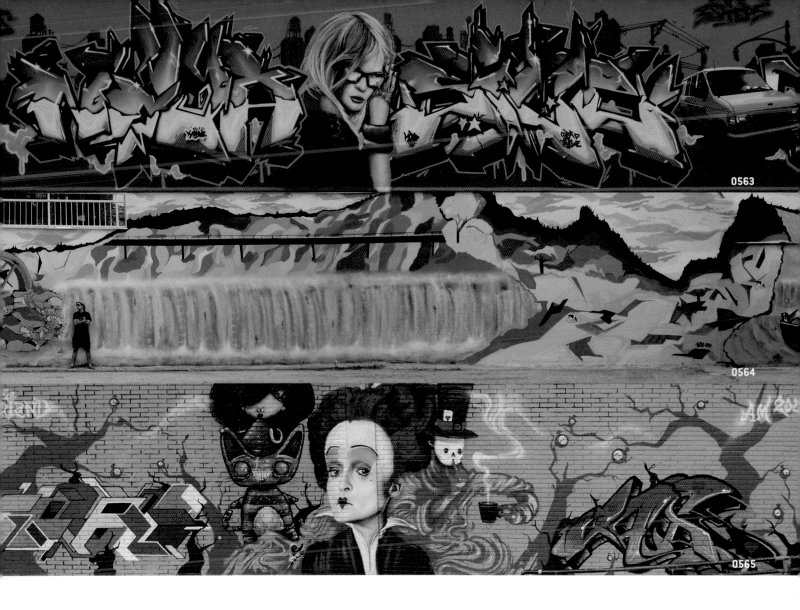

0563

0564

0565

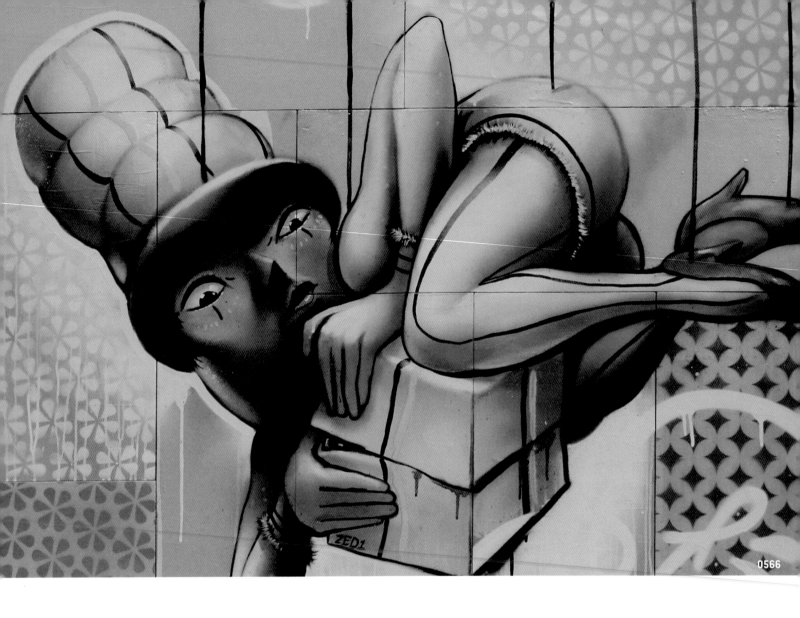
0566

0566 Zed1. Florence, Italy / 0567 Astrid AKA CHOUR (3PP crew). Paris, France

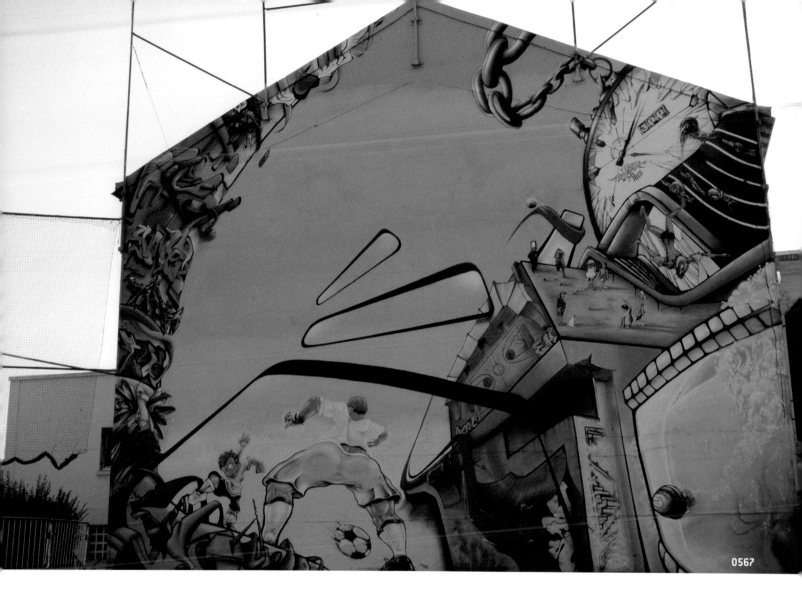

0567

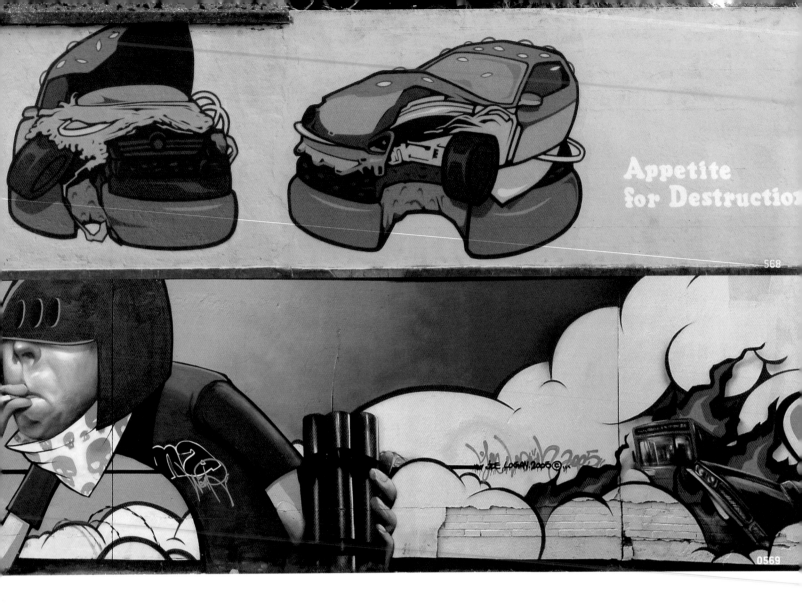

Appetite
for Destruction

0568 Sat One. Munich, Germany / 0569 Joe. Seville, Spain / 0570 Grito. Barcelona, Spain

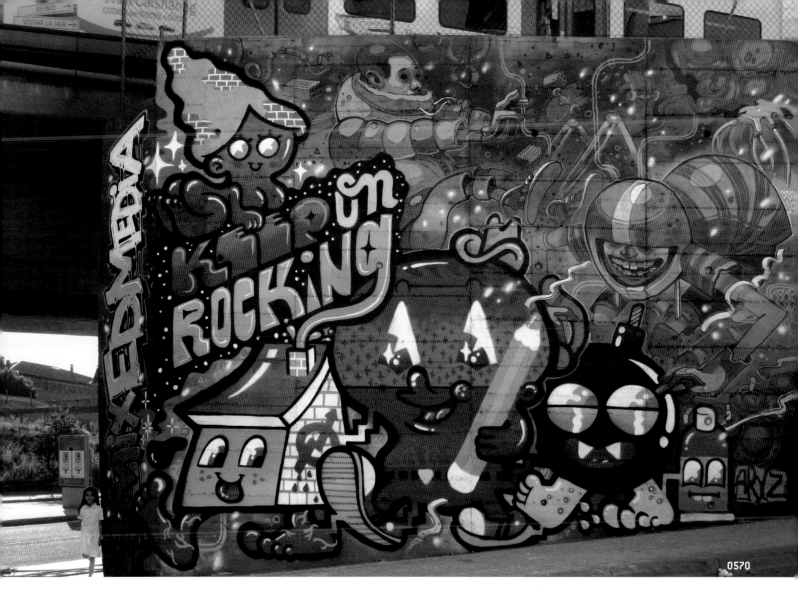

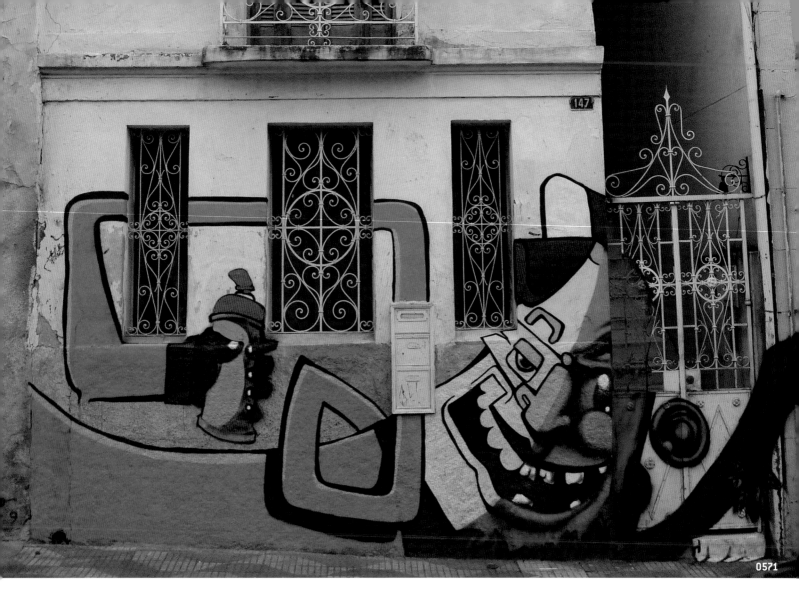

0571

0571 Biofa. São Paulo, Brazil / **0572** Fafa. Seville, Spain

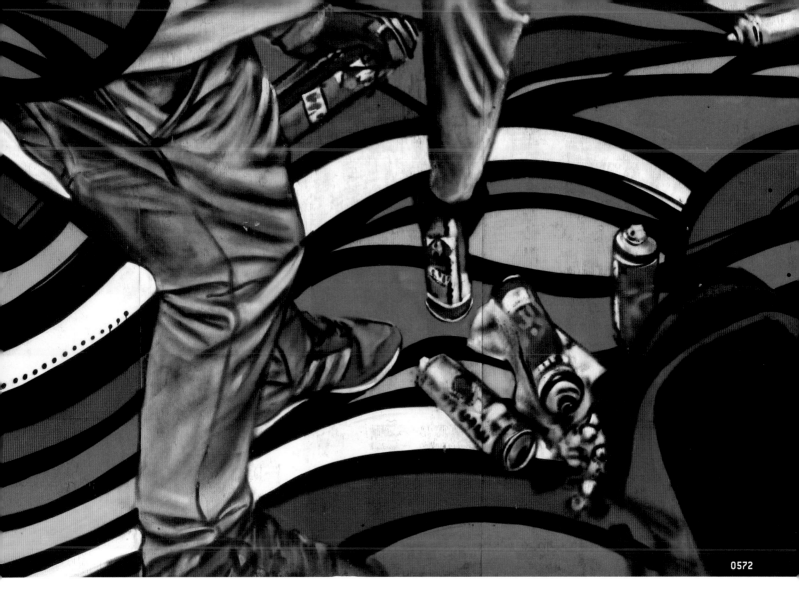

0572

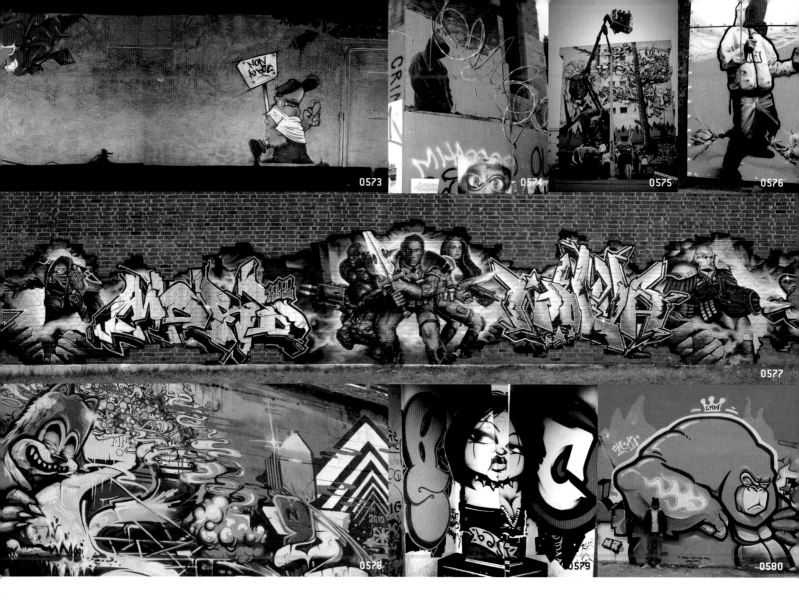

0573 Astrid AKA CHOUR (3PP crew). Paris, France / **0574** Dan Witz. New York, USA / **0575** Pariz One. Lisbon, Portugal / **0576** Mr. Dheo. Porto, Portugal / **0577** SiveOne (Kai H. Krieger). Gießen, Germany / **0578** Mr. Wany (Heavy Artillery Crew). Milan, Italy / **0579** BASK. Florida, USA / **0580** Koes. Bassano del Grappa, Italy / **0581** Fafa. Seville, Spain / **0582** Mr. Dheo. Porto, Portugal / **0583** Mr. Dheo. Porto, Portugal

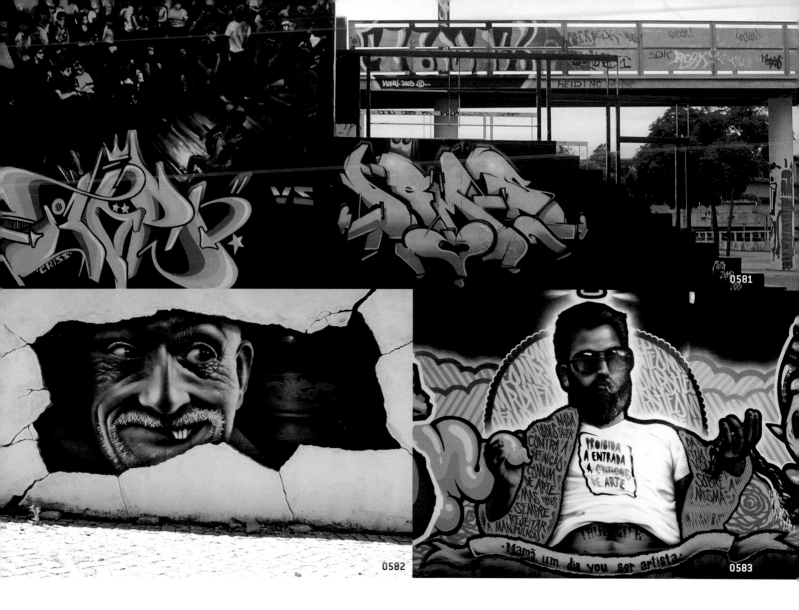

0581

0582

0583

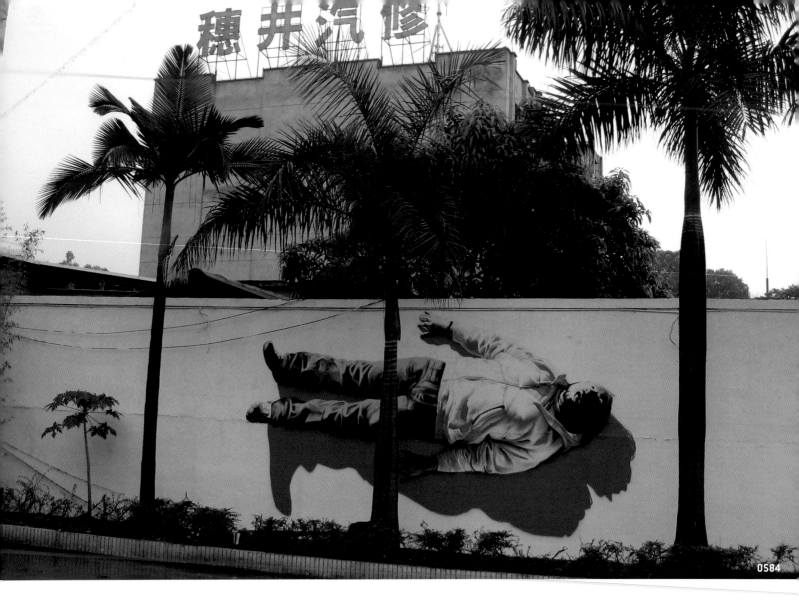

0584

0584 Tasso. Meerane, Germany / **0585** Tasso. Meerane, Germany

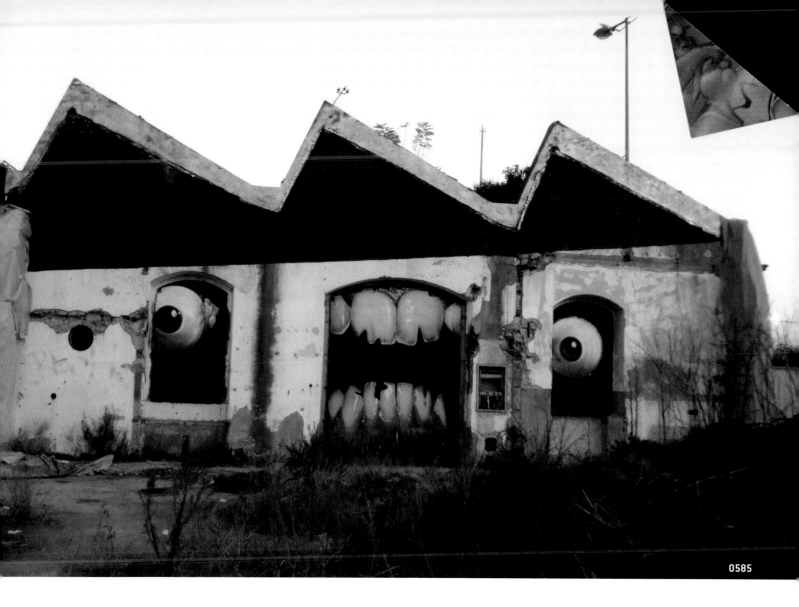

0585

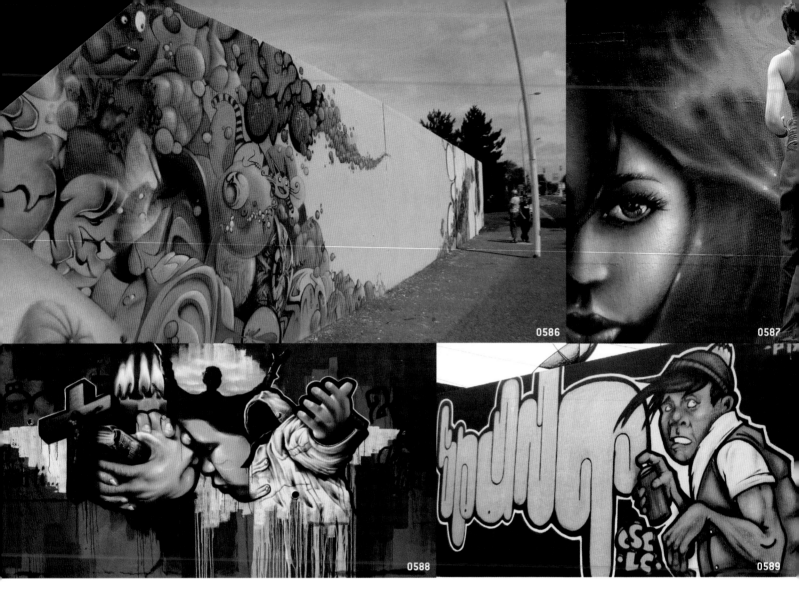

0586 Astrid AKA CHOUR (3PP crew). Paris, France / **0587** Astrid AKA CHOUR (3PP crew). Paris, France / **0588** Mr. Dheo. Porto, Portugal / **0589** Pixote Mushi. Diadema, São Paulo, Brazil / **0590** Fafa. Seville, Spain / **0591** Mr. Dheo. Porto, Portugal / **0592** Mr. Dheo. Porto, Portugal

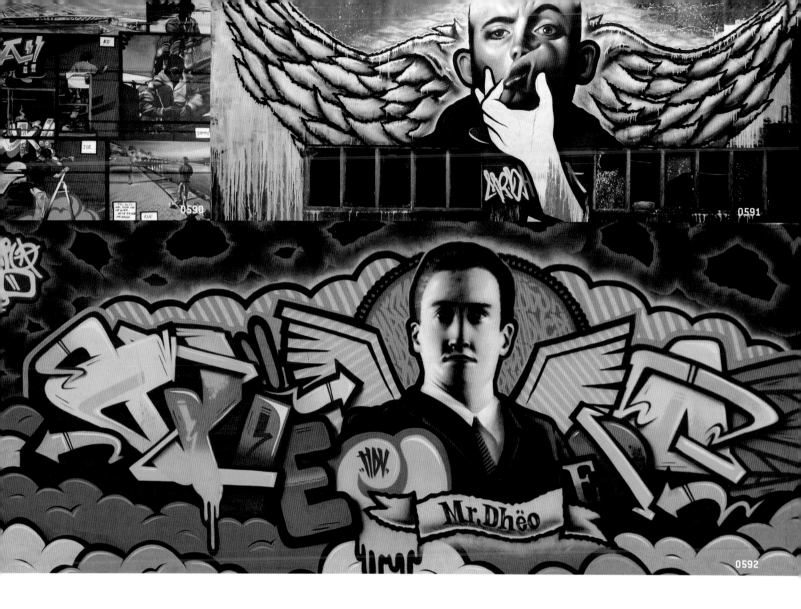

0590

0591

0592

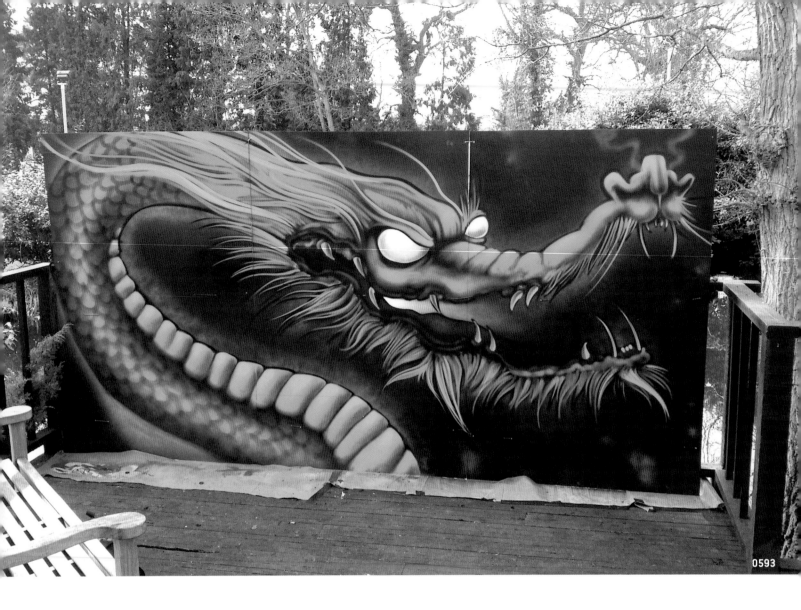

0593

0593 Brave 1 AKA Scotty~B. Essex, UK / **0594** Nychos. Vienna, Austria

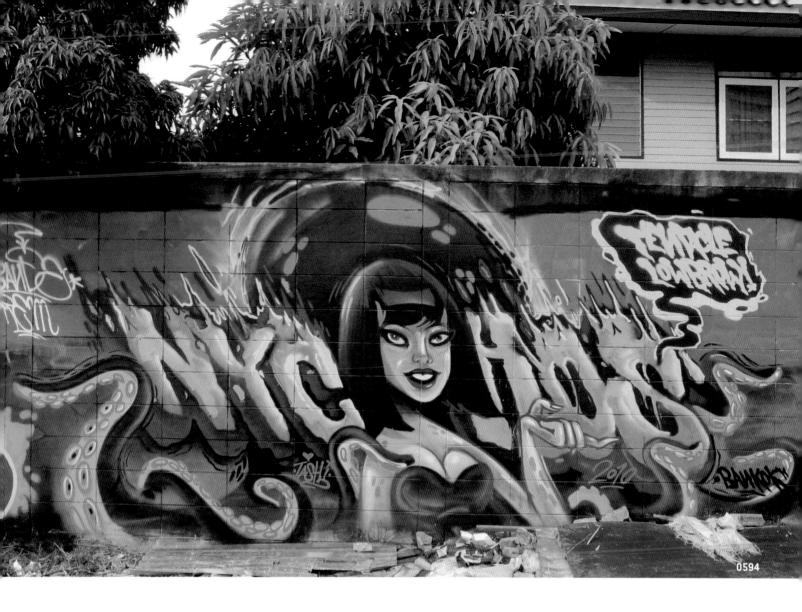

0594

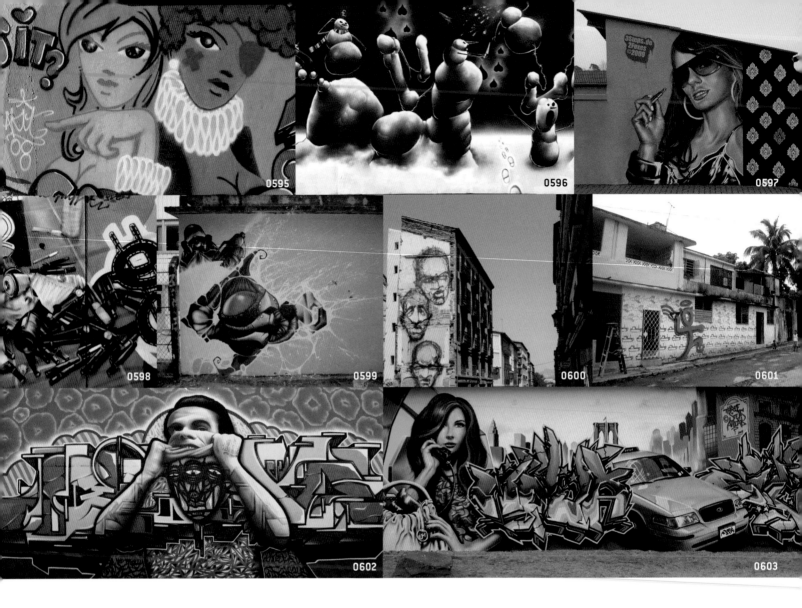

0595 AKIT. London, UK / 0596 SHOK-1. London, UK / 0597 SiveOne (Kai H. Krieger). Gießen, Germany / 0598 Fafa. Seville, Spain / 0599 Astrid AKA CHOUR (3PP crew). Paris, France / 0600 SUSO33. Madrid, Spain / 0601 Pos. Muri, Switzerland / 0602 Mr. Dheo. Porto, Portugal / 0603 SiveOne (Kai H. Krieger). Gießen, Germany / 0604 Mr. Dheo. Porto, Portugal / 0605 AKIT. London, UK / 0606 Malicia. Barcelona, Spain / 0607 Klaas Van der Linden. Ghent, Belgium / 0608 Mr. Wany (Heavy Artillery Crew). Milan, Italy / 0609 Insanewen (SPL Crew). Seville, Spain / 0610 Toast One. Zurich, Switzerland

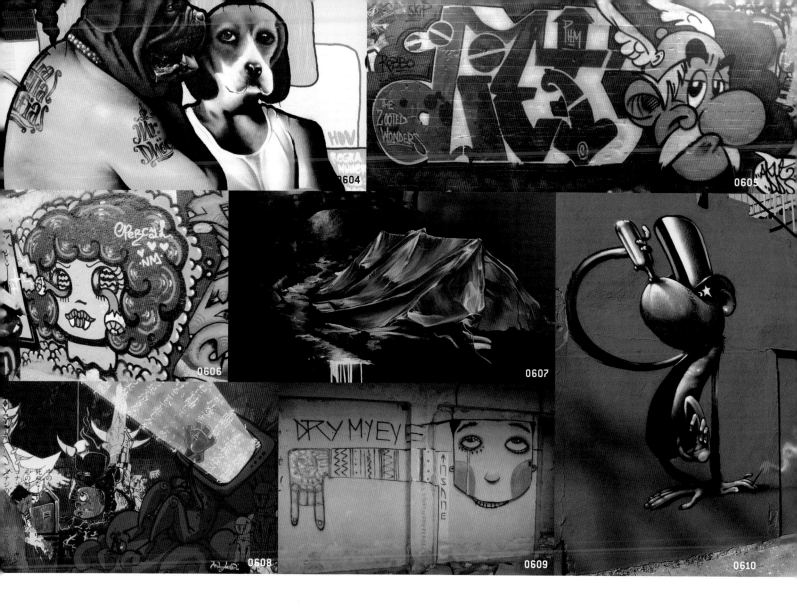

0604

0605

0606

0607

0608

0609

0610

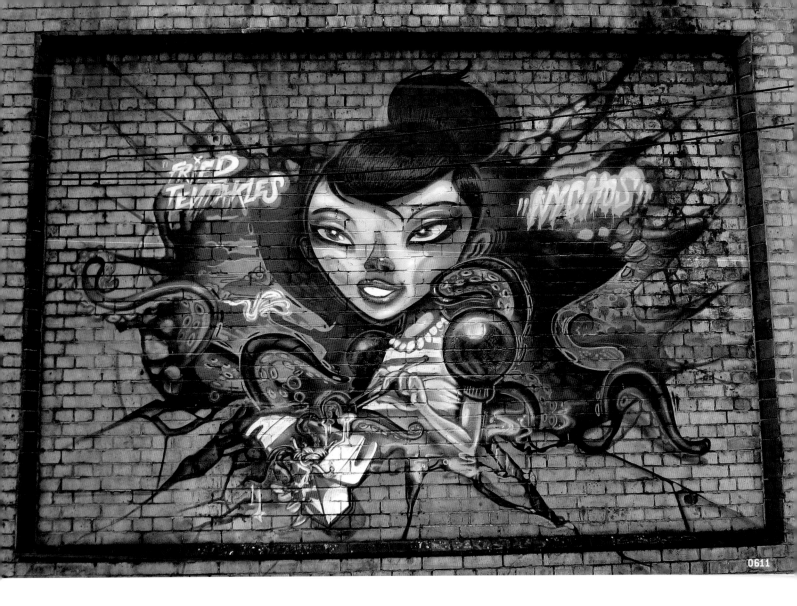

0611

0611 Nychos. Vienna, Austria / **0612** Mr. Flash (Joachim Pitt). Gießen, Germany

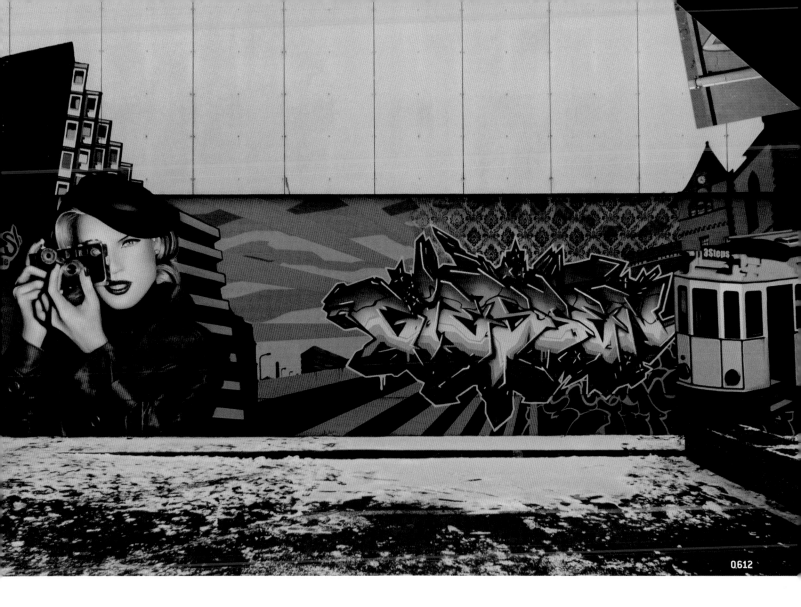

Q612

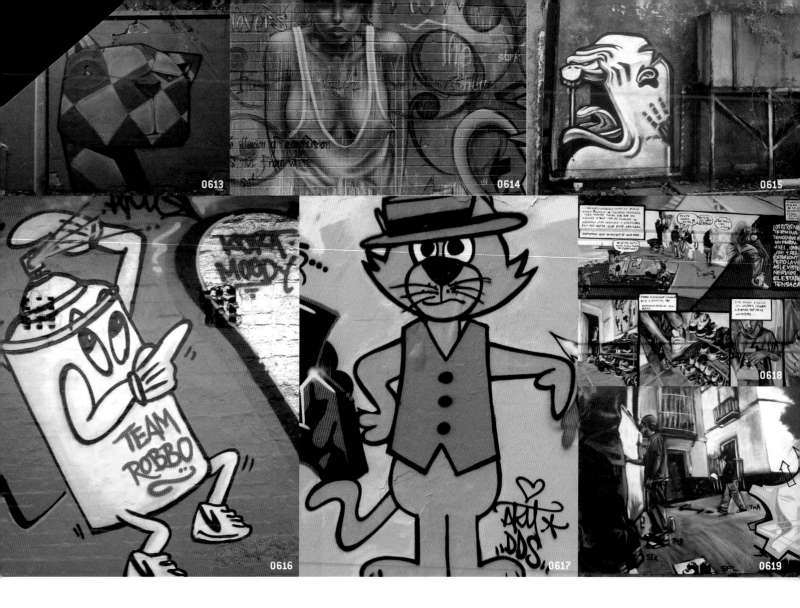

0613 Koes. Bassano del Grappa, Italy / 0614 MAC 1. Birmingham, UK / 0615 Koes. Bassano del Grappa, Italy / 0616 AKIT. London, UK / 0617 AKIT. London, UK / 0618 Fafa. Seville, Spain / 0619 Fafa. Seville, Spain / 0620 SiveOne (Kai H. Krieger). Gießen, Germany / 0621 Mr. Wany (Heavy Artillery Crew). Milan, Italy / 0622 SiveOne (Kai H. Krieger). Gießen, Germany / 0623 SiveOne (Kai H. Krieger). Gießen, Germany / 0624 Klaas Van der Linden. Ghent, Belgium / 0625 Fafa. Seville, Spain / 0626 SUSO33. Madrid, Spain / 0627 Ma'La. Mataró, Spain / 0628 Fafa. Seville, Spain / 0629 Grito. Barcelona, Spain / 0630 Ma'La. Mataró, Spain / 0631 SUSO33. Madrid, Spain

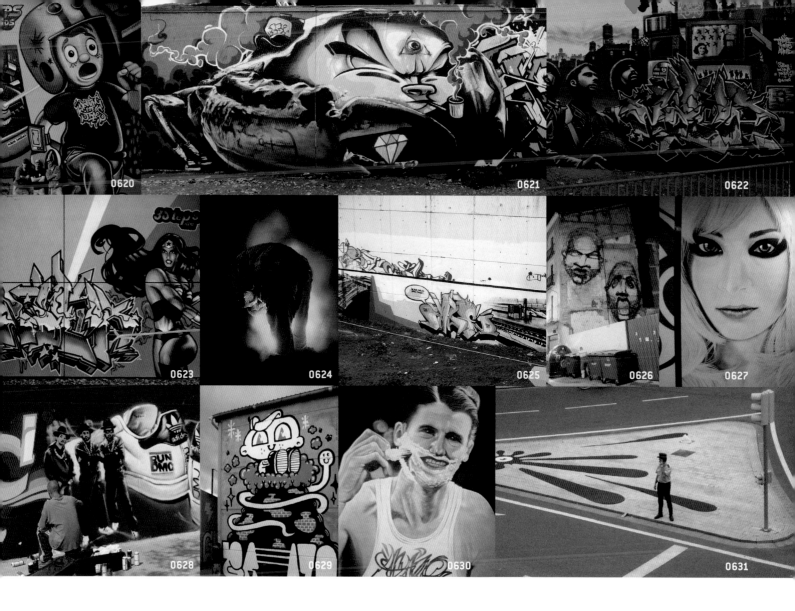

0620

0621

0622

0623

0624

0625

0626

0627

0628

0629

0630

0631

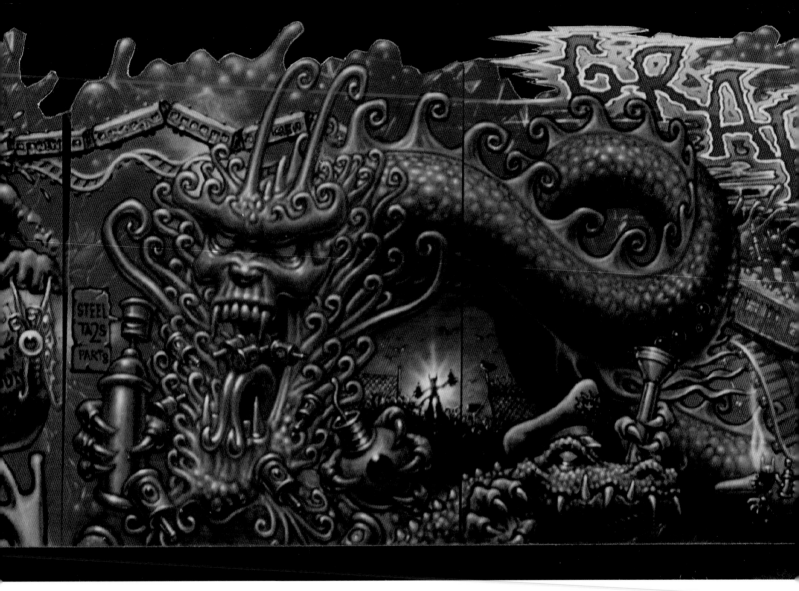

0632 Wonabc. Munich, Germany

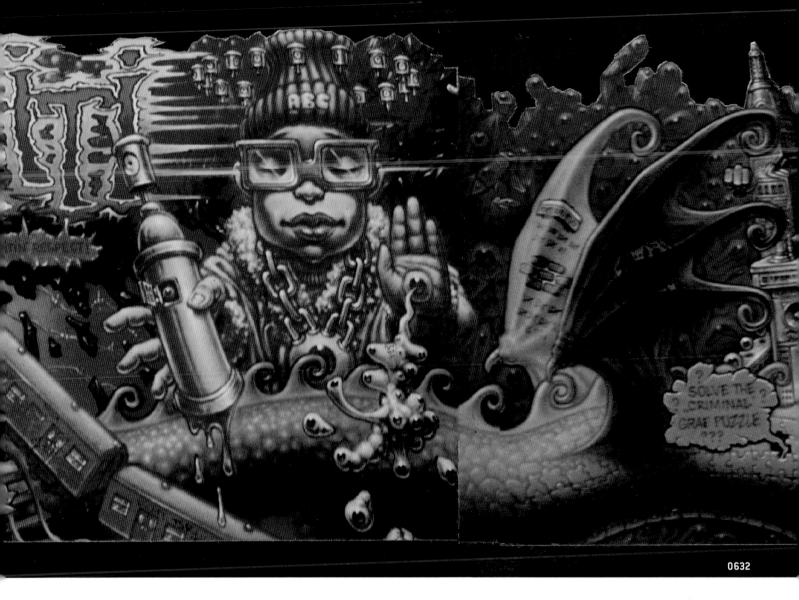

0632

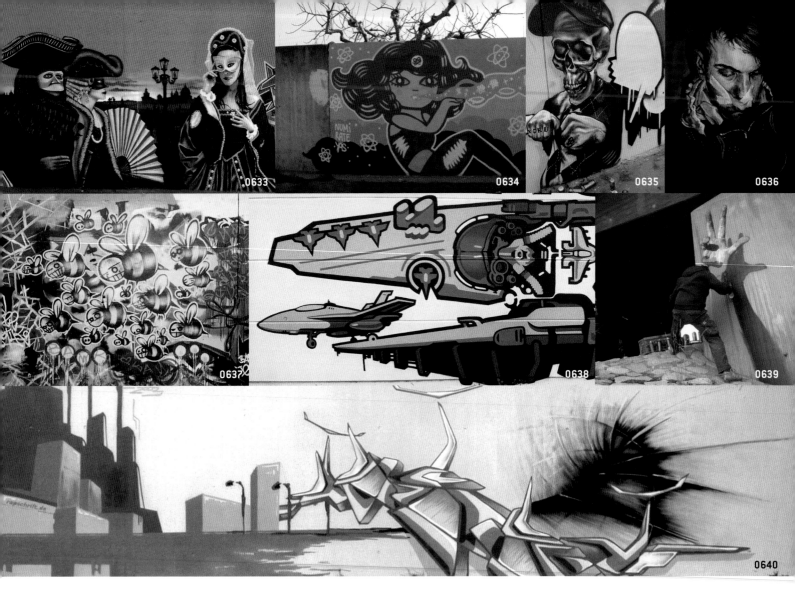

0633 SiveOne (Kai H. Krieger). Gießen, Germany / **0634** Malicia. Barcelona, Spain / **0635** Klaas Van der Linden. Ghent, Belgium / **0636** Klaas Van der Linden. Ghent, Belgium / **0637** BASK. Florida, USA / **0638** Sat One. Munich, Germany / **0639** Tasso. Meerane, Germany / **0640** Dyset. Munich, Germany / **0641** Malicia. Barcelona, Spain / **0642** Klaas Van der Linden. Ghent, Belgium / **0643** Biofa. São Paulo, Brazil / **0644** Fafa. Seville, Spain / **0645** Dyset. Munich, Germany / **0646** Ma'La. Mataró, Spain / **0647** SUSO33. Madrid, Spain / **0648** Brave 1 AKA Scotty-B. Essex, UK / **0649** Fafa. Seville, Spain

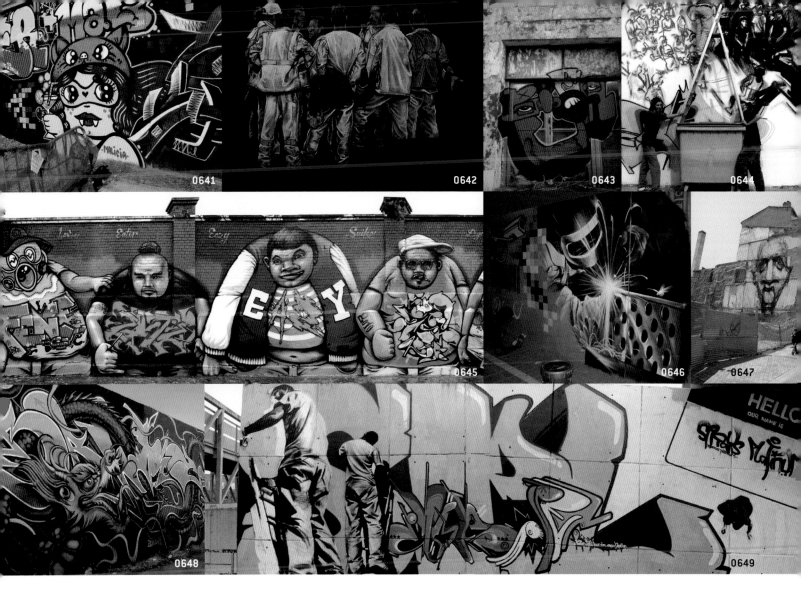

0641

0642

0643

0644

0645

0646

0647

0648

0649

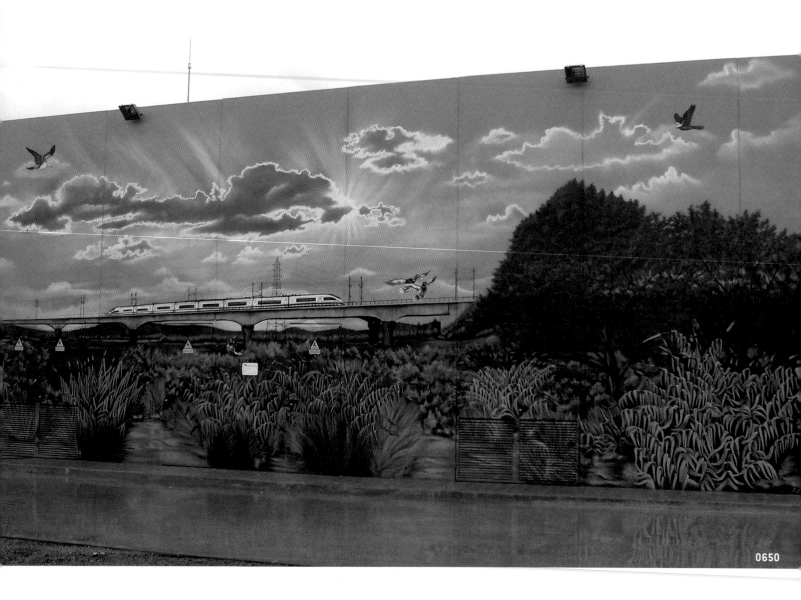

0650

0650 Ma'La. Mataró, Spain / **0651** SiveOne (Kai H. Krieger). Gießen, Germany

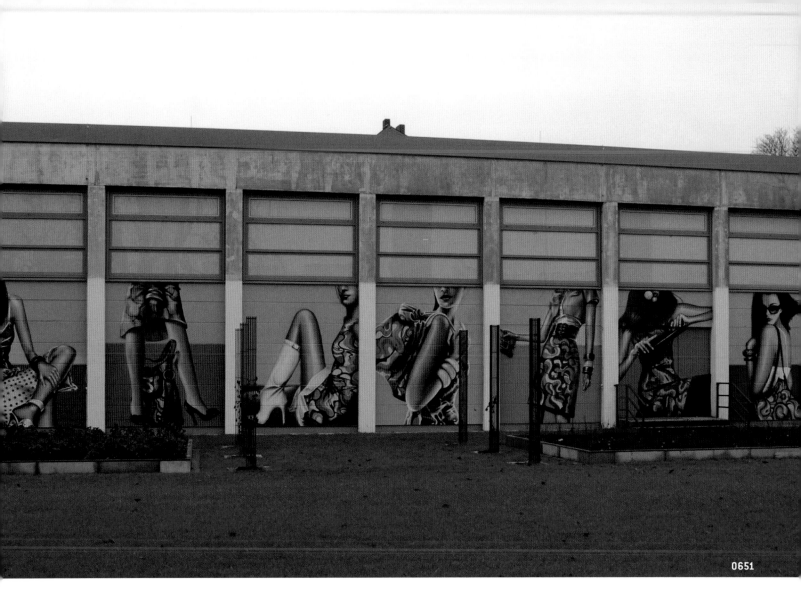

0651

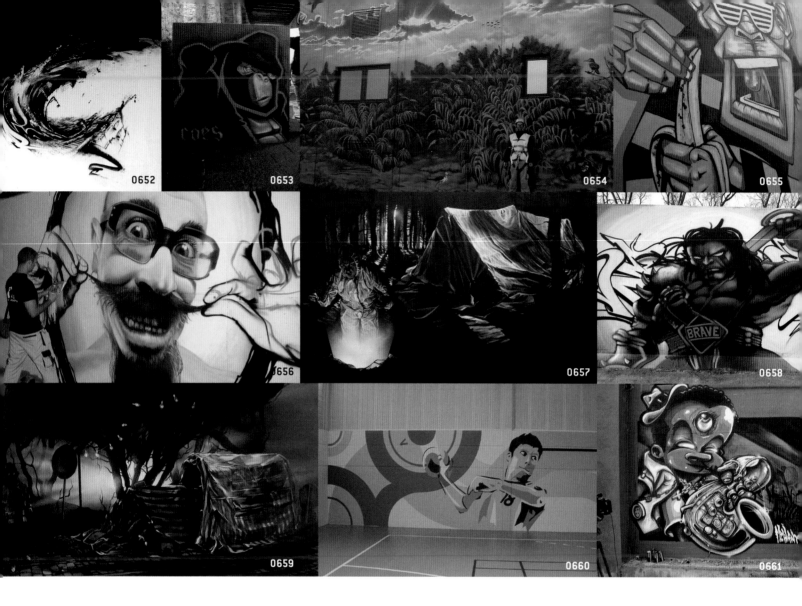

0652 Danny "casroc" Casu. Antwerp, Belgium / 0653 Koes. Bassano del Grappa, Italy / 0654 Ma'La. Mataró, Spain / 0655 Pixote Mushi. Diadema, São Paulo, Brazil / 0656 Ma'La. Mataró, Spain / 0657 Klaas Van der Linden. Ghent, Belgium / 0658 Brave 1 AKA Scotty~B. Essex, UK / 0659 Klaas Van der Linden. Ghent, Belgium / 0660 Astrid AKA CHOUR (3PP crew). Paris, France / 0661 Mr. Wany (Heavy Artillery Crew). Milan, Italy / 0662 SUSO33. Madrid, Spain / 0663 Mr. Dheo. Porto, Portugal / 0664 Ma'La. Mataró, Spain / 0665 Astrid AKA CHOUR (3PP crew). Paris, France / 0666 Klaas Van der Linden. Ghent, Belgium / 0667 Mr. Wany (Heavy Artillery Crew). Milan, Italy / 0668 Astrid AKA CHOUR (3PP crew). Paris, France / 0669 Astrid AKA CHOUR (3PP crew). Paris, France / 0670 Astrid AKA CHOUR (3PP crew). Paris, France / 0671 SHOK-1. London, UK

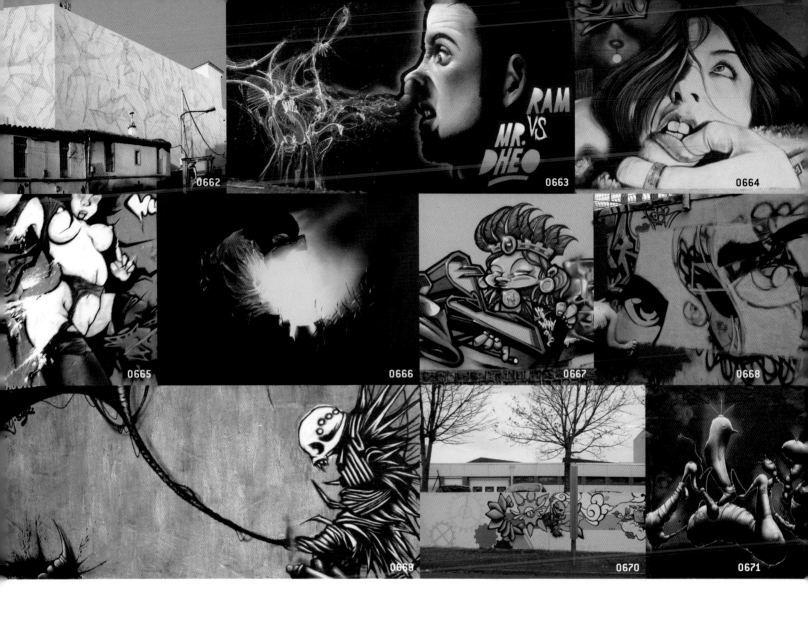

0662

0663

0664

0665

0666

0667

0668

0869

0670

0671

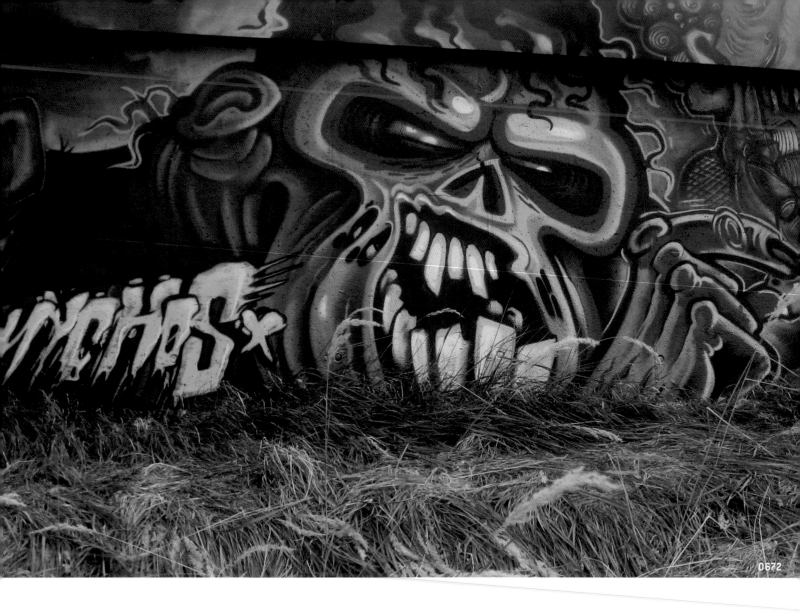

0672 Nychos. Vienna, Austria / **0673** Grito. Barcelona, Spain

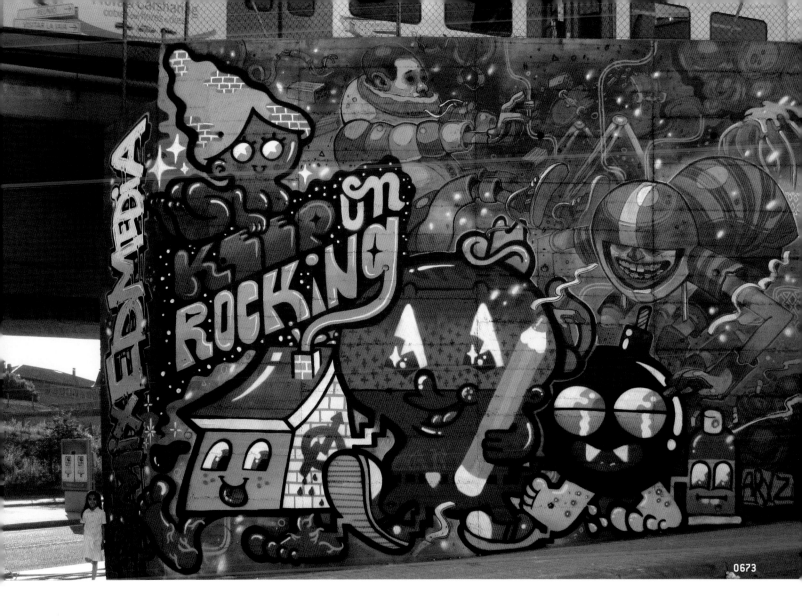

0673

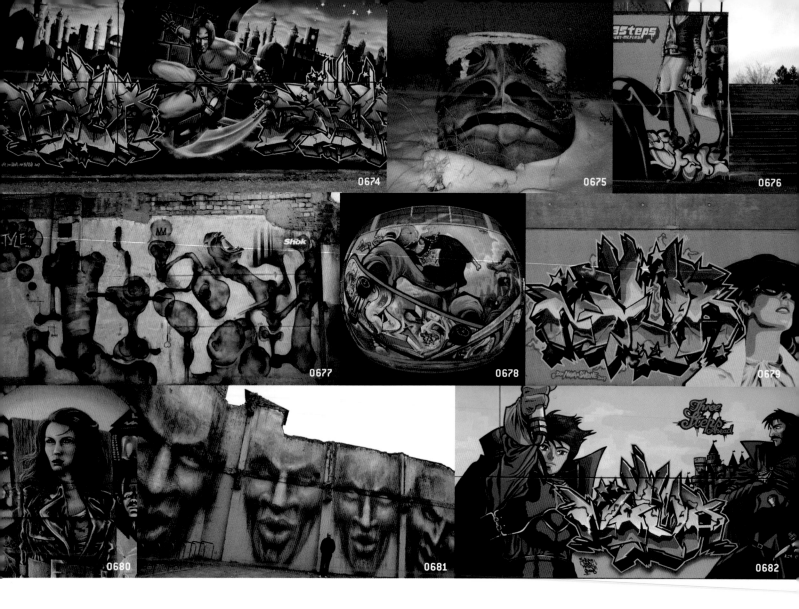

0674 Mr. Flash (Joachim Pitt). Gießen, Germany / 0675 Tasso. Meerane, Germany / 0676 SiveOne (Kai H. Krieger). Gießen, Germany / 0677 SHOK-1. London, UK / 0678 Mr. Wany (Heavy Artillery Crew). Milan, Italy / 0679 SiveOne (Kai H. Krieger). Gießen, Germany / 0680 SiveOne (Kai H. Krieger). Gießen, Germany / 0681 SUSO33. Madrid, Spain / 0682 SiveOne (Kai H. Krieger). Gießen, Germany / 0683 SUSO33. Madrid, Spain / 0684 SUSO33. Madrid, Spain / 0685 Wonabc. Munich, Germany / 0686 Astrid AKA CHOUR (3PP crew). Paris, France / 0687 MAC 1. Birmingham, UK / 0688 Mr. Wany (Heavy Artillery Crew). Milan, Italy / 0689 SiveOne (Kai H. Krieger). Gießen, Germany / 0690 Fafa. Seville, Spain / 0691 Brave 1 AKA Scotty - B. Essex, UK / 0692 SHOK-1. London, UK / 0693 Fafa. Seville, Spain

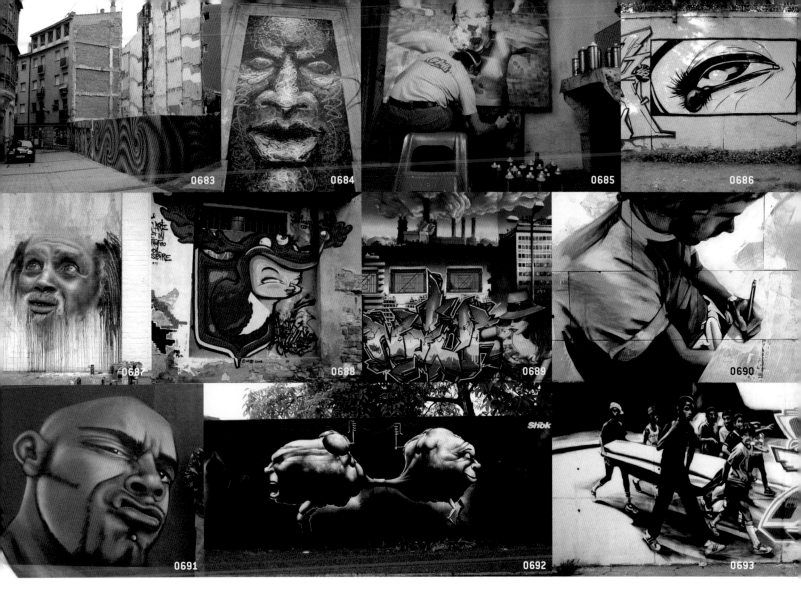

0683

0684

0685

0686

0687

0688

0689

0690

0691

0692

0693

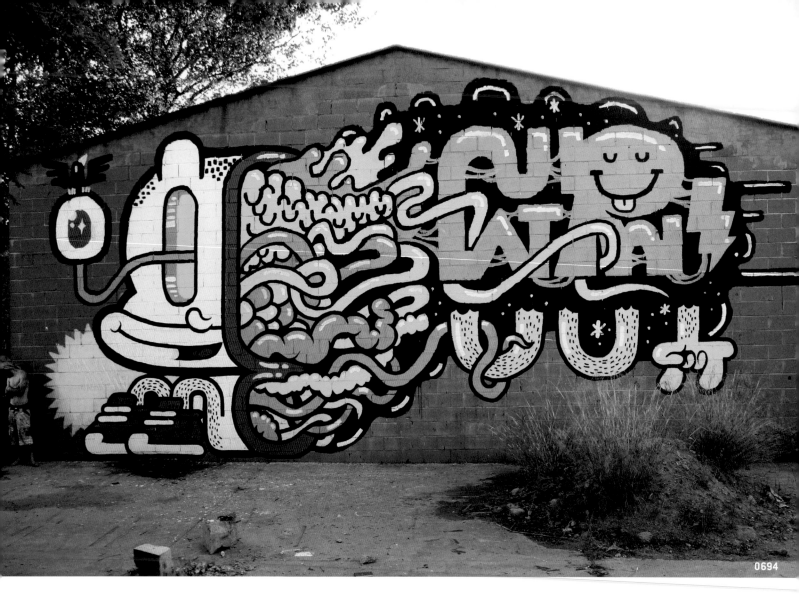

0694 Grito. Barcelona, Spain / 0695 Grito. Barcelona, Spain

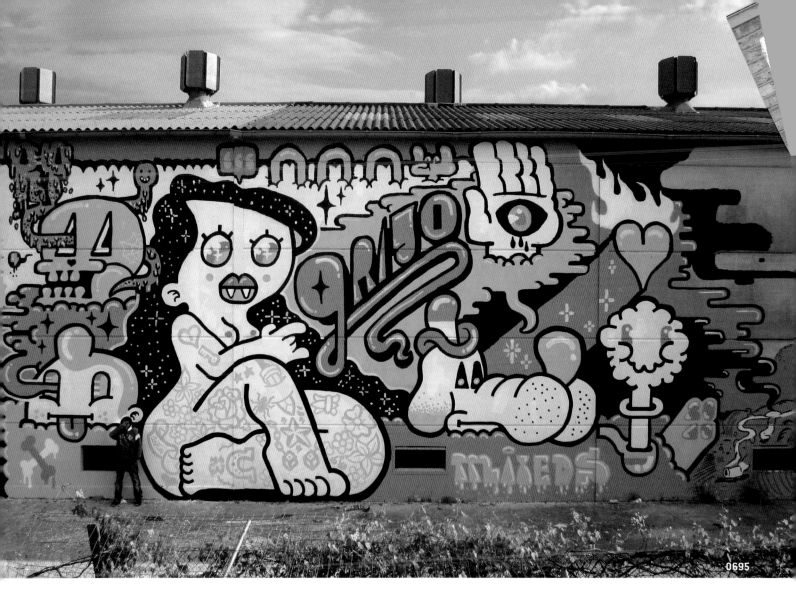

0695

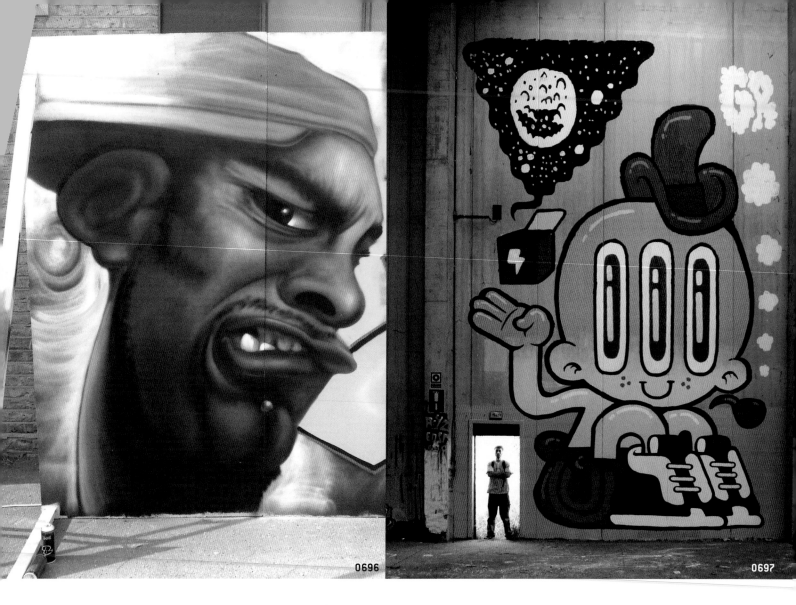

0696

0697

0696 Brave 1 AKA Scotty~B. Essex, UK / 0697 Grito. Barcelona, Spain / 0698 Brave 1 AKA Scotty~B. Essex, UK / 0699 Tasso. Meerane, Germany / 0700 Mr. Wany (Heavy Artillery Crew). Milan, Italy / 0701 Mr. Dheo. Porto, Portugal / 0702 MAC 1. Birmingham, UK / 0703 BASK. Florida, USA

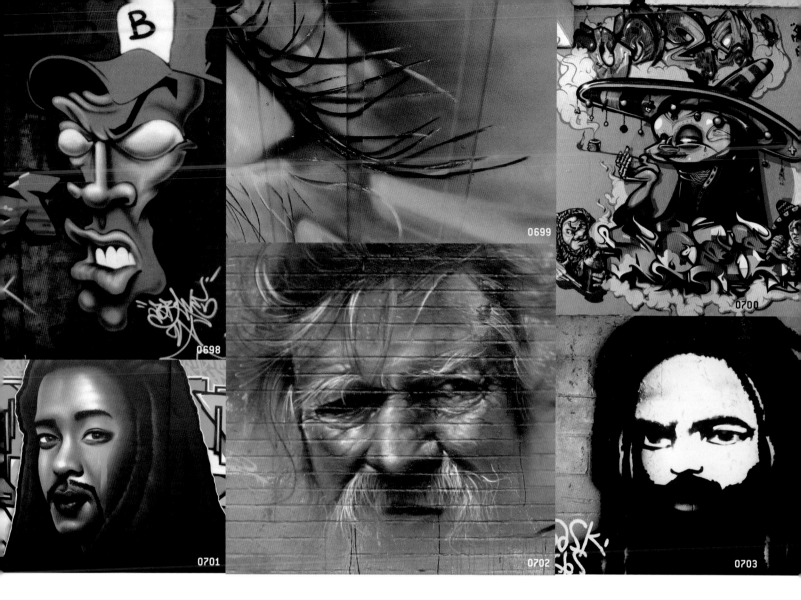

0698

0699

0700

0701

0702

0703

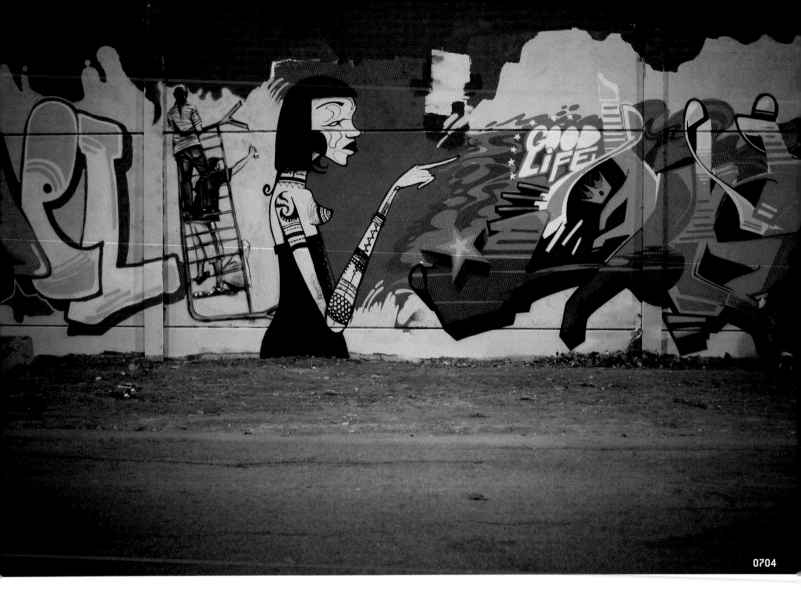

0704

0704 Insanewen (SPL Crew). Seville, Spain / 0705 Mr. Wany (Heavy Artillery Crew). Milan, Italy

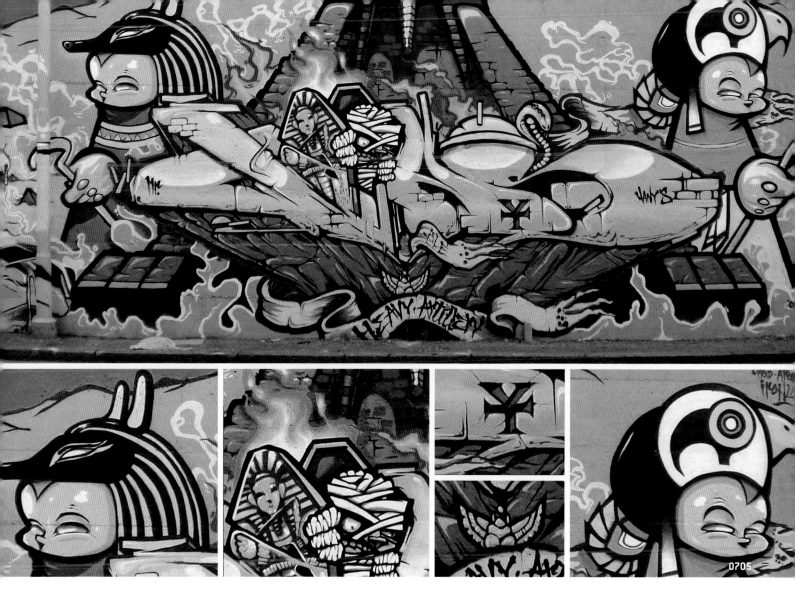

Although the characteristic tool for graffiti is spray paint, thousands of urban artists have opted to work totally or partially with alternative tools, such as stickers, stencils, rollers, and different types of paint or ink (plastic, acrylic, markers, etc.) Stickers and conventional brushes can achieve a degree of detail that is practically impossible with a spray can, even with the usual tricks of obstructing the nozzle to give finer lines. Stencils make it possible to repeat a single piece and even cover the streets of any city. Paint rollers let artists cover huge surfaces and create murals the size of a façade several stories high.

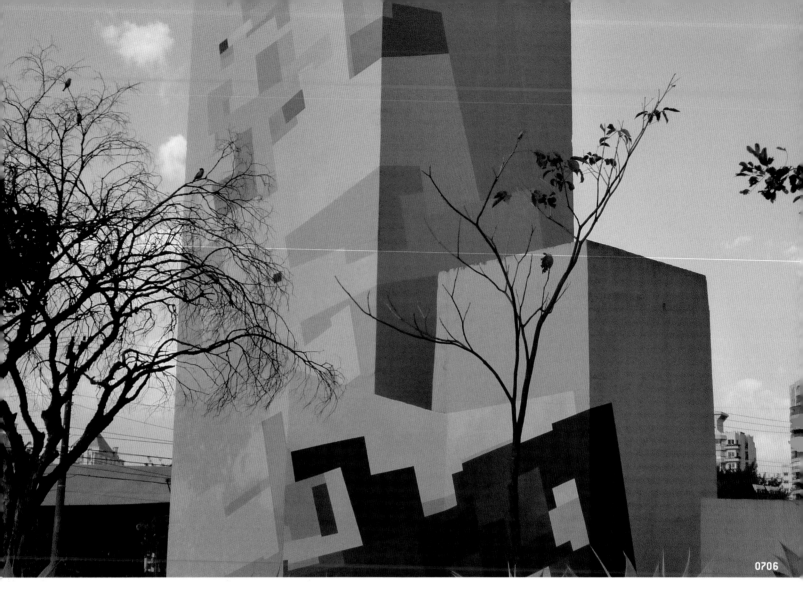

0706

0706 Nuria Mora. Madrid, Spain / **0707** Okuda. Santander, Spain

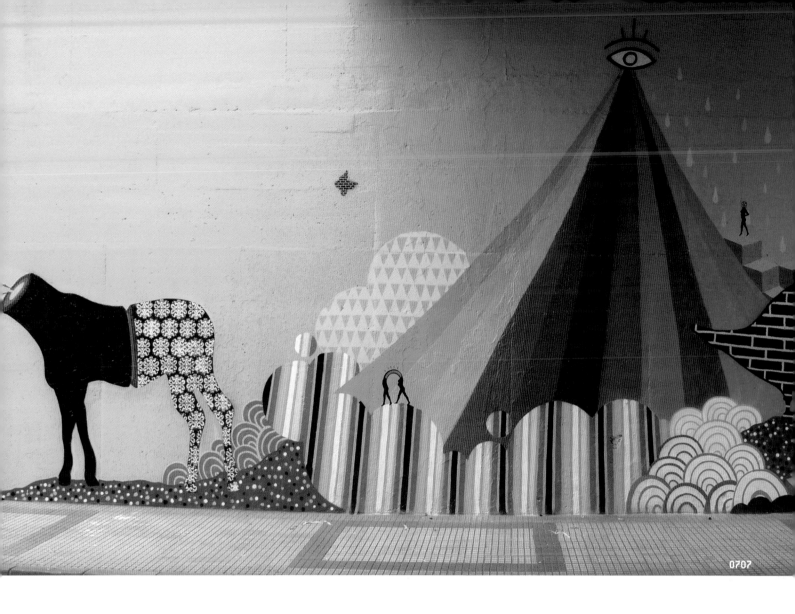

0707

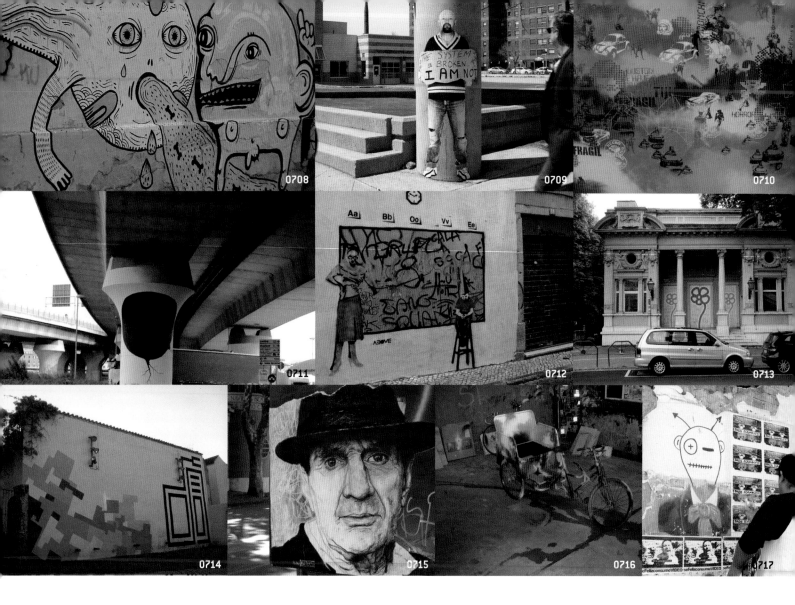

0708 Cobrinha. Buenos Aires, Argentina / 0709 Dan Bergeron/Fauxreel. Toronto, Canada / 0710 Acamonchi. San Diego, CA, USA / 0711 108. Alessandria, Italy / 0712 Above. San Francisco, CA, USA / 0713 Michael De Feo. New York, USA / 0714 Nuria Mora. Madrid, Spain / 0715 Drone. Lisbon, Portugal / 0716 Acamonchi. San Diego, CA, USA / 0717 Acamonchi. San Diego, CA, USA / 0718 Conor Harrington. Cork, London, UK / 0719 108. Alessandria, Italy / 0720 Btoy. Barcelona, Spain / 0721 Michael De Feo. New York, USA / 0722 Btoy. Barcelona, Spain / 0723 Skount. Almagro, Spain / 0724 Acamonchi. San Diego, CA, USA / 0725 Dan Bergeron/Fauxreel. Toronto, Canada / 0726 Dan Bergeron/Fauxreel. Toronto, Canada

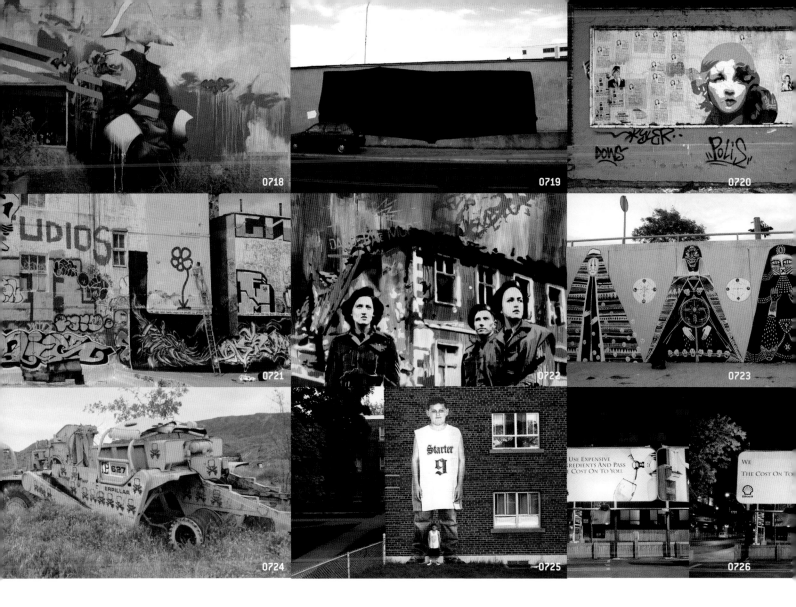

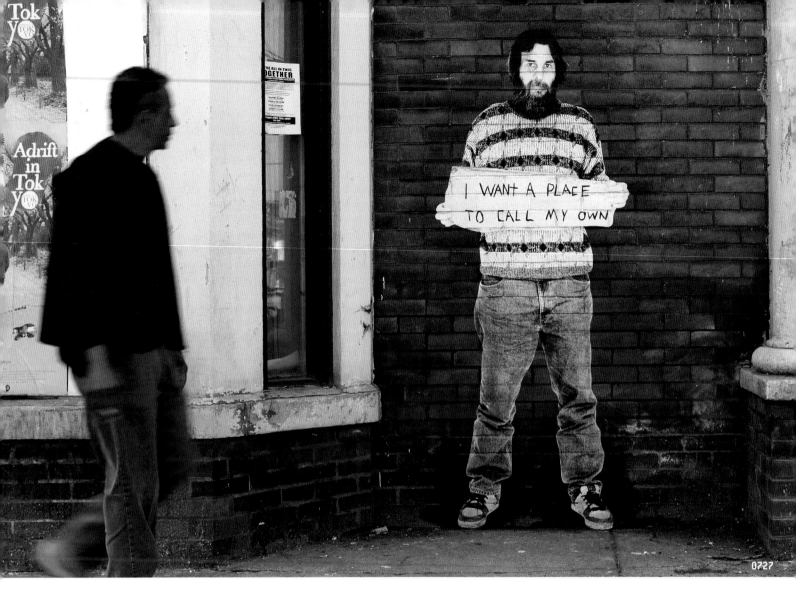

0727

0727 Dan Bergeron/Fauxreel. Toronto, Canada / **0728** Nuria Mora. Madrid, Spain

0728

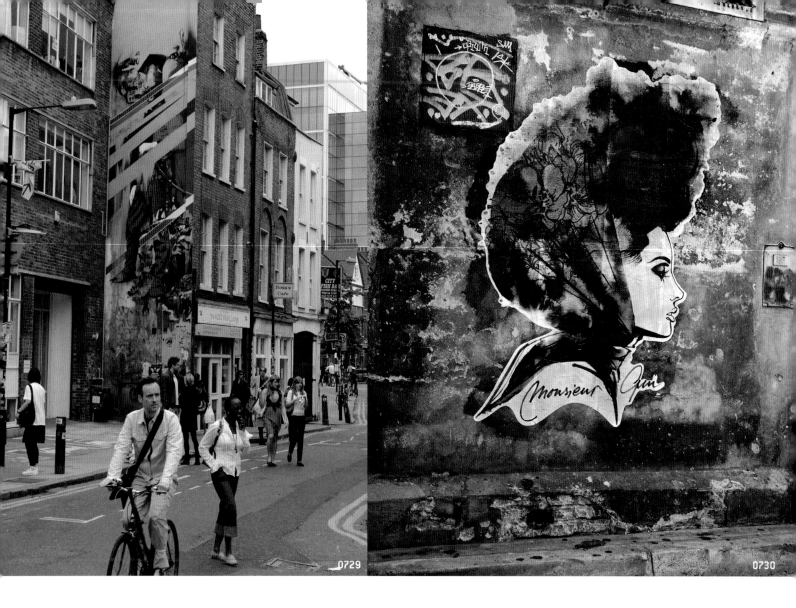

0729 Conor Harrington. Cork, London, UK / **0730** monsieur Qui. Paris, France / **0731** monsieur Qui. Paris, France

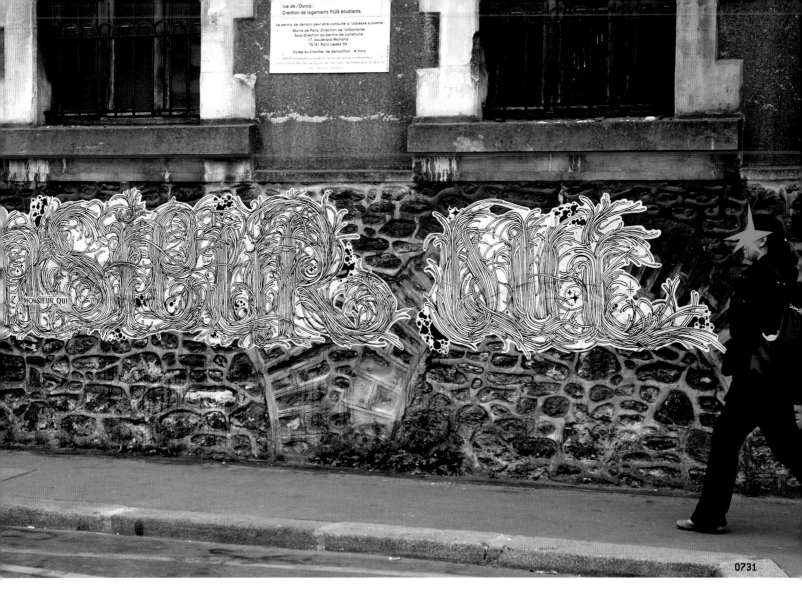

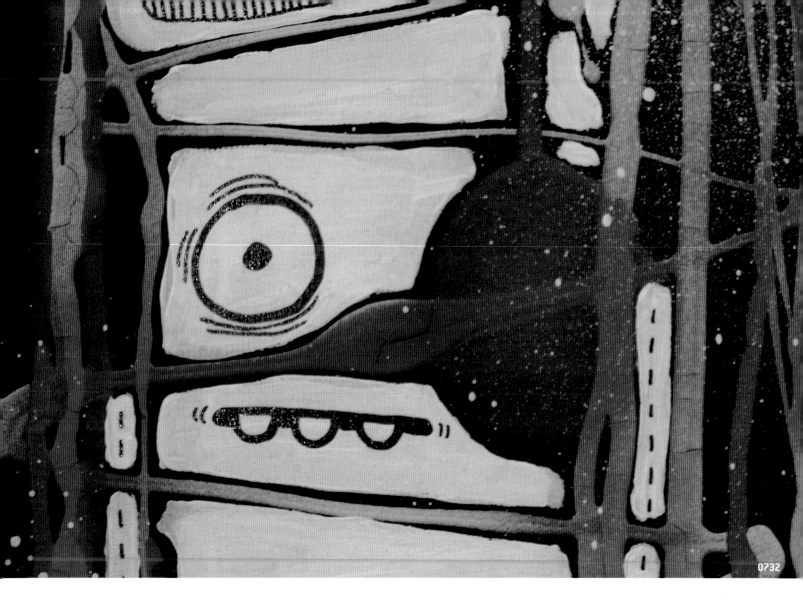

0732

0732 Cobrinha. Buenos Aires, Argentina / **0733** Koes. Bassano del Grappa, Italy

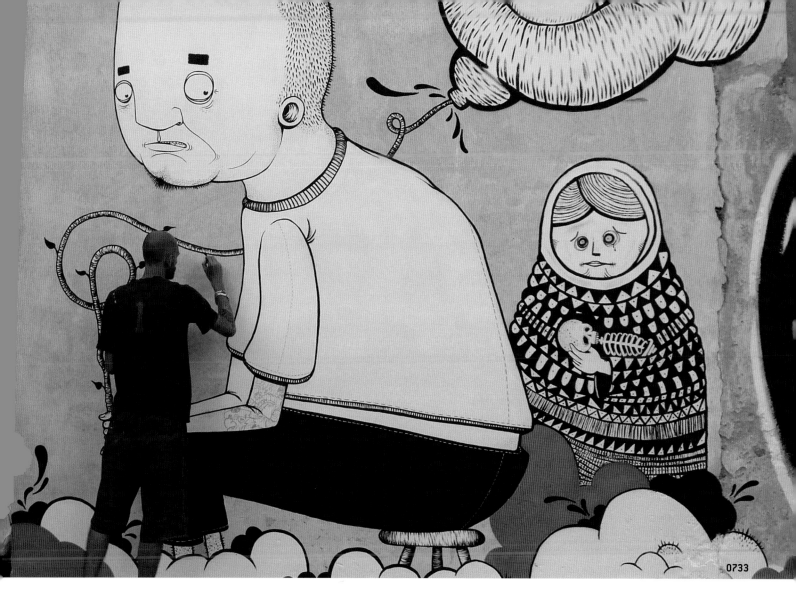

0733

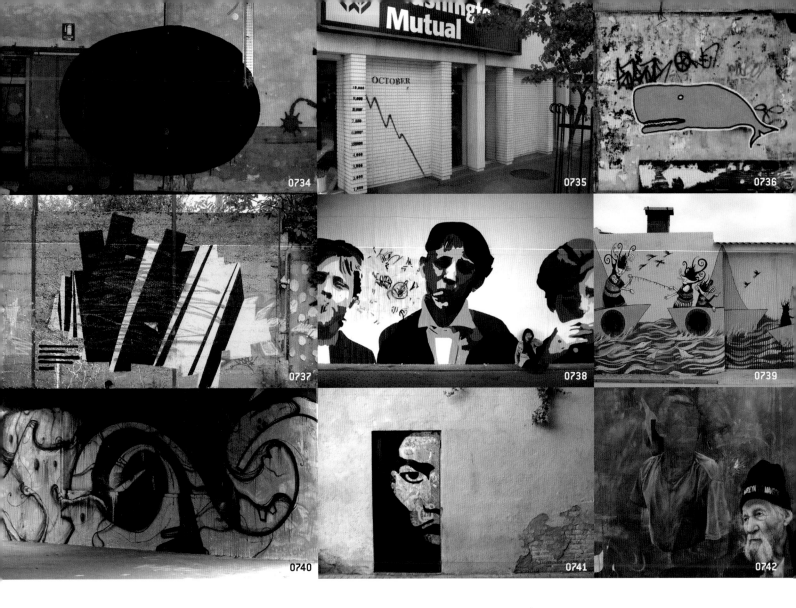

0734 108. Alessandria, Italy / 0735 Above. San Francisco, CA, USA / 0736 Michael De Feo. New York, USA / 0737 Via Grafik. Wiesbaden, Germany / 0738 Btoy. Barcelona, Spain / 0739 Skount. Almagro, Spain / 0740 dust. Freiburg, Germany / 0741 Dr. Hofmann. Barcelona, Spain / 0742 Drone. Lisbon, Portugal / 0743 Nuria Mora. Madrid, Spain

0743

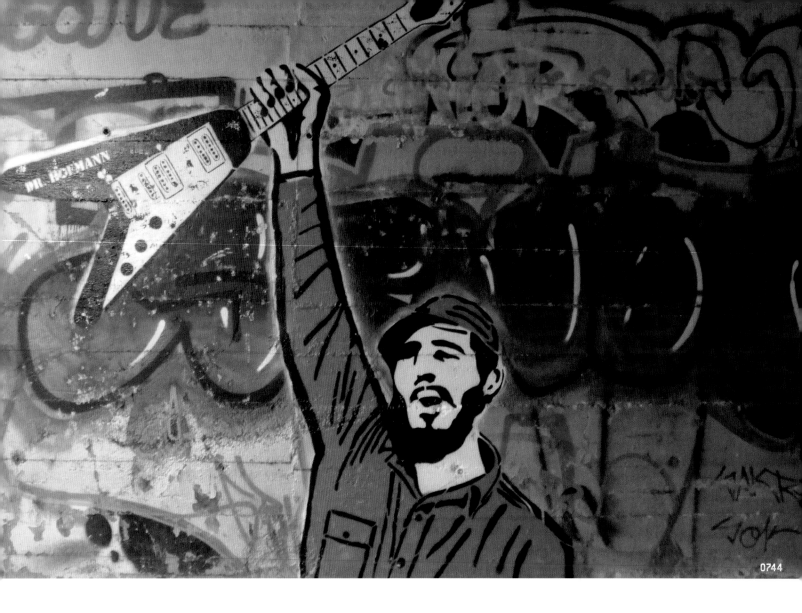

0744 Dr. Hofmann. Barcelona, Spain / **0745** Dr. Hofmann. Barcelona, Spain

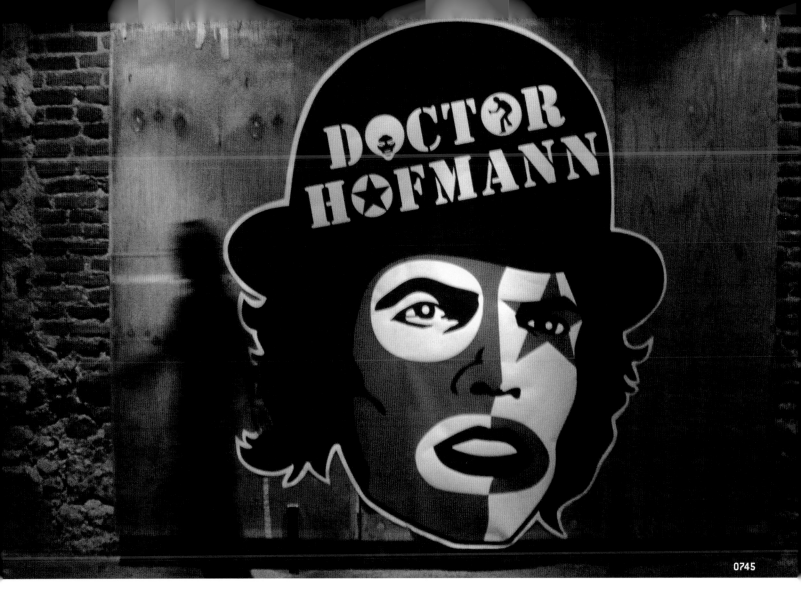

0745

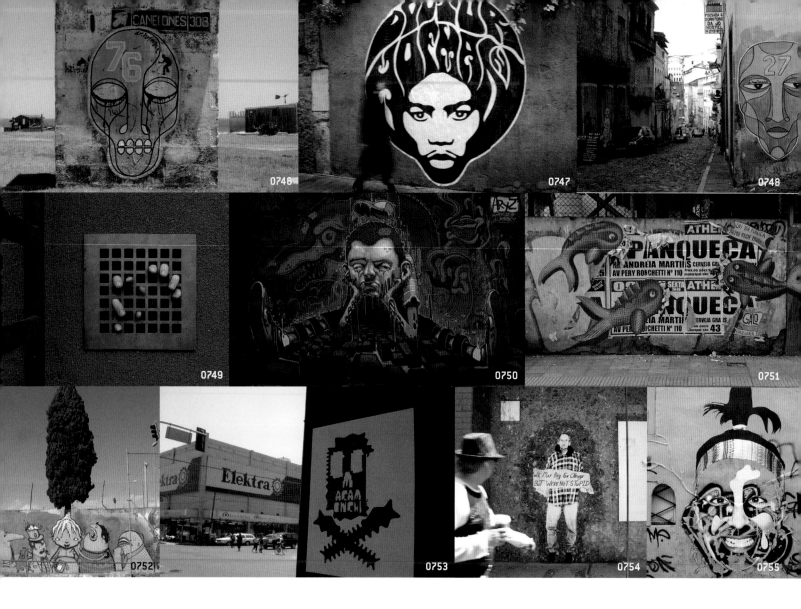

0746 Dr. Hofmann. Barcelona, Spain / 0747 Dr. Hofmann. Barcelona, Spain / 0748 Dr. Hofmann. Barcelona, Spain / 0749 Dan Witz. New York, USA / 0750 Aryz. Barcelona, Spain / 0751 Galo. São Paulo, Brazil / 0752 Koes. Bassano del Grappa, Italy / 0753 Acamonchi. San Diego, CA, USA / 0754 Dan Bergeron/Fauxreel. Toronto, Canada / 0755 Dan Bergeron/Fauxreel. Toronto, Canada / 0756 Btoy. Barcelona, Spain / 0757 Btoy. Barcelona, Spain / 0758 Dan Bergeron/Fauxreel. Toronto, Canada / 0759 108. Alessandria, Italy / 0760 Acamonchi. San Diego, CA, USA / 0761 Michael De Feo. New York, USA / 0762 Cobrinha. Buenos Aires, Argentina

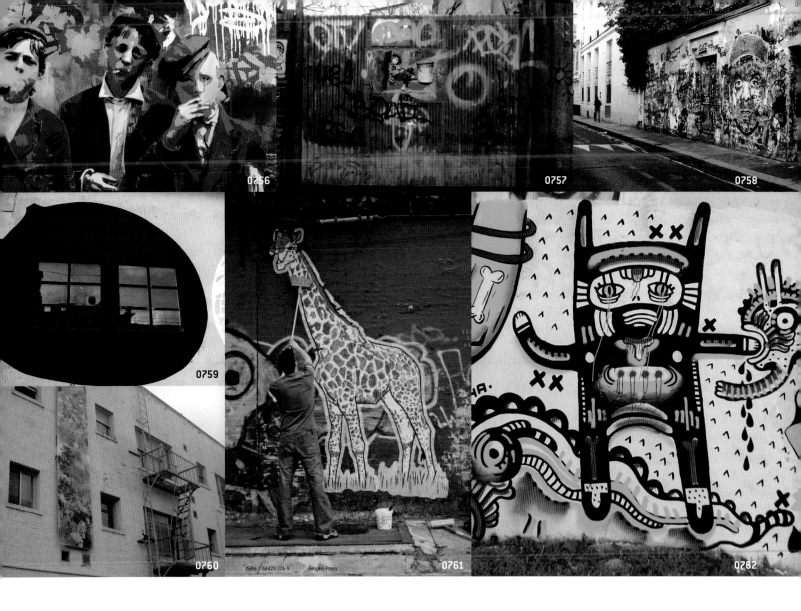

0756

0757

0758

0759

0760

ISBN: 1-58423-176-9 Gingko Press

0761

0762

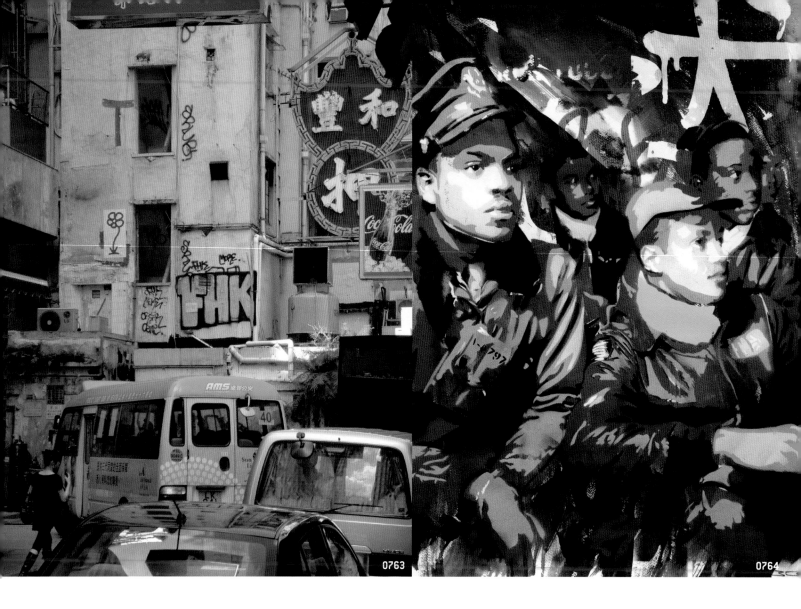

0763

0764

0763 Michael De Feo. New York, USA / **0764** Btoy. Barcelona, Spain / **0765** Cobrinha. Buenos Aires, Argentina / **0766** Via Grafik. Wiesbaden, Germany

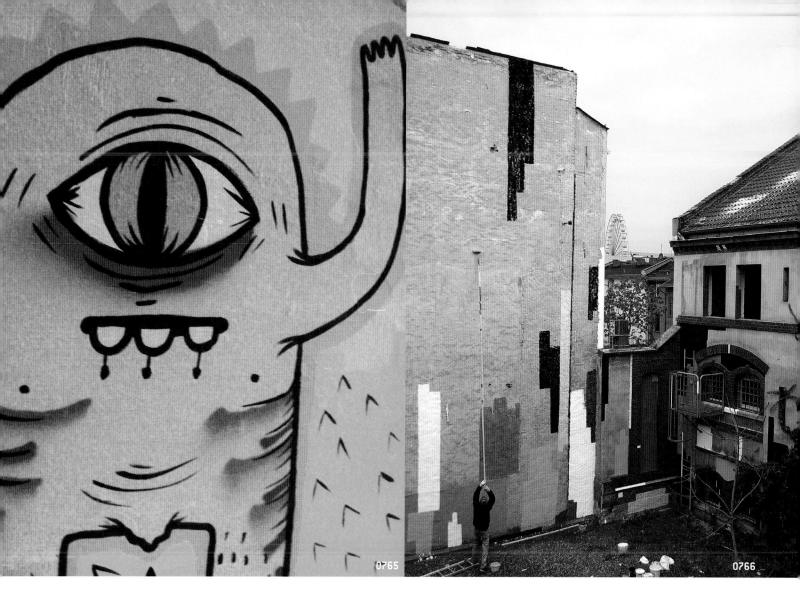

0765

0766

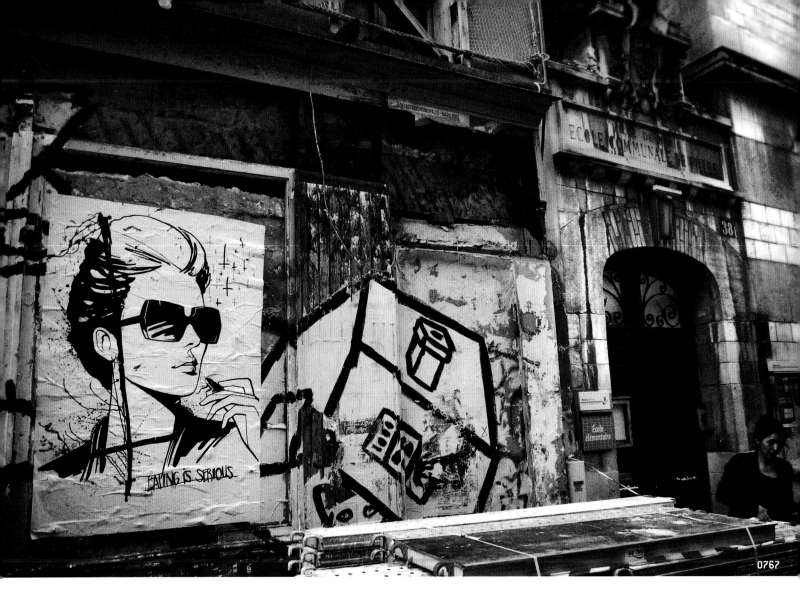

0767

0767 monsieur Qui. Paris, France / **0768** Target. Lisbon, Portugal / **0769** Tasso. Meerane, Germany / **0770** Cobrinha. Buenos Aires, Argentina / **0771** Phil Ashcroft AKA PhlAsh. London, UK / **0772** Chaz Bojorquez. Los Angeles, CA, USA / **0773** Anna Garforth. London, UK

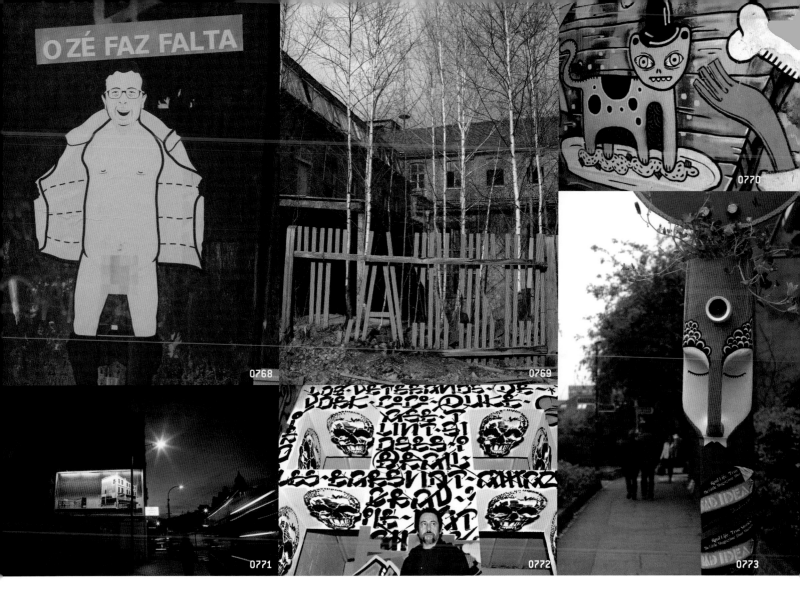

O ZÉ FAZ FALTA

0768

0769

0770

0771

0772

0773

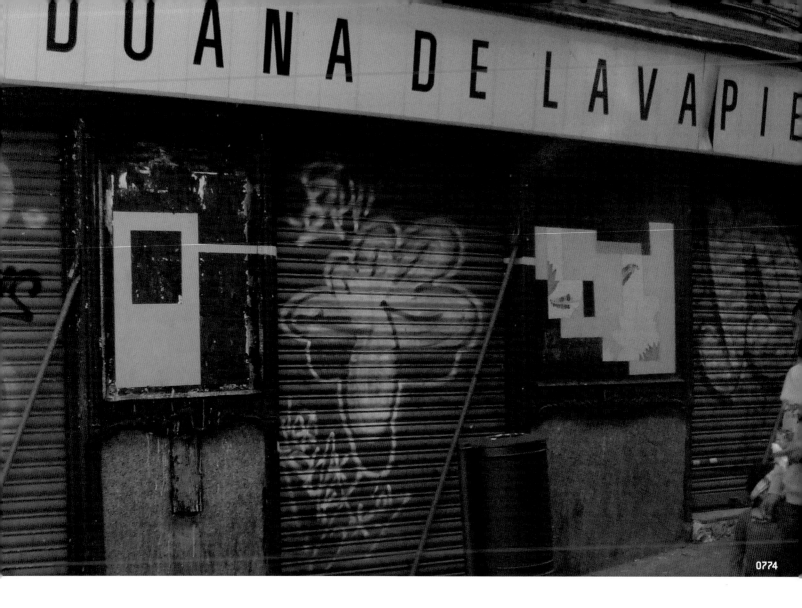

0774

0774 Nuria Mora. Madrid, Spain / **0775** Nuria Mora. Madrid, Spain

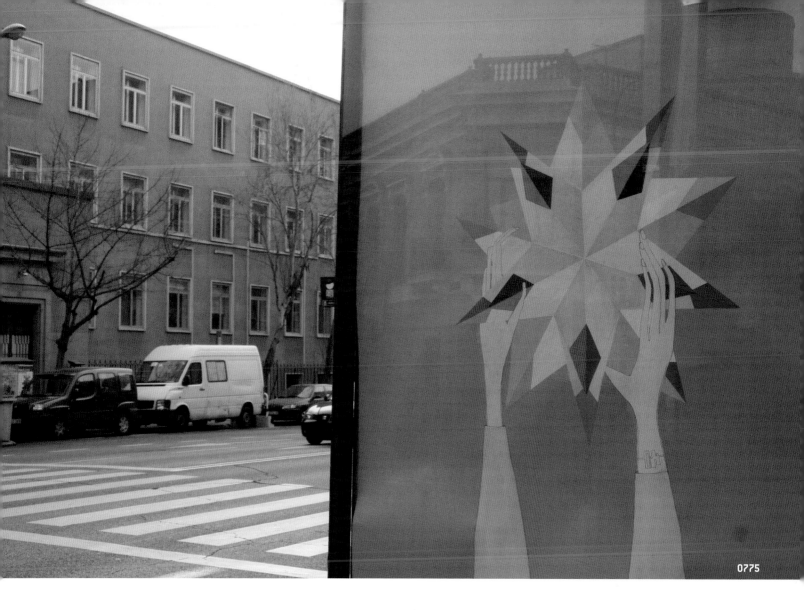

0775

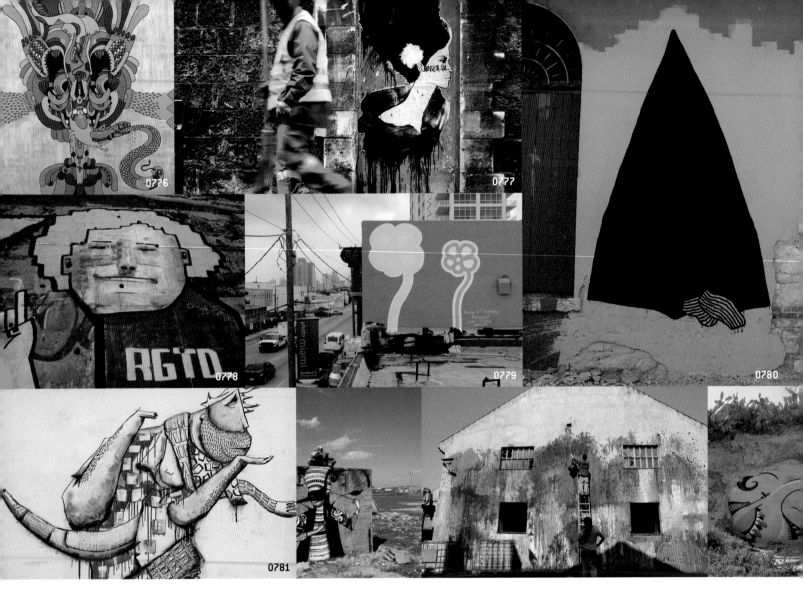

0776 Cobrinha. Buenos Aires, Argentina / 0777 monsieur Qui. Paris, France / 0778 Registred Kid. Barcelona, Spain / 0779 Michael De Feo. New York, USA / 0780 108. Alessandria, Italy / 0781 Frerk. Karlsruhe, Germany / 0782 Skount. Almagro, Spain / 0783 Skount. Almagro, Spain / 0784 Cobrinha. Buenos Aires, Argentina / 0785 Dr. Hofmann. Barcelona, Spain / 0786 Dan Witz. New York, USA / 0787 Aryz. Barcelona, Spain

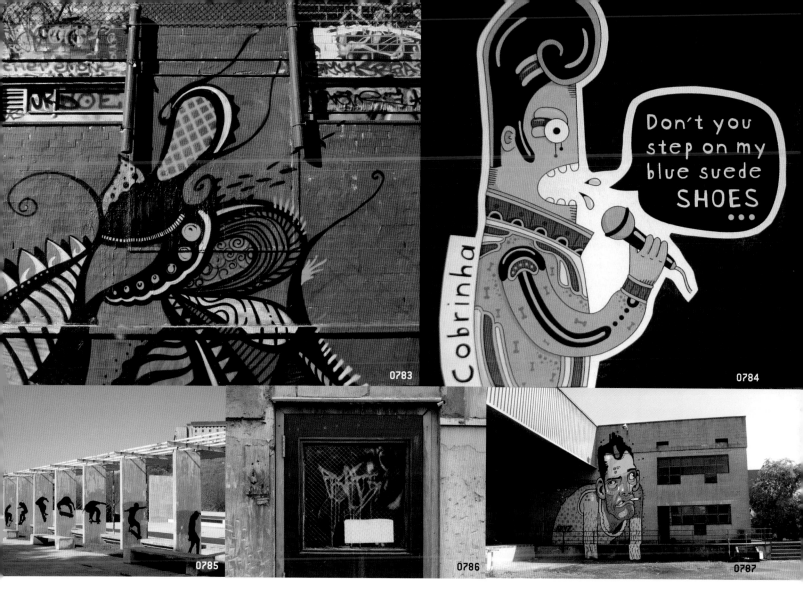

0783

0784

Cobrinha

Don't you step on my blue suede SHOES ...

0785

0786

0787

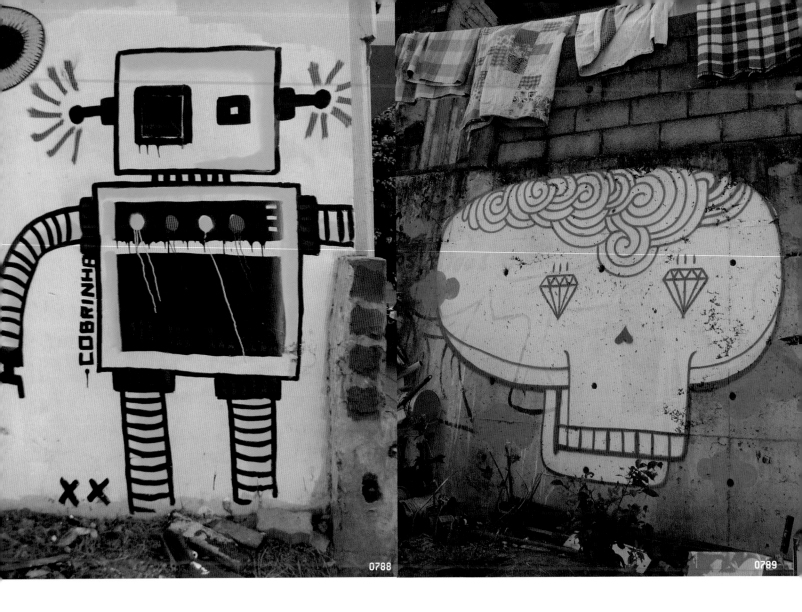

0788 Cobrinha. Buenos Aires, Argentina / **0789** Okuda. Santander, Spain / **0790** Target. Lisbon, Portugal

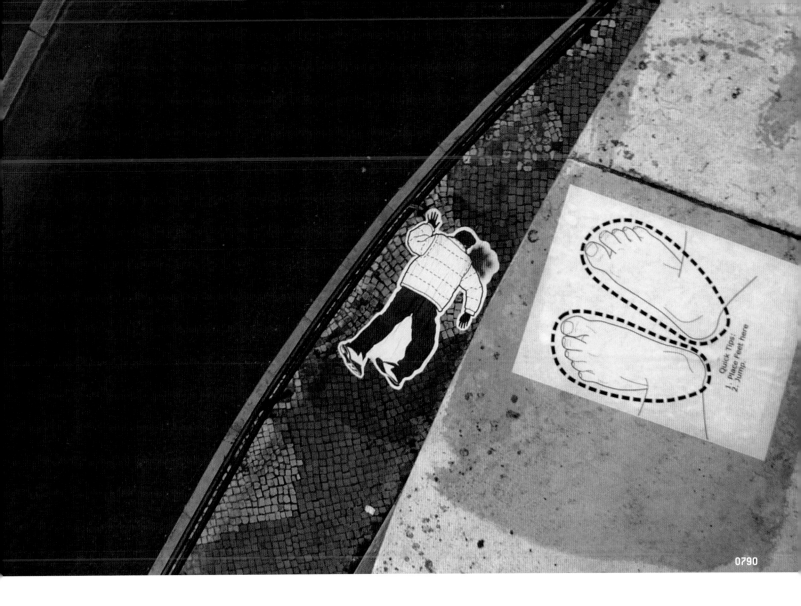

Quick Tips:
1. Place feet here
2. Jump.

0790

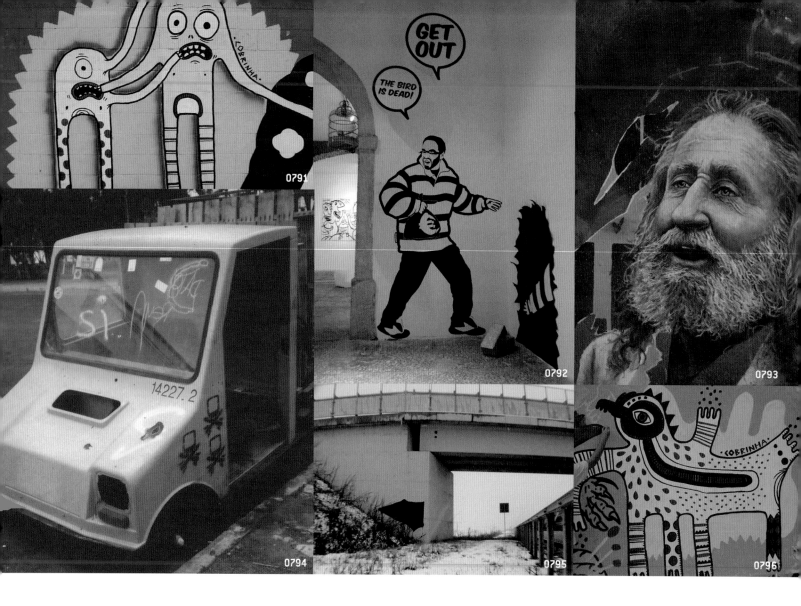

0791 Cobrinha. Buenos Aires, Argentina / 0792 Target. Lisbon, Portugal / 0793 Drone. Lisbon, Portugal / 0794 Acamonchi. San Diego, CA, USA / 0795 108. Alessandria, Italy / 0796 Cobrinha. Buenos Aires, Argentina / 0797 Insanewen (SPL Crew). Seville, Spain / 0798 Anna Garforth. London, UK / 0799 Phil Ashcroft AKA PhlAsh. London, UK / 0800 Registred Kid. Barcelona, Spain / 0801 Via Grafik. Wiesbaden, Germany / 0802 Btoy. Barcelona, Spain

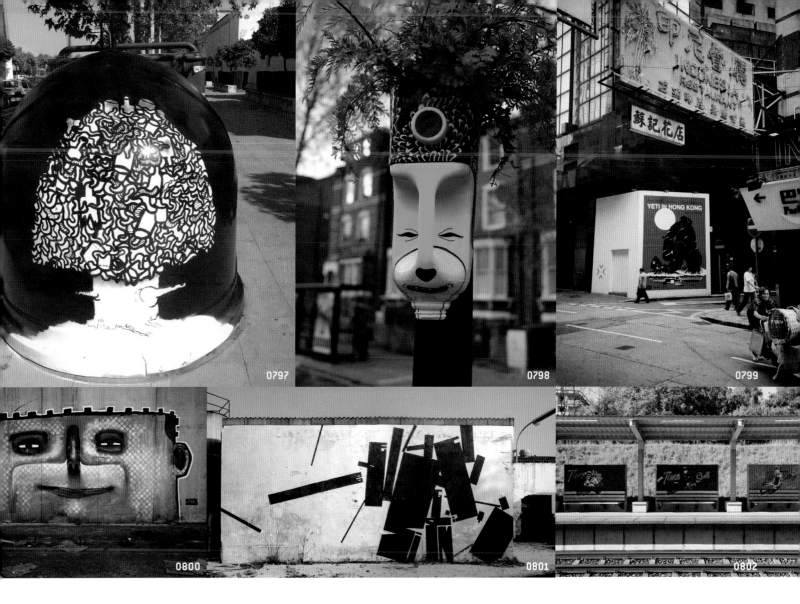

0797

0798

0799

0800

0801

0802

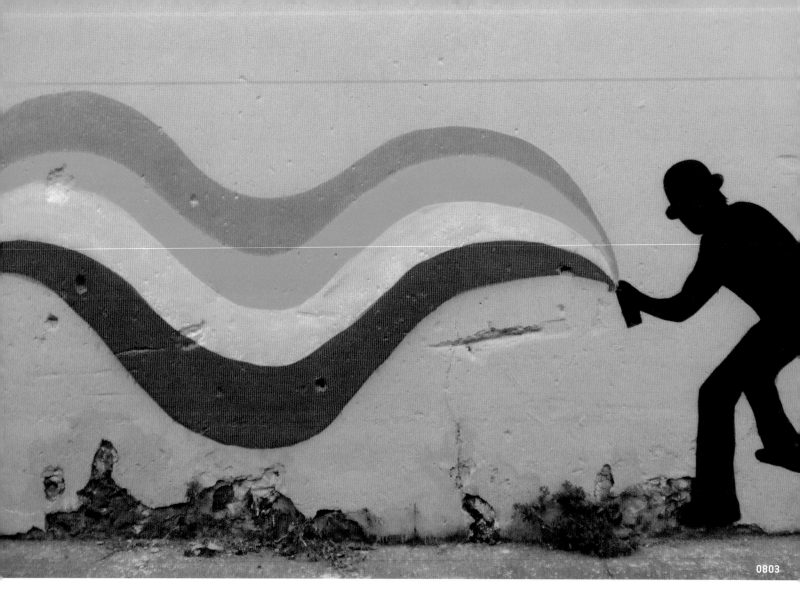

0803

0803 Dr. Hofmann. Barcelona, Spain / 0804 Dan Witz. New York, USA

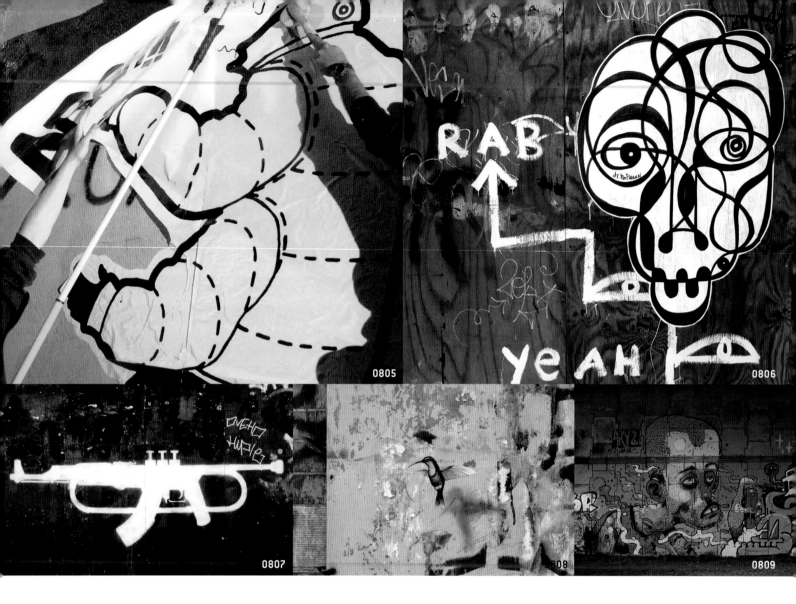

0805 Target. Lisbon, Portugal / 0806 Dr. Hofmann. Barcelona, Spain / 0807 Dr. Hofmann. Barcelona, Spain / 0808 Dan Witz. New York, USA / 0809 Aryz. Barcelona, Spain / 0810 Dr. Hofmann. Barcelona, Spain / 0811 Cobrinha. Buenos Aires, Argentina / 0812 Target. Lisbon, Portugal / 0813 Cobrinha. Buenos Aires, Argentina / 0814 Okuda. Santander, Spain

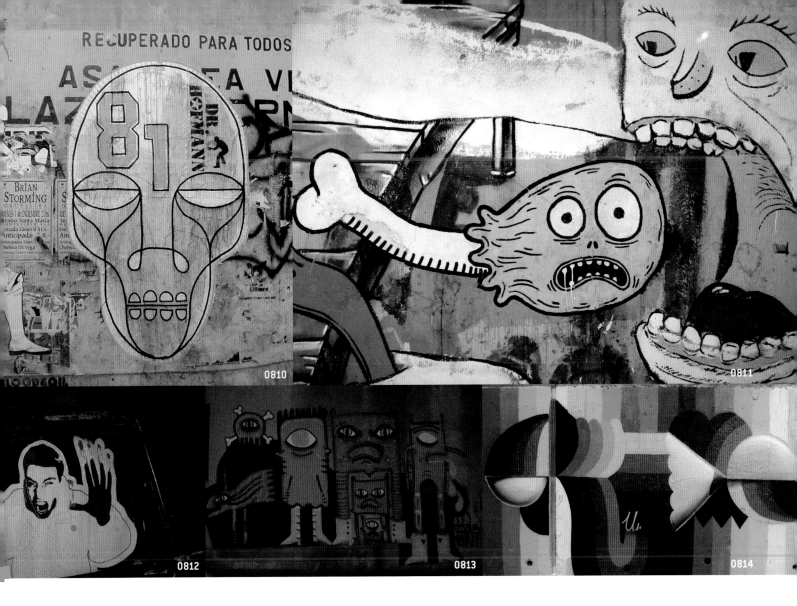

0810

0811

0812

0813

0814

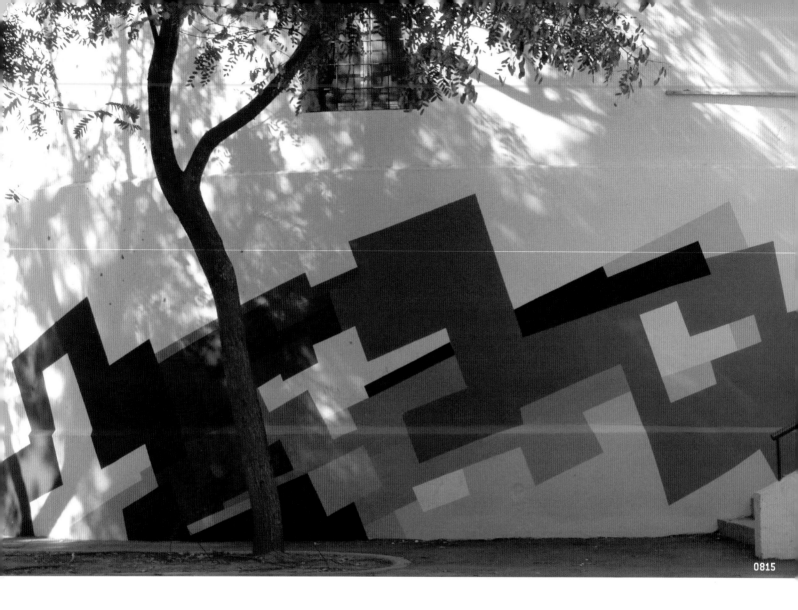

0815

0815 Nuria Mora. Madrid, Spain / **0816** monsieur Qui. Paris, France

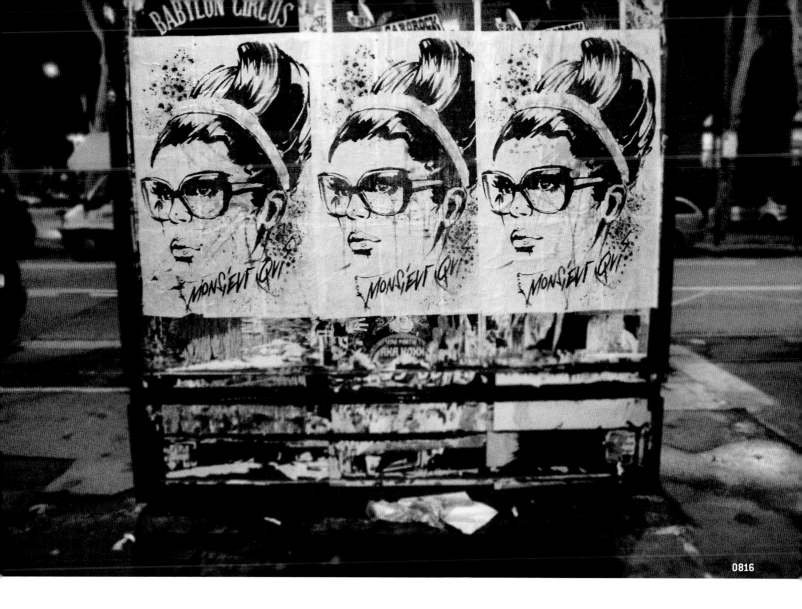

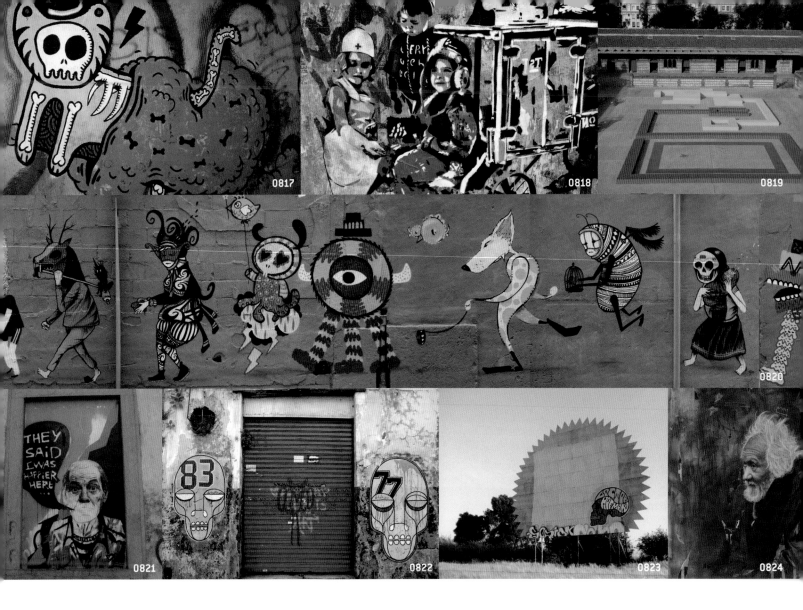

0817 Cobrinha. Buenos Aires, Argentina / 0818 Btoy. Barcelona, Spain / 0819 Nuria Mora. Madrid, Spain / 0820 Skount. Almagro, Spain / 0821 Drone. Lisbon, Portugal / 0822 Dr. Hofmann. Barcelona, Spain / 0823 Dr. Hofmann. Barcelona, Spain / 0824 Drone. Lisbon, Portugal / 0825 Via Grafik. Wiesbaden, Germany

0825

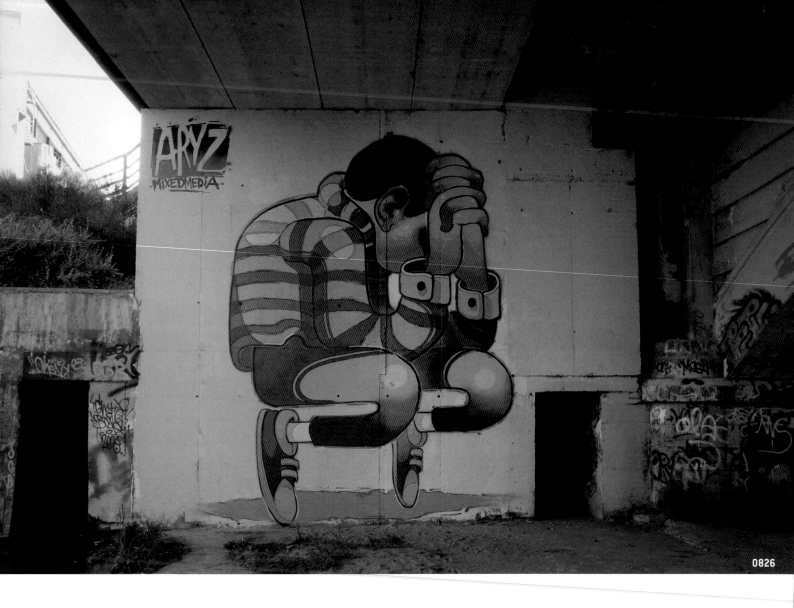

0826

0826 Aryz. Barcelona, Spain / **0827** Target. Lisbon, Portugal

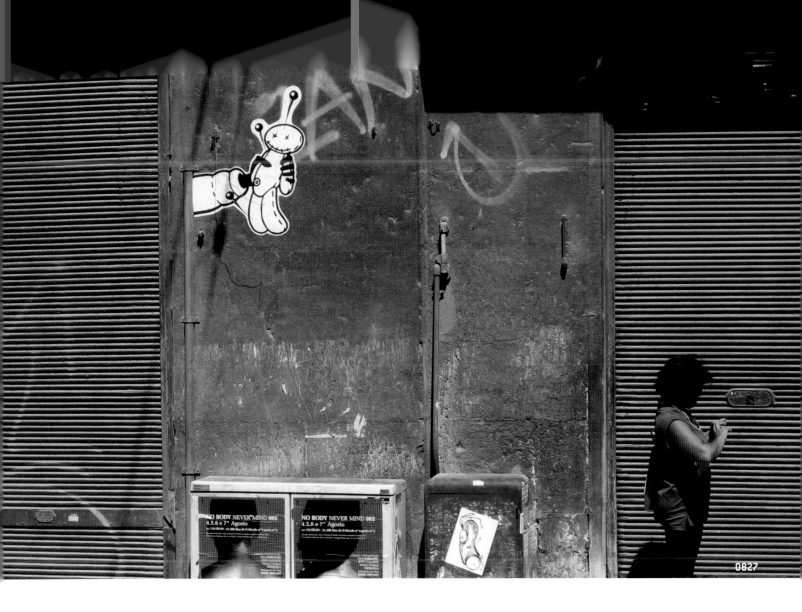

0827

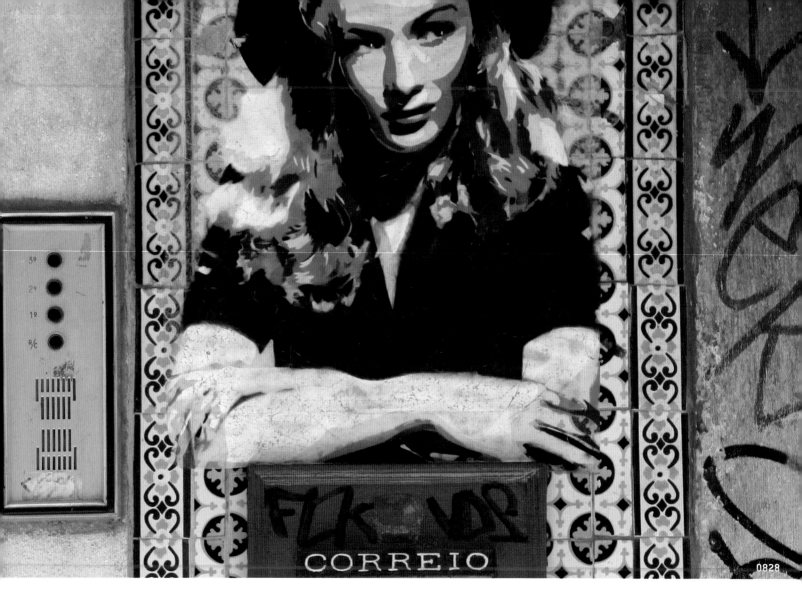

0828 Btoy. Barcelona, Spain / **0829** Dan Bergeron/Fauxreel. Toronto, Canada

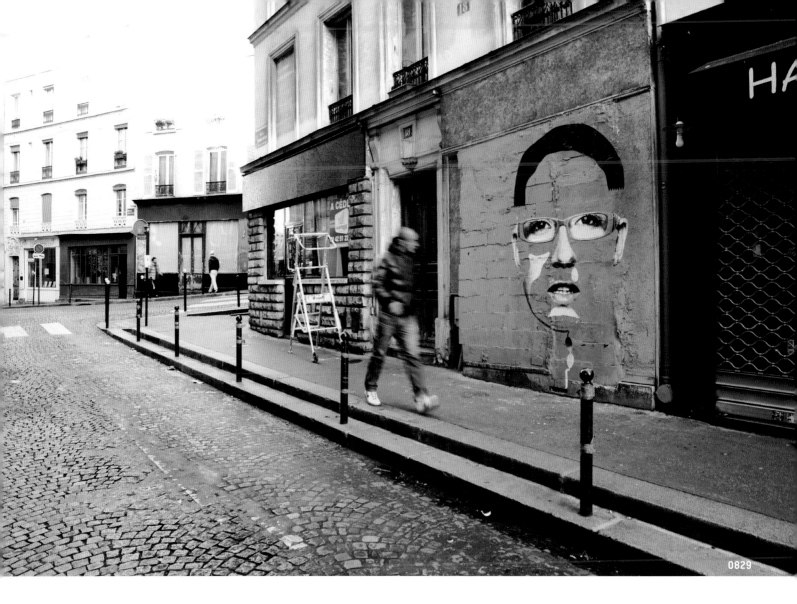

0829

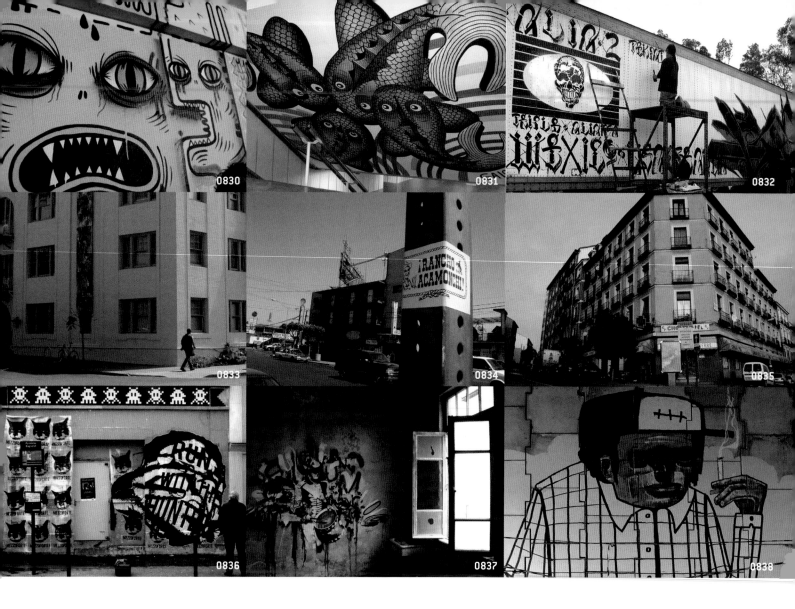

0830 Cobrinha. Buenos Aires, Argentina / 0831 Galo. São Paulo, Brazil / 0832 Chaz Bojorquez. Los Angeles, CA, USA / 0833 Acamonchi. San Diego, CA, USA / 0834 Acamonchi. San Diego, CA, USA / 0835 Nuria Mora. Madrid, Spain / 0836 Mezzoforte. Paris, France / 0837 Conor Harrington. Cork, London, UK / 0838 Registred Kid. Barcelona, Spain / 0839 Frerk. Karlsruhe, Germany / 0840 Via Grafik. Wiesbaden, Germany / 0841 Btoy. Barcelona, Spain / 0842 Skount. Almagro, Spain

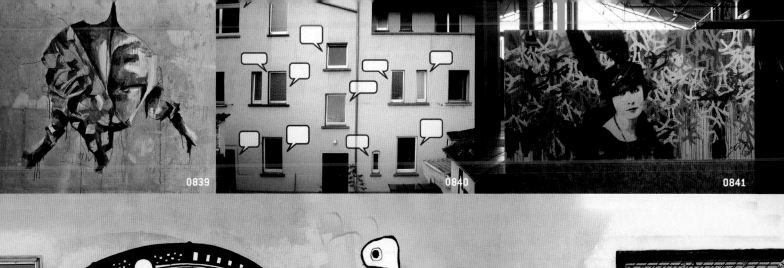

0839

0840

0841

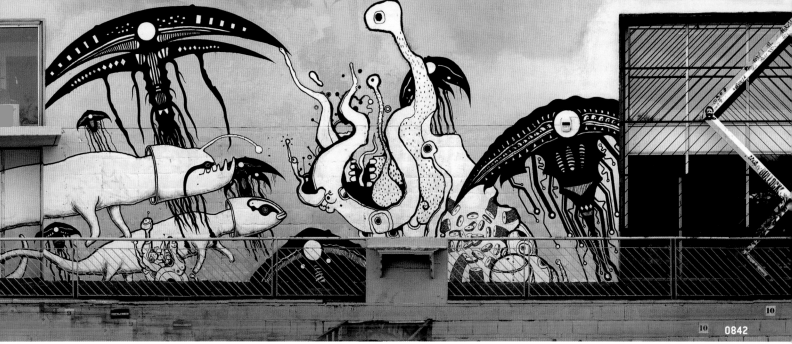

10 0842 10

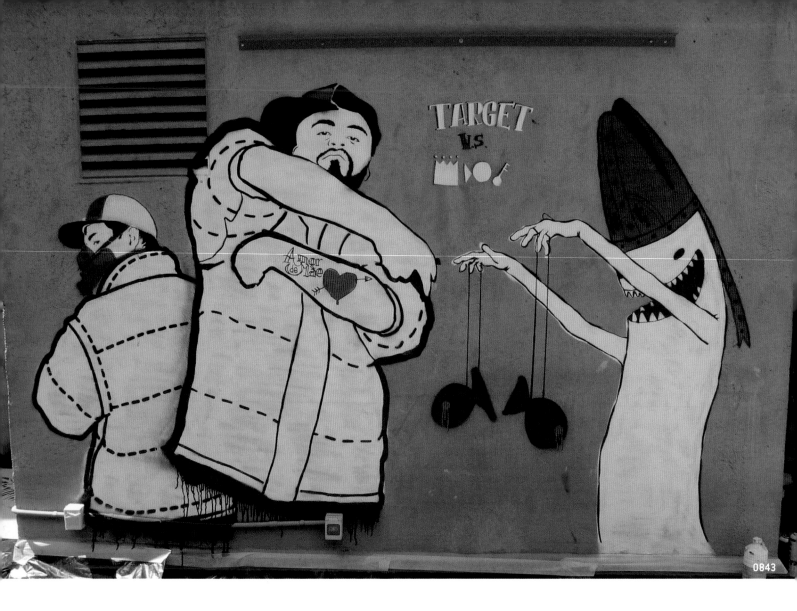

0843 Target. Lisbon, Portugal / **0844** Acamonchi. San Diego, CA, USA

0844

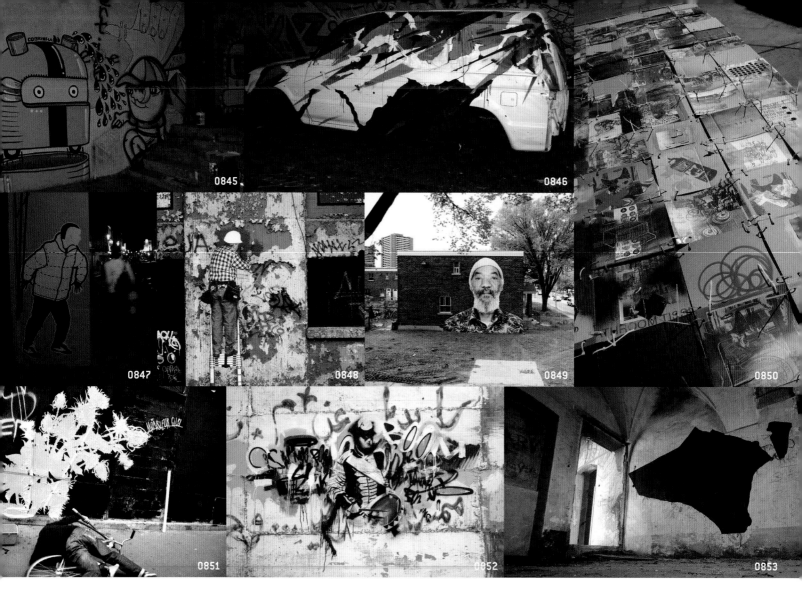

0845 Cobrinha. Buenos Aires, Argentina / **0846** Phil Ashcroft AKA PhlAsh. London, UK / **0847** Target. Lisbon, Portugal / **0848** Dan Bergeron/Fauxreel. Toronto, Canada / **0849** Dan Bergeron/Fauxreel. Toronto, Canada / **0850** Acamonchi. San Diego, CA, USA / **0851** monsieur Qui. Paris, France / **0852** Conor Harrington. Cork, London, UK / **0853** 108. Alessandria, Italy / **0854** Dan Bergeron/Fauxreel. Toronto, Canada / **0855** monsieur Qui. Paris, France / **0856** Dan Bergeron/Fauxreel. Toronto, Canada / **0857** monsieur Qui. Paris, France / **0858** Michael De Feo. New York, USA / **0859** Conor Harrington. Cork, London, UK / **0860** Conor Harrington. Cork, London, UK

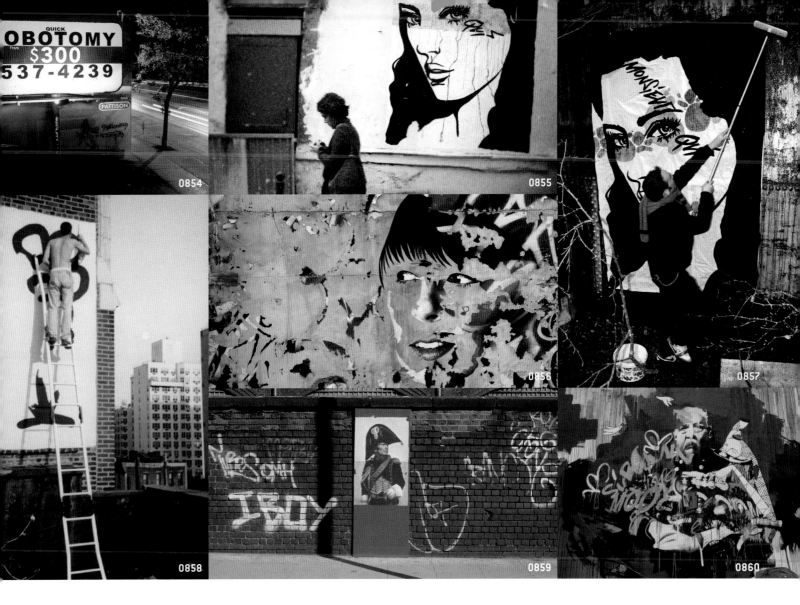

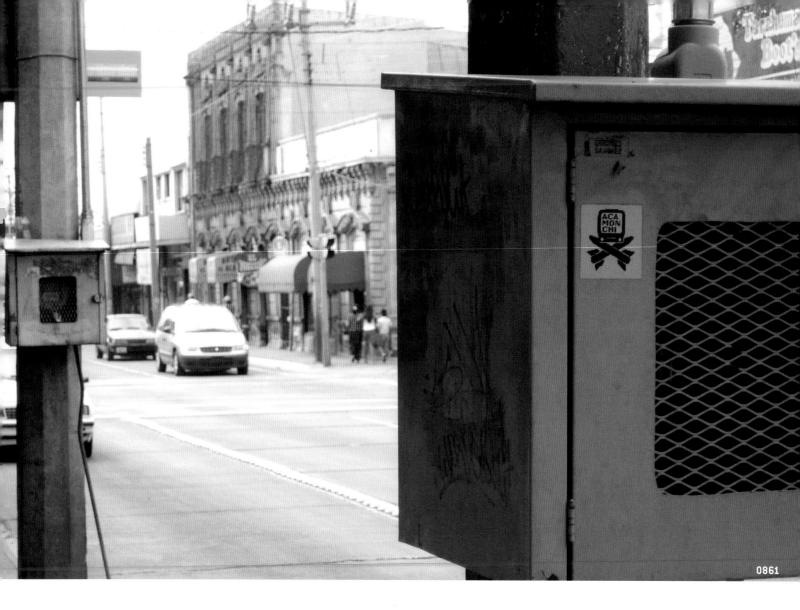

0861

0861 Acamonchi. San Diego, CA, USA / **0862** Dan Bergeron/Fauxreel. Toronto, Canada

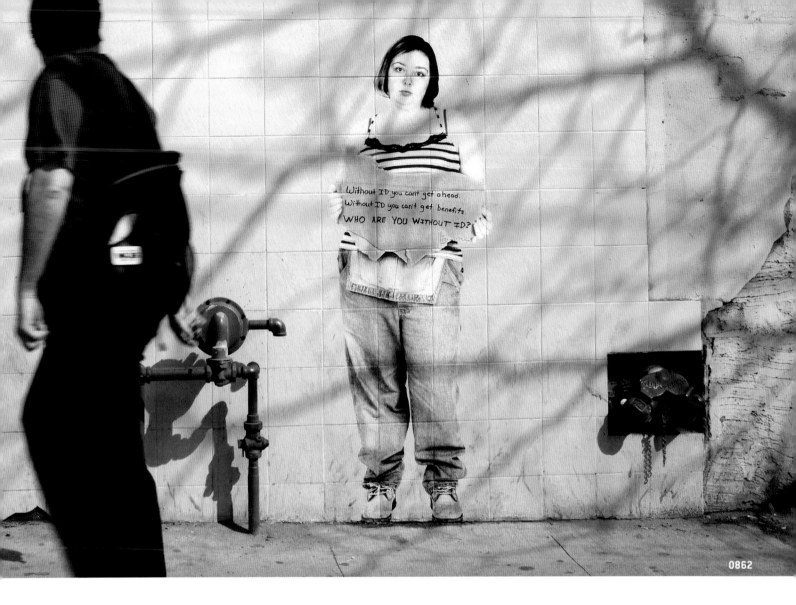

Without ID you can't get ahead.
Without ID you can't get benefits.
WHO ARE YOU WITHOUT ID?

0862

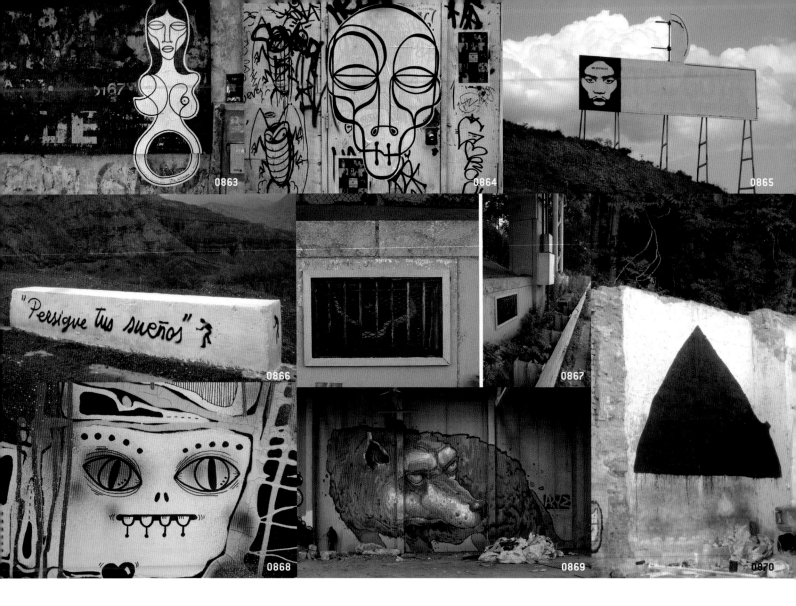

0863 Dr. Hofmann. Barcelona, Spain / 0864 Dr. Hofmann. Barcelona, Spain / 0865 Dr. Hofmann. Barcelona, Spain / 0866 Dr. Hofmann. Barcelona, Spain / 0867 Dan Witz. New York, USA / 0868 Cobrinha. Buenos Aires, Argentina / 0869 Aryz. Barcelona, Spain / 0870 108. Alessandria, Italy / 0871 Aryz. Barcelona, Spain / 0872 Eyeone. Los Angeles, CA, USA / 0873 Phil Ashcroft AKA PhlAsh. London, UK / 0874 Chaz Bojorquez. Los Angeles, CA, USA / 0875 Acamonchi. San Diego, CA, USA / 0876 Acamonchi. San Diego, CA, USA / 0877 Acamonchi. San Diego, CA, USA

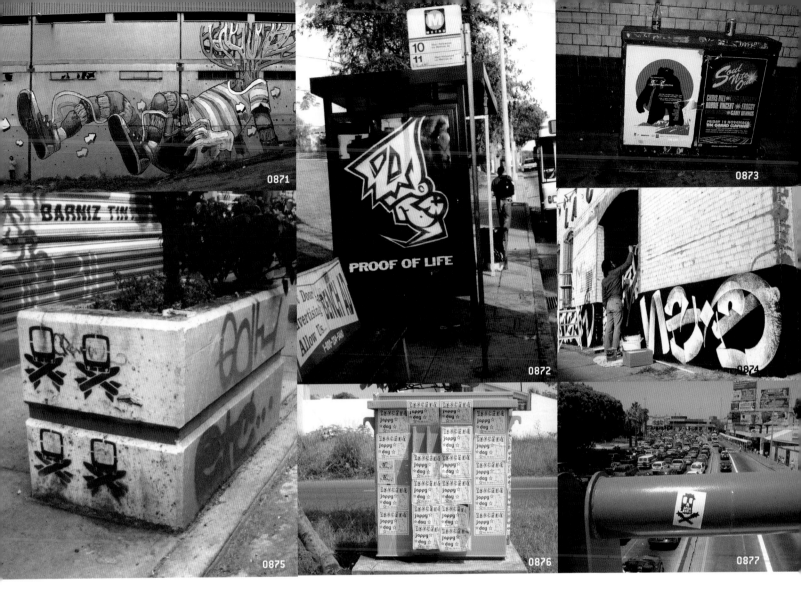

PROOF OF LIFE

0871
0872
0873
0874
0875
0876
0877

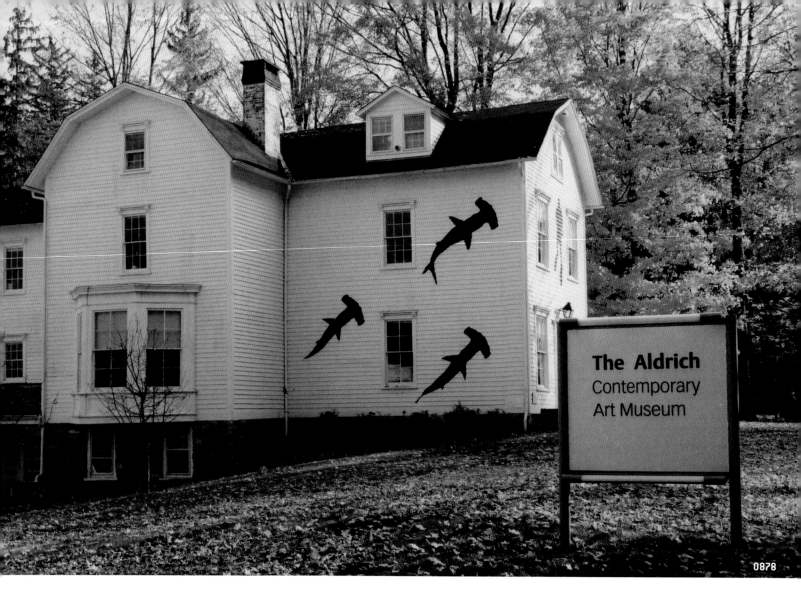

The Aldrich
Contemporary
Art Museum

0878

0878 Michael De Feo. New York, USA / **0879** Conor Harrington. Cork, London, UK

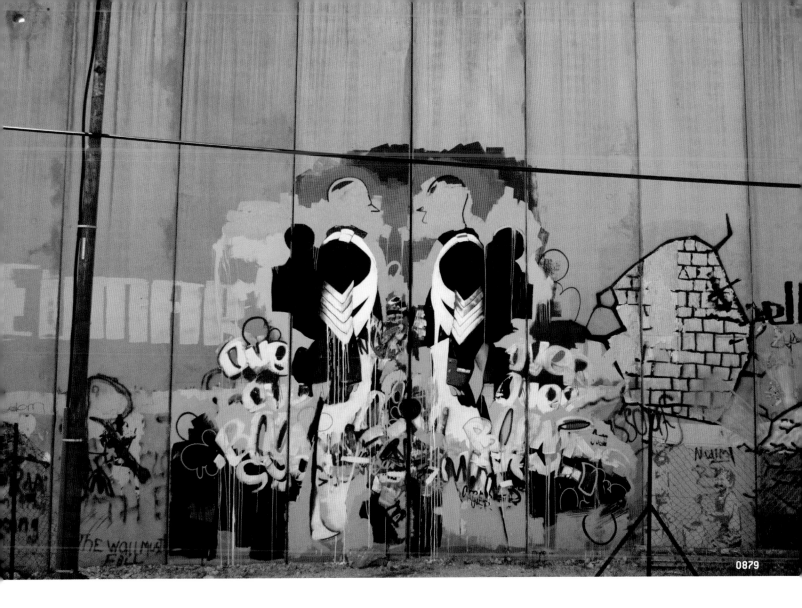

0879

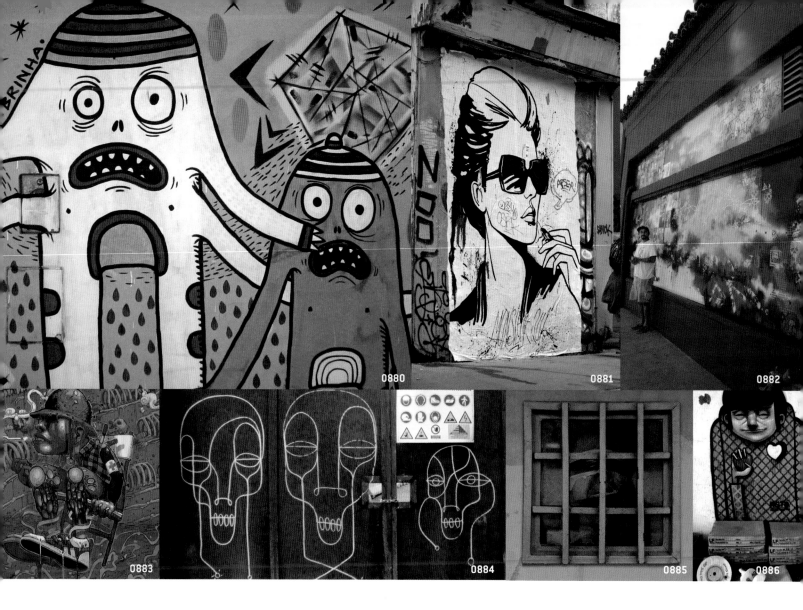

0880 Cobrinha. Buenos Aires, Argentina / **0881** monsieur Qui. Paris, France / **0882** Acamonchi. San Diego, CA, USA / **0883** Aryz. Barcelona, Spain / **0884** Dr. Hofmann. Barcelona, Spain / **0885** Dan Witz. New York, USA / **0886** Registred Kid. Barcelona, Spain / **0887** Mezzoforte. Paris, France / **0888** Dan Bergeron/Fauxreel. Toronto, Canada / **0889** Cobrinha. Buenos Aires, Argentina / **0890** Dan Bergeron/Fauxreel. Toronto, Canada / **0891** Michael De Feo. New York, USA / **0892** Dan Witz. New York, USA / **0893** Dr. Hofmann. Barcelona, Spain

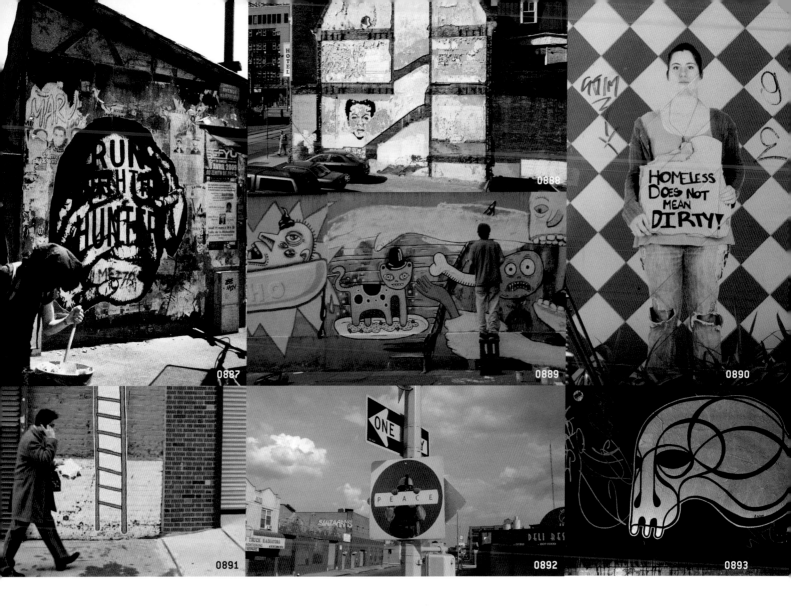

0888

0887

0889

0890

0891

0892

0893

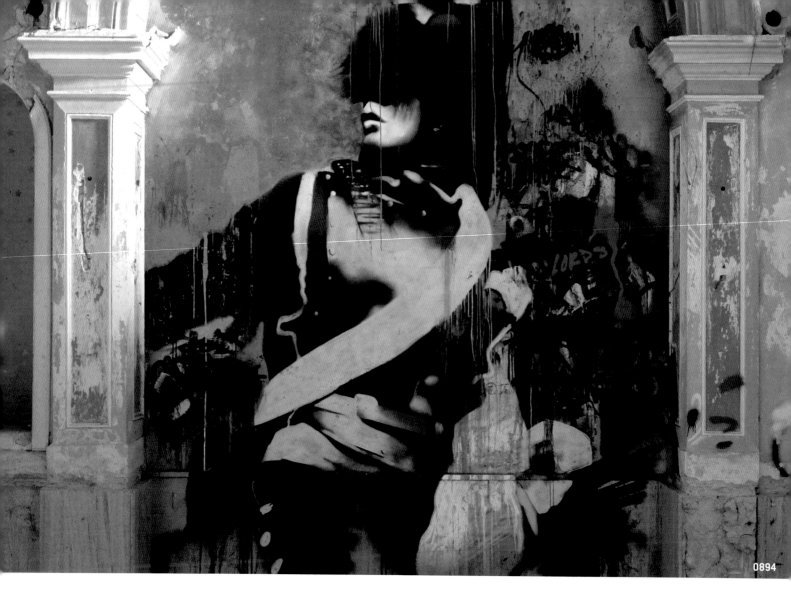

0894

0894 Conor Harrington. Cork, London, UK / **0895** Btoy. Barcelona, Spain

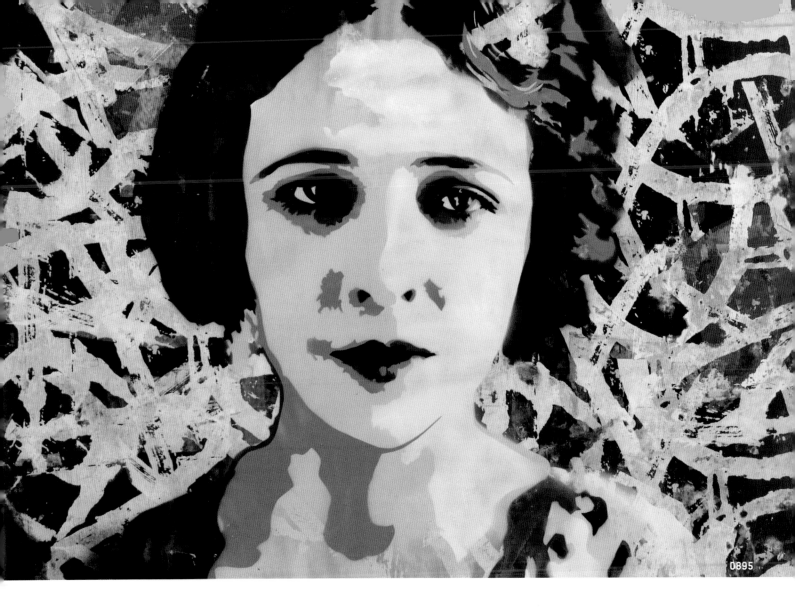

0895

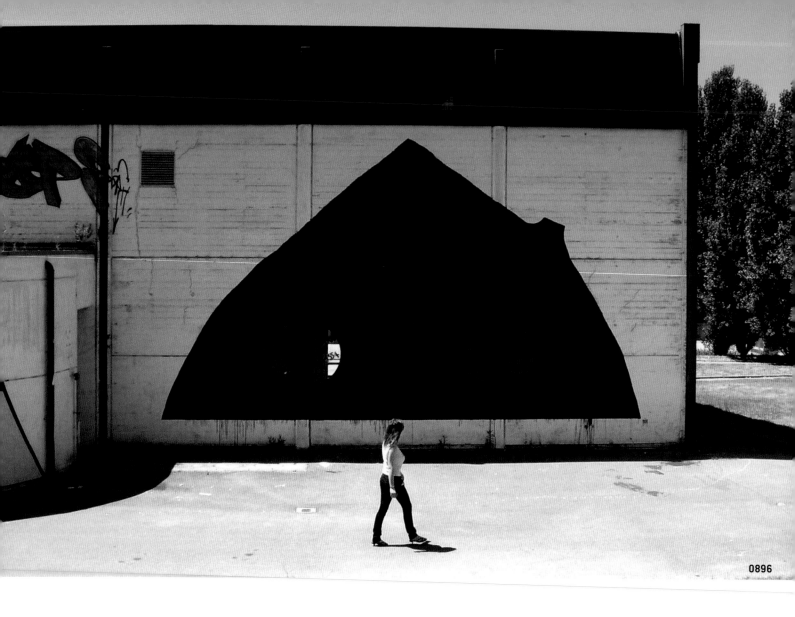

0896

0896 108. Alessandria, Italy / **0897** Michael De Feo. New York, USA

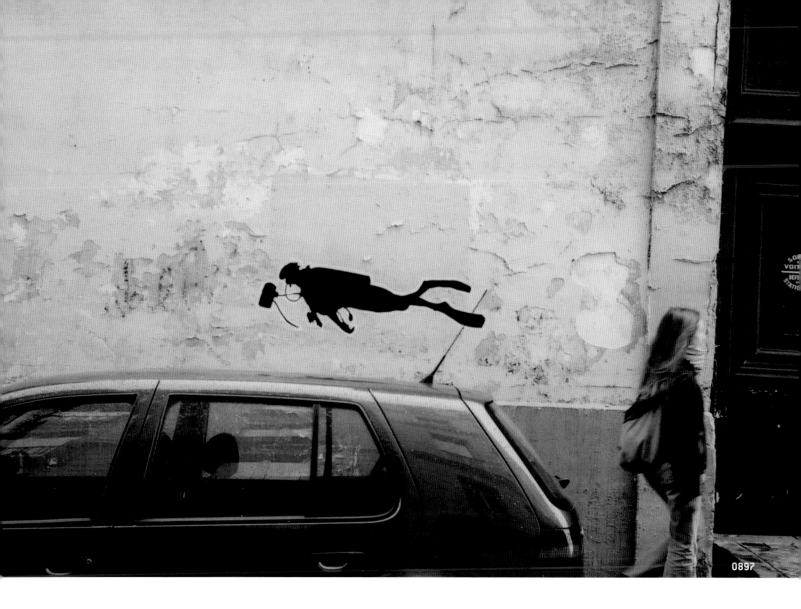

0897

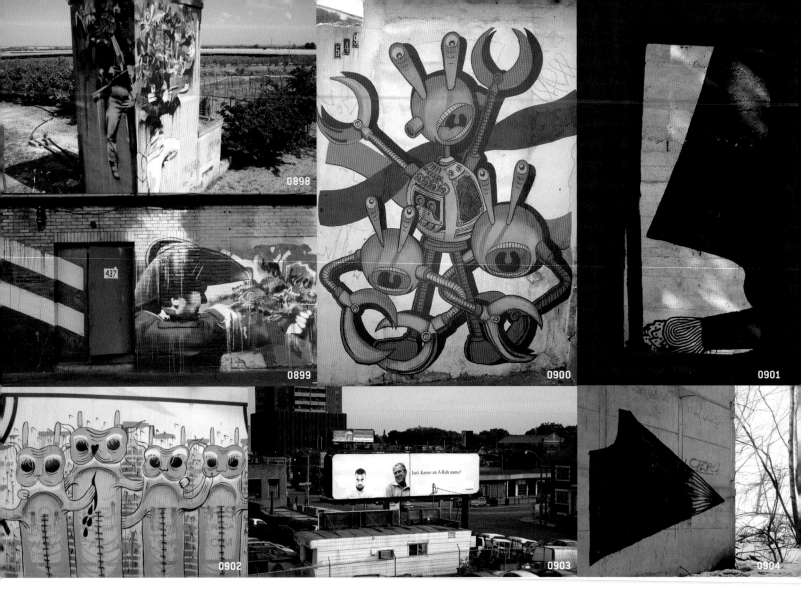

0898 Conor Harrington. Cork, London, UK / **0899** Conor Harrington. Cork, London, UK / **0900** Galo. São Paulo, Brazil / **0901** 108. Alessandria, Italy / **0902** Cobrinha. Buenos Aires, Argentina / **0903** Dan Bergeron/Fauxreel. Toronto, Canada / **0904** 108. Alessandria, Italy / **0905** monsieur Qui. Paris, France / **0906** Above. San Francisco, CA, USA

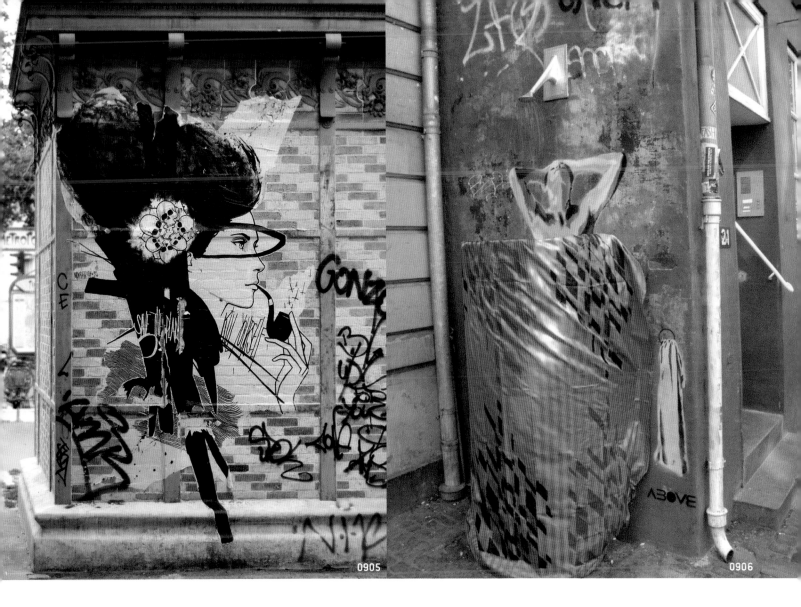

0905

0906

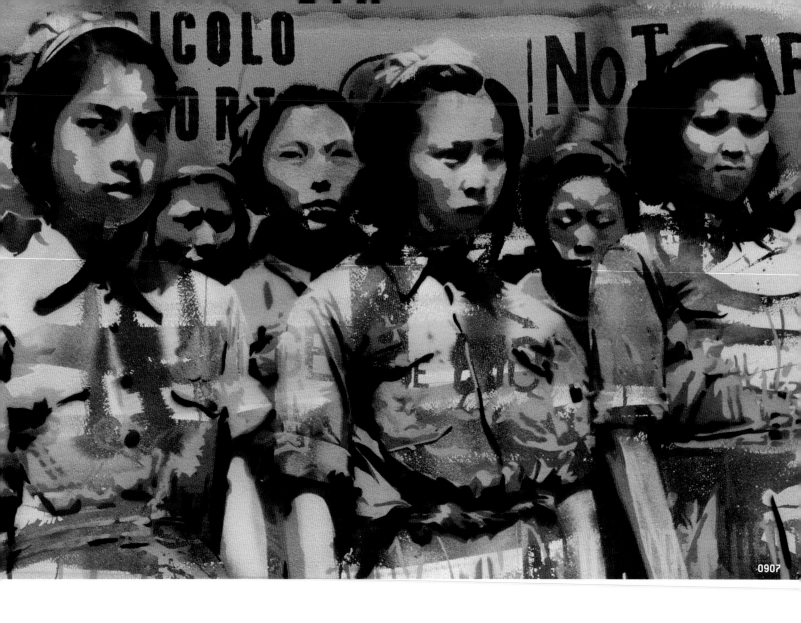

0907 Btoy. Barcelona, Spain / 0908 Skount. Almagro, Spain

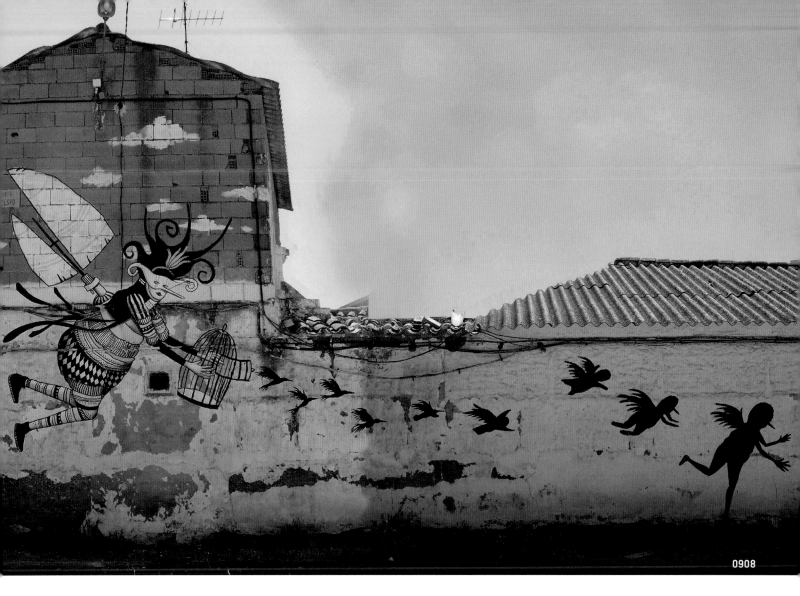

0908

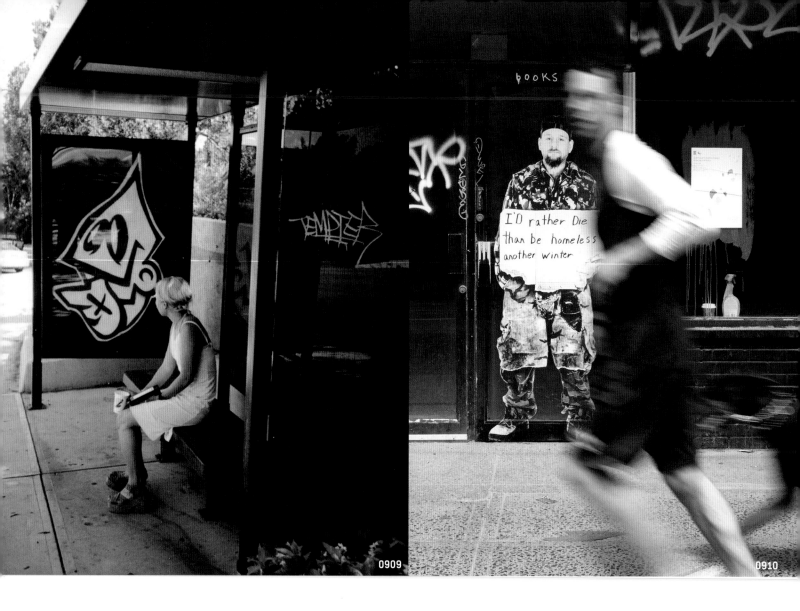

0909 Eyeone. Los Angeles, CA, USA / 0910 Dan Bergeron/Fauxreel. Toronto, Canada / 0911 Skount. Almagro, Spain / 0912 Registred Kid. Barcelona, Spain / 0913 Dr. Hofmann. Barcelona, Spain / 0914 Skount. Almagro, Spain / 0915 Aryz. Barcelona, Spain / 0916 Dr. Hofmann. Barcelona, Spain / 0917 Toast One. Zurich, Switzerland / 0918 Cobrinha. Buenos Aires, Argentina / 0919 Dan Bergeron/Fauxreel. Toronto, Canada

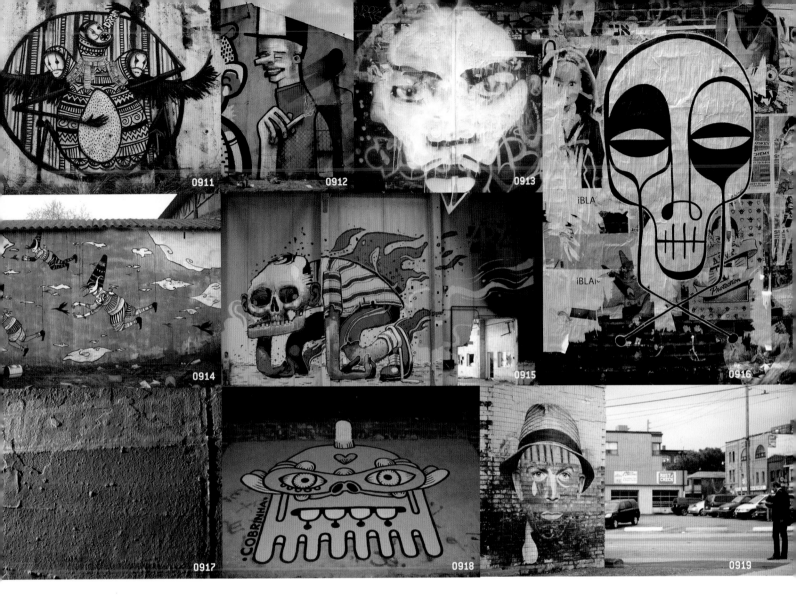

0911

0912

0913

0914

0915

0916

0917

0918

0919

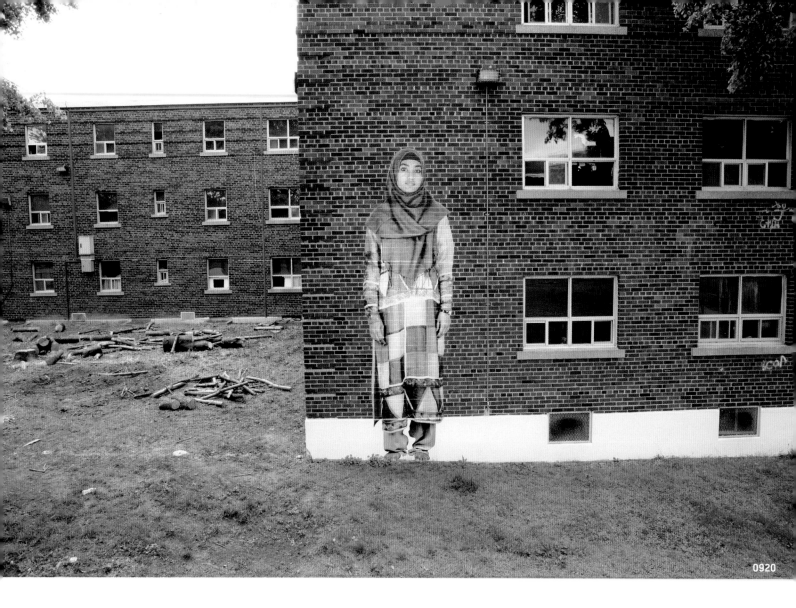

0920

0920 Dan Bergeron/Fauxreel. Toronto, Canada / **0921** Nuria Mora. Madrid, Spain

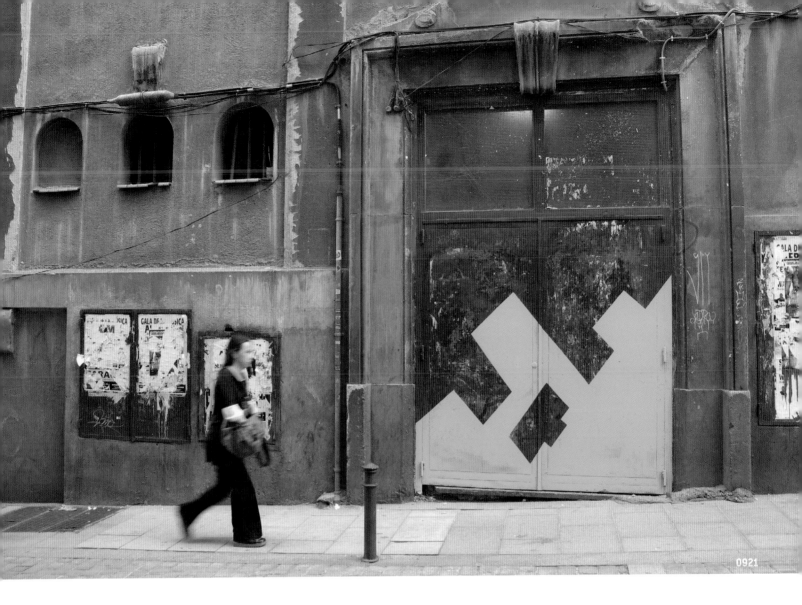

0921

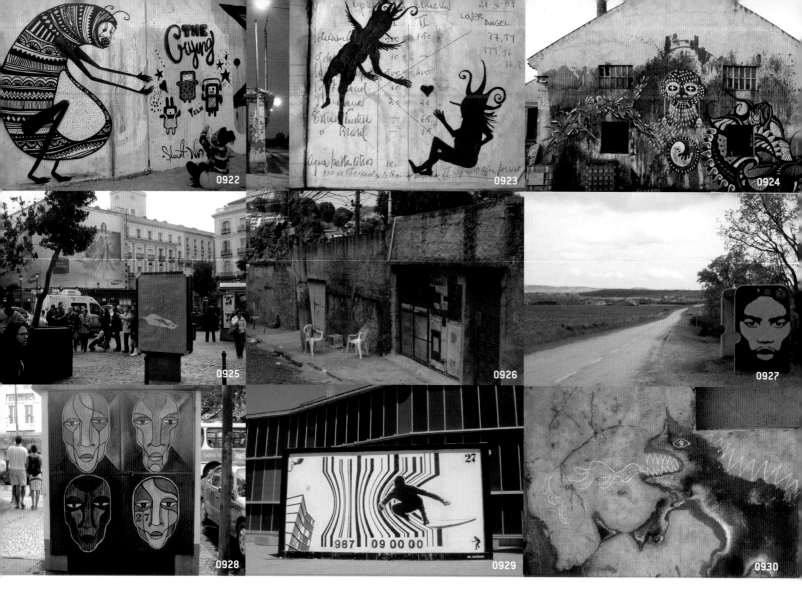

0922 Skount. Almagro, Spain / 0923 Skount. Almagro, Spain / 0924 Skount. Almagro, Spain / 0925 Nuria Mora. Madrid, Spain / 0926 Nuria Mora. Madrid, Spain / 0927 Dr. Hofmann. Barcelona, Spain / 0928 Dr. Hofmann. Barcelona, Spain / 0929 Dr. Hofmann. Barcelona, Spain / 0930 Dr. Hofmann. Barcelona, Spain / 0931 Drone. Lisbon, Portugal / 0932 Dr. Hofmann. Barcelona, Spain / 0933 Dr. Hofmann. Barcelona, Spain / 0934 Darco FBI. Paris, France / 0935 Dr. Hofmann. Barcelona, Spain / 0936 Dan Witz. New York, USA / 0937 Cobrinha. Buenos Aires, Argentina / 0938 Cobrinha. Buenos Aires, Argentina / 0939 Acamonchi. San Diego, CA, USA / 0940 Dan Bergeron/Fauxreel. Toronto, Canada / 0941 Mezzoforte. Paris, France / 0942 108. Alessandria, Italy

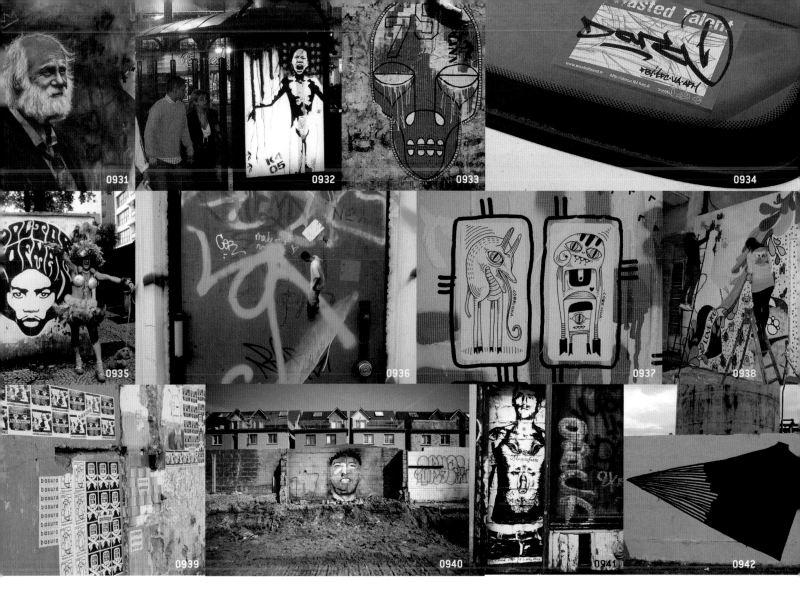

0931 0932 0933 0934
0935 0936 0937 0938
0939 0940 0941 0942

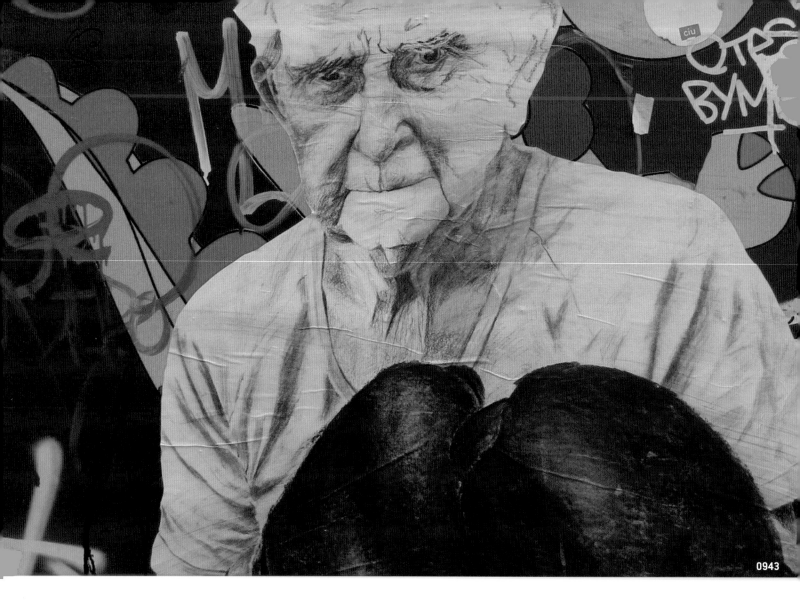

0943

0943 Drone. Lisbon, Portugal / **0944** Btoy. Barcelona, Spain

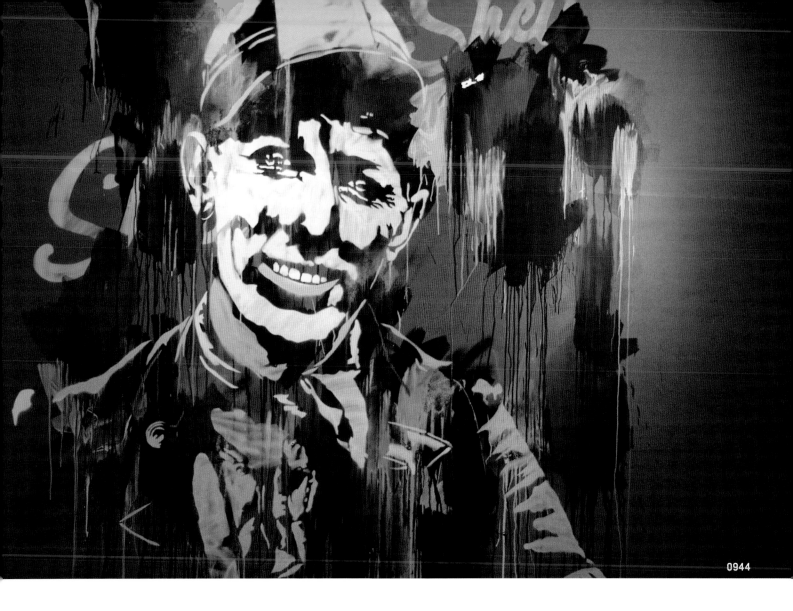

0944

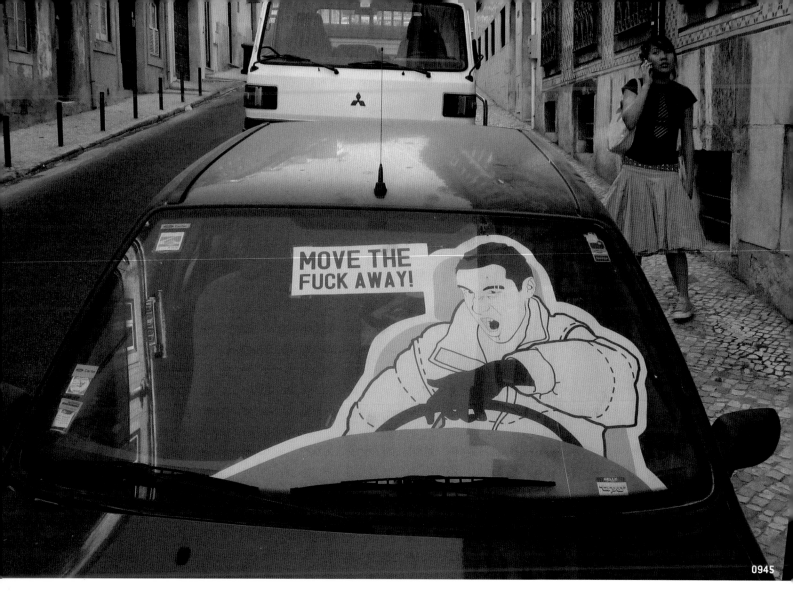

0945 Target. Lisbon, Portugal / **0946** Acamonchi. San Diego, CA, USA

0946

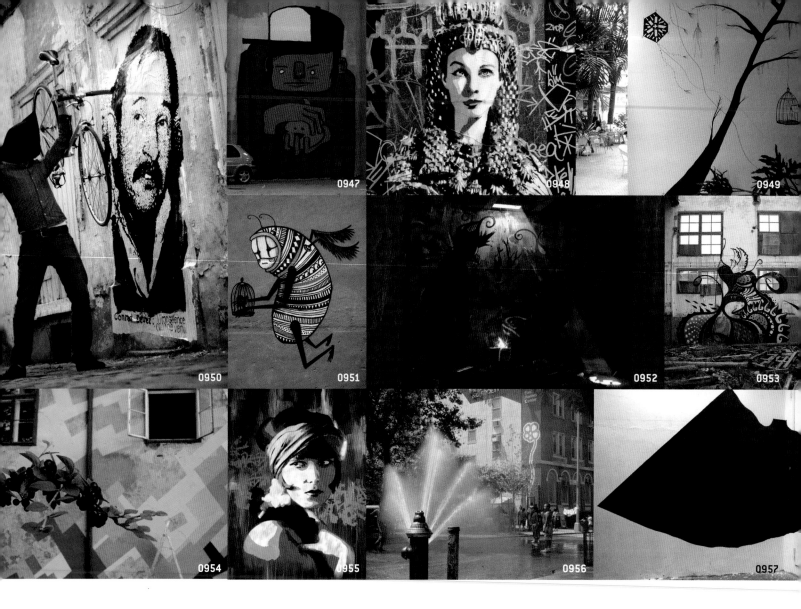

0947 Registred Kid. Barcelona, Spain / 0948 Btoy. Barcelona, Spain / 0949 Skount. Almagro, Spain / 0950 Mezzoforte. Paris, France / 0951 Skount. Almagro, Spain / 0952 Skount. Almagro, Spain / 0953 Skount. Almagro, Spain / 0954 Nuria Mora. Madrid, Spain / 0955 Btoy. Barcelona, Spain / 0956 Michael De Feo. New York, USA / 0957 108. Alessandria, Italy / 0958 Btoy. Barcelona, Spain / 0959 Conor Harrington. Cork, London, UK / 0960 Michael De Feo. New York, USA / 0961 Nuria Mora. Madrid, Spain / 0962 Registred Kid. Barcelona, Spain / 0963 monsieur Qui. Paris, France / 0964 Mezzoforte. Paris, France / 0965 Registred Kid. Barcelona, Spain / 0966 108. Alessandria, Italy / 0967 Mezzoforte. Paris, France

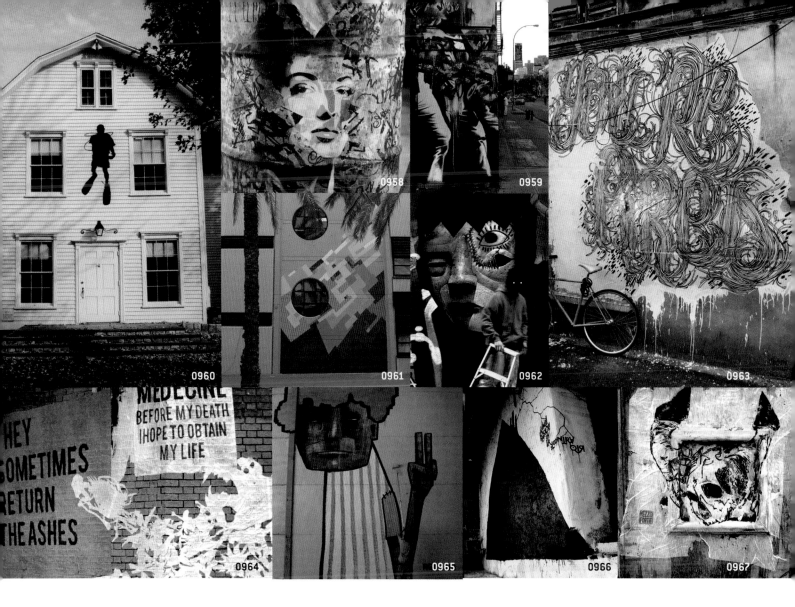

0958

0959

0960

0961

0962

0963

0964

0965

0966

0967

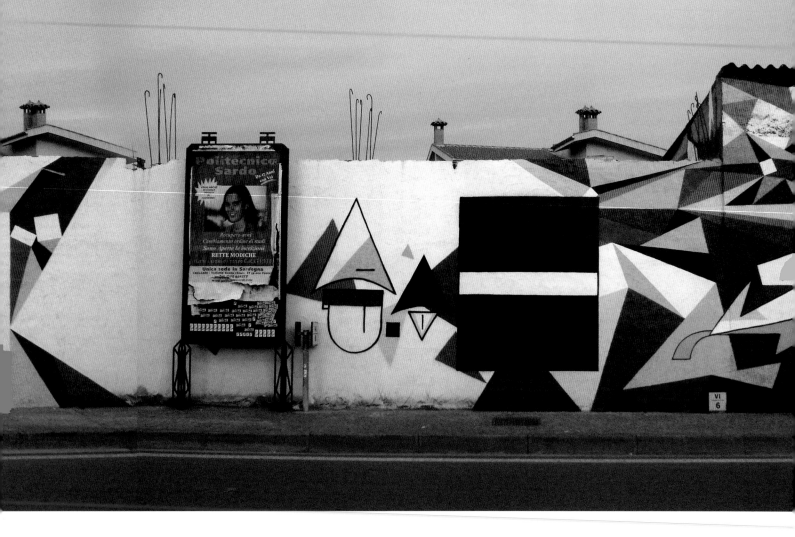

0968 Via Grafik. Wiesbaden, Germany

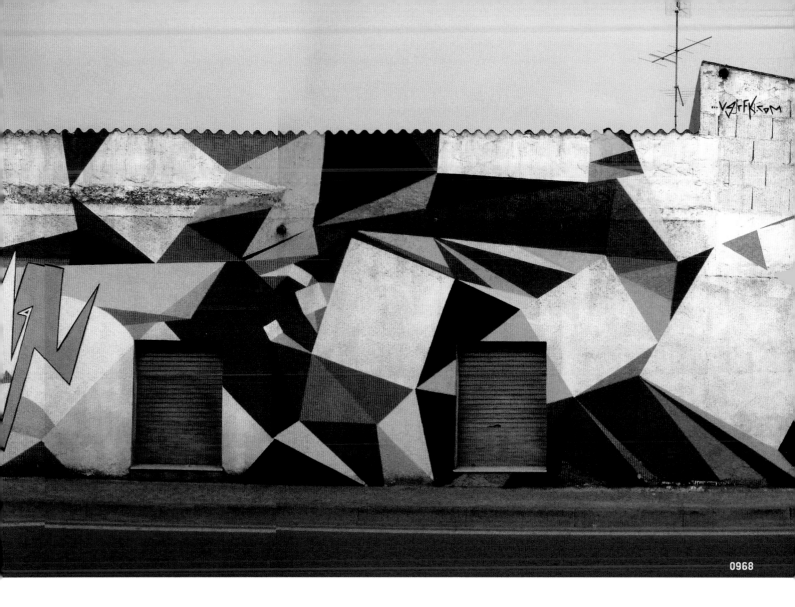

0968

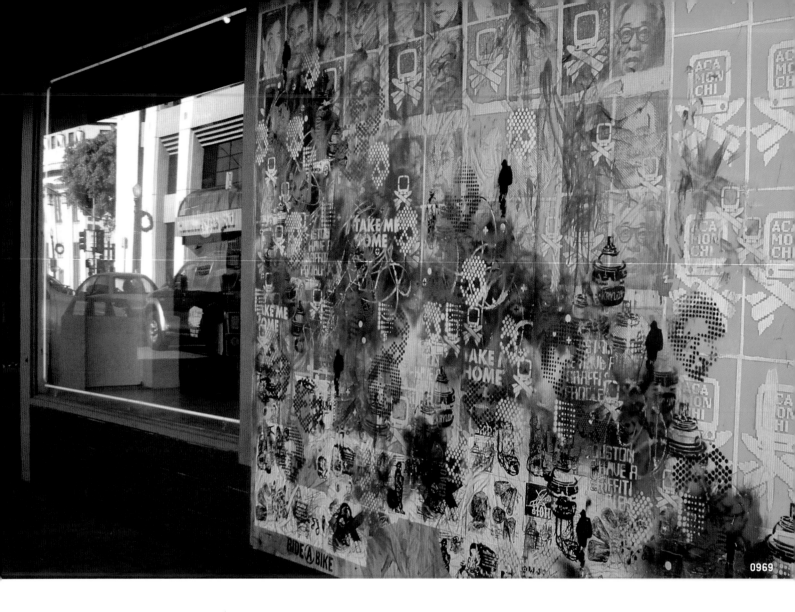

0969 Acamonchi. San Diego, CA, USA / **0970** Dan Bergeron/Fauxreel. Toronto, Canada

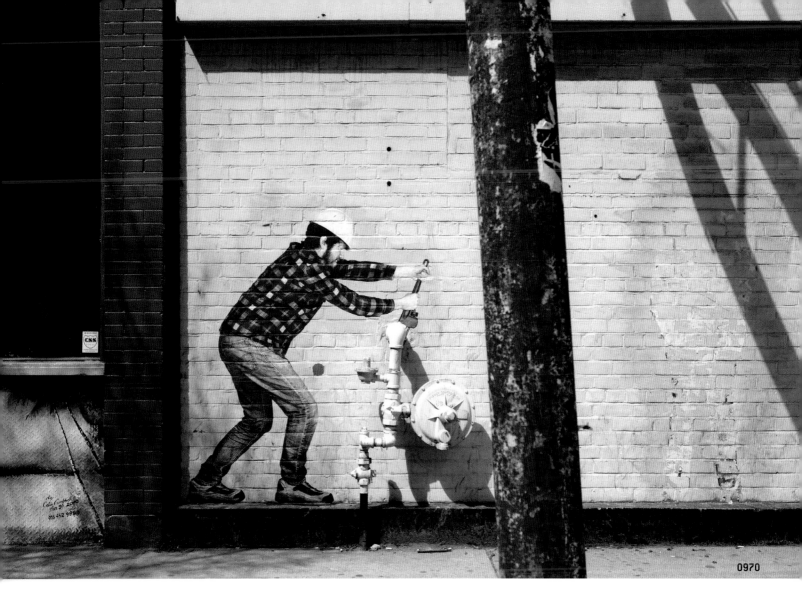

0970

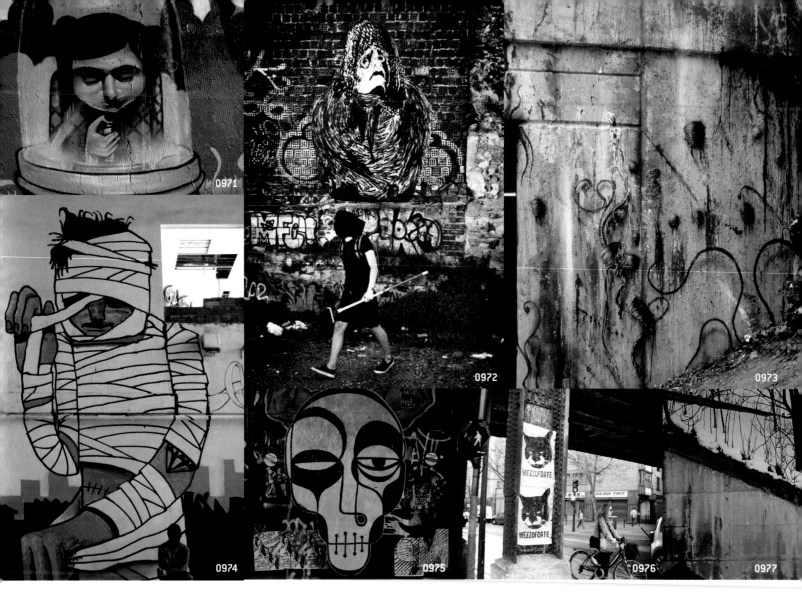

0971 Registred Kid. Barcelona, Spain / **0972** Mezzoforte. Paris, France / **0973** dust. Freiburg, Germany / **0974** Registred Kid. Barcelona, Spain / **0975** Dr. Hofmann. Barcelona, Spain / **0976** Mezzoforte. Paris, France / **0977** 108. Alessandria, Italy / **0978** Cobrinha. Buenos Aires, Argentina / **0979** Skount. Almagro, Spain / **0980** Registred Kid. Barcelona, Spain / **0981** 108. Alessandria, Italy / **0982** Doc Nova (Uwe H. Krieger). Gießen, Germany / **0983** dust. Freiburg, Germany / **0984** Aryz. Barcelona, Spain / **0985** Dr. Hofmann. Barcelona, Spain / **0986** Skount. Almagro, Spain / **0987** Cobrinha. Buenos Aires, Argentina

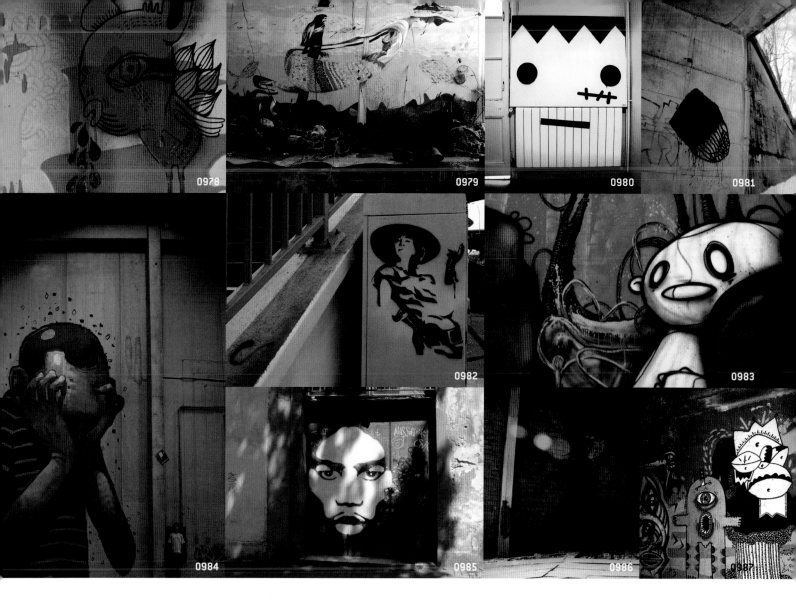

0978

0979

0980

0981

0982

0983

0984

0985

0986

0987

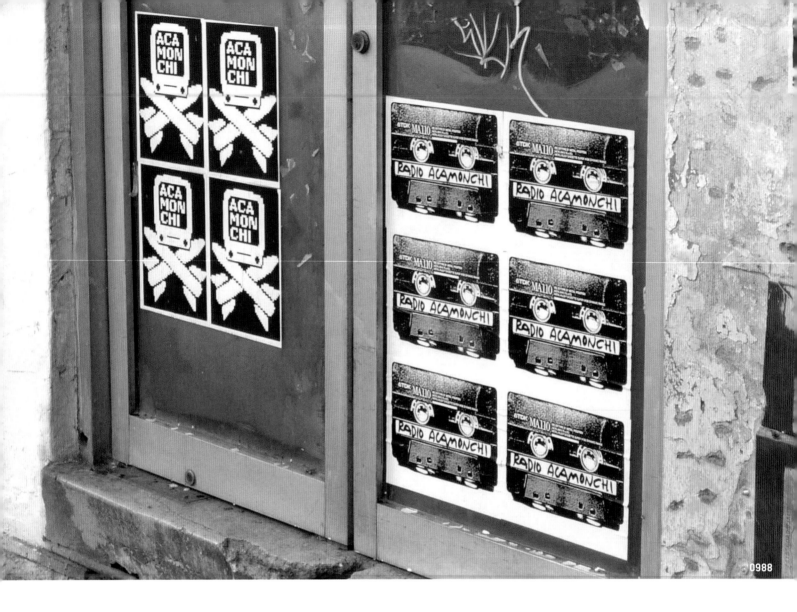

0988

0988 Acamonchi. San Diego, CA, USA / **0989** Skount. Almagro, Spain

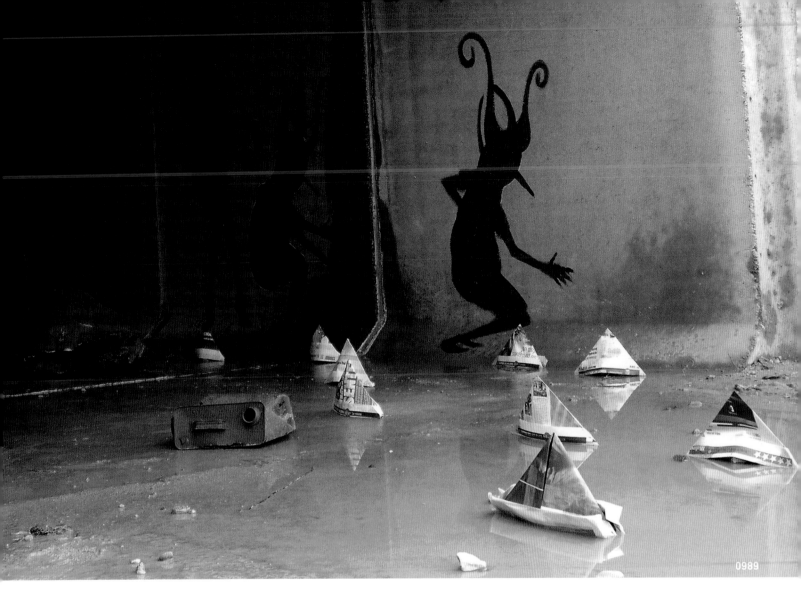

0989

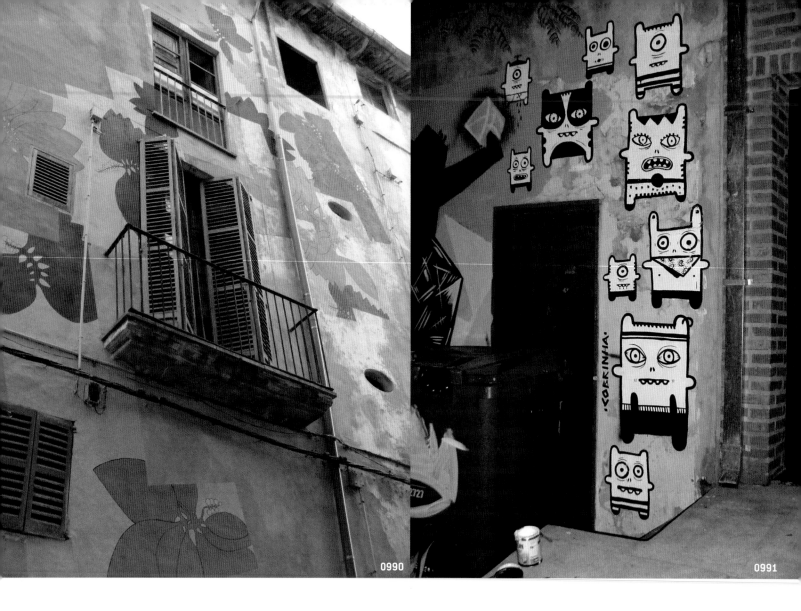

0990

0991

0990 Nuria Mora. Madrid, Spain / **0991** Cobrinha. Buenos Aires, Argentina / **0992** Conor Harrington. Cork, London, UK

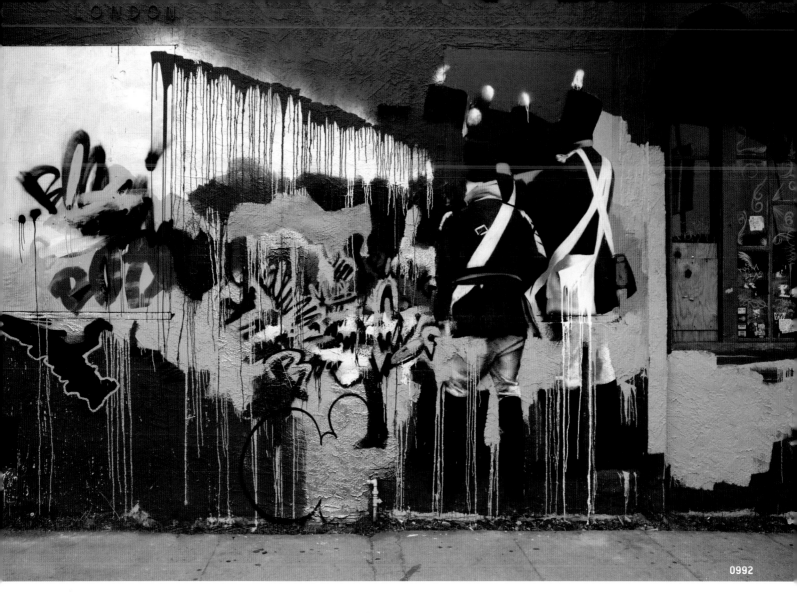

0992

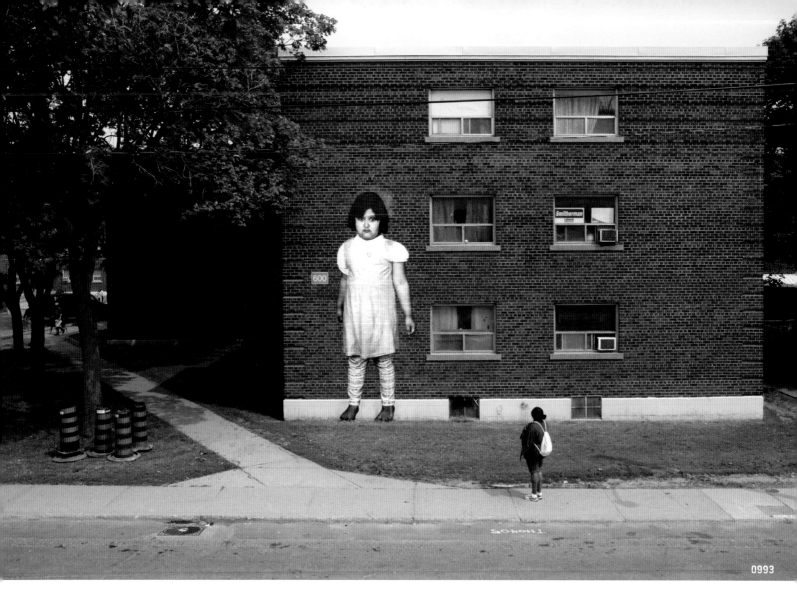

0993 Dan Bergeron/Fauxreel. Toronto, Canada / **0994** Mezzoforte. Paris, France

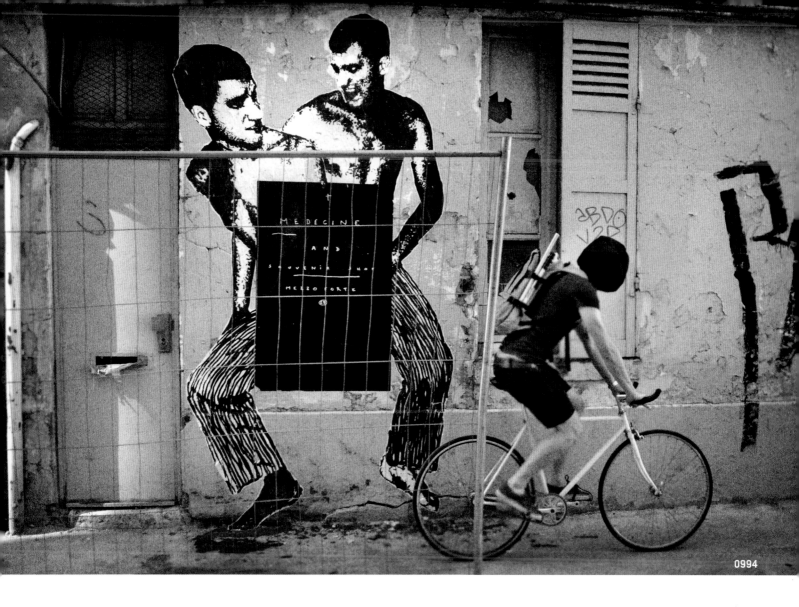

0994

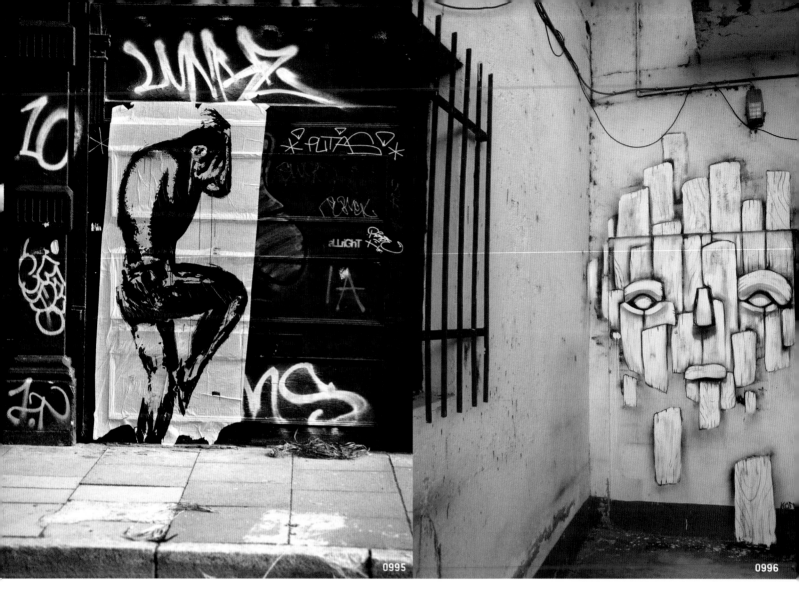

0995 Mezzoforte. Paris, France / **0996** Koes. Bassano del Grappa, Italy / **0997** Dr. Hofmann. Barcelona, Spain / **0998** Btoy. Barcelona, Spain

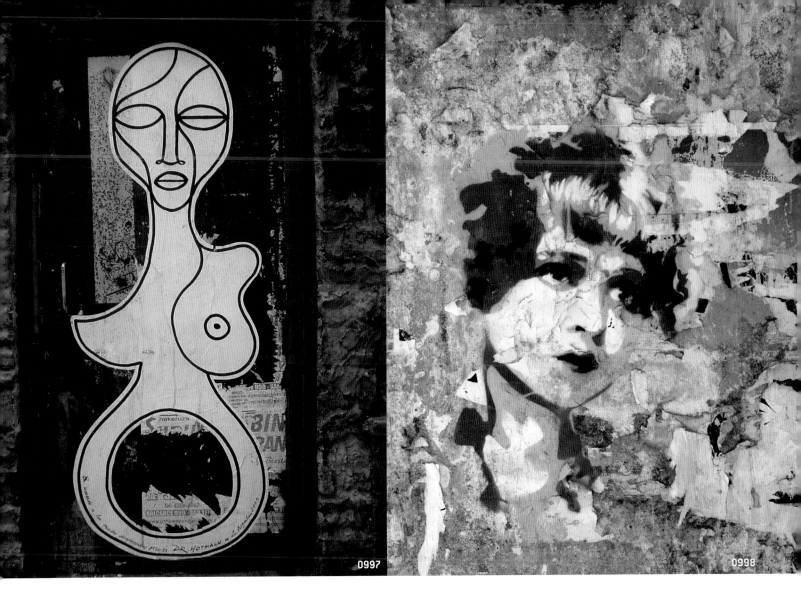

0997

0998

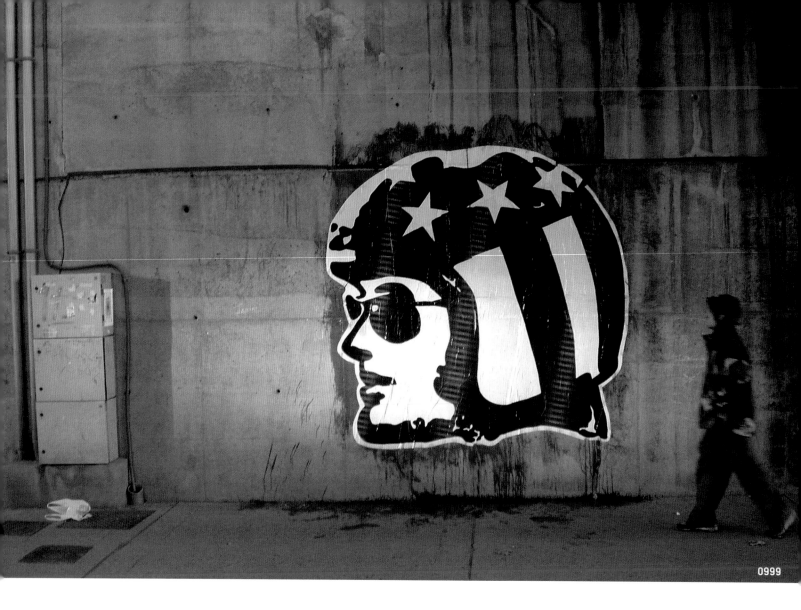

0999

0999 Dr. Hofmann. Barcelona, Spain / **1000** Dr. Hofmann. Barcelona, Spain

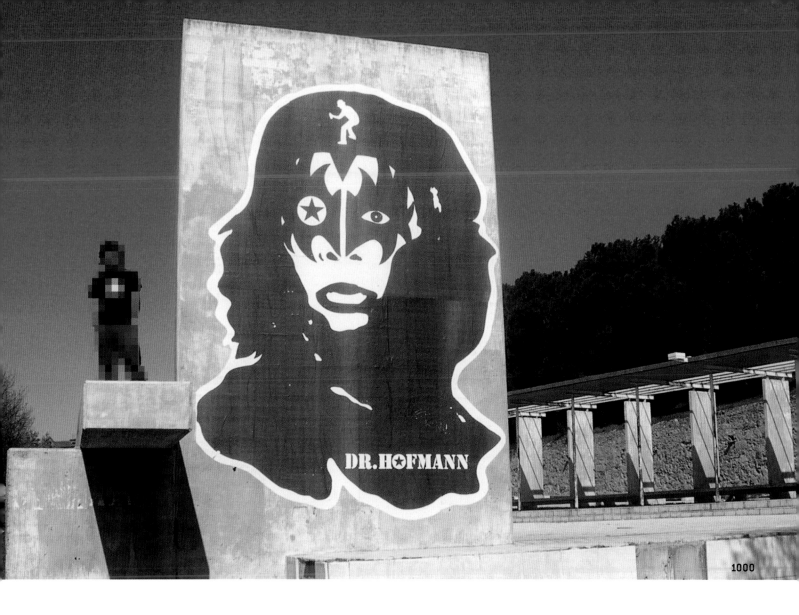

1000

DIRECTORY

108
www.108nero.com

Above
www.goabove.com

Acamonchi
www.flickr.com/photos/acamonchi/sets

AKIT
www.akit.co.uk

Anna Garforth
www.crosshatchling.co.uk

Aryz
www.aryz.es

Asia Komarova
www.asiakomarova.com
www.lespapillons-denuit.blogspot.com
www.youtube.com/asiakomarova

Astrid AKA CHOUR (3PP crew)
www.chour.20mn.com

Azek
www.azekone.com

BASK
www.knownasbask.com

Biofa
www.flickr.com/biofa
www.myspace.com/fabio_biofa

Bomber
www.bomber-graffiti.com

Brave 1 AKA Scotty~B
www.braveone.co.uk
www.myspace.com/brave1

Btoy
www.flickr.com/btoy

Cade
www.cadexl.blogspot.com

Chaz Bojorquez
www.chazbojorquez.com/book

Cobrinha
www.flickr.com/cobrinha_marian

Conor Harrington
conorharrington.com

Dan Bergeron/Fauxreel
www.fauxreel.ca

Dan Witz
www.danwitz.com

Danny "casroc" Casu
www.dannycasu.com

Darco FBI
http://darco.fbi.free.fr
http://fr-fr.facebook.com/pages/Darco-Fbi/129839087028356
http://asso-action-art.fr/actionart/darco.html
All Darco FBI images © ADAGP, Darco, Paris

Doc Nova (Uwe H. Krieger)
www.3steps.de

Dr. Hofmann
www.drhofmann.org

Drone
www.pedromatos.org

dust
www.dirtydust.de

Dyset
www.dyset.com
www.xhoch4.com

Eyeone
www.eyelost.com

Fafa
www.fafaworks.com
www.behance.net/fafaone

Fasim
http://fasimwild.carbonmade.com

Frerk
www.frerklebras.de

Galo
www.galosurreal.com

Grito
www.gr170.com

Insanewen (SPL Crew)
www.insanewen.com

Joan
www.joangel.de

Joe
http://joeking87.blogspot.com

Klaas Van der Linden
www.klaasvanderlinden.com

Koes
www.koes.it

MAC 1
www.flickr.com/photos/mac_1

Ma'La
www.mateolara.com

Malicia
www.numimalicia.com

Marc C. Woehr
www.marcwoehr.de

Mezzoforte
www.mezzoforte.fr

MFG Freight Crew (ECTOE, RTYPE, HAIKU, KOLA, SMUT)

Michael De Feo
www.mdefeo.com

monsieur Qui
www.monsieurqui.com

Mosaik
www.mosaikone.blogspot.com

Mr. Dheo
www.mrdheo.com

Mr. Flash (Joachim Pitt)
www.3steps.de

Mr. Wany (Heavy Artillery Crew)
www.wanyone.com

Nick Alive
http://nick-alive.blogspot.com
www.youtube.com/nickalive

Nados
www.toisestudio.com

Numi
www.numimalicia.com

Nuria Mora
http://nuriamora.com

Nychos
www.rabbiteyemovement.at

Okuda
www.okudart.es

Pariz One
www.ilovegraffiti.de/parizone

Phil Ashcroft AKA PhlAsh
www.philashcroft.com
http://philashcroft.tumblr.com
http://phlash.bigcartel.com
www.twitter.com/philashcroft

Pixote Mushi
www.pixotelc.blogspot.com
www.zuinn.com.br/pixote_mushi

Pose
www.pirminbreu.ch

Registred Kid
www.registredkid.com

Reso
www.reso1.de

Ripo
www.ripovisuals.com

RosyOne
www.rosyone.com
www.myspace.com/_rosyone
www.dopepose.com

Rusl
www.rusl1.de
www.myspace.com/ruslgrafx
www.flickr.com/photos/mrrusl

Sat One
www.satone.de

Seantwo (Loveletter crew)
www.yvo.li
www.a3collectif.ch

Seleka
www.ilovetocopy.com

SHOK-1
www.shok1.com

SiveOne (Kai H. Krieger)
www.3steps.de

Skount
www.skount-works.blogspot.com
www.flickr.com/photos/skount

SRG/Ger
www.srger.com

SUSO33
www.suso33.com

Target
www.stick2target.com

Tasso
www.ta55o.de
www.tasso-fassaden.de
www.myspace.com/el_kitsch_tasso
www.ibug-art.de

Toast One
www.toastone.com

Via Grafik
www.vgrfk.com

Wolfgang Krell
www.wolfgangkrell.de

Wonabc
www.wonabc.com

Zed1
www.zed1.it
www.myspace.com/xzed1x
www.myspace.com/bondagedesign

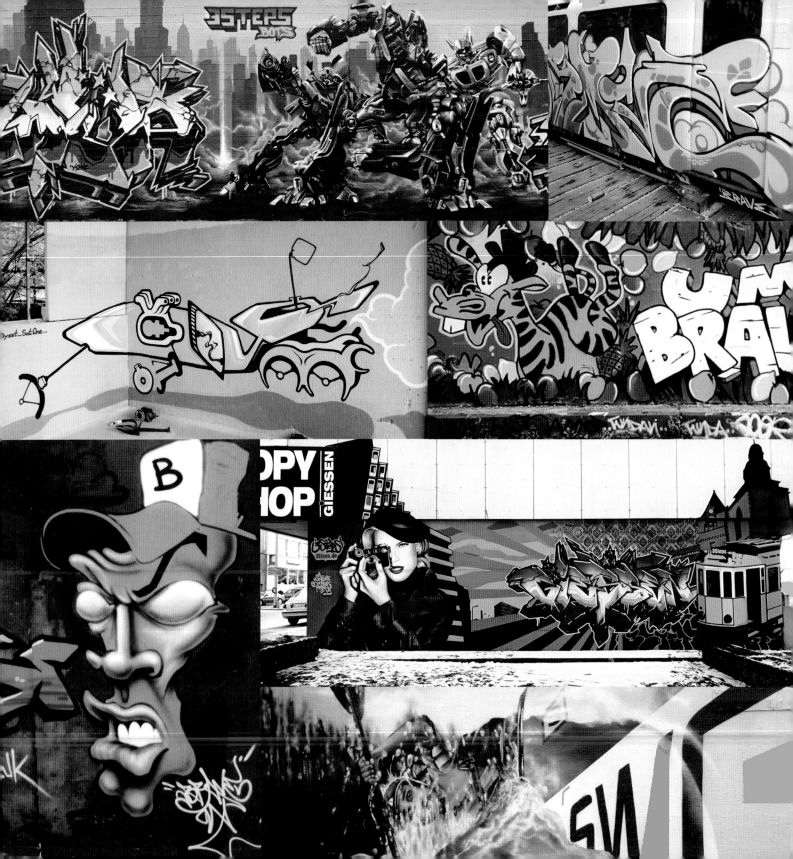